This Catalogue belongs to R.R. Bull
31 Regent Terrace EH7 5BS

Beyond
the Palace
Walls

 Islamic Art from the
State Hermitage Museum

Islamic Art
in a World Context

edited by
Mikhail B. Piotrovsky
and Anton D. Pritula

 **National
Museums
of Scotland**

NMS gratefully acknowledges
the generous sponsorship
of this publication
by the Moscow Narodny Bank

Published by
NMSE Publishing
a division of NMS Enterprises Limited
National Museums of Scotland
Chambers Street
Edinburgh EH1 1JF

British Library Cataloguing in Publication Data
A catalogue record for this book
is available from the British Library

10 digit ISBN: 1 905267 04 5
13 digit ISBN: 978 1 905267 04 0

Printed and bound in the United Kingdom by Cambridge Printing

www.nms.ac.uk
www.hermitagemuseum.org

Exhibition Credits

*Beyond the Palace Walls
Islamic Art from the
State Hermitage Museum*

National Museums of Scotland
Edinburgh
14 July to 5 November 2006

*Concept and co-organising of
exhibition:*
National Museums of Scotland
and State Hermitage Museum,
St Petersburg

NATIONAL MUSEUMS
OF SCOTLAND

Dr Gordon Rintoul, Director
National Museums of Scotland

Ms Mary Bryden, Director of
Public Programmes

Ms Catherine Holden, Director
of Marketing and Development

*Exhibition organising
committee:*
Dr Ulrike al-Khamis
Maureen Barrie

Exhibition working team:
Claire Allan
Steven Baird
Keith Brown
Tom Chisholm
Ros Clancey
Alison Cromarty
Alex Dyer
Jane Ferguson
Sarah Foskett
Michelle Foster Davies
Susan Gray
Vicky Hanley
Karen Inglis
Irene Kirkwood
Lesley-Ann Liddiard
Lyndsay McGill
Lynn McLean
Priscilla Ramage
Sandy Richardson
Charles Stable
Lyn Wall
Nicola Watt

Exhibition design:
Charlotte Hirst
Mairi MacLean
Helen Ferguson

STATE HERMITAGE MUSEUM

Exhibition steering committee:
Professor Mikhail Piotrovsky
Director, State Hermitage
Museum

Professor Georgy Vilinbakhov
Deputy Director (Research)

Dr Vladimir Matveev
Deputy Director
(Exhibitions and Development)

Tatiana Zagrebina
Deputy Director
(Chief Curator)

Dr Grigory Semenov
Head of the Department
of Oriental Art

Exhibition curator:
Dr Anton Pritula

Exhibition working team:
Dr Anton Pritula, Curator
 Department of Oriental Art
Dr Anatoly Ivanov, Curator
 Department of Oriental Art
Dr Adel Adamova, Curator
 Department of Oriental Art
Dr Grigory Semenov
 Head Curator, Department of
 Oriental Art
Svetlana Adaxina, Curator,
 Department of Oriental Art
Daria Vasilieva, Assistant,
 Department of Oriental Art
Anastasia Mikliaeva
 Head of Publication Section

*Photography (State Hermitage
Museum):*
Leonard Kheifets
Yury Molodkovets
Konstantin Siniavsky

*Restoration preparation of
the exhibits was made by the
artist-restorers of the State
Hermitage Museum:*
Tatiana Baranova
Alexey Bantikov
Natalia Bolshakova
Natalia Borisova
Svetlana Burshneva
Evgenia Cherepanova
Andrey Chulin
Cergey Cmirnov
Andrey Degtev
Marina Denisova
Galina Fedorova
Tatiana Grunina-Shkvarok
Angelina Karpechenkova
Valentina Khovanova
Tatiana Kolyadina
Christina Lavinskaya
Lyudmila Loginova
Igor Malkiel
Natalia Panchenko
Nina Pinyagina
Marina Popova
Anna Pozdnyak
Olga Senatorova
Tatyana Shlykova
Mariya Tikhonova
Natalia Yankovskaya

CATALOGUE

STATE HERMITAGE MUSEUM

*Authors and contributors to the
catalogue (State Hermitage
Museum):*
Adel T. Adamova (A.A.)
Svetlana B. Adaxina (S.A.)
Tatyana B. Arapova (T.A.)
Anatoly A. Ivanov (A.I.)
Elena N. Ivanova (E.I.)
Maria L. Menshikova (M.M.)
Ekaterina Nekrasova (E.N.)
Olga V. Osharina (O.O.)
Mikhail. B. Piotrovsky
Anton D. Pritula (A.P.)
Yury A. Pyatnitskiy (Yu.P.)
Grigory L. Semenov (G.L.S.)
Galina A. Serkina (G.A.S.)
Valentin G. Shkoda (V.Sh.)

Irina N. Ukhanova (I.U.)
Georgy V. Vilinbakhov (G.V.)
Tamara I. Zeimal (T.Z.)

NATIONAL MUSEUMS
OF SCOTLAND

*General editor for NMS and
author of NMS section:*
Dr Ulrike al-Khamis (U.Kh.)

Additional contributions:
Margaret Graves
Rose Watban

Catalogue project management:
Lesley Taylor
NMS Enterprises Limited –
Publishing
with Gillian Stewart
Marian Sumega

Catalogue layout and design:
Mark Blackadder

Translation:
Evgeniya Matyunina
with Stuart Robertson
Laurie Binnington

*Photography (National
Museums of Scotland):*
NMS Photography

Additional source material:

Prokudin-Gorskii photographs
used in 'The Art of Central Asia
(second half of the nineteenth to
the beginning of the twentieth
centuries)', are credited to the
Library of Congress, Prints &
Photographs Division, Prokudin-
Gorskii Collection [reproduction
nos. LC-DIG-prokc-20006 and
LC-DIG-prokc-21886.]

Published with support from
the National Museums of
Scotland.

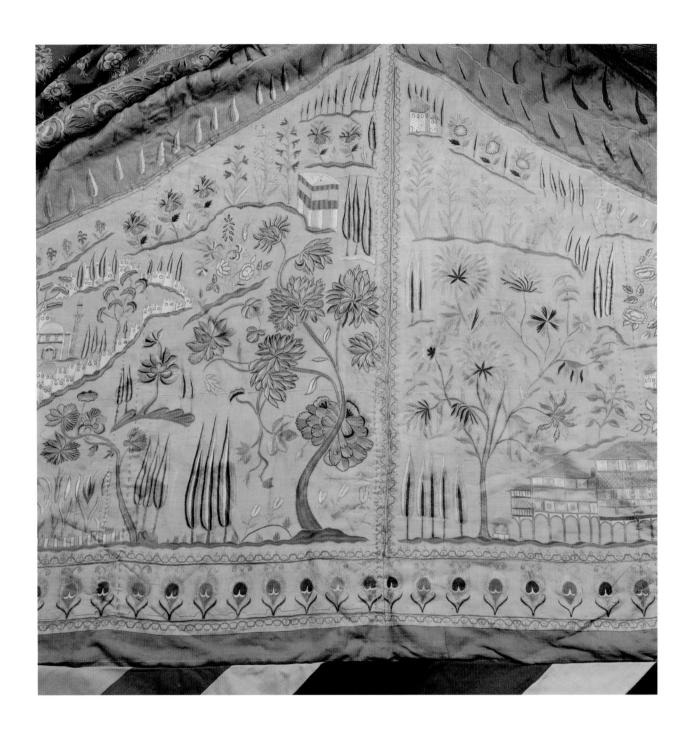

Contents

Foreword

Dr Gordon Rintoul
Director, *National Museums of Scotland*

The National Museums of Scotland is delighted to welcome back the State Hermitage Museum, St Petersburg, for a second year. Scottish links with Russia are historically strong, with trade and military connections that stretch back to the time of Peter the Great. Today that well established connection continues between the two countries.

This latest exhibition, 'Beyond the Palace Walls: Islamic Art from the State Hermitage Museum', has been built upon the foundations of mutual respect and friendship forged during last summer's highly successful exhibition, 'Nicholas and Alexandra: The Last Tsar and Tsarina'. It examines the beauty and diversity to be found in the artworks of Islamic cultures and demonstrates its willingness to adopt and adapt the traditions and craftsmanship of other cultures into a myriad of art forms. The exhibition is rich in costume, textiles and paintings, and features breathtaking works of art wrought in precious metals often studded with precious stones.

Central to the exhibition is a quite magnificent eighteenth-century Ottoman tent. Richly embroidered, the tent has never been on public display before. It offers a unique experience to the visitor, who will be able to enter the tent and marvel at the craftsmanship.

I am also delighted that the exhibition is part of this year's Festival of Muslim Cultures.

One person in particular has been instrumental in making this exhibition possible – Professor Mikhail Piotrovsky, Director of the State Hermitage Museum. I would like to take this opportunity to offer my gratitude to him for his continued support and generosity in agreeing to let us stage this wonderful exhibition.

I would also like to acknowledge the considerable contribution of the Embassy of Russia, London, in the bringing of this exhibition to Edinburgh, and Mr Vladimir Malygin, the Consul General for the Russian Federation here in Edinburgh, and his staff, who have worked tirelessly to assist our staff whenever possible. And, once again, we are indebted to Ms Geraldine Norman, the United Kingdom representative for the State Hermitage Museum, for all her help and advice.

I know my staff were delighted to work with the staff from the State Hermitage Museum once again and many strong working relationships have developed over the past year. Both exhibition teams take great pride in this achievement and have given their time and dedication to the project unstintingly. We are particularly indebted to Dr Anton Pritula, Curator in the Department of Oriental Art at the State Hermitage Museum, who was responsible for the original concept of the exhibition.

We hope that this partnership with the State Hermitage Museum continues to flourish and we look forward to collaborations with Professor Piotrovsky and his staff in the future.

Finally, on behalf of the National Museums of Scotland, I would like to thank HRH Prince Mohammed bin Nawaf Al-Saud, Ambassador of the Kingdom of Saudi Arabia to the United Kingdom, for his generous support of this exhibition, and Moscow Narodny Bank for their sponsorship of this catalogue.

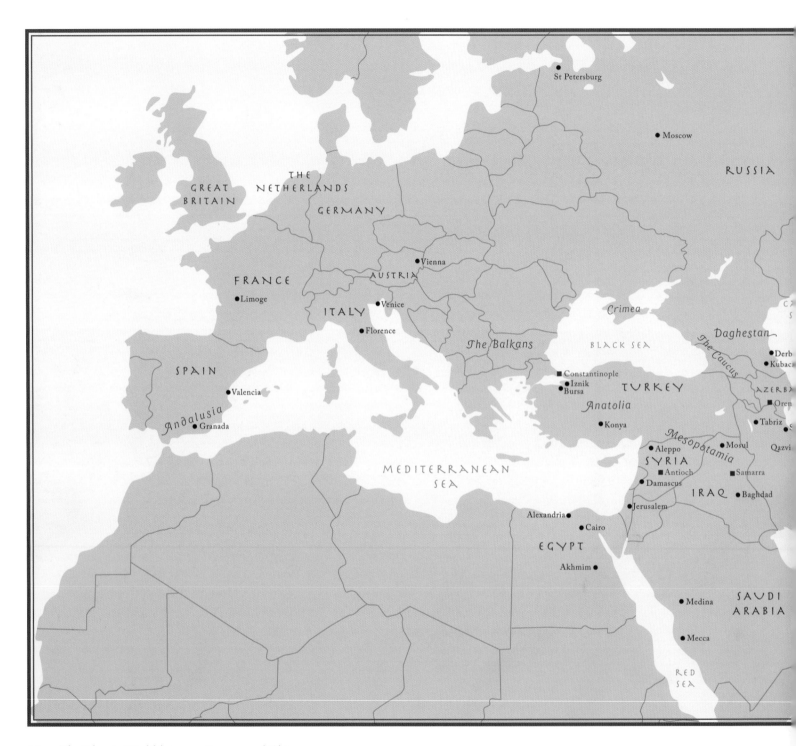

Map: The Islamic World between Europe and China.

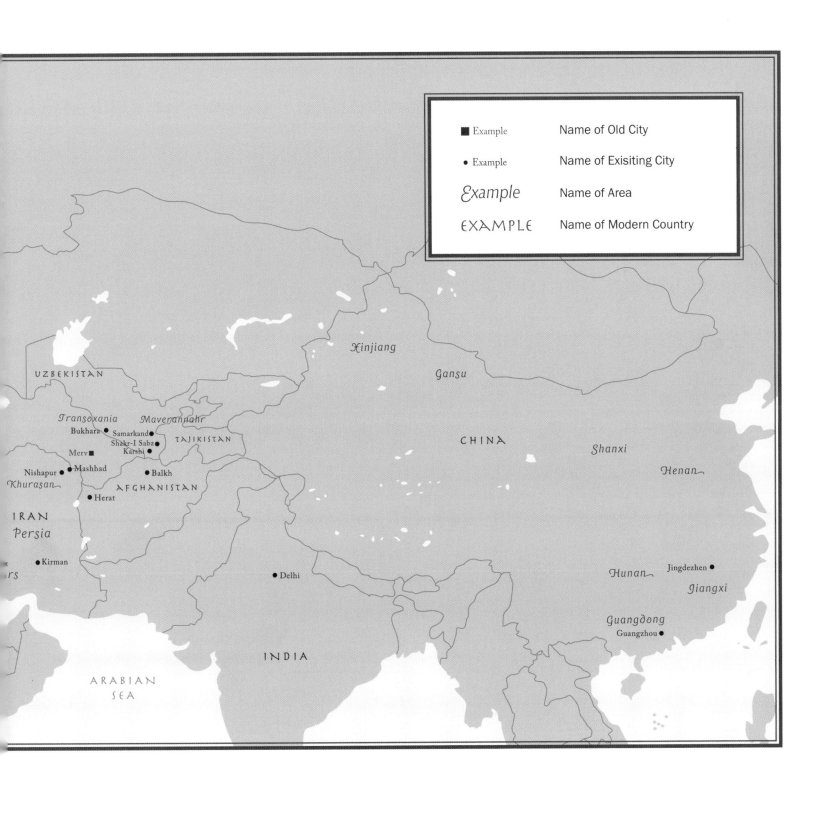

■ Example	Name of Old City
• Example	Name of Exisiting City
Example	Name of Area
EXAMPLE	Name of Modern Country

Xinjiang

Gansu

UZBEKISTAN

Transoxania *Maverannahr*

Bukhara • Samarkand •

Shakr-I Sabz •

TAJIKISTAN

Merv ■ Karshi •

CHINA

Shanxi

Nishapur • • Mashhad

Henan

Khurasan • Balkh

AFGHANISTAN

• Herat

IRAN

Persia

• Kirman

rs

• Delhi

Hunan Jingdezhen •

Jiangxi

INDIA

Guangdong

Guangzhou •

ARABIAN
SEA

Introduction

Between China and Europe
The Historical Context of Islamic Art

Professor Mikhail B. Piotrovsky
Director, *State Hermitage Museum*

Islamic art is an ambiguous and sometimes contentious term that includes the art of various peoples, at a time when they had adopted the religion of Islam. The creative work of these peoples is simultaneously a part of the development of the pre-Islamic cultural heritage, and a part of a single cultural world, united by Islam and its social and political institutions. This contradiction is itself one of the most appealing aspects of Islamic art. Its brilliant works of art are examples of a unique artistic language, which is at the same time both traditional and highly diverse. This is a language with many dialects and local vernaculars. Many, very different, peoples with their own separate histories, including art histories, were to accept Islam. Now we can easily distinguish between pieces made in Egypt, Iran, Central Asia, India or Spain.

Nevertheless, all these works share distinct traits, characteristics and techniques. They are all a part of the dynamic whole which is Islamic art – the art of the Muslim, or the Islamic, world. This art has absorbed the traditions and the rich heritage of all the peoples that built this world. Islamic art is also, in many ways, a statement of the many religious principles of Islam, and the way of life that came into being under the influence of that religion.

The same can be said to take place on a global scale. Every culture is part of a single human civilization.

Different cultures have common traits and unique differences, be they large or small. Many of these cultures have been in mutual contact for millennia. Traditionally, we have come to speak about the influence of one culture on another, though it may be more accurate to speak of a mutual exchange of influences. Trade links, religious preaching, wars and the conquest of foreign lands all generated mutual interaction between cultures. Such events ensure a dynamic unity, involving all of humanity. It is fascinating – and important – to trace these links and ties, their historical development, and the fantastical twists and turns they describe. This exhibition is intended to display the greatness of Islamic art, both its inner unity and its interactions with other great cultures, and cultural worlds.

Such interaction can be 'vertical' or 'horizontal'. Vertical interaction engages the roots, the sources, the regional substrata of a culture. Such interaction involves more than influences flowing from the past, but also includes the selection, interpretation and perception of this past within the framework of a later culture. An example is the contemporary perception of classical Islamic art. Horizontal links spread far wider: the Islamic world reaches from ancient China to India, Byzantium, and a Europe that was gradually rising to greatness. Islam was engaged in a constant process of interaction with all of these different parts of the world – a process

that had colossal cultural consequences. In different periods the importance of individual directions and movements may have changed, but together they interwove to hold a huge world together. Discoveries and inventions in art and science crossed continents in every possible direction.

Cultural artefacts were passed around the world like relay batons: Chinese porcelain was translated into Nishapur ware in the Islamic world, and then into Fatimid ceramics and Kashan ware. In the west the wave of invention brought lustre ceramics to the shores of Spain which spawned the ceramics of Christian Spain, and the famed Italian majolica. Just as it had brought together worlds in ancient times, so the Great Silk Road tied together the world under Islam. The Venetians brought Eastern fashions to Europe, and then brought European fashions to the East. Our exhibition is a modest attempt to trace certain aspects of this grand intercourse, to see and understand Islamic art in the multiplicity of connections, and to enhance the pleasure of exploring the field. The artefacts in the Hermitage give us a unique opportunity to do this sort of work; such dialogues with culture must surely be the mission of truly 'encyclopaedic' museums.

Of course, almost the same territories that the Islamic world covered had already seen a single, united culture that integrated many artistic traditions and value systems from around the world, both horizontally and vertically. This was the world of Hellenism, when the forays of Alexander the Great resulted in the birth of a civilization in which many traits of Eastern and Western cultures, and of old and new faiths, merged into one cultural body.

Arab, or Muslim, conquests were of the same scale, and in many ways had similar consequences. Immediately following the death of the Prophet Muhammad, Muslim units, and then whole armies, quickly conquered almost all the civilized world. A new, universal political system arose, new trade links, a new, universal view of the world, a new culture, a new art. In a series of distinct stages, the new world then integrated and assimilated its vast inheritance.

The Arabs brought a holy text – the Qur'an – and the Arabic language, in which it was created, and in which Arabic poetry was later written. This language and the Qur'an together contained the set of aesthetic principles that would influence the subsequent cultural synthesis. These included the mathematical transparency of structures, the rhythm and ornamental repetition of shapes and images, and the striving for the economic and elegant communication of abstract ideas, combined with a tangible specificity of recognizable details.

The Arabs had much experience in assimilating foreign artistic and social traditions in everyday life. They quickly accepted the heritage of Byzantium (in Syria and Egypt) and Sassanian Iran, as well as that of Central Asia. The craftsmen of newly-Islamicised peoples fulfilled commissions for new buildings, and new luxury and household items. Old canons and approaches were gradually replaced, due to the influence of new tastes and the ideas of clients, and as a result of interaction between various fundamental traditions.

One splendid example of this process is the famous Dome of the Rock in Jerusalem. This building clearly serves both artistic and ideological goals: to underscore the triumph of Islam, as both the victor and successor of previous monotheistic religions. There are no depictions of living creatures. The artistic motifs in the mosaics combine Byzantine techniques and styles with images

of priceless Iranian ornaments, hanging from bushes in Paradise. This can be thought of as the essence of Muslim integration of the artistic traditions of both worlds.

The medium of silverware, so typical of Sassanian culture and the domestic luxury of Byzantium, now assumed Islamic traits, and was soon to become the medium par excellence of Islamic art. Figurative art gradually became stylized and formalized. Where it was still considered acceptable to depict the figures of people and animals, these became more compact and schematic, while haloes ceased to be anything more than a decorative element. Sassanian and Byzantium motifs were transformed into a standard, almost canonical set of secular themes in Islamic art: a banquet, musicians, hunts, battles, astrological symbols. This was the alternative to a Christian system of strictly religious symbols.

Islamic art was born with its own innate system of rules and concepts. Like Byzantine art in that same initial period, and much like Protestant and Jewish art, Islamic art is intrinsically iconoclastic. It is considered impossible – improper – to use images of living creatures to narrate holy stories. Man learned about God through the Word, and not through pictures. Pictures, even icons, could distract from the path of pure monotheism, replacing God with idols. The depiction of people was only possible where there was no danger of idolatry.

Islamic art follows the Qur'an with regard to the principles of regularity, mathematical transparency and the repetitiveness of text. Thus appears an 'abstract' approach to art, one that combines three main elements of ornamentation. Calligraphy is subjected to scrupulous mathematical measurement, and serves both to please the eye, and as a form of communication with God. The beauty of God's word decorates books, day-to-day objects, even buildings. Calligraphy combines sacral meaning with sacral beauty. Inscriptions almost come to replace icons: they offer no threat of creating 'idolatrous images'.

As the abstract reasoning of theologians developed, and mathematics became ever more central to Muslim thought, a complex system of geometric ornament evolved as the optimal medium for illustrating the idea of an infinite, divine Absolute. The sprawling plant ornament of Byzantine and Sassanian art transforms into the strictly calibrated lines of the arabesque – an unending stream of 'grape vine' shoots with stylized images of fruit, animals and people. This is a form of beauty which recalls to the viewer the eternal benevolence shown by a merciful and loving God to his creation, which He has showered with the riches of nature, and which He guides through the endless cycles of earthly existence.

Grandiose architectural works are typical of Islamic art; these imitate the cosmic spheres, as if making them proportionate with man. Mosques are both colossal and intimate. Meanwhile, creative craftsmanship spreads to day-to-day household objects, to the applied arts, to objects intended to be held in the hands and examined in detail. Luxury items carry only the memory of their domestic uses. No one used luxurious, silver-inlaid buckets to wash in the baths, although everyone knew why the shape was originally created. There was almost no intermediate step between the monumental and the domestic; this is another of the fundamental differences between Islamic and Christian art.

These basic characteristics of Islamic art – including the unique style of two-dimensional depictions of solid

figures, with a set of canonical traits and a consistent repertoire of images – came into being during the beginning of the Umayyad and Abbasid Caliphates. They stabilized further in the eleventh century when the classical culture of Islam crystallized into an elegant system integrated into the theological and philosophical sciences, against a backdrop of political diversity that – like art itself – preserved a unified system of political power. The political reinforcement of Turkish elements in the ruling classes led to an increase in the influence of the steppe in works of art. The criteria and standards of beauty underwent a series of changes at this time. The rise of the Iranian nobility led to a new synthesis of Iranian components with elements that had already matured, both Islamic and those indigenous to Turkish culture. This explains the injection of tastes and traditions from Central Asia, India and China – the Great Silk Road had once again become a vital cultural conduit.

Now Islamic art acquires a new characteristic that would become as fundamental as 'mathematical asceticism'. This is also mathematical, but it is the 'love of life', the adoration of luxury and beauty as a reflection of the splendour of heaven that has been promised to the faithful. Such an aspect can be seen as both a beautification of this life and an exhortation of the life that awaits the righteous.

In Fatimid Egypt, which enjoyed active interaction with Mediterranean Europe and Byzantium in both secular and non-secular spheres, sophisticated styles of rock crystal and stone carving came into being, as well as rich weaving and exquisite ceramics. To the devoted, all these luxury objects, just like everything else within the Islamic world, held an inherent mystical significance.

In the thirteenth century the entire Eastern Islamic world was conquered by the Mongols. They destroyed a significant portion of the cultural treasures, as well as the cultural centres and powerhouses of the Islamic world, but failed to overcome the pervasive influence of high culture. They adopted Muslim concepts of beauty and luxury, accepted Islam and thus stimulated the continuing localization of Islamic art. After the Mongol conquest, interaction with the art of China and India flourished in the newly-formed states. The resurrection of the art of book illustration, for example, was fundamentally influenced by Chinese traditions. As in ceramics, the relay baton of painting techniques and motifs is handed from culture to culture. The Chinese style of drawing is combined with Iranian two-dimensional decoration, while Chinese clouds and dragons become a fixed feature of landscapes in book miniatures and rug patterns. Subtle elements of 'Chinese' aesthetics took on a wholly Islamic appearance, and in this new guise reached Europe – a forerunner of direct ties between Europe and China. The process was not one of straightforward borrowing or simple appropriation, but the total transplantation of traditions, as the Islamic world handed to Europe complete and fully-formed cultural phenomena. In the East of the Islamic world a new field of culture arose, where the traditions of Iran, India and China were combined and constantly re-worked by the Islamic world, to create the extraordinary and all-encompassing art of the Timurids, the Safavids and the Great Mughals. Decorative woven rugs were one of the main products of this synthesis, and soon became an omnipresent component of world culture.

Neither did Chinese culture remain aloof from Islam. Local Chinese Muslims created stunning examples of

Chinese Arabic calligraphy, a natural extension of traditional applied art forms.

In the West, the Islamic world assimilated and transformed the trends that flowed from the East. A new cultural space was forming, as neighbouring states around the Mediterranean joined in the transfer of cultural legacies and the assimilation of a single artistic language. In Muslim Spain, and occasionally Christian Sicily, cultural bilingualism evolved into a common language. Spain proved to be especially fertile ground – it was here that the philosophical inheritance of antiquity was transferred to the Christian world, now reinterpreted by Islam. After absorbing this reinvigorated legacy of Antiquity, Christian thought turned back to the sources of Antiquity to create a European hypostasis of ancient philosophy. Popular poetry was sometimes created in two languages, while the language of art was often already shared – this is why the mosque of Cordoba and the Alhambra have become the common heritage of today's Europe.

The Venetians built their city with fresh memories of the splendid metropolises of the Islamic world where they had easily accumulated their vast fortunes. The Crusades, despite the bitter ideological differences they represented, played a huge role in the artistic synthesis between Europe and the Islamic world. We know that the feudal rulers, both the Muslims and the Franks, quickly found common ground away from the battlefield, communicating easily, sometimes even enjoying friendships. Muslim tastes were quickly assumed by the Crusaders, before being passed on to Europe. Muslim luxury items, weapons, cloth, crystal goblets and precious wares became for Europe the standards of good taste, and spurred on local creativity and production. It was at this time, and especially during the rule of the Mamluks in Egypt, that we find a large number of works of art, created in a Muslim artistic language, but without any signs of religious attribution. It is clear that Muslim craftsmen often created works of art for Christian clients.

First, art objects from the East became a part of life in Europe. Crystal and glass goblets, luxurious cloths, and decorative rugs were shipped home from the East. Then they were gradually assimilated: glass and crystal were preserved in precious metal mounts, this time made by Europeans. Decorative cloths were used to make vestments for priests. Rugs were named after the artists that chose to paint them (such as 'Lotto Rugs' after Lotto Lorenzo, and 'Holbein Rugs' after Hans Holbein the Younger). The logical progression was to commission the manufacture of goods made by Muslim craftsmen, apparently specifically for export, for Christian customers.

Islamic art, as something known and tangible for Europeans, clearly played a role in stimulating the European Renaissance. It is accepted knowledge that Europe had its own traditions of spirituality and mysticism, but the East demonstrated to Europe an amazing combination of the love of mathematics, philosophy and life as an essentially organic process, together with a strong taste for living in elegance and luxury. This combination, already reminiscent of antiquity, was to take hold in Renaissance Europe once again.

In the seventeenth to the nineteenth centuries, Europe became the dominant force in this mutual exchange of influences.

Many European innovations in the arts quickly found their place in Islamic art. The plant ornament of the Taj Mahal follows Muslim aesthetics, even though it was inspired by European botanical atlases. Mean-

while, the jewellers of Mughal India used Colombian emeralds to create undeniably Eastern objects.

At the same time, Iranian and Indian artists used European engravings as inspiration for their own book miniatures, gradually displacing the traditional canons. The direct exposure to Venetian painting brought new techniques and a new sense of the world to Turkish miniature painting. The techniques of European easel painting were also to create a magnificent synthesis of artistic traditions, just as Iranian painting had during the rule of the Qajar dynasty in Iran.

All these processes continue even today. In places one can even observe a mutual reciprocity, although the European element is dominant. Nevertheless, one has the feeling that all the elements of mutual influence discussed above still have the potential to enrich each other further, as has been the case in the past.

The world has never truly been divided, and today's primitive, one-sided globalization is just one of many historical trends. All the world's cultures have taken something from each other in the past, and continue to do so. One element may be quickly adopted and assimilated into the indigenous culture, while another is rejected as incompatible; far more is simply forgotten, or taken too long to absorb. To me, this is the template for the future development of cultural 'relay batons', whose story we have tried to tell in this exhibition.

In any case, I am sure that these splendid creations by gifted artists and craftsmen are more convincing than any number of words.

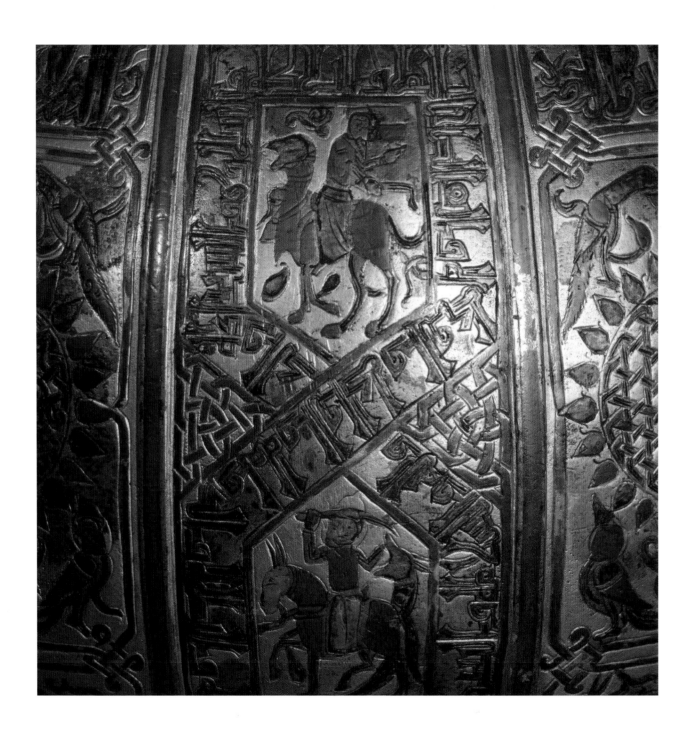

PART I: EARLY ISLAMIC ART UNTIL THE MONGOL INVASION
(seventh to thirteenth centuries A.D.)

The Art of the Caliphate

Mikhail B. Piotrovsky

After the death of the Prophet Muhammad in 632 the Muslim community was governed by 'representatives' or Caliphs. Military campaigns to conquer land for the new faith began, and the community was transformed into a state – the Caliphate. The first four Caliphs, who were called the 'rightly guided', ruled from Arabia. Then the Umayyad dynasty made Damascus the capital of the state. The borders of the new empire were rapidly expanding to include the main provinces of Byzantium: Egypt, Syria and North Africa, while Spain also became part of the Caliphate. To the East, all of Iran became Muslim, followed by Central Asia and North India. In 750 the Umayyads were deposed by the Abbasids, who founded a dynasty centred on Iraq and built a new capital – Baghdad.

In the tenth and eleventh centuries the control enjoyed by the Caliphs began to weaken. The provinces of the Caliphate, one after another, became either virtually or totally independent. In Baghdad itself, caliphal power was restricted by Iranian and Turkish troops and their commanders, as well as the highly volatile city population led by influential religious figures. However, the political fragmentation failed to destroy the highest level of unity: a shared basic religious doctrine (despite the presence of individual sects and movements), a common structure of political power, and the sense of belonging to a single *ummah*, or community of Islam. In art, too, diversity began to coexist with a basic and tangible unity.

The Caliphate created masterpieces of monumental art: grandiose new mosques and palaces were built, and entire new towns sprung up. Military victories brought rich booty to the towns, but intensive international trade would lead to the accumulation and flow of even greater riches. Luxury and beauty became the hallmarks of life among the upper and middle classes.

It was during this period the main characteristics of Islamic art began to form. The heritage of preceding cultures began to be assimilated, as the artistic languages of Iran and Byzantium were adapted to the needs and tastes of the Muslim world. Many works of this time clearly bear the traits and techniques of previous ages; these artefacts are the direct extension of previous artistic traditions, and are frequently hard to distinguish from similar artefacts made prior to the spread of Islam.

New artistic styles were gradually developed, and became fairly distinct by the eight and ninth centuries. The rule of the Abbasids in Iraq represented a crucial phase in the birth of a new culture – the gradual transformation of a complex artistic inheritance over a long period of time guaranteed that Islamic art evolved into its historically significant successor. Instead of being an isolated episode, Islamic Art can be seen as an important stage in the development of the cultures of the Mediterranean and the Orient, a continuation of the synthesis of Hellenistic and Persian culture.

This section includes several examples [cat. nos 1, 3 and 4], illustrating how the New evolved from the Old.

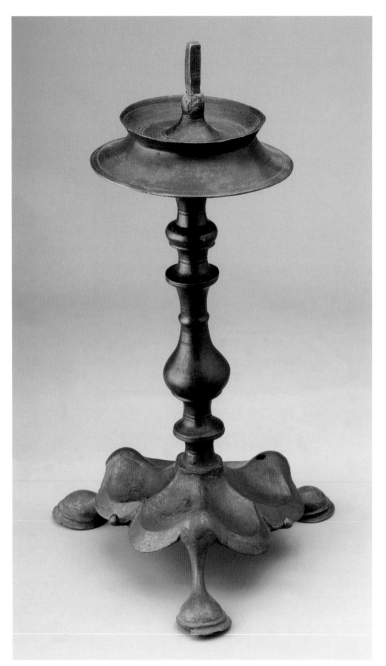

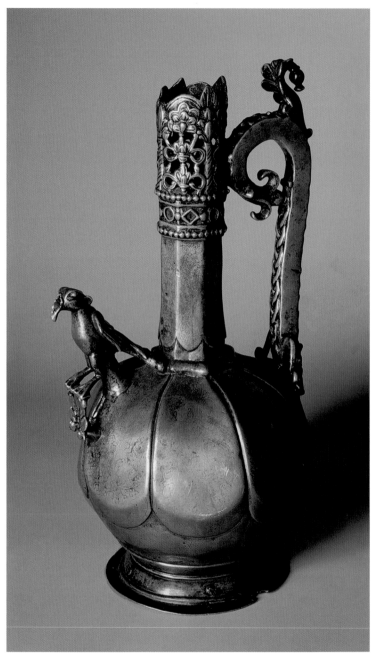

The Art of the Caliphate

1
CANDLESTICK

Egypt (Akhmim), 6th to 7th centuries

Cast bronze; 27.3 cm (height)

Origin: acquired in 1898 from V. G. Bock's expedition to Egypt

State Hermitage Museum, inv. no. 10584

References: Kryzhanovskaya 1926, p. 71

Candlesticks like this example are typical of the Eastern Mediterranean of the fifth to seventh centuries (Mango 1986, pp. 96-101, see figs. 11.3-6, 12.3-5; Gonosova and Kondoleon 1994, p. 259; *Byzantine Hours* 2001, p. 100, fig. 114). They represent a further development and stylized version of older prototypes. Most of these candlesticks, including ones made of silver, were discovered within the territory of Syria (Weitzmann, *et al.* 1981, p. 620, no. 556; Drayman-Weisser 1992, pp. 191-95, figs. 7-8; Ross 1962, p. 34, no. 34). Several researchers, in particular J. Strzygowski (1904, pp. 285-87), have suggested that they originally came from Alexandria in Egypt (Dalton 1911, no. 495; Wulf 1909, no. 1996, pl. 1; Ross 1962, p. 33, no. 33). Candlesticks of this size were usually put on a table or placed into a niche. (O.O.)

2
EWER

Iraq, 8th to 9th centuries

Cast bronze (brass), engraved; 40.5 cm (height)

Origin: acquired in 1925 from the State Academy for the History of Material Culture (A. A. Bobrinskiy Collection)

State Hermitage Museum, inv. no. IR-2316

References: Orbeli–Trever 1935, table 75; Marshak 1972, pp. 80, 81, illus. 16; Loukonine–Ivanov 1996, no. 85

Exhibitions: München 1912, B.II, Taf. 182; Leningrad 1935, p. 230, no. 1; Stockholm 1985, p. 108, no. 1; Kuwait 1990, no. 3; Amsterdam 1999, no. 201; St Petersburg 2000, no. 230

This ewer has an almost spherical body, high-faceted neck with an openwork finial, a spout in the form of a bird, and a handle decorated with a palmette containing a pomegranate. It belongs to a group of similar-shaped ewers, usually with engraved ornamentation on the body (although on a related ewer of identical shape from the Hermitage Collection there is also copper and silver inlay). Engraved ornamentation and a limited degree of metal-on-metal inlay were distinctive features of bronze items made in the central lands of the Caliphate from the eighth century and they occur on other items as well, e.g. a figure of an eagle dated 796-97 from the Hermitage, and a ewer made in Basra, now in the Museum of Georgia, Tbilisi. On the ewer under discussion, a small image of a butterfly (or bee?) can be seen beneath the feet of the bird-shaped spout. B. I. Marshak stated that this motif suggests contact between the art of the central Caliphate and the art of the Turkoman nomadic tribes in Central Asia. This was particularly intense in the eighth century, during the wars between the Muslims and Turkomans over the territory of Central Asia. If this is correct, this ewer was most likely produced at the end of the eighth to beginning of the ninth centuries, and its place of origin is assumed to be the capital of the Caliphate, i.e. Baghdad. (A.I.)

3
TRAY WITH A HORSEMAN

Eastern Mediterranean (Alexandria or Antiochia), 7th century

Cast bronze (brass), engraved; 56 cm (diameter)

Origin: acquired in 1930 from the State Museum of History, Moscow

State Hermitage Museum, inv. no. KZ-5759

References: Orbeli–Trever 1935, table 64; *Survey* 1939, vol. VI, pl. 236; Trever 1959, p. 316, table 26; Marshak 1978, pp. 27-28, 38, 41-42, 46; Mammaev 1989, illus. 68

Exhibition: Leningrad 1935, p. 231, no. 6

This tray belongs to a group of trays of similar shape. In the centre of the tray is a hunter on a horse, with a dog. Around the tray there is a wide rim, and around the centre there are four large medallions with images of gladiators fighting with wild animals.

There are known to be eleven such trays in different museum collections around the world, of which nine are intact: seven are kept in the Hermitage, fragments of a tenth are in Sweden; and the eleventh, with an added middle section (probably in the nineteenth century), is in private collection in St Petersburg.

It was long thought that most of these items were preserved in Daghestan; however, in the case of this tray, it is possible to prove with documentary evidence that it was in fact kept in the village of Kubachi (Daghestan) in the 1890s. Two trays were bought from people from Kubachi in 1926. They were among other artefacts brought for sale to the State Hermitage. However not all these artefacts had been kept in the village. Two more trays were acquired in 1924 from the Museum of Baron A. L. Stieglitz's Central School of Technical Drawing. Originally they were in the collection of V. P. Charkovsky, although little is known about their history before reaching this collection. Perhaps they were collected in

Iran or in Transcaucasia, where Charkovsky did military service, but this is a subject for further investigation.

All the trays under discussion here were reviewed in an extensive article by B. I. Marshak, published in 1978. The history of the formation of early Islamic art in the countries of the Eastern Caliphate, from the seventh to the ninth centuries, can be traced on these trays.

The decoration of the tray featured here has aspects of late classical and Byzantine artefacts, dated no later than the fifth to sixth centuries. However the absence of direct prototypes for this decoration, and the connection to other trays which are more Eastern in some elements and produced at a later date, allow us to consider this tray with the horseman as an 'article from a Hellenised Eastern Mediterranean centre such as Alexandria or Antiochia', datable to around the seventh century (Marshak 1978, p. 46). (A.I.)

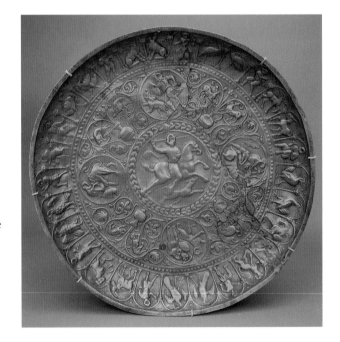

4
EWER

Iraq, 8th to 9th centuries

Cast bronze (brass), engraving, copper inlay; 39.2 cm (height)

Origin: acquired in 1925 from the State Academy for the History of Material Culture (A. A. Bobrinskiy Collection)

State Hermitage Museum, inv. no. KZ-5753

References: Orbeli–Trever 1935, table 72; Marshak 1972, pp. 85-87, illus. 11/4; al-Khamis 1998, pp. 9-19

Exhibitions: München 1912, B.II, Taf. 182; Leningrad 1935, p. 230, no. 9; Kuwait 1990, no. 2; Turku 1995, no. 9; Amsterdam 1999, no. 200; St Petersburg 2000, no. 229

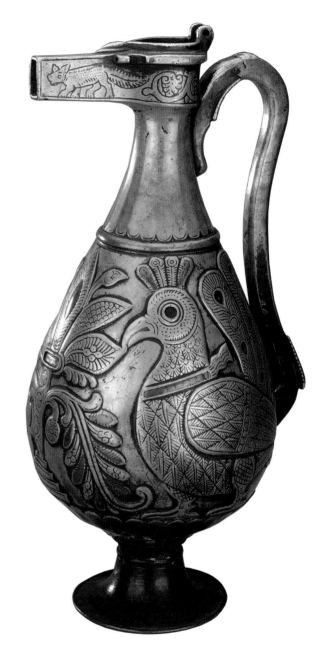

This ewer, with its image of two peacocks flanking a stylized date-palm, is one of the masterpieces among the early Islamic bronze artefacts in the Collection of the State Hermitage Museum.

Its shape and decoration reflect the artistic traditions of Sassanian Iran, Byzantium (and, through this, Roman art), as well as the traditions of ancient Mesopotamia. It also illustrates the complicated process of the formation of a new art in the Middle East after the creation of the Umayyad and Abbasid caliphates. This synthesis of art, in the eighth to ninth centuries, was described in detail in an article by U. al-Khamis, and also covered by B. I. Marshak. Although the work of al-Khamis concludes that the ewer was made in the ninth century, an earlier date cannot excluded, given that wonderful bronze items, such as the bronze eagle of uncertain provenance (dated to 180A.H./796-97A.D.) in the Hermitage Collection, were already being produced in that region during the late eighth century. (A.I.)

The Art of Arabic Countries
(tenth to thirteenth centuries)

Anton D. Pritula

After Syria and Egypt had been separated from the Caliphate under the Tulunid dynasty (868-905) and the rule of the next dynasty of the Ikhshidids (935-69), the economy in the region reached its peak under the Fatimids (909-1171). This dynasty, which adhered to an extreme form of Shi'ism, i.e. Isma'ilism, spread its influence not only throughout North Africa, Egypt and Syria, but took under its wing the province of Hijaz with its Holy Cities of Mecca and Medina.

The arts and trade prospered under the Fatimids as never before. Egypt and Syria flourished, becoming the most developed region of the Muslim world. Beautiful works of architecture, like the al-Aqmar Mosque in Cairo, were erected throughout the empire, and decorated with carved Kufic inscriptions (found on many artefacts, and influencing the developing arts of Islam). Fatimid Egypt saw the first appearance of medallions with inner radial inscriptions, originally symbolizing the rays of the sun, the mystical light emitted by Isma'ili teaching (Allan 2003, pp. 29-41).

Various kinds of rosettes also came to the fore now, probably symbolizing the sun of religious knowledge. They continued to be used over the centuries in Muslim art, changing by degrees to take on different meanings; that of simple solar symbols, or of solar symbols that symbolized royal authority (Allan 2003, p. 37, fig. 20). In the Mamluk period which followed that of the Fatimids, rosettes with the titles of such sultans as Muhammad ibn Qalawun who ruled between the late thirteenth and early fourteenth centuries, provide another example of this kind of reinterpretation [cat. no. 38].

Among the greatest artistic achievements of the Fatimid period is the development of overglaze lustre decoration as a ceramic technique. Perhaps the most

7
TRAY
(see page 15)

characteristic decorative technique of ceramic production, it was later employed elsewhere in the Islamic world, Spain included [cat. nos. 97-100], for centuries (illus. 1). It is now an accepted fact that lustre ceramics came to Syria and Iran from Egypt. Iranian lustre ceramics are made of a sophisticated fritware body which post-dates ceramic wares made from common earthenware. Egyptian lustre ceramic production under the Fatimids, on the other hand, gives us a myriad of intermediate body materials; this leads to the supposition that the lustre technique came to Iran from Egypt on ready-formed fritware (Watson 1999, p. 300). This invention proved to be truly revolutionary in ceramic production.

It is also significant that the art of miniature painting in Fatimid Egypt had clearly undergone, thus far, no serious development (James 1977, pp. 13,14). Therefore the most important form of fine art was the genre of painted lustre ceramics, exemplified by the work of the outstanding craftsman Muslim (Meinecke-Berg 1999, pp. 349-58). Monumental Egyptian painting, recalling for the most part Samarra paintings, was probably, however, more regulated in its art form. Some fragments have come down to us, along with information about its official patronage. For example, during the reign of the Caliph al-Mustansir billah (1035-94), a competition was arranged between two artists depicting a figure emerging from a niche, and in contrast one going into a niche. One of the artists was Iraqi, indicating the strong links to Iraqi painting (James 1977, pp. 12-13).

Of equal importance are carved articles made of rock crystal that were popular in Europe and which adorned many European collections. A lamp in the Hermitage is one such example, later set into a gilt and enamelled frame in Italy (see illus. 2). Interestingly, this masterpiece is traditionally thought to emanate from Iraq. However, the form of both leaves and stem, worked with a slanting stroke, and finally the singular treatment of the motif of the horn of plenty or cornucopia, are typical of Fatimid

Illus. 1: Fragments of lustre ceramics from Fatimid Egypt. (*State Hermitage Museum*)

Illus. 2: Rock crystal lamp from Fatimid Egypt. (*State Hermitage Museum*)

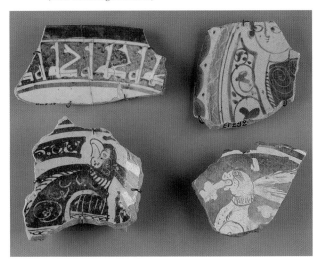

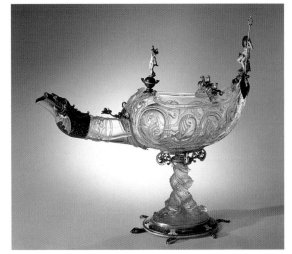

Egyptian production. Equally, no reliable link can be made with Iraq for these articles made of rock crystal.

Stone-cutting also reached a high level. Wash-hand basins and other objects are well-known examples of the work of Egyptian stone-cutters that include a marble fountain in the Hermitage Collection in the shape of a comical lion with a huge head and tiny body [cat. no. 6].

In many respects the art of Fatimid Egypt continues and develops Hellenistic traditions in form and decoration. For example, buckets with straight sides, like the example in the Hermitage collection [cat. no. 5] are a development of Coptic prototypes (Allan 1986.1, p. 19). Bronze lamp-stands or candlesticks, with bases on three feet, including a type with polylobed base, are a development of the Hellenistic inheritance [see cat. no. 1]. The tripod of the lamp-stand, which has a similar base to one in the British Museum in London, should be dated to the Fatimid period.[1] Many items of similar shape attributed to Iran are known only from the twelfth century onwards and are therefore probably later derivatives.

For the most part, Hellenistic subjects are also to be found on lustre ceramics. For example, a dish depicting an old man with a leopard, from the Benaki Museum, reflects the legacy of Hellenistic pastoral scenes (Meinecke-Berg 1999, p. 352).

The continued flowering of trade and the economy in Syria and Egypt is linked to the Ayyubid dynasty. Its founders, of Kurdish origin, who served in the garrison town of Aleppo, carried out a *coup d'état* in 1169. The first real ruler of the dynasty, Salah ad-Din (Saladin), contested what remained of Fatimid authority and introduced consistent Sunni politics. In 1187 Saladin captured Jerusalem from the Crusaders after they had ruled the Holy City for nearly ninety years. Ayyubid

dynastic rule arguably coincided with a period of heightened Islamic religious feelings. However, power was seized by Turkish slaves (the Mamluks) in 1250, who served in the sultan's army and brought Ayyubid rule in Syria and Egypt to an end. In the town of Nama (Syria), as in some other towns, the Ayyubid dynasty did however continue its existence for many decades in a subordinate capacity.

During the relatively short period of Ayyubid rule there was a profusion of ceramic styles, distinguished by their artistic sophistication. Particularly widespread were vessels with wild beasts and vegetal ornamentation [see cat. no. 8]. Lustre ceramic art was evidently introduced from Fatimid Egypt. Ceramic design linked with Raqqa was Persian through and through. The beautiful, sometimes multi-figured compositions, typical of the Raqqa style, recall the Persian so-called mina'i style connected with Kashan. However, it must be noted that, unlike the Persian mina'i, Syrian ceramics do not use overglaze.

In addition to high-quality ceramics, enamelled glassware of worldwide fame originated in Syria at this time, while Iranian glass of the same period was not enamelled. Enamelling techniques used on glass and on ceramics are different, and although a link between Syrian glass and Iranian ceramic enamelling has been suggested, in O. Watson's view 'a direct borrowing by Syrian glassblowers from the potters of Kashan is out of the question' (Watson 1998, p. 18). The first reliably-dated glass object to be enamelled is thought to have been a large bottle, fashioned for the Ayyubid Sultan an-Nasir Salah ad-Din Yusuf II (1237-60) (see Ward 1998, p. 30).

The thirteenth century saw the spread of bronze and brassware with rich silver inlay. At this time, inlaid and engraved work from Mosul in Northern Mesopotamia reached and influenced Syrian metalwork. Indeed, Arab

metalware production now expanded throughout the region. Badr ad-Din Lu'lu', former slave of the local ruler Arslan Shah I, came to power in Mosul (1233-59). He is considered to have been a patron of the arts. Five bronze objects made for this ruler are known to us. D. S. Rice commented on one of them, the famous Blacas Ewer, remarking that Mosul is undoubtedly the place of its production (Rice 1957.2, pp. 285-326). A further five objects can be associated with Mosul, and Rice rightly pointed out that these bear the name of Mosul's ruler Badr ad-Din Lu'lu', although the place of production is not indicated (Rice 1957.2, p. 285). These items, it should be said, generally lack the craftsman's name. One further object to be added to this group is a recently-published pen-case by the craftsman Ali b. Yahya al-Mawsili, dated to 1255-56 and now preserved in the David Collection in Copenhagen. This piece has an inscription indicating that it was 'made in Mosul' (Folsach 2001, no. 506).

There are many more objects by craftsmen with a Mosul *nisba* (another 27 according to Rice) made in other Middle Eastern towns or simply without any indication of place of production (Folsach 2001, p. 326). An even greater number of objects reveals stylistic similarities to the products of the Mosul craftsmen. These craftsmen, who from at least the beginning of the thirteenth century began to make use of silver and also copper inlay, changed from a precious metal to a bronze or brass base from the mid-thirteenth century onwards. We know some Mosul craftsmen transferred to Syria, where they continued to work in the same style. Their technique was apparently borrowed from Khurasan. The similarity of technique is evidence of this, as well as the adoption of similar subjects: e.g. scenes of astrology, banqueting and individual revellers [e.g. cat. no. 7].

The wording of benedictory inscriptions on Mosul brasses is similar to that found on those from Khurasan. The craftsmen wish the customer everlasting fame, success, power, long life, and so on. The inscriptions are linked with depictions of people banqueting and of musicians, all visual expressions of the desire for a happy life. Heavenly bodies (signs of the zodiac or planets) also form part of the visual canon of good wishes, as the influence of heavenly bodies on the fate of human beings was an important part of popular belief in the Muslim world.

In general it can be said that the iconographic themes of the decoration on the average product bound for the market consisted, roughly speaking, of a varying combination of the following elements:

1. BLESSINGS
 inscription + depiction of heavenly bodies + revellers and musicians
2. SYMBOLS OF IMPERIAL POWER
 e.g. a ruler enthroned or scenes that depict aspects of hunting (like a predator tearing at its prey)
3. EXOTICISM
 amusement (i.e. fantastical beings or vegetal ornamentation)

The prominence or absence of the second element varies depending on the customer: for example, it is emphasised where the customer is well-connected to structures of power. However, there are many exceptions, and all the elements are often so tightly interwoven as to be inseparable from each other. Nonetheless, we can say that their invariable presence and fixed repertoire bear witness to the almost mathematical calculation of the

object's decorative theme. Or, more likely, market considerations led to the establishment of a strict pictorial canon that lasted over many generations of craftsmen, which we can only now guess at.

The thirteenth century, in contrast to the Fatimid period, saw a great expansion of miniature painting. In this period we can speak about the influence of miniatures on the depiction of objects of applied art, including bronze objects. Thus the Hermitage tray, depicting a king on a throne [cat. no. 7] corresponds closely to a miniature in the *Kitab al-Aghani* (*Book of Songs*) manuscript, produced in Mosul in 1219 (James 1977, fig. 14, p. 29). Consequently, the tray may be convincingly linked to this town.

A further question of interest remains: does the collection of images on the various objects represent a cohesive, overall theme, or can we only speak about a compilation of unrelated images, i.e. elements that have been randomly brought together? This question should be directed at the whole of the applied art of the Islamic world. Unfortunately we are thus far unable to provide a clear answer. In some cases it is unfathomable that a unified composition should underlie the decoration. For example, a ewer in the Louvre, Paris, probably of thirteenth-century Syrian origin, shows in addition to scenes of Christian imagery a popular hunting scene of the legendary Persian King Bahram Gur and his slave girl Azade (Baer 1989, p. 16, pl. 52). However, these two distinct iconographic groups are situated in different bands, so here we should speak of several thematic bands on a single object. On the other hand, looking at the images of revellers and musicians on Mosul metalwork, they sometimes seem intended to provide a unified theme for the object. They either occur as part of extensive banquet scenes, or individually, set into a medallion [cat. no. 36], or as a recurring motif on the same object. On a number of large objects these medallions, with their figural motifs, are spread across the entire surface of the product. This is probably an original attempt at economising in the context of mass production. Similar iconographic elements recur on different objects. The main theme repeated is that of a banqueting figure holding a beaker, plus a figure drinking from a large bottle. Flautists are repeated three or four times on a single object, drummers two or three times, and on one occasion we find a drummer accompanied by musicians playing a zither and a harp.[2]

All these individual elements have been taken from large-scale banqueting scenes which, in turn, reflect banquets held in a contemporary palace or wealthy house. Consequently, the sum of the individual scenes of feasting distributed all over the object is intended to evoke the subject matter of a royal banquet, and therefore can be assumed to provide it with one coherent iconographic programme.

The first known dated objects produced in the 'Mosul style' were for Syrian customers of the 1220-30s. There is a dish from a Yemeni collection for the Ayyubid ruler al-Malik al-Kamil (1218-38) (Frankfurt/Main 1992, p. 135, exhibition), and also a pyxis for the ruler of Aleppo, al-Malik al-Aziz (1216-36) (Paris 2002, no. 43, exhibition), as well as a jug for the emir of the same sultan, made by the craftsman Qasim ibn Ali al-Mawsili, dated 1232 (Rice 1953, pp. 66-69, pls. X, XI). The location of yet another dish, inscribed with the name of Sultan al-Kamil I, which once belonged to a private collection in Paris, was unknown to the researcher G. Migeon (Migeon 1907, p. 51). Two well-known items belong to the same circle: a canteen with Christian motifs (Atil, *et al.* 1985, no. 17), and a basin

with an inscription honouring the Ayyubid Sultan Najm ad-Din Ayyub (Atil, *et al.* 1985, no. 18).

All the items that have come down to us from the thirteenth century were made at the request of the rulers of Syria and al-Jazira (Northern Mesopotamia). All are decorated with silver inlay throughout. These include items made for Badr ad-Din Lu'lu', and a jug and basin for Atabeg Sanjar-Shah (1208-48) (Allan 1982, no. 6, p. 56). However, the exclusive use of silver inlay can hardly be explained by geography or chronology. The earliest known object of this group is the pyxis made for the ruler of Aleppo, al-Malik al-Aziz, between 1231 and 1233, a time when copper and then gold inlay were widely used. An example of an object with copper inlay from Damascus is a censer from the Aron Collection (Allan 1986.1, no. 1); another from Syria is a jug with Christian motifs (Paris 2002, no. 100, exhibition). It is a fact of interest that the craftsman Hussein b. Muhammad al-Mawsili made a gold-inlaid candle-holder in Damascus for an officer of the Yemeni sultan (Paris 2002, no. 125), while in 1258 he was making the famous jug for the last Ayyubid of Damascus, al-Malik an-Nasir Yusif (1237-60) with solely silver inlay work (Paris 1971, no. 52). The famous censer from the 1270s in the British Museum, made for the Governor of Damascus, Badr ad-Din Baysari (whose career began under the Ayyubids), is inlaid solely with silver.

The academic J. Allan has frequently put forward a hypothesis as to the origin of artistic inlaid metalwork of the twelfth century from similarly fashioned silver products. The hypothesis in the first instance refers to Iranian material (Allan 1977, pp. 15-21). The 'Mosul style' is usually interpreted as being the result of fusion with inlaid decorative programmes adopted from Khurasani metalwork.

The derivation of individual forms of bronze objects made in the Arab world from Eastern silver models appears unconvincing (from spoons, domed censers, etc.). Many elements of style as well, in particular the background in the form of small spirals without foliage, so typical of Mosul workmanship, is nowhere to be found on Khurasan bronze from which we can rightly derive the 'Mosul style'. On the other hand, this background is typical of 'Western group' silverware (when compared with East Khurasan), which extended to the Western boundary of the Islamic world. If the presence of purely silver inlay on items from the court circles of thirteenth-century Syria and al-Jazira is not simply coincidence, it is possible it reflects a kind of custom or etiquette in which the silver banqueting vessels once prevailed.

The art of the Ayyubid period, both in terms of production technology and design, created the basis for further development of the decorative arts in the region under the subsequent Mamluk dynasty.

NOTES:

1. Inv. no. 1914 5-151. It is true that this shaft has a cylindrical form, while the Hermitage example [cat. no. 1] consists of several hinges. Both of these types of shafts are to be found on Iranian products, and both were probably known to Egyptian crafts-men. It was apparently also the case that, having a common base, they could be used with a lamp-stand and candlestick.

2. For example, calculations carried out on the basin from the Nuhad Es-Said Collection, beautifully displayed in the Freer and Sackler Galleries (Allan 1982, no. 12) and also on several Hermitage items, are so far unpub-lished (e.g. the tray base, State Hermitage Museum, IR-1583, is probably 13th-century Syrian). On many other published items, the results of observations have to be considered incomplete, as there is no possibility of conducting a full survey.

The Art of Arabic Countries

5
BUCKET

Egypt, 10th to 11th centuries

Bronze (brass); 12.5 cm (height)

Origin: acquired in 1891 from the Archaeological Commission

State Hermitage Museum, inv. no. IR-1427

Inscription (on handle): 'Blessings, fortune, happiness, glory and longevity to the owner of this.'

Inscription (on side): 'In the name of Allah, gracious and merciful! Blessing from Allah, fortune, happiness, glory, festivity and longevity to the owner of this.'

References: Yastrebov 1983, p. 14, illus. 17; pp. 45-46, illus. 25

Exhibition: Kuwait 1999, no. 14

This bucket represents one of the most characteristic metalware forms in Egypt during the tenth to eleventh centuries. The type originates in the Hellenistic world, but is decorated in Fatimid style with a belt of Kufic inscriptions, set against a stippled and foliated background. There are several buckets preserved that are similar in shape and decoration. The most famous examples are in the Keir Collection in London (Fehervari 1976, nos. 24, 26) and in the Islamic Art Museum in Cairo (Wien 1998, no. 192, exhibition). (A.P.)

6
LION FOUNTAINHEAD

Egypt, 11th to 12th centuries

Stone; 18 cm (length), 14 cm (height)

Origin: acquired in 1898 from V. G. Bock's expedition to Egypt

State Hermitage Museum, inv. no. EG-841

Exhibited for the first time

This fountainhead in the shape of a lion was used to decorate the fountain of a mansion or religious complex and could have been used for ablutions. A narrow water channel runs through the lion's body, with two small openings at the mouth and at its rear. Although similar lion fountains were spread widely throughout the Islamic world, Fatimid Egypt or Syria should be considered as the place of origin for this particular lion. There is a comparable image of a 'big-headed' lion with a disproportionally small body on a glass bottle from Sabra-Mansuriyya, and also on a glass goblet from San Marco Cathedral in Venice, probably made in Egypt (Kroeger 1999, figs. 14, 15a). (A.P.)

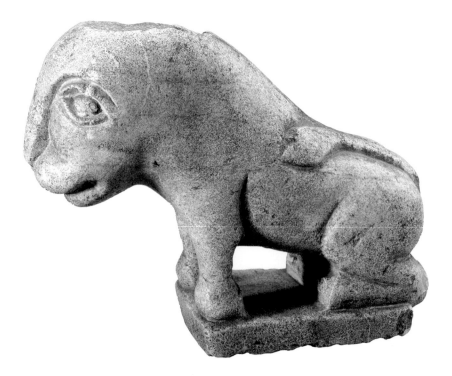

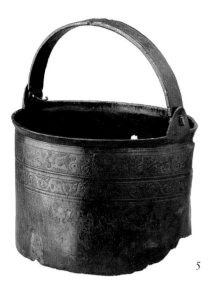

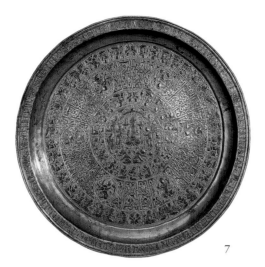

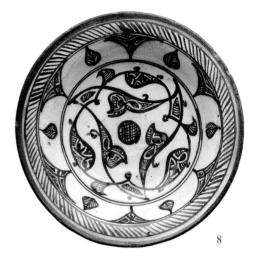

5

7

8

7

TRAY (see detail on page 8)

Iraq, first half of 13th century

Bronze (brass), silver inlay; 44 cm (diameter)

Inscription: long and standard benedictory inscription around the rim

Origin: acquired in 1925 from the State Academy for the History of Material Culture

State Hermitage Museum, inv. no. IR-1455

Exhibitions: Amsterdam 1999, no. 123; St Petersburg 2000, no. 128

This tray is a typical example of metalwork from Northern Mesopotamia (Mosul school). Trays bearing similar images of an enthroned ruler in the centre, which also feature angels and lions, can be seen on many objects of the thirteenth century from this region (Ward 1993, fig. 66). The circular arrangement of the decorative elements on the tray recalls that of the 'seven planets'; the ruler occupies the place of the Sun at the centre, while the other motifs correspond to the six planets that surround it. There is a similar decoration on a basin from the Archaeological Museum in Tehran, where the central medallion showing a ruling figure is surrounded by medallions bearing the signs of the zodiac (Baer 1989, fig. 91).

On many of the beautifully accomplished items of both the Mosul and the Khurasan schools, the inlay is incised next to the engraved contour of the image. However in this tray the inlay work has been executed in a most unusual manner: the craftsman has left a distinct gap between them. It may be deliberate: a technique probably used to imitate an image done in relief. (A.P.)

8

PLATE

Syria, 13th century

Stoneware, two-colour painting under transparent lacquer; 26 cm (diameter)

Origin: acquisition unknown

State Hermitage Museum, inv. no. VG-2504

Published for the first time/not in exhibition

Ceramics with underglaze painting done in black and blue pigment are among the most characteristic of ceramic types from Syria. They continued to be produced during the centuries that followed, under Mamluk rule. The decoration on this piece slightly resembles that on a cup in the Louvre in Paris, made during the same period (Paris 2002, p. 132, exhibition). (A.P.)

9
CANDLESTICK

Syria or Iraq, 13th century

Bronze (brass), silver inlay; 13.7 cm (height)

Origin: acquired in 1925 from the Museum of the former Central
School of Technical Drawing of Baron A. L. Stieglitz

State Hermitage Museum, inv. no. IR-1469

Reference: Baer 1989, pp. 33-49

Exhibitions: Kuwait 1999, no. 49; St Petersburg 1998, no. 265

The standing figures of Christian clergy depicted on this
candlestick allow us to associate it with a distinctive
group of bronze items, dated to the thirteenth century,
which are famous for their Christian themes. Although
all these items are connected with Ayyubid Syria, this
approach may seem over-simplified. Christian com-
munities lived all over the Muslim East, including the
territories now known as modern Iran and Iraq. More-
over, there are no candlesticks of this form that can be
safely attributed to Syria. Therefore it is possible that
this candlestick could have been produced in Iraq or in
Western Iran, where such a form is more typical. (A.P.)

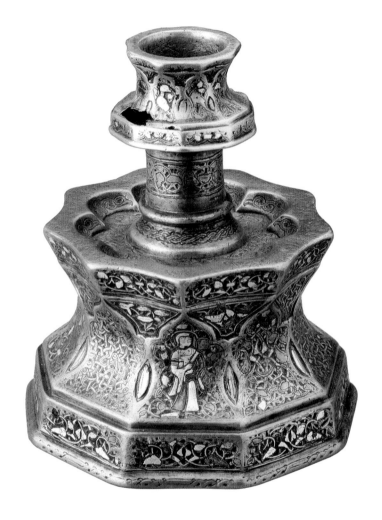

Seljuq Art in Asia Minor

Anatoly A. Ivanov

The appearance of large numbers of Turks in Iran, Iraq and Asia Minor in the second half of the eleventh century led to the creation of the huge empire of the great Seljuqs, which lasted until the mid-twelfth century. After it dissolved into a number of minor states in the territory of Asia Minor, the Rum (or Konya) Sultanate arose, centred on the town of Konya. This lasted until the mid-fourteenth century, when it was conquered by the Mongol Ilkhanid dynasty of Iran.

The art of the Konya Sultanate is best known for its architectural monuments which have a long history of research. As M. Meinecke's work has shown, the architects and craftsmen of the architectural decoration included many refugees (judging by their *nisbas*) from Western and Southern Iran as well as Khurasan and Central Asia (Meinecke 1976). Little is known of the detail of these craftsmen's lives, but the *nisbas* are indicators of clan, and give some idea of their movement from Iran to the West, both in search of work and as an escape from the Mongol invasion of the thirteenth century.

As far as the applied arts of Asia Minor are concerned, a very diverse picture can be observed. In the sphere of metalwork, D. S. Rice has published a bronze openwork lamp, made in Konya in 1280 by a craftsman with the *nisba* al-Nasibini ('born in Nasibin'), a town in Central Iraq. Meanwhile, A. S. Melikian-Chirvani has accurately connected a large group of bronze candlesticks to late thirteenth-century Konya, which Rice had previously linked to Azerbaijan (Melikian-Chirvani 1987). There are now grounds for considering a number of buckets as being of thirteenth-century Asia Minor production; these include the famous 'Fulda bucket' (A. Ivanov 2004, no. 13). Of course there is no stylistic unity among the enumerated bronze (brass) buckets; but it takes a certain amount of time to form a separate school, and Asia Minor drew craftsmen from Iran, Northern Iraq (al-Jazira) and Syria. It is unlikely that a parallel yet separate school could have been formed by the time Ilkhanid Iran had swallowed up the Konya Sultanate. In all likelihood the call for high-class craftsmen was compensated for by the skilled craftsmen who had emigrated and received their training in different artistic traditions.

For now therefore, on various counts, we have to link the products to craftsmen working in Asia Minor of the thirteenth to early fourteenth centuries. A study of metalwork of different schools in Middle Eastern lands will possibly help us to assign new items made in the Konya Sultanate of Asia Minor.

Seljuq Art in Asia Minor

10
BOTTLE

Iran, end of 11th to beginning of 12th centuries

Cast silver, niello; 11.5 cm (diameter), 20.6 cm (height)

Origin: acquired in 2002 through the Acquisition Commission

State Hermitage Museum, inv. no. S-504

Reference: Marshak 2004

The bottom and the handle, which this bottle once had, are now missing. The Hermitage bottle is an example of the metalwork of the Seljuq period. It shows elements of Eastern and Western Islamic silverwork current during the rule of that dynasty which had united vast territories. The inscription on the body says: 'Constant glory and prosperity and power and happiness and well-being to the owner of this [bottle].' The inscription, as well as the background – the spirals without a leaf in the middle – are typical for the Western group of silver items made as far west as Spain. The same applies to the palmettes, which can be seen on the Hermitage bottle.

At the same time, the medallions and script of the Kufic inscription ('Blessing and felicity and happiness and fortune and peace and honour and health and praise and rise and a long life to the owner of this') have close stylistic links with the bottle of Ibn Shazan, a political character from Balkh in Central Asia (killed in 1041). Both the medallions and the type of Kufic are typical stylistic features of the Eastern group of Islamic silver.

The Hermitage bottle is one of the earliest items to feature a central *naskhi* inscription on the shoulder. In the composition of its decoration, it precedes the Mosul-Syrian bronze ewers of the thirteenth century. (B.M.)

11
MIRROR

Iran or Antolia, 13th century

Cast bronze (brass), engraving; 10.8 cm (diameter)

Origin: acquired in 1891 from the Imperial Archaeological Commission (bought in Samarkand in 1888)

State Hermitage Museum, inv. no. IR-1580

Published for the first time

There are mirrors bearing an image of two addorsed sphinxes in the collections of the world's big museums.

On the edge of this mirror, along the high rim, there is an Arabic inscription of repeated good wishes (see Melikian-Chirvani 1982, p. 58, transl.). The number of known artefacts of this type is roughly one hundred.

The form of these mirrors relates back to original models. They occur over a very wide area: Central Asia and Iran in the east, as well as in the northern regions of the Middle Volga in the thirteenth and fourteenth centuries during the rule of the Golden Horde. Finds in the east of Iran, and Central Asia, gave some scholars grounds to attribute the production of these mirrors to thirteenth-century Iran, although more recently a new attribution to thirteenth-century Anatolia has been suggested. Detailed evidence for such an attribution is in the process of being brought together. (A.I.)

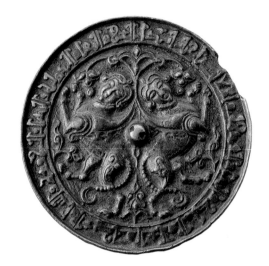

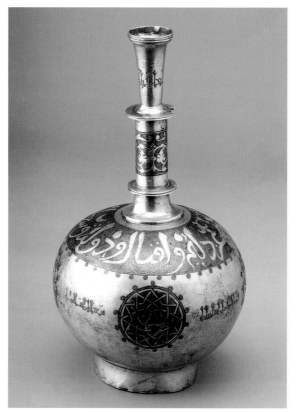

10

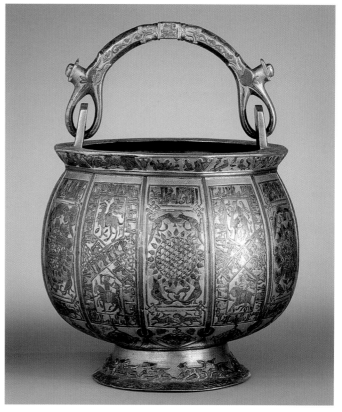

13

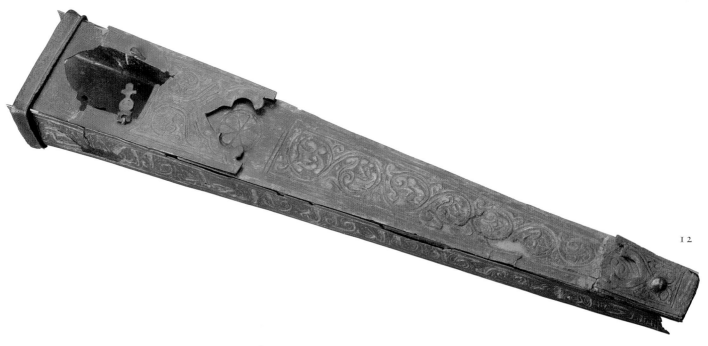

12

12
QALAMDAN (PEN-CASE)

Iran or Asia Minor, 12th to early 13th centuries

Bronze (brass), forging, engraving; 22.8cm (length), 4.5cm (width)

Origin: acquired in 1905 from the Imperial Archaeological Commission

State Hermitage Museum, inv. no. H-186

Published for the first time

This bronze qalamdan (or pen-case) was discovered during excavations in Khersones (the Crimea) in 1903. It belongs to the most widespread type of pen-case. It is shaped like an elongated wedge, with rounded edges and a sliding section. This pen-case used to have a pull-out middle section where pens and other writing implements were kept. The inkwell was placed on the top, in a special socket. The top lid is decorated with floral ornament in the form of spirals with palmettes, and there are Arabic inscriptions on the sides, executed in *naskhi* script: 'Long-term glory and fortune and might and success to the owner of this.' There are two large medallions on the base (one with a bird, the other with a palmette) and a strip of two interlaced lines. The letters of the inscription have hollows (grooves) for fixing the inlay, but it appears that this pen-case was never inlaid.

In terms of its shape, this pen-case belongs to similar Khurasani items of the twelfth to the beginning of the thirteenth centuries, but later-dated objects usually had silver inlay. The less than skilful craftsmanship of the ornament and inscriptions suggests that it was not made in Khurasan, but in another region, perhaps Asia Minor where Iranian art exerted a strong influence in the thirteenth century; or even in Khersones itself (although there is as yet no final proof of this beyond the place of discovery). (A.I.)

13
BUCKET

Anatolia, mid-13th century

Craftsman: Muhammad ibn Nasir ibn Muhammad al-Haravi

Bronze (brass), silver, copper, gilding, casting, inlay, engraving; 18.5 cm (height), 21.5 cm (diameter)

Origin: bought in 1995

State Hermitage Museum, inv. no. IR-1668

References: Mayer 1959, p. 71 (all bibliography before 1959); Grube 1966, fig. 42; Gyuzalyan 1978, pp. 53-83; Dushanbe 1980, pp. 167-68; Loukonine–Ivanov 1996, p. 126; Ivanov 2004, pp. 171-79

Exhibitions: Stockholm 1985, p. 137, p. 2; St Petersburg 2000, p. 8; London 2004, p. 40

The history of this remarkable piece of art – or, to be precise, its route to the State Hermitage – has been very complicated. The bucket appeared in the second half of the nineteenth century in the collection of L. Fuld in Paris and then it disappeared out of sight of specialists and collectors until 1926, when a representative of the Fabergé family in Leningrad offered to sell the piece to the Hermitage. For some reason the deal did not go through; the owner took the bucket away and after some time emigrated, and the bucket disappeared again. In 1946 it was spotted in an antique shop in Leningrad on Gertsen Street (Bolshaya Morskaya), location of the main shop of the Fabergé Company before the October Revolution in 1917. The bucket was then purchased by an individual and then, after nine years, it was offered to the Hermitage once again. On this occasion it was bought.

It was thought for a while that the bucket was made in Iran, in the province of Khurasan, during the second half of the twelfth century. The evidence in favour of this provenance was the *nisba* of the craftsman, 'al-Haravi', as well as the form of the bucket and its decoration with

inlay of silver and copper. The bucket was described thus in an article by L. T. Gyuzalyan in 1978.

However, there were some remaining doubts about this attribution. First, the background on the bucket is gilt; yet the many Khurasan items of the twelfth century are not. Second, its shape is not quite spherical, but slightly prolate; and the ornament decorating the bucket consists of vertical and not horizontal bands, as found on Khurasan buckets. Gilding on thirteenth-century bronze items was noted on items produced in Anatolia; the vertical bands of decoration, and an identical shape of bucket, are associated with thirteenth-century items which are difficult to attribute to Iran.

In addition, further elements of the ornament also indicated Anatolia. This allowed A. Ivanov to conclude that this remarkable artefact was indeed made in Anatolia in the middle of the thirteenth century. (A.I)

14
TRAY

Northern Syria or South-East Anatolia, 12th century
Silver, niello, gilding, forging, engraving; 36.5 cm x 21.5 cm
Origin: presented in 1977 by the University of Ekaterinburg
State Hermitage Museum: inv. no. IR-2125
Reference: Fyodorova 1982, pp. 190-93

This tray was discovered near the town of Surgut in the middle of the course of the river Ob in Western Siberia. Its rectangular shape, with a deep middle section, bears comparison to bronze (brass) and silver items from Khurasan and Maverannahr in the twelfth century. The Arabic inscription in the two cartouches above and below the central medallion, is created in Kufic script: 'Glory and fortune to sheik al-amid Master Abu Rushd (or Zayd) Rashid personal (servant).' It is evident from

the content of the inscription that the owner held the position of a vizier, although it is not clear under which ruler. Some letters in the last four words have been altered by the craftsman, which may indicate that the craftsman could not sell the tray to the original customer, or that the latter did not live long enough to see the tray completed.

Some details of the ornament – the interpretation of the figures of the dragons in the central medallion and in the medallions in the corners of the border – suggest that the tray was produced in Northern Syria or South-East Anatolia. (A.I.)

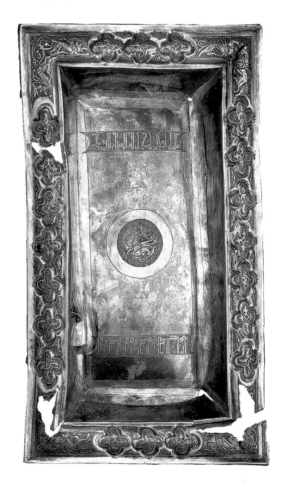

Iranian Art
before the Mongol Invasion

Anatoly A. Ivanov

When discussing Iranian art of the period before the Mongol invasion of the 1220s, the first examples that spring to mind are the tenth to eleventh-century Nishapur-Samarkand ceramics of the Samanid period and the twelfth-century bronzewares of Khurasan. This is, of course, as it should be, but these objects give us merely a hint of the development of art in the Khurasan province of Eastern Iran, while the central and southern areas of the country have remained slightly in the shadow. This is due to the fact that, thus far, we cannot attribute with certainty any artefacts of this period to these areas. A number of bronze pen-cases and astrolabes, the work of twelfth-century craftsmen with the *nisba* 'Isfahani', have only appeared on the antiques market in recent decades. Consequently it is understandable that the picture of the development of art in early Islamic Iran is incomplete. Only architecture can give us some idea of a consecutive development over the whole of Iran at the time, but this cannot be said of its applied arts.

Of course the role of Khurasan in the history of metalware produced in Iran from the tenth century to the beginning of the thirteenth century is immense, and for the twelfth-century perhaps even slightly exaggerated. A. S. Melikian-Chirvani was correct in turning his attention to the study of earlier artefacts, which he linked with Khurasan. Indeed this research ought to be continued and new indicators sought out to assist precise dating.

17
CAT
(see page 26)

In addition, we must identify groupings based on technique and style that will help to solve the problem of attribution, as the work of craftsmen from other regions can be found among the artefacts which are at present thought to originate from Khurasan [see cat. nos. 34-35 which are made in Maverannahr].

The study of bronze (or brass) artefacts of tenth to early thirteenth-century Khurasan allows us to pose the question about the development of Iranian art. It has long been well known to the world of research that great changes took place in Iranian art in the eleventh century. The reasons have been attributed to the appearance of the Seljuq Turks, who created a great new empire. However another point of view, held by R. Ettinghausen (Ettinghausen 1950), states that the reasons for the eleventh-century changes are to be found in the history, growth and development of Khurasani towns at the time. This view would appear to be more accurate.

The group of 'white bronzes' (Melikian-Chirvani's term) – artefacts decorated with a number of circles with a dot in the middle – disappeared in eleventh-century Khurasan. They had made their appearance in the first centuries of Islam and their dating has remained unclear until now, since they possess neither inscription nor date. These 'dotted circles' were in turn used to form the decorative elements on vessels. The situation changed at the end of the tenth or beginning of the eleventh century, when the first inscriptions in Kufic script began to appear on these 'white bronze' vessels. This allows a more objective dating of their manufacture. The role of 'the dotted circles' changed radically: having been the chief element of composition, the 'dotted circles' now began to fill the background and became greatly reduced in size. Also about this time,

bronzeware with images of people and living creatures began to appear, together with a great number of well-wishing inscriptions in Arabic. Frequently they included the name of the craftsman. Elements of ornament and letters of the inscriptions had nicks along the edges, as though designed for fixing metal inlay which, however, has never been one of their features (as in the Maverannahr production from the tenth to eleventh centuries) [see cat. no. 34]. Again, the background of the ornamentation and inscriptions is filled with tiny 'circles with dots'.

People depicted on these vessels are shown wearing double-horned hats, which were accepted items of headgear at the court of the Ghaznavid dynasty. This detail allows us to date this group of vessels to the end of the tenth or the first half of the eleventh centuries. It can also be noted that none of these items has any other metal inlay.

Most probably this group disappeared with the fall of the Ghaznavid dynasty in Khurasan and the coming to power of the Seljuqs. On the objects that are possible to date, admittedly with some uncertainty, to the second half of the eleventh or beginning of the twelfth centuries, we do not see any depiction of people, although living creatures are present. At this time, the second half of the eleventh century, the beginnings of silver and copper inlaid work can be observed on Khurasan artefacts and this technique gathers momentum towards the middle of the twelfth century [see cat. no. 23].

As recent research has shown, the composition of the copper alloys (bronze – brass) also underwent change between the eleventh and twelfth centuries. Consequently we can speak about the beginning of change in the production of Khurasan metalware somewhere around

the mid-eleventh century. This concurs well with the changes that, according to M. Rogers in 1973, can be observed in Khurasani architecture of the same period. Whether this process of change also had an impact on contemporary Khurasani pottery is still not clear.

The Mongol invasion destroyed all the large towns of Khurasan and we can only talk about bronzeware production in this area again from the second half of the fifteenth century onwards, even though the town of Herat began its revival as early as the 1230-40s, and by the fourteenth century it was already the capital of the Kart dynasty.

The central and southern parts of Iran suffered less from the first Mongol raid in the 1220s and production of artistic pottery in Kashan is well known throughout the thirteenth century [cat. nos. 66-67, 70-75]. Later, from the early fourteenth century, we can talk about the production of beautiful bronze (or brass) ware, inlaid with gold and silver, in Fars in Southern Iran. Kashan meanwhile ceased to be a centre of pottery production and in the following centuries there are no known products from this town. It is unclear where the characteristic blue-and-white, Chinese-style ceramics of the fourteenth to early fifteenth centuries were produced. However, Khurasan began to prosper once again in the fifteenth century under the Timurid dynasty. Western and southern regions of fifteenth-century Iran were famed for their monumental architecture and schools of miniature painting. Surviving works of applied art from those regions, however, still wait to be discovered.

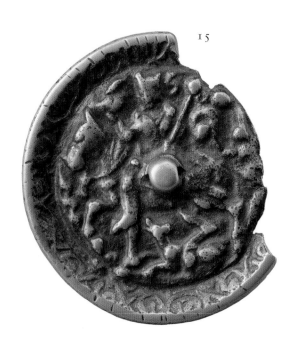

15

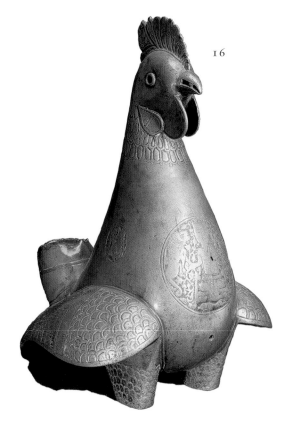

16

Iranian Art before the Mongol Invasion

15
MIRROR

Iran, 11th century

Bronze (brass), casting, engraving; 5.5 cm (diameter)

Origin: year of acquisition unknown

State Hermitage Museum, inv. no. IR-1706

Published for the first time/not in exhibition

It is thought that this form of round flat mirror, which has a pierced boss in the centre on its face, first appeared in the countries of the Middle East under the influence of Chinese prototypes. This particular small mirror has a thickened border decorated with a floral ornament on its face. There is a hunting scene in the middle; and a horseman riding to the left in the centre, holding a hunting bird on the left hand and a club in his right hand. There is an animal sitting on the croup of the horse, most likely a cheetah. A figure of a hare can also be seen in front of its muzzle, and there is a figure of a dog under the horse's feet.

The horseman has a hat with two pointed ends on his head. It resembles the 'double-horned hats' worn at the court of the Ghaznavid dynasty. Thus we can date the production of this mirror to the first half of the eleventh century.

Hunting was a favourite form of aristocratic enter-tainment at that time and there are other contemporary mirrors with similar hunting scenes.

A number of magical signs were engraved on the back at a later date: these include three six-pointed stars, and, below them, a scorpion and an animal of a feline kind. This composition is surrounded with a double row of pseudo-inscriptions in Kufic script. (A.I.)

16
ROOSTER

Iran, end of 10th to beginning of 11th centuries

Bronze (brass), casting, engraving; 36 cm (height)

Origin: acquired in 1925 from the State Academy for the History of Material Culture (A. A. Bobrinskiy Collection)

State Hermitage Museum, inv. no. IR-2323

References: Orbeli–Trever 1935, table 82; Dyakonov 1947, table V; *Content and Context of Visual Arts in the Islamic World* 1988, p. 42, illus. 9; Loukonine–Ivanov 1996, p. 103

Exhibitions: Leningrad 1925, table IX; Leningrad 1935, p. 231, no. 5; St Petersburg 2000, no. 241

It was traditionally thought that this particular figure of a rooster was designed as an incense-burner. However this idea can be discarded as it is not obvious where the smoke is supposed to have escaped from – the holes on the bird's head are very small.

Instead this figure is more likely to have been a vessel for water (or wine?). The lower part has been removed (the feet) and the tail construction has been damaged (the liquid may well have been poured through the tail). There is a single hole beneath each wing – the remains of the supporting tubes which kept the vessel stable when full.

The style of the feathers on the throat, wings, and feet of the rooster links it to earlier figurative water vessels. An image of a ruler, sitting on a throne, has been placed in a large medallion on the bird's chest. There is also a lion, hunting bird, and a dog which is lying beside him.

The absence of any inscriptions or inlay work in another metal, suggests that the figure of the rooster was made in Iran at the end of the tenth or the beginning of the eleventh centuries. (A.I.)

17

CAT (see page 22)

Iran, second half of 12th to beginning of 13th centuries

Bronze (brass), casting, engraving, inlay; 8.8 cm (height),
17 cm (length)

Origin: acquired in 1925 from the State Academy for the History
of Material Culture (A. A. Bobrinskiy Collection)

State Hermitage Museum, inv. no. IR-1433

Reference: Egyed 1955, p. 65, fig. 1

Exhibitions: Munich 1912, B.II, Taf. 152; Kuwait 1990,
no. 37; Amsterdam 1999, no. 205; St Petersburg 2000, no. 234

The ornament and copper inlay on this figure of a cat
allow us to attribute it to Khurasan and the second half of
the twelfth century. Several similar figures have survived;
some of them are attached to a base. The use of these
figures remains unclear. Most likely they were simply for
decoration. (A.I.)

18

ZEBU

Iran, Muharram 603A.H./August to September 1206

Craftsman: Ali ibn Muhammad ibn Abu'l Qasim an-Naqqash

Bronze (brass), silver, casting, inlay, engraving; 35 cm (height)

Origin: acquired in 1930 from the State Antiques

State Hermitage Museum, inv. no. AZ-225

References: Mayer 1959, p. 36 (all bibliography before 1959);
Gyuzalyan 1968, pp. 102-105; *Great Art Treasures* 1994, p. 405;
Loukonine–Ivanov 1996, p. 127; Piotrovsky 2001, p. 78

Exhibitions: London 1976, no. 178; Stockholm 1985, p. 136,
no. 1; Kuwait 1990, no. 39; Maastricht 1994, no. 6; Amsterdam
1999, no. 119; St Petersburg 2000, no. 124

This famous vessel used for water was, at one time, richly
decorated with silver inlay. It is the latest figured vessel
known to us. Making such a complicated composition
was a great achievement for the master craftsman, as he
noted in the inscription on the cow's neck and head: 'This
cow and the calf and the lion – all three of them were
cast in one go with the help of God Fair, Almighty owing
to the deed [i.e. order] of Ruzbekh ibn Afridun (ibn)
Burzin. Blessing to the owner of this – Shah-Burzin ibn
Afridun (ibn) Burzin. Made by Ali ibn Muhammad ibn
Abu'l Qasim an-Naqqash in Muharram of the year 603.'

It is interesting to note that the customer who ordered
the vessel, and its owner, had Iranian names, although
written with the Arabic word 'ibn' ('son'). The inscrip-
tion is written in Persian with Arabic elements, which
were very rare at the end of the twelfth to the beginning
of the thirteenth centuries. At the same time the name
of the craftsman is purely Arabic. Such a curious combi-
nation of names shows the retention of old Iranian
traditions at the beginning of the thirteenth century and
the gradual increase of the role of the Persian language
used in inscriptions on items (the dominance of the
Persian language occurred in the fourteenth century).

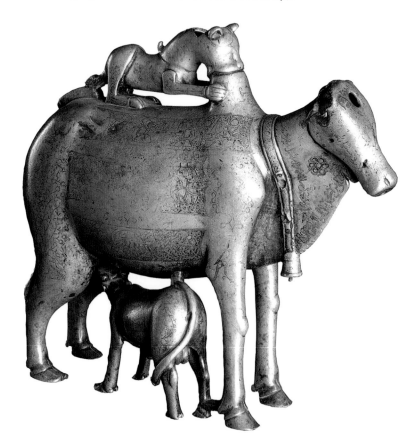

The authors of the first publications dedicated to this artefact thought the water vessel was made in Shirvan (Northern Azerbaijan). However, according to traditional sources, it was merely bought in that province. Coppersmith schools in Shirvan in the second half of the twelfth to the beginning of the thirteenth centuries have yet to be discovered. The ornaments decorating the water vessel link it to Khurasan bronze items of that time, which allows us to speak of Ali ibn Muhammad as one of the craftsmen of that school. (A.I.)

19

CANDLESTICK BASE

Iran, end of 12th to beginning of 13th centuries

Bronze (brass), copper, forging, engraving, inlay; 20 cm (height)

Origin: acquired in 1925 from the State Academy for the History of Material Culture (A. A. Bobrinskiy Collection)

State Hermitage Museum, inv. no. IR-1458

References: Fry 1910, p. 328, pl. II(2); Kühnel 1963, no. 137; Loukonine–Ivanov 1996, no. 123

Exhibitions: München 1912, B.II, Taf. 144; St Petersburg 2004, no. 115

Bronze (brass) items of different shapes, inlaid with copper and silver, which originated from the Iranian province of Khurasan in the twelfth century, are well represented in many of the world's museums. It is interesting that among the various items, including lighting fixtures, candlesticks are rarely seen. However, a variety of candlestick bases have survived, of a different shape, that date to the second half of the thirteenth century and are made in the countries of the Middle East.

Among twelfth-century Khurasan candlesticks, only one shape of candlestick is known; it has a round conical base and a holder for the candle, and the shape of the base is not repeated in that of the candle socket, as in later candlesticks of the thirteenth to fourteenth centuries (cf.

fully preserved items with a similar shape and ornament in *Survey* 1939, vol. VI, pl. 1321; Migeon 1907, p. 167, fig. 143).

One similarly decorated candlestick, dated 561 A.H/ 1166 A.D appeared recently in *Die Gärten des Islam* (Forkl, *et al.* no. 82). It was inlaid with silver, and in the middle of the base there were rows of six-pointed relief medallions, although there are no birds or lions in relief. However, some elements of the design of this precisely dated candlestick, and also the candlestick with six-pointed relief medallions from the David Collection (cf. David Collection, no. 71) do not have any connection with other Khurasan bronze items of that time. This raises some questions for researchers.

The Hermitage candlestick base once found its way to the settlement of Kubachi (Daghestan), where it was used for keeping grocery items like nuts, flour or dry fruit, which is apparent from the legs and the copper sheet in place of the candleholder socket. (A.I.)

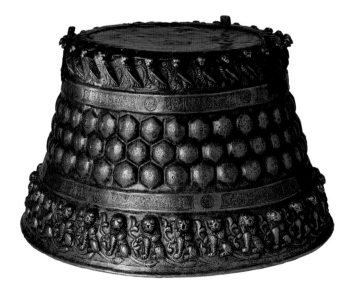

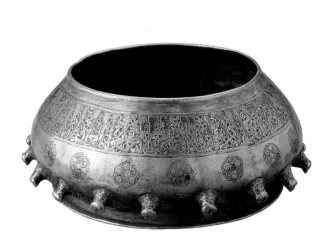

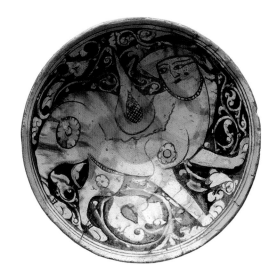

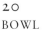

20
BOWL

Iran (Khurasan), second half of 12th to beginning of 13th centuries

Bronze (brass), silver, copper, forging, inlay, engraving;
15 cm (diameter), 6.2 cm (height)

Origin: acquired in 1885 from the A. P. Bazilevsky Collection

State Hermitage Museum, inv. no. IR-1540

Published for the first time

This vessel on a wide base, with a turned-up edge, has
sides tapering towards the top which are decorated with
a band of a long Arabic well-wishing inscription along
the edge. Below this are medallions made from seven
circles; and, further down, figures of birds in relief, their
heads pointing downwards. On the base of the vessel
there is an engraved medallion, with a sphinx walking to
the left.

 In technique and style this vessel is a typical product
of the Khurasan coppersmiths of the second half of the
twelfth to the beginning of the thirteenth centuries. The
purpose of the vessel remains unclear. (A.I.)

21
BOWL

Iran, 12th century

Faience, glaze, carving; 18 cm (diameter), 6.6 cm (height)

Origin: acquired in the 1940s (exact year unknown)

State Hermitage Museum, inv. no. IR-1721

Published for the first time

Works of faience with a red earthenware body, the surface
coated with a cream slip, were decorated with images of
people, animals, mythical creatures and floral ornaments.
The decoration is achieved by cutting away the back-
ground around the ornaments, so that the red ceramic
body is revealed. Sometimes these exposed areas were
painted brown.

 This type of pottery or ceramic was called 'Gabri' for
a long time, but then became known as 'Garrus' after
the region in the south of Iranian Azerbaijan where this
style was produced in the eleventh to twelfth centuries.

 This bowl from the Hermitage was assembled out of
many fragments, and the muzzle of the animal was, most
probably, inserted from another vessel.

 The bowl was presented by Princess Ashraf Pahlevi
when she visited Leningrad in the mid-1940s. (A.I.)

22

JUG

Iran, 10th century

Silver, tin, gilding, forging, engraving; 17 cm (height)

Origin: acquired in 1896 from the Imperial Archaeological Commission

State Hermitage Museum, inv. no. VZ-796

References: Smirnov 1909, no. 128; Marshak 1976, pp. 155-56; Loukonine–Ivanov 1996, p. 95; Piotrovsky 2001, p. 65

Exhibition: St Petersburg, 2000, no. 110

This jug is decorated with a floral scroll and geometric ornament in relief. The figures of the birds, created in a high relief on the body of the jug, are worthy of note. They resemble birds on Khurasan bronze items from the second half of the twelfth century. However, this jug was made much earlier, which is proved by the inscription on the lower part of the neck, written in a simple Kufic script: 'A blessing from Allah and well-being and happiness to al-Hussain ibn Ali.' The form of the inscription, and the nature of the Kufic script, testify to the fact that the jug was made in the tenth century. Unfortunately, the owner of this item cannot be similarly identified with sufficient accuracy. (A.I.)

23

QALAMDAN (PEN-CASE)

Iran (Khurasan), 20 Zil Khad 542 A.H./2 April 1148

Craftsman: 'Umar ibn al-Fadl ibn Yusuf al-Bayya'

Bronze (brass), silver, copper, casting, engraving, inlay; 18.8 cm (length)

Origin: acquired in 1925 from the Asiatic Museum (now the Institute of Oriental Studies) of the Academy of Science of the USSR

State Hermitage Museum, inv. no. SA-12688

References: Mayer 1959, p. 87 (all bibliography until 1959); Gyuzalyan 1968, pp. 95-119; Loukonine–Ivanov 1996, no. 115

Exhibitions: Leningrad 1935, p. 368, no. 5; Kuwait 1990, no. 28; St Petersburg 2004, no. 111

This qalamdan (pen-case) is the earliest precisely-dated twelfth-century Khurasan bronze artefact. All the features of the Khurasani style of bronzeware decoration in the twelfth century are evident here: inlay with silver and copper, the background of the inscriptions filled with stems and leaves curled in spirals, and inscriptions created in Kufic and *naskhi* styles. Apart from Arabic inscriptions, there are also Persian poems appearing on this pen-case, a feature which is noted on bronze items for the first time in this particular artefact.

It is possible that the craftsman of the pen-case, and the owner, Ali ibn Yusuf ibn 'Uthman al-Hajji, were related.

An article by L. T. Gyuzalyan, devoted to the research of this item, was published in 1968. All the inscriptions, both Arabic and Persian, were listed in this article. (A.I.)

24

DISH

Azerbaijan (Oren-Kala), 12th to beginning of 13th centuries

Craftsman: Nasir Azerbaijan

Earthenware slip painting, carving under transparent glaze;
17 cm (diameter)

Origin: acquired in 1966 from the Archaeological Department of
the Russian Academy of Science

State Hermitage Museum, inv. no. AZ-1507

Reference: Gyuzalyan 1959, pp. 324-50, illus. 19

Exhibition: Turku 1995, no 215

This bowl was found during the excavations of the
settlement Oren-Kala in Azerbaijan, which can be identi-
fied as the medieval town of Baylakan, according to the
seals on some of the vessels which contain the places
of their production. The town was demolished by the
Mongols in 1221. (Attempts to rebuild the town were
made in the thirteenth and fifteenth centuries.)

The excavations on the settlement began in 1953 and
continued for some years; the bowl was discovered during
the excavation season of 1954. It is an important example
of local ceramics. Decorated with carving and poly-
chromic glazes (with yellow, green and brown paints), a
hunter is shooting a bow into a running deer. The hat of
the hunter with its distinctive 'horns' on the sides, as well
as the line of the features of the face and the long hair,
are similar to the image of a royal hunter on a bowl
from Nishapur or Afrasiyab dated to around 1000 (see
The Nasser D. Khalili Collection of Islamic Art, London;
Amsterdam 1999, no. 138; St Petersburg 2004, p. 153).
The sleeves of the hunter's dress on the Hermitage bowl
are decorated with *tiraz*-bands with an illegible Arabic
inscription; while the background is decorated with
floral motifs. The engraved inscription at the top says:
'amila Nasir' ('made by Nasir'). (A.A.)

25

BOWL

Iran (Khurasan), beginning of 13th century

Bronze (brass), silver, forging, inlay, engraving; 18.5 (diameter),
8.5 cm (diameter)

Origin: acquired from the Imperial Archaeological Commission
(year unknown)

State Hermitage Museum, inv. no. SA-12701

Published for the first time/not in exhibition

This bowl from the Hermitage Collection rests on a high
base, the sides opening up towards the top. It is decorated
along the inside surface edge only, with two lines of orna-
ment. On the first line there is an Arabic well-wishing
inscription in *naskhi* script, set against a background of
twisted stems and leaves. The list of blessings is not quite
typical; the words are written carelessly and some are
not easy to read: 'Glory, fortune, success and patronage
and glory[?] and well-being[?] and patronage and well-
being[?] and patronage and well-being and eternity.' The
second line has a row of leaves pointing downwards.

The edge of the bowl has been cut off slightly, and
the top ends of the letters are now damaged. The shape
of the bowl bears direct comparison with other ceramic
artefacts; and testifies to the influence of ceramic shapes
on metal items, which is a rare occurrence. (A.I.)

26

EWER

Iran, first half of 12th century

Craftsman: Nasir

Cast bronze (brass), copper inlay, engraving; 37.5 cm (height)

Origin: acquired in 1930 from the Asiatic Museum (later Institute
of Oriental Studies) of the Academy of Science of the USSR

State Hermitage Museum, inv. no. SA-12680

Reference: Loukonine–Ivanov 1996, no. 124

Exhibitions: Leningrad 1935, p. 362, no. 2; St Petersburg 2000,
p. 37, illus. 20

This ewer is the only work of this craftsman known to us to date. Another ewer, identical in shape and also a piece of work by Nasir, most probably belongs to a namesake (Baer 1987, pp. 5-12). Judging from the copper inlay, and the background treatment underlying the inscriptions which show stems that have tiny leaves rolled in spirals plus three palmettes in the middle, the Nasir who made this vessel worked in Khurasan in the twelfth century (perhaps no earlier than the second quarter). He applied the same, fully developed Khurasani style of decoration which is found on the famous bronze pen-case in the Hermitage [542/1148; cat. no. 23].

However, the rounded body of this ewer (its neck comes from another item), and the position of the craftsman's signature ('Nasir made it' in Kufic script) in a visible area immediately beneath the lip of the neck, links this piece to a large group of ewers with rounded (sometimes pumpkin-shaped) bodies, which began to be produced around the middle of the eleventh century. Approximately forty survive to this day. An early example of this group, without inlay work, was made by the craftsman Shams (illustrated in *Survey* 1939, vol. VI, pl. 12776). A slightly later ewer, with silver inlay, was published by Abu-l-Faraj al-'Ush in 1972 (pp. 187-90, pls. 1-6). Since only the earlier ewers in the group lack the spiral stems in the background of the inscriptions, the inclination is to consider the Hermitage ewer as the latest example within their chronological sequence.

The neck of this ewer was taken from some other twelfth-century ewer, but it has not been joined to the body correctly as the lip is to the side of the inscription. It is not clear how the original neck and handle were joined to the body as there remains no sign of an attachment area on the body of the ewer. (A.I.)

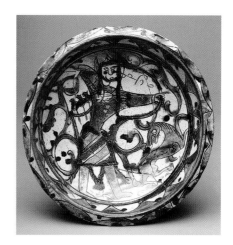

24

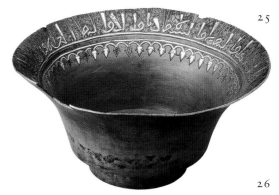

25

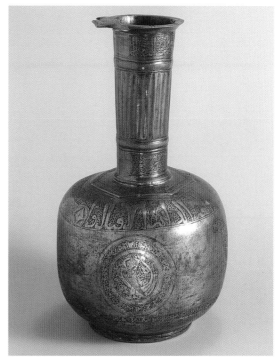

26

The Art of Central Asia

Grigory L. Semenov

The Arab conquest of Central Asia in the early eighth century was a crucial moment in the history of this region. From the eighth century Central Asia had been under the control of the Caliphate. The Tahirid dynasty came to power in Khurasan at the beginning of the ninth century; they were not only hereditary viceroys of the Eastern provinces of the Caliphate, but in practice became its independent rulers. Initially under the Tahirids, the Samanid dynasty was given control of the more important province of Maverannahr. After the fall of the Tahirids (873) a complex power struggle led finally to the Samanids uniting these two provinces under their rule (c.900). At the beginning of the eleventh century, power passed to the nomadic Turkic dynasty of the Qarakhanids.

The Arab conquest of Central Asia changed the region's cultural life. Not only was religion affected (most of the population were Zoroastrians), but the language changed as well. Soghdian, Khorezmian and Bactrian were exchanged for Farsi, while Arabic reigned supreme as the written language. A further consequence of the Arab conquest was the weakening cultural ties with China and India. In their place came closer links with Iran and the Middle East.

In Central Asia, Islamic values clashed with those of a centuries-old traditional urban civilization, as most of the towns of the region, in which cultural life had been concentrated, had managed to survive the onslaught of the invaders.

The new religion introduced several innovative architectural concepts to the region, such as the mosque with its minaret, and the madrasah. The layout of the mausoleum of Ismail Samani in Bukhara, for example, is derived from the *chortaks*, the temples of fire worship of Iran. The caravanserais also began to adopt a previously unknown type of layout; but this is perhaps not surprising, given that they were situated along the main trade routes that helped to convey ideas as well as commodities. Finally, the groundplan of bath-houses began to imitate those of the thermal baths of antiquity.

The majority of these new architectural concepts were brought ready-made to Central Asia from the Middle East after their absorption by the Caliphate. The main new material used for building the vast structures was fired brick which replaced mud brick, a building material composed of water, sandy clay and straw or other organic materials, which was shaped into bricks. From the twelfth century onwards, mosques and minarets were faced with glazed tiles.

The layout of living quarters underwent significant change too. The great halls of wealthy homes, once decorated with figurative art, disappeared. However, contrary to popular perception with regard to Islam's negative attitude towards figural decoration, monumental decorative art did continue its existence under Islam. Thus the wall paintings of the palaces in the city of Afrasiyab, dating to the tenth and twelfth centuries, effectively continue the pre-Islamic tradition of secular painting. Bath complexes also retained their wall paintings, to which healing properties were ascribed, although now these were increasingly decorated with pictures of flowers, trees, animals and people.

Between the ninth and twelfth centuries, carved work for interior decoration became very popular and could be found in mosques, palaces, and even in the houses of ordinary citizens. The subject matter was usually orna-

mental; however, depictions of animals were occasionally observed.

As part of the Caliphate, Central Asia also benefited from the introduction of new technologies. Glass was perhaps an object of luxury for the ancient Soghdians, but by the ninth to tenth centuries it had increased in quantity and was striking in its variety. In this exhibition this is represented by a small glass jug [cat. no. 33]. The shapes of glass vessels were often mirrored in both ceramics and metal, and it has been suggested that cheap glass replicas were intended to imitate expensive silver and gold vessels.

The appearance of glazed ware, i.e. monochrome pottery with a green glaze that was already well-known in Sassanian Iran, was another novelty. The earliest examples can be dated to the eighth century. Additionally, among other early forms of glaze, we find potash and stannous alkaline opaque glaze. Indeed, there is even evidence of pottery of high craftsmanship with a clear lead glaze applied over a white slip. This type of ceramic ware is thought to have emerged in imitation of expensive Chinese porcelain. Indeed the Muslim writer and scientist Al-Biruni commented that in his day (late tenth to early eleventh centuries), the cost of a Chinese porcelain vessel in Iran was ten golden coins (dinars).

Particularly apparent was the desire to imitate Chinese ceramics from the T'ang period that had a mottled yellow-green glaze decoration (so-called sancai ware). In the exhibition [cat. no. 28] is a Chinese vessel from the T'ang period, as well as one from Central Asia which is inspired by T'ang sancai ware [cat. no. 29].

Bowls and jugs inscribed with good wishes in Arabic are another popular type of white-slip ceramics found in the ninth to tenth centuries. Samarkand and Nishapur were specific centres of production for these ceramics, but the area they were made in also included much of Central Asia, Iran and Afghanistan. By the early eleventh century, inscriptions had become illegible and had turned into an ornamental detail. Despite the dislike of figurative depiction in Islamic dogma, this type of art continued in ceramic production as well. One example is the vase decorated with ducks, which is in the exhibition [cat. no. 27].

It is difficult to distinguish between metal products made in Khurasan and Maverannahr during this period. This is further complicated by the fact that many deposits of metal objects found in Central Asia were of Khurasanian production. A. Ivanov's essay on page 38, 'The Metalwork of Central Asia', discusses the different types of bronzeware that can be attributed to Central Asia and Iran.

Ceramics and glassware are often intended as cheap imitations of pieces made in more expensive materials. The shapes of many vessels stem from metal originals. This is noticeable on the cup [cat. no. 30] with a white slip and inscription. The link is even more obvious in other contemporary ceramics covered with a plain green glaze or remaining unglazed. These often show cylindrical forms and sharp breaks that are uncharacteristic for clay objects, as well as imitations of metalware features like riveting, twisted handles and notched ornamentation.

Vessels inscribed with good wishes indicate that these are specially ordered presents. In effect they are a continuation of the tradition of Sassanian silver dishes whose imagery may also have had the purpose of conveying good wishes and which may likewise have been intended as gifts.

The Art of Central Asia

27
VASE

Maverannakhr (Samarkand), 10th century

Earthenware, white slip, clear glaze, underglaze painting; 29 cm (height)

Origin: acquired in 1906 from the A. Polovtsev Collection

State Hermitage Museum, inv. no. SA-13204

Reference: Dushanbe 1980, fig. 93

Exhibitions: Kuwait 1990, no. 9; Amsterdam 1999, no. 215; St Petersburg 2000, no. 246

Painted motifs executed in brown, red and olive-green pigments were applied to the surface of this pear-shaped vase over a white slip. Its neck has not been preserved. The glaze is transparent and yellowish. It belongs to the lustre-style ceramics of the Samanid period, i.e. tenth century. Lustre (from the French *lustre*, 'to shine') is a metallic pigment, applied to the clear glaze of pre-fired ceramics before a second firing. The latter takes place in a reducing atmosphere, without oxygen, and results in a metallic or lustre shine on the surface of the ceramic vessel. Lustre ceramics were produced mainly in the Middle East and were popular. As the lustre technique was unknown in Central Asia, imported vessels of this type were in high demand. Local ceramicists also started to imitate the imported lustre wares in Maverannahr; Samarkand played a leading role in production.

The ornament on this vase, with figures of birds walking from right to left within a pleated band, imitates the polychrome lustre designs of ninth-century Iraq in terms of glaze and pigment colour. The decorative style is typical of Khurasan and Maverannahr. (V.Sh.)

28
T'ANG VASE

China (Henan, Shanxi provinces), first half of 8th century

Earthenware, coloured glazes; 13 cm (height), 11.8 cm (diameter)

Origin: acquired in 2000 through Expert Acquisition Commission

State Hermitage Museum, inv. no. LK-2926

Published for the first time

This spherical vessel is a typical example of ceramic ware made in the workshops of Northern China (Watson, 1984, pl. 183, *T'ang pottery*, 1988, no. 74). It has a wide neck with a projecting lip and rests on three legs in the shape of lion paws. It is covered with glazes of amber-brown, green and white. Items with this distinct glaze decoration were not only popular in China. Imitations can be found among the ceramics of both the Middle East and Japan. (T.A.)

29
BOWL

Central Asia (Bukhara oasis), 10th to 11th centuries

Thrown ceramic body, glazed; 20.8 cm (diameter), 6 cm (height)

Origin: acquired in 1940 from among items of the State Hermitage expedition to Paykend (Bukhara region, Uzbekistan)

State Hermitage Museum, inv. no. SA-10494

Published for the first time

This cup has tapering sides and sits on a flat base. It shows incised designs under a clear glaze, as well as green and brown spots, splashes and festoons. (T.Z.)

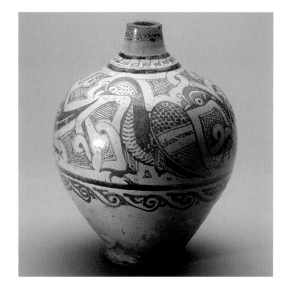

27

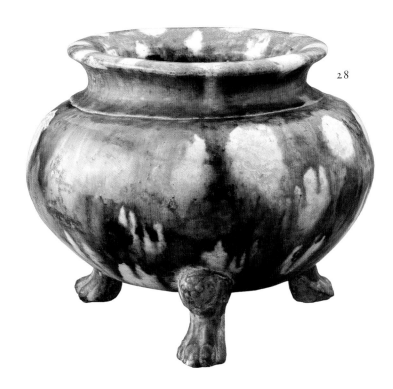

28

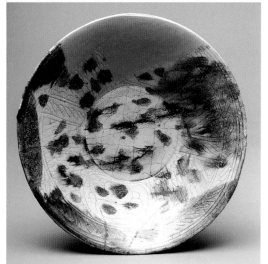

29

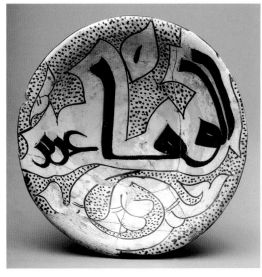

32

30

CUP

Central Asia, 11th century

Light pink earthenware, white slip, underglaze painting, transparent glaze, stylized Arabic inscription; 15 cm (length)

Origin: acquired in 1936 from Yusupov

State Hermitage Museum, inv. no. SA-7175

Reference: Bolshakov 1958, p. 38

In its form, a cylindrical body on a low foot with a small loop handle surmounted by a distinctive thumb-rest, this cup relates back to metal originals. Its decoration, however, includes the application of a white slip under a transparent glaze, and belongs to a large group of ceramics that imitate Chinese porcelain. The stylised Arabic inscription in simple foliated Kufic around the outside repeats the saying: 'You will be rewarded.' The inscription style dates the cup to the eleventh century. At that time the lengthy Arabic inscriptions of the ninth to tenth centuries began to be replaced with others that were difficult to read, or completely impossible to decipher, and were intended to be merely decorative. (G.L.S.)

31

VASE

Central Asia, late 12th to early 13th centuries

Terracotta, stamping in kalyba; 14.2 cm (height)

Origin: acquired in Khauz-Khan Settlement (Turkmenistan)

State Hermitage Museum, inv. no. SA-15422

References: Adykov 1962, no. 1, pp. 90-92; Balashova 1972, pp. 91-106

Not in exhibition

Enclosed within lobed arches, separated by pronounced pillars that appear on this non-pouring ewer, there are scenes from the epic poem 'Khusrow and Shirin' by the Persian poet Nizami (1141-1203). The main character, Farhad, is a skilful artist and sculptor, a hero who has performed many feats. On the request of his beloved Shirin, Farhad constructed a canal so that the future wife of the king, Khusrow Parviz, could receive milk from the mountain pastures every day.

Given the dates of the poet's life and this ewer's production, this is the earliest depiction of the immortal poem. (V.Sh.)

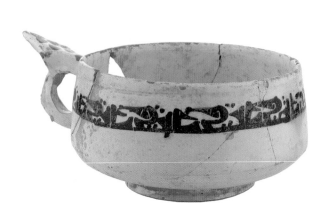

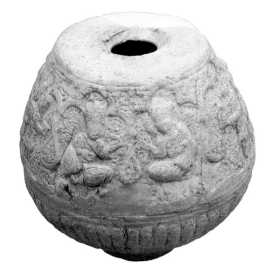

32

BOWL (see page 35)

Central Asia (Afrasiyab), 10th century

Clay, white slip, underglaze painting, transparent glaze;
10 cm (diameter)

Origin: acquisition unknown

State Hermitage Museum, inv. no. SA-13198

Reference: O. G. Bolshakova 1958, p. 38

In terms of its form, and mainly in its decoration, this
semi-spherical cup on a low base belongs to the so-called
dishes of 'Afrasiyab' type, named after the place they
were first discovered, Afrasiyab, a settlement of the old
Samarkand. Later the same type of ceramics or pottery
was found in Nishapur, confirming close links between
the two regions during the Samanid period.

 The inscription, in Kufic script, is written across the
middle of the dish: 'Loyalty is precious.' The inscription
is enclosed within a plain band that closely follows its
contours. The whole arrangement is set against a dotted
background. All the remaining space beneath the
inscription is filled with a stylised vine shoot, again set
against a dotted background. There is also a small leaf
to the left of the inscription. It appears that the distinc-
tive dotted style of the background treatment is an
imitation of the one found on more expensive metal and
lustre wares, which had in turn imitated lustre wares.
This particular type of background treatment is not seen
on ceramics after the tenth century. (G.L.S.)

33

JUG

Central Asia (Uzbekistan), 10th to 11th centuries

Glass; 9.9 cm (height), 2.6 cm (diameter of body)

Origin: acquired in 1937 from B. N. Kastalskiy Collection

State Hermitage Museum, inv. no. SA-2418

Exhibition: 'Culture and arts of Central Asia' (on permanent
display)

This jug is of greenish glass, with a faceted spherical
fluted body on a solid base, and a high trumpet-shaped
neck. A curved handle is attached to the upper edge of
the neck and rests on the shoulder of the fluted body
below. (T.Z.)

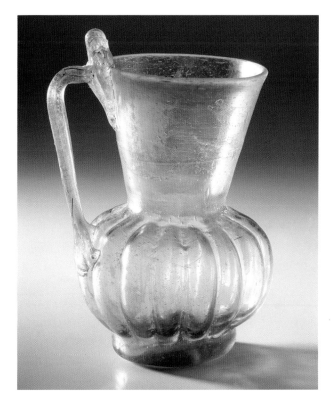

The Metalwork of Central Asia

Anatoly A. Ivanov

The study of metal artefacts from Central Asia first arose as a research topic in the 1960s. Above all there was a need for a precise definition of the medieval cultural and historical boundary between Iran and Central Asia: was it the river Amu Darya or the frontier between Russia (later on, the Soviet Union) and Iran, including part of Afghanistan? Soviet historical literature assumed the latter. If this was the case, then part of historical Khurasan would be excluded from Iran, while Tokharistan, the ancient Bactria, would form part of Central Asia.

In fact we have to go back to the first position which assumed that the boundary between Iran and Central Asia (as indeed between Iran and Turan) was indeed the Amu Darya. In that case the territory lying to the north of the river would correspond to what the Arabs called Maverannahr, 'that which lies beyond the river'. This would then leave the Khurasan bronze (or brass) artefacts of the Middle Ages (or until the Mongol conquest in the 1220s) in Iranian territory, and not divided among Turkmenia, Afghanistan and Iran.

A considerable amount has been written about the bronze artefacts of Khurasan, in particular those with inlaid silver and copper decoration dating from the later twelfth to the early thirteenth centuries. Apart from A. S. Melikian-Chirvani, scarcely any writer has shown any interest in the metalwork produced in Khurasan during the tenth and eleventh centuries, and without knowledge about this material we fail to understand the flowering of this artistic genre in the twelfth century. Naturally we are also constrained by the lack of precise dating and attribution to where the tenth to eleventh century articles were produced, a problem that does

not arise with regard to later twelfth-century Khurasan.

In the meantime, however, material continues to be gathered, and a more objective picture of the history of bronze production in Khurasan from the tenth to the early thirteenth centuries is beginning to emerge, while providing subject matter for further research.

For the purpose of this essay, what interests us is the development of metalwork production in Maverannahr, taking this to mean in the first instance bronze (or brass objects). Only a very few isolated silver products are known to have survived from this region, while steel products have not survived at all.

Unfortunately to date we have not found a single bronze object from the tenth to the early thirteenth centuries which carries an inscription that might link it to one of the towns within the Maverannahr region. (Only one has an inscription linking it with late twelfth-century Khurasan.) Nor do we know of any tenth to thirteenth-century object signed by a craftsman whose name includes a *nisba* related to even one of the towns of Maverannahr. (The *nisba*, from Arabic *nasaba*, 'to refer', is the method used to convey the person's affiliation with a town, area, tribe, profession, and so on.)

Of course the *nisba* is not a reliable indicator of a craftsman's workplace, but in the case of Khurasan we have the names of at least five craftsmen with five different *nisbas*, while we do not have a single example for Maverannahr from the period between the tenth and thirteenth centuries.

A further task was to look for a distinctive grouping (or groupings) with regard to technique and style of production among the bronze artefacts usually designated as Khurasanian; such a group or groups would

be differentiated from Khurasan material in terms of either form or decoration and would be connected with Maverannahr on the basis of either originating, or at least having been purchased, from there. Unfortunately archaeology is of very little help in this respect as excavations have produced virtually no bronze objects or, to be more precise, such findings have been extremely rare. They have been found as part of treasure troves, but these finds have lain in store and remained unpublished for decades. This means that it has been impossible thus far to determine the origin of the objects or the precise time of their burial.

At present there are five such groupings, united by one common feature other than their material composition: all lack any form of metal inlay.

The first group contains large bowls characterised by the fact that the second band around the outer surface is never decorated [see cat. no. 35], trays with slightly inward curving edges, dishes with broad rims [see cat. no. 34], and vessels with gradually narrowing sides (see the vessel in the Ankara Ethnographical Museum, published in Rice 1958). In total 51 artefacts belong to this group. The majority of the bowls (24 out of 30) were either bought or found in Maverannahr, where five of the 19 trays were also bought. One plate was found somewhere in Ferghana.

The contours of the ornamentation and inscriptions on all these objects were made by incisions along the edges apparently to provide a setting for the metal inlay which, however, has always been lacking.

Two bowls and a tray, belonging to this group stylistically, form the exception in terms of decoration: they possess a small amount of copper and silver inlay. However these items date to the late twelfth or early thirteenth centuries and are late exponents of the group.

The bowls are in the Victoria and Albert Museum, London (see Melikian-Chirvani 1982, nos. 25-26), and the tray is in Michigan University Museum (see Soucek 1978, no. 66).

The second group consists of five ewers with a small palmette on the handle (see Marshak 1972).

The third group includes some ewers with a round body, tall neck and a straight handle, purchased in Maverannahr (see Marshak 1972, pp. 73-75). It has to be noted, however, that ewers of this shape were also obtained in places other than this region and the number of known pieces has greatly increased since 1972. This calls for a new, more detailed examination.

The fourth group contains identically-shaped ewers with the craftsman's signature, 'Ahmad'. We now know of 31 ewers, of which 22 were bought or found in Maverannahr. We can provisionally establish that the craftsman was active during the second half of the eleventh century. However it is not clear where he lived: the ewers that were found point to Ferghana (in the East), to Saganiyan in southern Uzbekistan, to Khurasan, and even Sinkiang. There is no biographical information about Ahmad in any written sources.

The fifth and last group consists of 27 bronze mortars with highly original decoration: their upper rim is crenulated. They were found as part of a huge trove in the town of Budrach in the south of Uzbekistan (see Ilyasov 1993) and date to the eleventh century.

It is very strange that we cannot detect any connection in the decoration or shape of the artefacts of these five groups. Consequently we must suppose that we are dealing with the output of different workshops in different towns, operating at different times. This may well be so, but the artefacts of the first group can be dated reasonably to the end of the tenth or the begin-

ning of the eleventh centuries. (They consist of three distinct chronological groups and were produced in workshops which flourished in the twelfth century with a clear influence of Khurasan production.)

It is still unclear in which towns of Maverannahr the metal workshops functioned, and further study is needed on this subject (cf. Ivanov 1996; 1998).

The Mongol invasion in the 1220s totally eradicated all the large towns of Maverannahr and Khurasan. There was a long period during which nothing is known of the fate of metallurgical production in these two large regions. If we have been successful in identifying a group of jug-makers active there from the fifteenth century [see cat. no. 90] and the output of Shir Ali Dimashqi's workshop [cat. no. 79], we still have to fill a gap of six centuries as far as the metalwork of Maverannahr is concerned. This is because the bronze artefacts preserved in the mausoleum of Ahmad Yasavi in Turkestan were not made by local, but by Iranian and Syrian craftsmen (see Ivanov 1981). Only from the nineteenth century onwards do we begin to see the development of a varied bronze (brass) metalwork production in Maverannahr, but thus far it has not been the subject of research.

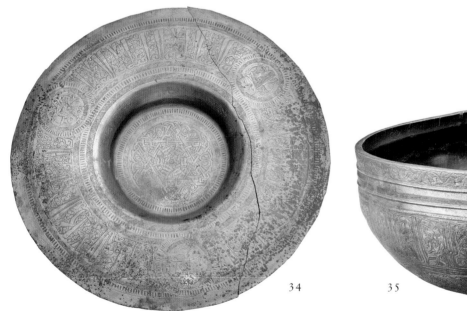

34

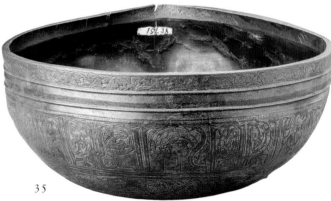

35

40

The Metalwork of Central Asia

34
PLATE

Central Asia (Maverannahr), 11th century

Bronze (brass), forging, engraving; 45.7 cm (diameter)

Origin: purchased in 2004

State Hermitage Museum, inv. no. PE-832

Published for the first time/not in exhibition

This plate has a broad rim, a deep circular well and a flat base without legs. It is decorated with an engraved design and an inscription of good wishes in Arabic (*naskhi* script): 'With happiness, and power, and safety, [and] thanksgiving, and well-being, and safety from harm, and prosperity, and power, and blessing,[?] and victory, [and] eternal life.' The background of the inscription is filled with small palmettes with five petals. The letters of the inscription and parts of the decoration are executed with a slight incision along the edges (known as 'swallow's tail'). This type of incision was usually created as a setting for the inlay, but there has never been any inlay work done on this plate. The lettering is very elongated at the top and the way the letter 'sin' is written, like three small circles, as well as the wide rim, are very important factors for establishing where the plate was made.

All these features – the lack of inlay, the background filled in with five-petalled palmettes, the peculiarities of the script, and the original wide-rimmed shape – allow us to state that the plate was made in Maverannahr in Central Asia in the eleventh century. (For further details on the work of this school of coppersmiths, cf. Ivanov 1996, pp. 244-47; Ivanov 1998, pp. 168-74). (A.I.)

35
BOWL

Central Asia (Maverannahr), 12th century

Bronze (brass), forging, engraving; 24 cm (diameter), 11 cm (height)

Acquisition origin: purchased in 1926 from S. Mahomedov (Kubachi)

State Hermitage Museum, inv. no. VS-751

Published for the first time/not in exhibition

This semi-spherical bowl belongs to a fairly large group of items, which were found or bought in the territory of historic Maverannahr, the territory north of the river Amu Darya, now in Central Asia).

More than thirty such bowls are known about, with the characteristic second band on their outer surface (always undecorated) and lack of other metal inlay. But the letters of the inscriptions and the decorative rim are done consciously to create the impression of being inlaid. Only two bowls of this group, dated to the twelfth century, have a small amount of silver and copper inlay (in the Victoria and Albert Museum, cf. Melikian-Chirvani 1982, nos. 25-26).

The earliest bowls date to the tenth century, a second group to the eleventh, while a third group, to which this Hermitage bowl belongs, to the twelfth century. The proof of this is the filling in of the background of the inscriptions with spiral stems and palmettes at the end, as on Khurasan products of the same period. Five-petalled palmettes form part of the background of two of the early groups. The images of the signs of the zodiac, running dogs and the presence of wickerwork on the Hermitage bowl, all testify to the influence of the Khurasan style. (A.I.)

PART II: ISLAMIC ART AND CHINA

(late thirteenth to sixteenth centuries A.D.)

Mamluk Art

Anton D. Pritula

The word 'Mamluk' (the passive participle of the Arabic word, meaning 'to rule') denotes people bought or captured, and given special schooling to serve the sultan as emirs or 'officers' of different ranks. This tradition dates from the first Islamic century, and then it spread into virtually every country in the Islamic world. The highest positions of state were often occupied by slaves like these, who would frequently organise palace *coup d'états*. After the death of the Ayyubid Sultan Najm ad-Din (1240-49), there was a whole series of *coups* when power passed from one Mamluk emir to another, until Baibars I came to power (1260-77). Baibars worked energetically to strengthen both state and economy. The first years of Mamluk rule were marked by two massive victories over the Crusaders (1250) and the Mongols (1260). The Mamluk sultans controlled not only Syria and Egypt, but also part of North Africa and the Hijaz with its Holy Cities of Mecca and Medina.

Under the Mamluk rulers, architecture and the applied arts flourished as never before. A major achievement was the production of beautifully illuminated manuscripts, including spectacular copies of the Qur'an. These were commissioned for, or dedicated to, mosques, religious schools (madrasah) and libraries which the Mamluks built as expressions of piety and whose majestic structures largely survive until the present day.

Applied art of the period was meant to serve the imperial hierarchy. Hand-crafted items made of different materials had emblems or blazons that marked a patron's position in the ranks of the Mamluk hierarchy. Sometimes the individual's name was indicated on an artefact, as proof of a special commission. However, more often items bore a standard form of inscription in praise of an anonymous emir. Such objects may lead us to suspect the existence of mass production. Although ceramics, textiles, and wooden objects with bone and mother-

43
HORN-SHAPED GOBLET
(see page 56)

of-pearl inlay, are worthy of note with regard to the high quality of their execution, the most outstanding pieces are arguably contemporary brass or bronze metalwares with metal-on-metal inlay, together with exquisite enamelled glass objects. There was a huge demand for such objects in Europe.

The inlaid bronze or brass items achieved great popularity and occupied a special place among palace and domestic interior furnishings. They were most likely used as banqueting ware and utensils, because silver and gold items were probably not much in use at that time. For this reason, it appears, many bronze items were crafted with the true finesse of a jeweller. By the early fourteenth century the imperial style was already achieving its distinctive characteristics, a style later known to the world as the Mamluk style. Its basic features are a prominent inscription naming the official, i.e. the patron, in *thuluth* script, and the emblem or blazon of the individual's profession in a round medallion or shield. From the point of view of form at any rate, during the first century of the Mamluk state's existence Ayyubid models continued to be used: domed censers, waisted goblets, two kinds of basins (with a shallow or a concave bottom), 'large' candlesticks (with sloping sides), and small ones (with a tripod base) [see cat. no. 38] as well as caskets [cat. no. 36]. In as much as the Mamluk style with its emblems took shape gradually, over decades, it is very difficult to distinguish late Ayyubid items from early Mamluk ones. Many decorative elements were preserved from the earlier period. Revellers and musicians – typical of all Middle Eastern art – are frequently depicted [cf. cat. no. 36]. Astrological motifs also appear. Indeed, the portrayal of the signs of the zodiac, as a cycle or individually, is typical of Muslim iconography: note the lion with its 'guardian planet', the sun, on a spoon in the Hermitage Collection [cat. no. 37]. This motif reflects one of the zodiacal constellations in its planetary 'house'. J. Allan is of the opinion that the often-encountered motif of a rosette with six circles placed around a circular centre, which occurs on a tray, also from the Hermitage Collection [cat. no. 44] has astral significance as well. A related circular arrangement, often met with in Muslim art, includes personifications of the seven planets placed around a central image of the Sun (Allan 2004, p. 36.)

Another favourite theme of Islamic art is the animal chase, which is also widely represented in Mamluk art. Such fantastic beasts as the sphinx and unicorn can be found among the animals. Indeed, the theme of the unicorn hunting an elephant, as noted on a spoon from the Hermitage, recurs frequently. R. Ettinghausen believes that the theme was borrowed from Indian mythological creations (Ettinghausen 1950, p. 90). Nevertheless, he attributed Mamluk objects with this particular motif to Egypt. Today they are almost certainly thought to have been made in Damascus. Thus the motif appears, for example, on an Ayyubid tray with Christian images in the Hermitage (London 2004, no. 41), on the famous Mamluk 'Baptistery of St Louis', and also on a Mamluk goblet from Turin, published by D. S. Rice, who was the first to suggest a link between the animal chase theme and Syrian iconography (Rice 1957, p. 489, fig. 3, pl. II).

Although Cairo was the state capital, Damascus was better known as the centre of production for metalware. There is information to suggest that, in 1293, Sultan Muhammad Qalawun owned one hundred copper (much more likely bronze) candlesticks in Damascus (Allan 1986.1, p. 50.5). It further suggests that such works of art as the 'Baptistery of St Louis'

were made in Damascus, along with other, very finely-wrought items, such as, for example, a basin decorated with superb multi-figure compositions of warriors, dated by different historians to the period between the 1290s (Atil 1981, no. 21.6) and the mid-fourteenth century (see Ward 1999, p. 9).

Alongside the production of inlaid metalwork there were items with simple engraved decoration. One such object is the Hermitage copper basin [cat. no. 42] showing a band of alternating interwoven arabesque and inscriptions engraved on a background of scroll stems with small leaves. A basin from the Museum of Islamic Art in Cairo is similar in form and decoration, as is another basin of similar type from the Khalili Collection. The basin from the Cairo Museum (Wiet 1932, no. 3937, pl. XLII), with the inscription of Sultan Muhammad ibn Qalawun (1293-94, 1299-1309, 1310-41), tells us when these pieces were made, and the Hermitage basin also gives us its place of production, Damascus, famous for its high-quality metalwares.

Mamluk rule also saw the highly developed production of enamelled glassware. There are dozens, if not hundreds, of glass hanging lamps that were made for use in mosques, mausoleums and madrasahs. The rulers and their emirs devoted huge sums of money to the building and decoration of places of worship and ordered hundreds of these lamps, usually inscribed with their names. There are, however, examples of lamps that contain no inscription [see cat. no. 40]. The shape of the lamp is of course variable. Typical of some examples is a high leg and angular body, as, for example, on a lamp from the hospice of Karim ad-Din (1310-20s) (Atil 1981, no. 53), or that of Tukuzdamur (1330-45) (Ward 1998, cover illus.). Others have a low or even shallow foot, a waisted body, and smooth contours (Carboni 2001, no. 115). Both types were produced concurrently. What is not clear is what the difference is based on, and connections with the accepted style of this or that workshop.

A multitude of different forms of enamelled glassware were made for secular purposes. Objects are preserved which imitate metalware forms and decoration. These include candlesticks (Hardie 1998, pl. 20.5), and basins (Ward 1998, pl. 9.2). Small cups widening towards the brim are the most widespread. Their decoration varies from simple bands or medallions, to architectural ensembles or birds. A fair number of musicians, dancers and revellers are also represented; these were popular motifs among the repertoire of Muslim art. Unfortunately, goblets of this type rarely include the name of the owner or craftsman and cannot be dated accurately. Thus the Hermitage horn illustrated with Christian priests [cat. no. 43] is usually dated to the fourteenth century, while S. Carboni, the leading specialist on Islamic glassware, gives it an earlier, thirteenth-century date (Carboni 2001, no. 121, p. 207). This date is also applied to another splendid bottle which features a similar design of priests and Christian churches. Although these representations are typical of the thirteenth century, Christian communities continued to exist in these territories even later. Thus related designs could still appear on artefacts many centuries later, as on the Aleppo tile which was made in 1699, during the Ottoman period [cat. no. 115].

In general the decoration of Mamluk artefacts shows a strong discernable Chinese influence. East Asian styles were brought to the Middle East by the Mongol conquerors in the second half of the thirteenth century, and are also found in Iranian production. Chinese silk textiles and other goods were imported,

and items found in Mamluk burials bear witness to this fact [see cat. nos. 95-96]. These artefacts in turn inspired Mamluk artisans to include eastern elements in the decoration of textiles, metalwork and glassware [cat. no. 94]. However, it appears that artefacts with an obvious Chinese influence, made in a Mamluk environment, do not occur until the early fourteenth century.[1] Only then do eastern elements become a favoured component within the decorative scheme. In the mid-fourteenth century, probably in the reign of al-Malik an-Nasir Hasan (1347-61), the lotus flower motif first appears in central medallions of various types of inlaid metalwork (cf. for example Allan 1982, no. 14; and also the British Museum candlestick, inv. no. 1953 10-21, 2), which is proof of its transformation into a very popular motif.

At the end of the fourteenth to beginning of the fifteenth centuries, plague and an economic crisis in the Mamluk empire led to a decline in trade. A shortage of silver, gold and copper caused a virtual halt in the production of inlaid bronze (brass) work (Allan 1984, pp. 85-92). However the production of enamelled glassware continued: a few fifteenth-century lamps have been preserved, the latest of which comes from the reign of Sultan Qaitbay (1468-96) (Carboni 2004, pp. 69-76, figs. 1-4).

From the later fourteenth century onwards, Venetian merchants began intense trade relations with the Middle East. Inlaid bronzework was the essential article of export from Mamluk lands into Europe. Despite the difficult economic conditions at the time, there was mass production of inlaid bronzework for export. One stylistic group of this type of work was connected with Damascus. This group consisted of spherical incense-burners, similar to the State Hermitage style of censer [cat. no. 48], trays with a raised centre, lidded bowls, and bowls without lids (both with and without a spout). None of these forms is of European provenance. The spherical open-work incense-burners are generally thought to have been borrowed from Ta'ng dynasty China by the Muslim metalworkers, its Middle Eastern derivatives appearing in the thirteenth century (cf. incense-burners of the seventh to ninth centuries: Atil 1985, p. 172, fig. 61).

The raised-centre trays have been found among fourteenth-century items with inscriptions referring to Mamluk emirs.[2] Allan considers them to be an enlargement of the *piala* (Allan 1986.1, p. 43) (a wide-brimmed cup without handles, for drinking green tea)[3] of similar shape; and bowls, with and without spout, are also widely known in the Muslim East. Earlier Mamluk examples are known to have their sides bent at an angle;[4] indeed, possibly the only shape whose origin is not entirely clear is that of the lidded bowl. As we do not know of any European prototype, we have to search for one among the artefacts of Middle Eastern metalworkers. As to the decoration of such bowls, Allan has demonstrated that it is Mamluk Qur'an illuminations (Allan 1986.1, p. 56).

Similarly-formed European artefacts are usually of a later date and imitate the Eastern model. In this way one can say that, in contrast, the idea of goods for export for the European consumer lay in their exotic nature.

The evolution of traditional Mamluk ware for export can be usefully illustrated by looking at candlesticks. At least twelve miniature candlesticks with different European crests survive from the Mamluk period: four in the British Museum,[5] four in the Venetian Museum (Venice 1994, no. 306), two in the Victoria and Albert Museum (Allan 1986.1, pp. 53, 54, fig. 42),

and two which were sold at auction at Sotheby's (1992, fig. 124).

The unique Hermitage candlestick in this exhibition [cat. no. 45] is linked to the above group of candlesticks with regard to its small scale and its overall shape of socket with vertical sides. However, the Hermitage candlestick is more squat, and its shoulder has a hollow to allow the wax to escape, typical of Middle Eastern candlesticks but not a feature of those for export. Apart from this, the Hermitage candlestick has a less projecting shoulder above the body than the export variety.

The Hermitage candlestick, in its shape and dimensions, can be compared to at least two candlesticks with customary Mamluk decoration, made for Muslim customers. The first, in the Keir Collection, can be dated to the late thirteenth or early fourteenth centuries (with an inscription of the client's name, 'ibn Sa'id al-Talashi': Fehervary 1976, no. 158).

The second is a candlestick from the British Museum, similar in form to the above, with an inscription of an un-named Mamluk emir, datable to the end of the thirteenth or first half of the fourteenth centuries (unpublished: inv. no. 1953 10-21, 2). Its base contains lotus decorated medallions, which apparently made their appearance in Mamluk art from the fourteenth century.

The animal scenes on the Hermitage candlestick can be compared to similar scenes on various examples of Mamluk metalware, in particular a pyxis ordered by Emir Aydamir Ashrafi, dated to 1371 and made in Aleppo, with stylistically similar pictures of lions and animals with hoofs (Rice 1953, pl. 1, figs. 5, 6). However, the main difference lies in the fact that the pyxis shows traditional Islamic scenes of a hunter pursuing prey, while the Hermitage candlestick has rather stiffly executed scenes of animals, almost completely symmet-

rical on either side, giving them a somewhat 'heraldic' look. This symmetrical manner of depicting animals can be found on other Mamluk bronzeware designed for export.[6] The pictures on these examples are similar to those on the Hermitage candlestick, but are even more symmetrical and executed much more crudely. A goblet from the British Museum has the same shape as other examples usually dated from the late fourteenth to early fifteenth centuries (see Ward: *Islamic Metalwork*, London 1993, p. 115, fig. 17, the Hermitage cup with silver inlay, inv. no. EG-1254, illus. 4). This is typical of goods designed for export. On the candlesticks for export of the same date we also find a variety of animals depicted, of symmetrical proportion and again of cruder execution than the decoration on the Hermitage candlestick [cat. no. 45]. For example, on at least three of them we find a large picture of winged lions evidently growing from a central lotus and enclosing it on either side (two candlesticks from Sotheby's [Sotheby's 1992, fig. 124]; one candlestick from the British Museum collection: inv. no. 1855 12-1.7). On one other candlestick, there are two lions in symmetrical position on either side of a plant of abstract design (British Museum Collection; inv. no. 78 12-30.720).

Taking into account the similarity of the images on the Hermitage candlestick, and those on the pyxis of the Syrian Governor Aydamir of 1371, the former can be dated to the second half of the fourteenth century, and to a Syrian locality.

The blazon depicted on the Hermitage candlestick appears to represent the blazon of the Lusignans, the dynasty of the 'Kingdom of Jerusalem', misinterpreted by a Muslim craftsman.[7] A shield, if meant for export, is usually made to European specifications. The round

medallion should also contain, with the exception of the Hermitage candlestick, a European blazon: although it appears on the inner surface of a basin which bears the inscription of Elizabeth of Habsburg (1337-42) (Ward 1989, s.205, no. 230). This basin is probably the earliest surviving example of something designed for export. It also confirms that the Hermitage candlestick was one of the first examples of export ware: a Muslim craftsman, who perhaps would not be aware of the finer points of heraldry, bringing together all he has observed on coins and through various texts.

The Lusignans at that time ruled over Cyprus alone, and no longer possessed Jerusalem (captured by Salah ad-Din in 1187), or even Acre (captured by the Mamluk Sultan al-Ashraf Khalil b. Qalawun in 1291). However, they were able to order products from Muslim craftsmen in the region of Syria, as exemplified by a famous basin (Ward 1989, p. 207, taf. 234, 235). Such orders probably also included the Hermitage candlestick, commissioned, if the dating is right, during the reign of Hugo IV (1324-59), or his successors, Peter I (1359-69) and Peter II (1369-82) of the House of Lusignan.

Thus we can reach the following conclusions: the workshops producing goods for export from approximately the mid-fourteenth century onwards, initially produced the traditional metalware of the Syro-Egyptian production line of its day. This explains the use of local forms and decoration. Later, with the collapse of the internal market, these workshops began to specialise exclusively on production for export. This explains their gradual deviation from local prototypes.

The locality of the production of a second distinct group of metalwork for export requires some discussion. This group contained lidded bowls, trays and pots, all decorated with small inlaid arabesque scrolls of stalks with divided leaves. The design often incorporates different types of medallion. The majority of the items, which are well represented in European collections, bear the signature of Mahmud al-Kurdi, the best known craftsman of his time, the fifteenth century. Among his handiwork is the Hermitage tray [cat. no. 49]. Two leading specialists on Arab artistic metalware, J. Allan and R. Ward, differ on the question of the place where this group was made. While the former considers Cairo in Mamluk Egypt to be al-Kurdi's place of work (Allan 1986.2, pp. 169-70), the latter links it to Western Iran (Ward 1993, p. 80). A Mamluk Egyptian or Syrian origin is to be preferred. The arabesques and medallions used by al-Kurdi are similar to those in illuminated Qur'ans copied in fifteenth-century Cairo, and also resemble architectural decoration found on Mamluk building complexes in Cairo, built under Sultan Qaitbay (1468-96) (Allan 1986.2, pp. 169-70). Apart from this, however, we have nothing to confirm that Western Iran took such an active role in the Venetian trade, particularly in the export of metalware. Products of this group later spawned a range of imitations in Europe, and subsequently European, especially Venetian, craftsmen acquired the technique of metal-on-metal inlay from the Middle East.

In 1516 the Mamluk sultan's forces were defeated by the Ottoman Sultan Selim I at Aleppo, shortly after he had crushed Safavid Iran. The last Mamluk sultan, Tumanbay, was defeated and then executed in 1517. The Arab world was to remain under the rule of Ottoman Turkey for four centuries.

Mamluk art undoubtedly exercised a strong influence both on Europe and on neighbouring parts of the Islamic world, particularly in metalwork. Although at the beginning of the thirteenth century the metalwork

in Arab countries experienced the greatest influence of Iranian work and adapted its metal-on-metal inlay techniques, towards the end of the century the situation changed sharply and was in fact reversed. At that time Iranian craftsmen, who worked for local dynasties in Iran and especially in the southern province of Fars, began to build on the achievements of the 'Mamluk' metalwork style, initially developed for Mamluk rulers and those of their circle. Large *thuluth* inscriptions became fashionable, forming the basis of decoration and copying the Mamluk convention of listing royal or official titles. Inscriptions in roundels and horizontal inscriptions frequently containing the name of the ruler, now appeared, just as they did on Mamluk products (Melikian-Chirvani 1982, no. 101). The fashion for 'Western' (i.e. Syro-Egyptian) type products found expression in the borrowing of different forms and shapes as well. Bowls, basins and trays [cat. no. 76],[8] similar to Mamluk examples in shape, became widespread, as well as ewers with long, straight spouts, and candlesticks that differed from Eastern Iranian, Khurasanian examples, but remained similar to Syro-Egyptian products (cf., for example, St Petersburg 2004, nos. 121, 122).

NOTES:

1. Typically for Chinese iconography, the lion is shown this way on the flask from the Gulbenkian Museum (Carboni 2001, no. 127).

2. Cf., for example, the tray from the Freer Gallery Collection with the inscription of the Emir of the Sultan entitled al-Malik an-Nasir, to be dated, judging by the style of inscription, no later than mid-14th century (Atil 1985, no. 22); and likewise the tray from the Keir Collection (Fehervari 1976, no. 158).

3. With a lip: in the Aron Collection there is a similar cup with the inscription of the Emir of the Sultan al-Malik an-Nasir, i.e. one of the sultans who ruled no later than mid-14th century – the time of Sultan al-Malik an-Nasir Hasan (Allan 1982, no. 21). J. Allan considers this type of ware to be a jug for pouring wine; the lip also served as a handle.

4. Without lip: goblet from Turin (Rice 1953, pl. 1, figs 5, 6); goblet from the Aron Collection (Allan 1986.1, no. 12).

5. Only one has been published: Ward 1993, p. 28, pl. 17; Ward 1989, no. 263. Four other candlesticks (inv. nos. 1855 12-1.6, 1855 12-1.7, 1855 12-1, 78 12-30.720) should be published soon by R. Ward in the catalogue of Islamic Metalwork of the British Museum Collection.

6. E.g., the goblet without a lip, with a European blazon, with scenes of animals, in the collection of the Museum of East (Moscow) with animal scenes: inv. no. 515II; 23 cm (diameter), 12 cm (height). No reproduction permitted. Two scenes appear on the goblet, each of which is repeated once again: (1) two symmetrical antelopes with sides of wood; (2) two symmetrical lions under a tree, over which a bird is flying.

7. According to E. A. Yarovaya of the Numismatics Department of the State Hermitage, this blazon is unique with no known comparison. We cannot treat the central cross as divided into fields. In such a case, by the rules of heraldry, the picture in the left field ought to be repeated in a third one, while the second is repeated in a fourth field. Here the design is the same in all four fields. It is more reasonable therefore to assume that the centre is not divided into fields, and also the cross, as we can see by the traces of inlay strengthening which, in breadth, is equal to the breadth of the small crosses. So what we have is a peculiar de-formation of the blazon of the Crusaders' Kingdom of Jerusalem. However, it is distinct from its usual appearance, for example, on the famous basin of Hugo (IV) Lusignan, King of Cyprus and Jerusalem (1324-59), or on coins of the same dynasty, starting with Henry II (1285-1324), where, on the Hermitage candlestick, the small crosses have two cross-beams apiece. This kind of cross is met, if rarely, as a concise and simplified depiction of the entire Jerusalem blazon as a whole. Thus, in E. A. Yarovaya's opinion, on the Hermitage candlestick we see the fusion of two types of blazon: the full version and a simplified version. Nonetheless, we cannot exclude the fact that the Hermitage candlestick depicts a kind of blazon, connected to Jerusalem, which is totally unknown.

8. A similar Persian tray, like the State Hermitage example which is a copy of a Mamluk original, is in the collection of the Victoria and Albert Museum (Melikian–Chirvani 1982, no. 94).

Mamluk Art

36
CASKET

Syria, 13th century

Bronze, casting, silver inlay; 10 cm (height with lid),
9.8 cm (diameter)

Origin: acquired in 1925 from the Museum of the former Central
School of Technical Drawing of Baron A. L. Stieglitz

State Hermitage Museum, inv. no. IR-1490 a,b

Reference: Pritula 2004, pp. 127-30, illus. 1

The outside edge of this casket is decorated with a benevolent inscription in *naskhi/thuluth* script, separated by three medallions: 'Fame and stability, and ... mercy, safety and prayer.'

The round medallions contain figures of musicians and revellers making merry; including a man with a tambourine, a flautist, and a man holding a goblet.

The base of the Hermitage casket is decorated underneath with a round medallion. It shows a geometric ornament within a six-pointed star, surrounded by a lattice band. The inscription appears in typical Mamluk epigraphic style, in *thuluth* script. The letters of the inscription, which occupy a central position in the decoration of the casket, are fairly wide, and are displaced vertically, which indicates that the piece was made no earlier than the mid-thirteenth century. The fact that the background of the Hermitage casket, inside the medallions with revellers, is free of any inlay, indicates that this object was made no later than the 1270-80s. In other words, this is a fairly high-quality but nevertheless mass-produced piece, made in a Syrian town at the end of the Ayyubid or the beginning of the Mamluk period. (A.P.)

37
SPOON

Syria (Damascus?), 1250-70s

Brass, silver and gold inlay; 14.2 cm (length)

Origin: acquired in 1898 by V. G. Bock

State Hermitage Museum, inv. no. IR-1544

Reference: Pritula 2004, p. 130, illus. 2

The front of this spoon bears a round medallion containing the images of a lion and the sun. The stem is decorated with running animals. The back of the lid has an 'animated runner'. Apart from the usual leaves, one can also see leaves in the shape of a cat's head, although unfortunately only one of three inlaid plates in this shape has survived. Many such arabesque figures with lions' heads have survived on Syrian and Egyptian wares, and this is thought to be associated with the mythical waqwaq tree, mentioned in Persian and Arabic poetry, as well as in the captivating fables or *dastans*. This ornamental aspect is used almost up to the first quarter of the fourteenth century. The presence on the work of traditional backgrounds, without inlay, establishes an upper time limit: no later than the 1270s or 1280s.

The subtlety and precision of the inlay and engraving on this Hermitage spoon indicates that it may have come from one of the workshops in Damascus. (A.P.)

36

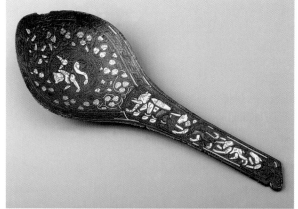

37

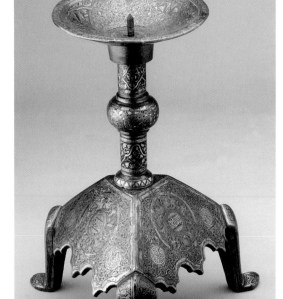

38

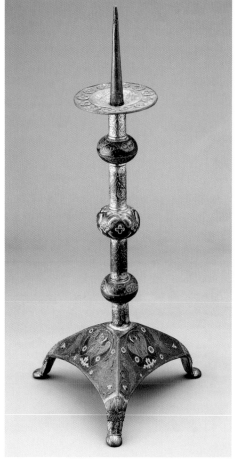

39

38

CANDLESTICK

Syria or Egypt, 14th century

Brass, silver and gold inlay; 23 cm (height)

Origin: acquired in 1885 from the A. P. Bazilevsky Collection

State Hermitage Museum, inv. no. EG-764

Exhibition: Kuwait 2000, no. 56

Many such candlesticks from the fourteenth and fifteenth centuries are known to have come from Syria or Egypt. There are usually three hinge pivots on the stem. This example was altered at a later date and the stem was shortened and inverted; the standard Mamluk inscription of the anonymous emir was also inverted. The base has a medallion, indicating the name of a sultan: al-Malik an-Nasir (most likely Muhammad ibn Qalawun, 1293-94, 1299-1309 and 1310-41).

These candlesticks were mass-produced and written sources mention hundreds being commissioned in Damascus, which increases the probability that the Hermitage example was made in Syria. (A.P.)

39

CANDLESTICK

France (Limoges), last quarter of 12th century

Copper, enamel, forging, repoussé, carving, engraving, champlevé, gilding; 37 cm (height)

Origin: acquired in 1885 from the A. P. Bazilevsky Collection in Paris (acquired prior to 1865)

State Hermitage Museum, inv. no. F-205 b (B.301)

References: Darcel 1865, p. 519; Darcel 1874, no. 227; Linas 1886, p. 5, no. 3; Kondakov 1891, p. 201, no. 13; Rupin 1890, p. 526; Kube 1921, p. 29; Braun 1932, p. 525; Kryzhanovskaya 1991, p. 72; Brimo de Laroussilhe 1995, p. 76, no. 2

Exhibitions: Paris 1895, no. 640; Paris 1867, no. 2088; Paris 1878; Leningrad 1986, no. 91

The tripod shape, with feet carved in the shape of lion heads and paws is typical for Limoges candlesticks of the second half of the twelfth and beginning of the thirteenth centuries. The number of globular projections on the stem usually varies from one to five. Earlier pieces (from the mid-twelfth century) have a spherical base, while closer to the turn of that century a pyramid-shaped base was common. A symmetrical composition with a round medallion in the centre was most frequently placed in the centre of the trapezoidal surface.

The images used to decorate such candlesticks – most frequently battle scenes, wild animals or mythical creatures – generally do not help us determine the purpose of such wares. It is generally thought that they could be either secular or church items. The depiction of angels on this piece, however, strongly indicates that it was used in church, especially because there is a second candlestick, which forms a pair with this one (State Hermitage Museum, inv. no. F-205 a). Such pairs were placed on altars, and a fair number have survived (State Hermitage Museum, inv. nos. F-1938 a, b).

The enamel on the pediment is of high quality, with engraved vermiculé ornament on the stem, fine and elegant sprouts with three-leafed crenellated finials on the sirens' tails; while the contours and details of the figures are filled with red enamel. These features are all typical of early Limoges work, and allow the piece to be dated to the last quarter of the twelfth century. This candlestick has been decorated with unusual care, with fine engraving work and stippling (along the sprouts and the undulating line around the medallion and on the siren's bodies – the typical Limoges ornament consisting of triple points). This, along with the undulating ornament around the medallion, and the ornament consisting of triple points on the sirens' bodies, are typical of Limoges pieces.

Limoges enamel products were especially popular in Europe of the Middle Ages, and were common as far as Scandinavia and Russia, and even as far as the Middle East. Archaeological research indicates with some certainty that Limoges products made their way to Palestinian territory.

During excavations in 1863 near the Basilica of the Nativity in Bethlehem, a pair of candlesticks (c.1150), a single candlestick (c.1170-80) and a crosier (closer to mid-thirteenth century) were found (Enlart 1925, p. 196). The St Catherine Monastery at Sinai has a plaque taken from a book cover, which bears an image of Christ in glory (early twelfth century), most probably brought by Crusaders as a gift (New York 1996, p. 46). In addition, several *circa* 1250-75 pyxes and gemellions (Metropolitan Museum of Art, inv. no. 49.56.8, Cluny, inv. Cl. 1653) feature the coat-of-arms of the Kingdom of Jerusalem.

According to M. M. Gauthier (Gauthier et François 1987, nos. 70, 125), the first two candlesticks from Bethlehem were made for the Holy Land by Limoges master craftsmen; the second was probably made at a local workshop, which appeared to be influenced by the Limoges school (although there is no proof of the existence of such a workshop). It is harder to determine where the above-mentioned pieces bearing the coat-of-arms were made, as we have no information about their origin.

There is some indirect information to suggest contact between Aquitaine and the Holy Land, the earliest and most important example of which is the gift of part of the Holy Cross, from the King of Jerusalem to the Grandmont Monastery (1174) (New York 1996, p. 45, no. 131). (E.N.)

40

MOSQUE LAMP AND PENDANT

Syria or Egypt, first half of 14th century (lamp);
Egypt, 12th century (pendant)

Glass, enamel; 30.7 cm (height)

Origin: acquired in 1924 from the Countess E. V. Shuvalova Collection; pendant acquired in 1898 by V. G. Bock

State Hermitage Museum, inv. nos. EG-493 (lamp), EG-937 (pendant)

Exhibitions: Amsterdam 1999, no. 12; St Petersburg 2000, no. 13

It is known that this lamp was made several centuries later than the pendant. During the period when the pendant was being made, decoration of glass using enamels was not common, and for this reason a lamp with a very different type of decoration was intended. However, as metal items last longer than glass, such pendants could be used for several centuries. The pendant has the shape of the 'hand of Fatima', a symbol found across the Islamic world.

The tall foot and sharp inflection in the lower part of the body of the lamp suggest it was made in the fourteenth century. Many lamps have a similar shape, such as the lamp in Boston Museum, bearing the inscription of Karim ad-Din (1310-20), the lamp of the Emir of Tukuztimur (1330-45) in the British Museum, and other lamps from the thirteenth century. Lamps from a later period appear to have a rounder body and shorter foot. (A.P.)

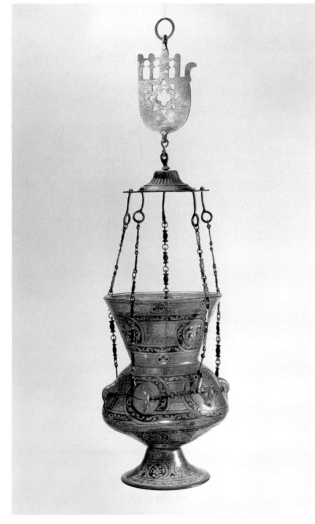

40

41

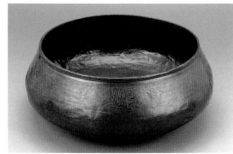

42

41
HAT

Egypt, 14th century
Silk; 16 cm (diameter), 12 cm (height)
Origin: acquisition unknown
State Hermitage Museum, inv. no. EG-934
Published for the first time

This headwear is seen in many different sizes, and was probably worn by adults and children. A band of fabric could also be wrapped around it, forming an *imamah* or turban. Several such hats are known in museums around the world, including the Museum of Islamic Art in Cairo, and the Cleveland Museum. (Atil 1981, no. 117). (A.P.)

42
BASIN

Syria (Damascus), mid-14th century
Copper; 51 cm (diameter)
Origin: purchased in 1980 from S. N. Hanukaev
State Hermitage Museum, inv. no. EG-1235
Exhibition: Kuwait 1990, no. 58
Not in exhibition

The inscription on the side of this basin states: 'Part of that, made by order of a pauper before his Lord, Baltut al-Bidri al-Marvani, ustadar of his highness al-Maulavi al-Shihabi al-Marvani, master … as-Saida in Damascus.' The decoration of the basin consists of arabesques, alternating with scalloped medallions and cartouches with an inscription against a background of spiral stems. This piece has no inlay, but was made at the same time as pieces with inlay (certainly no later than the fourteenth century). In later periods the background of spiral stems on such Syrian or Egyptian pieces without inlay was replaced with a lattice, and then with long leaves with curled shoots. (A.P.)

55

43
HORN-SHAPED GOBLET (see page 44)

Syria, 14th century (goblet); Germany, 1551 (mounts)

Glass, enamel, silver, gilding; 29.5 cm (height)

Origin: acquired in 1860 from the Kunstkammer

State Hermitage Museum, inv. no. VZ-827

References: Museum 1741, Taf. III, fig. 3; Bakmeister 1779,
pp. 177, 178; Kondakov 1891, p. 170, no. 47; Veselovsky 1900,
p. 457 (goblet without mounts); Foelkersam 1902, pp. 81-83;
Lapkovskaya 1971, pl. 83 (bibliography); Hermitage 1981,
p. 92; Ward 1998, fig. 171; Piotrovsky 2001, p. 90

Exhibitions: Berlin 1989, s.211; Neverov 1992, no. 161;
St Petersburg 1996A, no. 218; St Petersburg 1998, no. 68;
Amsterdam 1999, no. 167; St Petersburg 2000, no. 190

The fate of this unique object remains a mystery; this is
one of Russia's oldest museum exhibits. In the 1730s it
was already housed in St Petersburg's Kunstkammer,
Russia's first public museum. However it is not known
when it entered the museum, or where it came from. The
goblet is in some way linked to the Russian Empire by
the silver mount, which was commissioned in 1551 by
Bruno von Drolshagen for his son Jürgen (the coat-of-
arms of the Drolshagens can be found in the centre of
the mount). The Drolshagens were members of the
Teutonic order of *Fratres Militiae Christi*, or the Brothers
of the Sword, and owned lands in Livonia (now East
Latvia). The mount may have been commissioned for
Jürgen's marriage, as below the German inscription is
the image of a man and woman, and the woman is seen
with headwear traditionally worn by brides in Germany
at the time. It is not especially clear where the silver
mount could have been made – in Germany, perhaps
(the style of a German craftsman is very visible), or in

Livonia by a craftsman of the German school (or some-
one German-trained) – both are possible. There are,
unfortunately, no stamps on the mount.

The Teutonic order of the Brothers of the Sword came
into being in the Holy Land in Palestine (in the 1230s its
members relocated to the Baltic region), and it is very
likely that one of the members of this group brought with
them this unique glass wine goblet, whose shape clearly
imitates European goblets.

The goblet was made from Syrian glass in the four-
teenth century, and is decorated with enamels of different
colours, typical of glass items from Syria at that time.
The vessel has two bands with inscriptions; in the upper
inscription, Arabic letters in gold against a dark blue
background read: 'Fame to our sultan, the wise king, the
wise, the just, who fights for the faith, the triumphant
victor ...' (the name of the sultan is not mentioned).
The second inscription, which has not survived well, and
is partly hidden by the middle of the mount, is almost a
repeat of the first: 'Fame to our master the sultan, wise
king, just, who fights for the faith, who stands guard
[at the borders].' Between the two bands is ornamental
decoration of four standing figures, dressed in clothes of
different colours, and holding books in their hands. It is
very possible that these are the four Evangelists, as there
were a large number of Christians in Syria in the thir-
teenth to fourteenth centuries, and artefacts were created
here that combined elements of both Islamic and
Christian art.

This unique relic has travelled a long and interesting
way from fourteenth-century Syria to eighteenth-century
St Petersburg. (A.I.)

44
TRAY WITH STAND

Egypt, 14th century
Bronze (brass), silver and copper inlay; 47.5 cm (diameter),
22 cm (height)
Origin: purchased in 1901 from I. A. Balas
State Hermitage Museum, inv. no. EG-767
Exhibition: Kuwait 1990, no. 52

The foot of this tray has two similar bands of verses,
inscribed in *thuluth* script, where the lower band is
longer: 'Fame and success forever and long life / To you,
o master of great dignity / And honour, constant happi-
ness' The tray itself bears a graffito by a later owner:
'Fatima, daughter of Abd an-Nasir.'

This tray, with its tall foot, is one of 33 known metal
pieces commissioned by the Rasulid dynasty of Yemen.
This is confirmed by the decoration of the base and the
surface of the tray itself, with its five-petal rosettes in
round medallions, considered to be the coat-of-arms of
this dynasty.

The rosettes themselves were inlaid with silver and
the background is red copper. Although copper inlay
was no longer used by the mid-thirteenth century, it con-
tinued to be found in heraldic images, where colour was
an important component. In all the remaining decorative
elements of this object, silver inlay was used.

This tray, with its tall foot, was apparently intended
for sweets and fruits, such as those served during a
banquet. Many images, both on miniatures and on metal
artefacts, show similar trays placed before seated revellers.
However, few trays of this shape have survived; separated
bases for trays and trays without a foot are far more
typical. (A.P.)

45
CANDLESTICK

Syria, 14th century
Brass, silver inlay; 8.3 cm (diameter), 10.5 cm (height)
Origin: acquisition unknown
State Hermitage Museum, inv. no. EG-1250
Published for the first time

The walls of the base are decorated with three scenes
involving animals, divided by round medallions with a
coat-of-arms: two antelopes against a background of
fruit trees, two birds of prey mauling gazelles, and two
lions either side of a plant (most likely, a lotus). The
lower part of the base is decorated with animals in a
race: dogs running after hares.

The base is decorated with a coat-of-arms in round
medallions. This is apparently the coat-of-arms of
Lusignan (somewhat distorted by the Muslim craftsman)
whose rule at this time spread no further than Cyprus.
This candlestick was probably made earlier than other,
similar works intended for export. Considering the
similarity of the images on the Hermitage candlestick
and the pyxis of the Syrian Governor, Aydamir, of 1371
(Rice 1953, pls. 1, figs. 5, 6), this piece can be dated to
the second half of the fourteenth century, and most
probably was made in Syria. (A.P.)

45

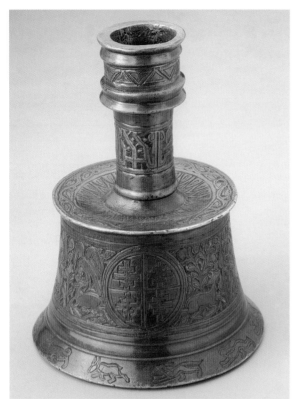

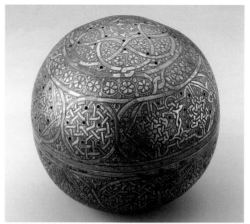

48

44

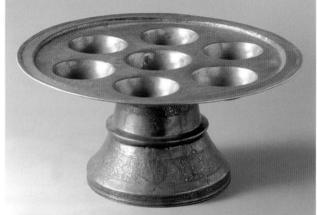

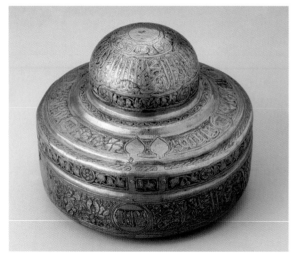

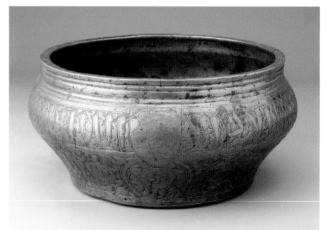

46

47

46
BOX

Syria or Egypt, beginning of 14th century

Bronze (brass), silver and gold inlay, blacking;
10.5 cm (diameter), 4 cm (height)

Inscriptions (cartouches at base and on lid): 'Fame be to our master, triumphant king, helper of peace and faith Muhammad ibn Qalawun, may his victory be famous!'

Inscription (medallions on lid): 'Victorious king.'

Inscription (medallions on wall of base): 'Fame be to our master, the sultan.'

Origin: acquistion unknown

State Hermitage Museum, inv. no. EG-765 a,b

Exhibitions: Kuwait 1990, no. 17, St Petersburg 2001, no. 131

This splendidly decorated box was thought to have been made in the workshop of one of the capital cities, either Cairo or more likely Damascus. It is very similar in shape and decoration to a box in the collection of Nuhad es-Said (Allan 1982, no. 14), which also has inscriptions including the name of sultan Muhammad ibn Qalawun (1293-94, 1299-1309, 1310-41). J. Allan suggests that such boxes were used to store incense, which was burned in palaces in incense-burners. In his opinion the shape of such boxes imitates the famous Dome of the Rock Mosque; this is confirmed by comparing it with the body of a Persian incense-burner from the Louvre, of the same period (Paris 1977, no. 330), which is probably a copy of a Mamluk artefact, and takes the shape of a polygon, similar to a mosque or mausoleum. (A.P.)

47
BOWL

Syria, end of 14th to first half of 15th centuries

Bronze, silver inlay; 9 cm (height), 17.5 cm (diameter at rim)

Inscription: (*naskhi* script around rim): 'His high Excellency, the master, great emir, protector, ..., saviour, ..., treasure, saviour, helper, ruler, decider, the royal.'

Origin: purchased in 1904 from A. S. Velyaminova-Zernovaya

State Hermitage Museum, inv. no. EG-759

Exhibition: Kuwait 1990, no. 55

This bowl was made for export to Europe. Bowls of similar shape, with and without spouts, are known, and are thought to have been manufactured in Damascus. The piece is decorated with a European coat-of-arms, which also decorates the base of the bowl. The closest known comparison, in terms of shape and decoration, is a bowl in Stockholm, dated to the beginning of the fifteenth century (Ward 1989, p. 206, pls. 232, 233). However, unlike that piece, the Hermitage bowl has no gold inlay. (A.P.)

48
INCENSE-BURNER

Syria (Damascus), 15th century

Bronze (brass), silver inlay; 14 cm (diameter)

Origin: acquisition unknown

State Hermitage Museum, inv. no. IR-1426

Published for the first time

This ball-shaped incense-burner is one of a large group of such objects manufactured in Damascus for export to Europe. Dozens of similar incense-burners have survived in European collections. Inside, a small tray is mounted on ball-bearings, ensuring that the incense maintains a horizontal position. (A.P.)

49
TRAY

Egypt (Cairo) or Syria, 15th century

Craftsman: Mahmud al-Kurdi

Bronze (brass), silver inlay; 30 cm (diameter)

Origin: acquired in 1925 from the Museum of the former Central School of Technical Drawing of Baron A. L. Stieglitz

State Hermitage Museum, inv. no. VS-235

Inscription (central medallion): 'decorated by the teacher Mahmud al-Kurdi.'

Reference: Miller 1955, pp. 40-41

Exhibition: Paris 1903, pl. 26

One of many works by the craftsman Mahmud al-Kurdi, referenced by G. Migeon in 1903 (pl. 26), this tray was acquired in 1914 for the Museum at the Central School of Technical Drawing of Baron A. L Stieglitz in St Petersburg.

Like other works by Mahmud al-Kurdi, the Hermitage tray is a virtuoso piece, in which the composition of the ornament is beautifully balanced. However, unlike for example, the tray in the British Museum (see Ward 1993, p. 102), there is no gold inlay on the Hermitage tray. (A.P.)

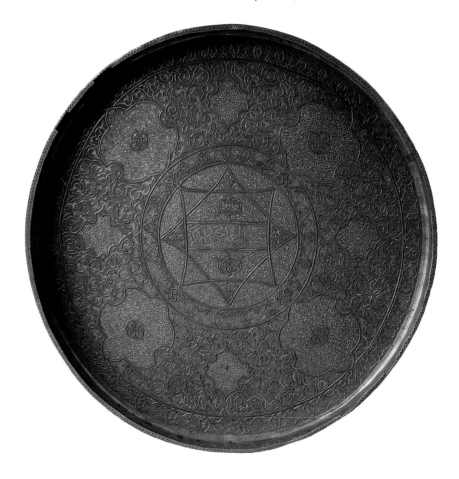

The Culture of Kubachi

Anatoly A. Ivanov

The village of Kubachi is in the Daghestan Republic of the Russian Federation. It is situated approximately sixty kilometres to the west of the town of Derbent. The name 'Kubachi' is a Turkic word for a maker of chain mail. In the nineteenth and early twentieth centuries the inhabitants used to decorate their weapons artistically, whether side-arms or artillery. They also cast pots in Kubachi, although admittedly of low artistic value, as well as various bronze and copper vessels.

Another feature of the village brought it to international attention: its trade in famous works of art. Kubachi homes have preserved a great deal of Iranian pottery from the fifteenth to nineteenth centuries, Iranian bronze and copperware of various periods, examples of Syro-Egyptian bronze artefacts from the thirteenth to nineteenth centuries, as well as Iranian textiles from the sixteenth to nineteenth centuries. Although these items were handed down through the generations, no one knows when the collections first appeared. There are many theories concerning the history of their formation. European travellers in the late nineteenth century began to circulate information about the existence of collections of antique objects in the houses of the Kubachi villagers, and at the end of the century the firm of Kelekian began to make regular purchases of their fifteenth to nineteenth-century pottery. Because of this the pottery, with its characteristic dark blue cobalt decoration, became known as 'Kubachi ware', although neither the village itself, nor Daghestan, produced pottery with a white body as the clay there was of the wrong type.

The existence of stone relief works in Kubachi has been known since the scholar B. Dorn visited the village in 1861. The maps of his journeys were published in 1871 and 1895 (Dorn 1871 and 1895). However, at the time they did not arouse any scientific interest, either in Russia or overseas. Indeed, study of the reliefs only began in the 1920s and a great number of relief works were removed from the village. Two large collections were established: one in the Daghestan Historical Museum in Makhachkala; the other in the State Hermitage Museum. At the beginning of the 1930s seven reliefs were exported, most likely sold, abroad; these all appeared in a publication by A. Salmony (Salmony 1943). In the 1930s two types of bronze cauldron ('open' and 'closed') attracted the attention of scholars (Orbeli 1938). Then, after a long interval, interest in these particular works of art resumed in the 1960s and 1970s (Kilchevskaya 1962 and 1968; Kubachi 1976). It can be said that a new period of research into the Kubachi works of art had now begun, particularly as the magnificent tombstones from this village had also become objects of scholarly interest for the very first time. As a result it emerged that there were no ancient pieces datable earlier than the beginning of the fourteenth century (Kubachi 1976, pp. 170-72), and the hey-day of both carved stone artwork and cauldron production of the 'open' type [see cat. no. 50] had only occurred in the village between the second half of the fourteenth and beginning of the fifteenth centuries.

The conclusion reached about the relatively late date for the antiquities from Kubachi posed a new problem: their respective connection with 'historical Zirikhgeran' and Kubachi. Arab geographical literature, from the ninth century onwards, mentions a kingdom (or village) of 'Zirikhgeran', Persian for 'chain mail makers'. It

was located in Daghestan, but its exact situation was unknown, and no one who wrote about it had ever been there. We still do not know where 'historical Zirikhgeran' actually was, and this remains an important challenge for scholarship up to the present day.

In the 1140s the Spanish traveller Abu Hamid al-Garnati visited Derbent. He wrote that, apart from chain mail, different bronze artefacts were produced in Zirikhstan (meaning Zirikhgeran) (see al-Garnati 1971, p. 50; and historical information on Zirkhgeran in Fraehn 1839).

When the question of the date of the Kubachi antiquities began to be resolved, with the aid of the tombstones in the 1970s, it emerged that both the reliefs and the cauldrons, which so far (and without much evidence) had been dated to between the twelfth and fourteenth centuries, were in fact produced much later, around the late fourteenth or early fifteenth centuries. This meant that they could no longer be linked to the artistic production of 'historical Zirikhstan'. An added problem is the prevailing assumption that 'historical Zirikhstan' and 'Kubachi' were one and the same, and that later, from the end of the fifteenth century onwards, the place name 'Zirikhstan' had been replaced by 'Kubachi'. However, none of these two place names has any connection with the Dargin language, spoken in Kubachi, and neither the local population nor the village uses it.

There are three groups of antiquities from the village of Kubachi, dated to the fourteenth and fifteenth centuries, the period when art flourished in this village. These groups do not contain chain mail, weaponry or jewellery artefacts of the fourteenth to fifteenth centuries, as they have not survived to the present day.

The first group is composed of tombstones from the fourteenth to early fifteenth centuries (although there are also later ones, particularly from the nineteenth century), which are magnificent examples of stone carving. There are over one hundred examples, including three with exact dates: 783A.H./1381-82A.D, 784/1382-83 and 802/1399-1400. The inscriptions are in Arabic, although a poetic inscription which is in Persian has been recorded on two stones (Ivanov 1987, pp. 221-22, English summary, p. 224). The plant-like decoration in the shape of *Islimi* arabesques has a clear connection with a group of Iranian traditional pieces in the broadest sense, not necessarily directly with Iran itself.

The second group comprises stone reliefs, preserved for the most part in fragments. It will never be known what buildings they adorned in the fourteenth to fifteenth centuries. They were arranged at random in buildings under investigation by experts in the second half of the nineteenth and first half of the twentieth centuries (the number of reliefs on the walls of houses indicated the wealth of the owner). Taking into account the St Petersburg Collection in the Hermitage, the one at Makhachkala, and the buildings in the village itself, the number of fragments reaches five hundred.

The designs on these fragments and complete objects are executed in low and high relief. On items executed in high relief, the stone itself (of argillaceous schist) and the floral decoration have parallels and direct links with the materials and ornamentation of the village tombstones. Things are more complicated, however, with the stones which are decorated in low relief. Limestone, non-existent in the rocks around Kubachi, is predominant in these pieces, but there are also reliefs made out of argillaceous schist. An overwhelming number of fragments are decorated with five-petal rosettes, which are not found on the village

tombstones. We can therefore assume that the stones with low relief decoration were not made in Kubachi, but somewhere close by before being brought to the village. Their production is dated to the second half of the fourteenth or beginning of the fifteenth centuries, as there is a tympanum decorated with a five-petal rosette made in 807/1405. In other words there were two distinct centres operating at the same time, producing stone relief work using different materials and with varying designs.

Turning to the third group of Kubachi pieces, the bronze cauldrons, we find that cauldrons of the 'closed' type [cat no. 60] are often decorated with a five-petal rosette design (particularly cauldrons of a period later than this example. The construction of the sides of the cauldrons with four flanged wings links them with the cauldrons of the 'open' type [cat. no. 50], which were definitely cast in Kubachi. Once again, this testifies to the fact that the centre of production of stones with low relief designs and that of 'closed' type cauldrons was in Daghestan, not far from Kubachi.

The origins of Kubachi art continue to stimulate discussion. There are two points of view. The first maintains that Kubachi art is the result of the development of art in Upper Daghestan and that 'Zirikhgeran' is identical to 'Kubachi' (Mammaev 1989). The second view suggests that Kubachi art of the fourteenth and fifteenth centuries was introduced possibly by incomers, perhaps even from Asia Minor: this belief was recorded among villagers in the 1860s (Ivanov 1987, p. 214; see notes on the abundant literature on the subject of Kubachi). A number of indirect points appear to support the second view.

It has been difficult to this day to work out who the fourteenth-century inhabitants of Kubachi were, in terms of their ethnic origins. Personal names, recorded in Arabic letters on the grave slabs, have yet to be deciphered. At a guess they were not Muslims; Islam only took root in the village from the early fourteenth century. Today the inhabitants of Kubachi are Sunni; there is no sign of Shi'i sympathies in village inscriptions. It is intriguing that the depictions of living creatures on many reliefs have been symbolically beheaded, a sign of religious iconoclasm; although at what point in history this happened remains unknown.

From the fourteenth century onwards Kubachi art appears completely devoid of foreign influences and does not appear affected by the art of Middle Eastern countries.

The village of Kubachi, and its population, have always occupied a special position in Daghestan. Throughout the eighteenth and first half of the nineteenth centuries, stories circulated in coastal Daghestan (by the Caspian Sea) that the forebears of the people of Kubachi had been Christians and Europeans. These led to continuing interest in the village of Kubachi, both in Russia and in Europe. It took the visit of B. Dorn to Kubachi in 1861 to question these legends. The true origins of the inhabitants of Kubachi and their art call out for future research.

The Culture of Kubachi

50
CAULDRON

Daghestan (Kubachi settlement), second half of 14th century

Bronze (brass), casting, repoussé; 61 cm (diameter), 33 cm (height)

Origin: purchased in 1973

State Hermitage Museum, inv. no. VC-1103

References: Kubachi 1976, nos. 36-38; Ivanov 1977; Mammaev 1989, fig. 72

Exhibition: Turku 1995, no. 244

Not in exhibition/not pictured

The shape of this piece is reminiscent of bronze, open-type cauldrons made in Iran. Such a cauldron apparently found its way into the Kubachi settlement in the fourteenth century, and served as a catalyst for the production of similar objects in Kubachi in the second half of the fourteenth century. We are confident of this date because the letters of the Arabic inscription ('Fame, prosperity', located on the wing, where the craftsman's name was usually added to Iranian cauldrons), and the undulating stem with leaves which forms a background to the inscription, have direct analogies among tomb artefacts of the second half of the fourteenth century in precisely this settlement.

It should be noted that foundry craftsmen in Kubachi did not just blindly copy the shape of Iranian cauldrons, but added new details: a new spout shape, and linkages between the wings and other ornaments. Such linkages between the wings are seen in Kubachi cauldrons of much later periods, before they gradually began to vanish). Literature contains references to a total of five cauldrons (including the Hermitage piece), cast from one model. The fate of three of these is unknown.

It should be noted that Kubachi casters in the fourteenth century were in search of new cauldron shapes, as two 'open-type' cauldrons have survived (one in the Hermitage, inv. no. TP-197, and the other in the Victoria and Albert Museum, London, no. 1416-1903), with only a round edge (no wings). These 'open-type' cauldrons are decorated with pseudo-inscriptions, where letters are created to look like those in the benevolent inscription on this cauldron.

It would appear that the shape of a cauldron without wings was not popular, as no other examples of such a style are known about. (A.I.)

51
RELIEF

Daghestan (Kubachi settlement), 14th century

Stone (argillaceous schist), red glaze, carving, polishing; 29 cm x 24 cm

Origin: acquired in 1928 from the Daghestan Museum (Makhachkala)

State Hermitage Museum, inv. no. TP-93

References: Bashkirov 1931, fig. 6; Kilchevskaya 1968, fig. 6; Kubachi 1976, no. 45; Mammaev 1989, fig. 165

This stone bears a shallow relief depiction of two men in triangular headwear. One of them is holding a sabre, while the other holds a jug and a goblet. Between them there are dogs. The theme is unknown, as no written sources have survived from the Middle Ages that describe life in the mountainous regions around Kubachi. The literature offers various, highly speculative, explanations of the picture. (A.I.)

52
RELIEF

Daghestan (Kubachi settlement), 14th century

Stone (argillaceous schist), carving, polishing; 24 cm x 25 cm

Origin: acquired in 1928 from the Daghestan Museum (Makhachkala)

State Hermitage Museum, inv. no. TP-97

References: Bashkirov 1931, pl. 23; Orbeli 1938, pl. 63; Kilchevskaya 1962, pl. III/4; Kilcheskaya 1968, fig. 38; Kubachi 1976, no. 28

Not in exhibition

This stone is decorated with an image in deep relief [unlike cat. nos. 51 and 53-55]. Judging by the costume, this is a man holding a jug and goblet (although it has been suggested that it is a woman). Judging by the frame on the left, it can be surmised that this fragment is the right, lower part of some form of tympanum, an architectural form well known in Kubachi [see cat. no. 57]. (A.I.)

53
RELIEF

Daghestan (Kubachi settlement), 14th century

Stone (argillaceous schist), carving, polishing; 29.7 cm x 18.5 cm

Origin: acquired in 1929 from the Daghestan Museum (Makhachkala)

State Hermitage Museum, inv. no. TP-111

Published for the first time

The theme of this relief does not have any clear explanation. It is possible that this was a purely decorative piece, although it is unlikely that there was no symbolic meaning whatsoever. At this stage it is impossible to offer an objective description of the contents. (A.I.)

54
RELIEF

Daghestan (Kubachi settlement), 14th century

Stone (argillaceous schist), red glaze, carving, polishing; 25.5 cm x 24 cm

Origin: acquired in 1928 from Daghestan Museum (Makhachkala)

State Hermitage Museum, inv. no. TP-127

Reference: Bashkirov 1931, pl. 68

This stone portrays two unicorns with strange, long tails in shallow relief. The image is surrounded by a frame with plant ornament. Unicorns are found on artefacts of the thirteenth and fourteenth centuries in Syria and Egypt, but it is yet difficult to determine what significance they had in Daghestan. (A.I.)

55
RELIEF

Daghestan (Kubachi settlement), 14th century

Stone (argillaceous schist), carving, polishing; 48 cm x 25 cm

Origin: acquired in 1928 from the Daghestan Museum (Makhachkala)

State Hermitage Museum, inv. no. TP-96

References: Bashkirov 1931, pl. 16; Orbeli 1938, pl. 62; Kilchevskaya 1962, pl. V/3; Kubachi 1976, no. 41; Mammaev 1987, fig. 2; Mammaev 1989, fig. 166

Not in exhibition

The theme of this image, created in shallow relief, is clear: it depicts a hunting pen, and the hunt of an unknown ruler. The clothes and headwear worn by the figure are the same as those in another relief [cat. no. 51]. Hunting pens for wild animals were known in the Middle East as early as the fifth and sixth centuries. The pen here is depicted in slightly abstract form, but the theme remains obvious. The heads of the hunter and the animals were destroyed at a later date. (A.I.)

51

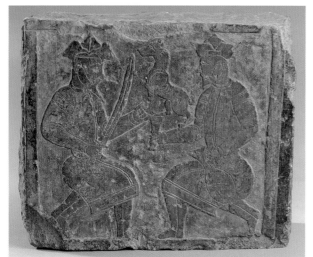

52

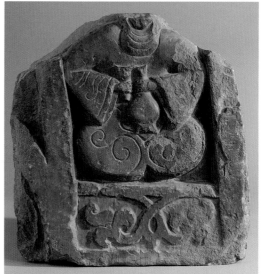

53

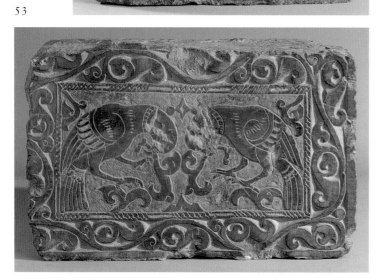

55

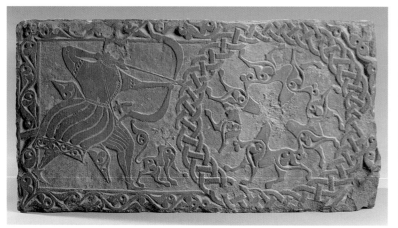

54

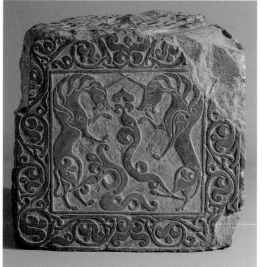

56

RELIEF

Daghestan (Kubachi settlement), 14th century

Stone (argillaceous schist), carving, polishing; 137 cm x 33 cm

Origin: acquired in 1928 from the Daghestan Museum (Makhachkala)

State Hermitage Museum, inv. no. TP-100 a,b,c

References: Dorn 1895, pls. XIV/20, 24, 25; Bashkirov 1931, figs. 1, 2, pls. 5-7; Orbeli 1938, pls. 60, 61; Kilchevskaya 1962, pls. III/1, 2; Kilchevskaya 1968, figs. 27, 28; Kubachi 1976, no. 31; Mammaev 1989, fig. 160

Not in exhibition

This is one of the famous Kubachi reliefs which caught the attention of the academic B. Dorn as early as 1861, during his visit to the settlement. The relief shows military and sporting competitions: to the left is a ball game, indicated by the long-handled rackets held by horse riders (and not by the presence of balls, as is sometimes mentioned). In the centre are wrestlers; while target-shooting is depicted on the right. Below, a round stamp is covered by what might be the prizes: a bow case and a quiver. Interestingly the costumes of the characters are very different to those worn by the figures depicted on the shallow-relief stones. The heads of the characters were broken off at a later date.

It has not been possible to determine where this relief was originally located. (A.I.)

57

RELIEF

Daghestan (Kubachi settlement), first half of 14th century

Stone (argillaceous schist), carving, polishing; 156.5 cm x 89 cm

Origin: acquired in 1928 from the Daghestan Museum (Makhachkala)

State Hermitage Museum, inv. no. TP-150

References: Dorn 1895, pl. XVI/2; Bashkirov 1931, fig. 16, pl. 71; Orbeli 1938, pl. 64; Kilchevskaya 1962, pl. III/7; Kilchevskaya 1968, fig. 49; Kubachi 1976, no. 124; Mammaev 1987, fig. 5; Mammaev 1989, fig. 146

Not in exhibition

This tympanum was also noted by B. Dorn in 1861. Since then much has been written about its theme (a lion and a wild boar) and the pseudo-inscription on the tympanum.

These lion and wild boar images are not the only examples to appear on deep-relief Kubachi artefacts, but these ones are unusually large. It is unclear what the struggle between the lion and the boar really symbolized (in other reliefs this theme does not occupy a central position).

The pseudo-inscription has been the subject of much discussion. The letters are similar to those in the Arabic alphabet, but the inscription has not been successfully deciphered. Comparison with tombstone inscriptions in the 1970s led to a breakthrough, however, when it was found that a small group of tombstones had imitation Arabic inscriptions and these stones were created before the middle of the fourteenth century (see Kubachi 1976, no. 123). It thus became clear that the tympanum should be dated to the first half of the fourteenth century, when Islam was gradually infiltrating the settlement. (A.I.)

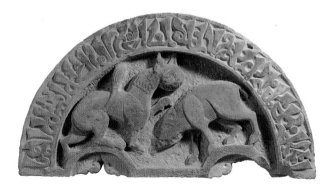

58
FRAGMENT OF A SCULPTURE

Daghestan (Kubachi settlement), 14th century(?)

Polished and carved stone; 14 cm x 12 cm x 9 cm

Origin: acquired in 1928 from the Daghestan Museum
(Makhachkala)

State Hermitage Museum, inv. no. TP-99

Published for the first time/not in exhibition

It is difficult to determine what this object is: a frag-
ment of a round sculpture or part of a composition in
deep relief. The large chips in the stone to the right,
bottom and rear, indicate the second possibility. More-
over, sculptures in the round have not been found among
reliefs from the Kubachi settlement; and few faces of
people have survived on the reliefs – they were damaged
at a later time (for reasons unknown).

The face of the man is also damaged; the chin may
have been broken off. The degree of craftsmanship in the
carving of the head is not considered to be especially high.
It is possible that this sculpture (or relief) was created at
a much later date than the main group of reliefs which
were made in the fourteenth and early fifteenth centuries.
(A.I.)

59
LAMP

Daghestan (Kubachi settlement), 14th to 15th centuries

Cast bronze (brass), with relief decoration; 45.3 cm (diameter),
12 cm (height)

Origin: acquired in 1929 from the Daghestan Museum
(Makhachkala)

State Hermitage Museum, inv. no. TP-178

Published for the first time

Lamps of varying shapes have long been common in
Islamic countries of the Middle East, and bronze lamps
from these countries are found in all museum collections.
Usually they are not very large, and have just one element
for holding a wick, although lamps with several wick
holders have been found. The only known lamp with
twelve large wick holders originated in Kubachi.

The large plant ornament on the lamp is connected
to the decoration of the 'closed-type' cauldrons and
reliefs, decorated with a five-petal palmette. Such orna-
ment is not typical of Kubachi pieces. For this reason it
can be considered that this lamp is not connected to
Kubachi art of the fourteenth and early fifteenth centuries,
but was created in the same place, where 'closed-type'
cauldrons were cast. It has not yet been possible to
identify this area (or settlement). (A.I.)

60
CAULDRON

Daghestan, 14th century

Cast bronze (brass), relief decoration; 55 cm (height),
62 cm (diameter)

Origin: acquired in 1925 from the State Academy for the History
of Material Culture (A. A. Bobrinskiy Collection)

State Hermitage Museum, inv. no. TP-167

References: Kilchevskaya 1959, fig. 15; Kilchevskaya 1962, pl. IV,
no. 4; Kilchevskaya 1968, figs. 58, 59; Kilchevskaya 1973, pl. 297;
Mammaev 1989, fig. 77

This cauldron stands on three feet and has an almost
ball-shaped body, an inflected edge with four wings,
four round handles in the middle of the body, and is an
example of the 'closed-type' of cauldron (see Orbeli
1938). Such cauldrons were purchased at different times
in Daghestan and, most likely, were manufactured there,

although the precise location is unknown. The 'closed-type' cauldrons were bought in the second half of the nineteenth century, not only in the Kubachi settlement, but also in other Daghestan villages. The structure of the rim of these objects, with four flanges, indicates that they were manufactured near Kubachi, where cauldrons with four flanges were cast in the second half of the fourteenth century [see cat. no. 50]; the structure of the side of the cauldron is also similar to Iranian cauldrons [see cat. no. 61].

The technique for manufacturing the 'closed-type' cauldrons is very distinctive, as is the decoration; and it differs from those cast in Kubachi. The latter were assembled from separate cast parts and were often decorated with images of horsemen, gryphons, lions and wolves (or dogs), as well as ornament in the form of a five-petal palmette. Images of gryphons appear only on early Kubachi cauldrons of the second half of the fourteenth century; this also indicates that 'closed-type' cauldrons were manufactured somewhere near Kubachi.

It is extremely unusual, and intriguing, that there are no inscriptions on any of these types of cauldron.

As far as we can now tell, 'closed-type' cauldrons with images of live animals (like this example) can be dated to the fourteenth century, while other cauldrons of this type, but with plant ornament, were made much later, although it is difficult to determine a precise date for these pieces. (A.I.)

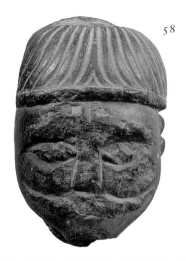

58

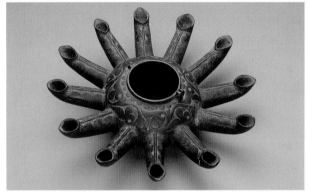

59

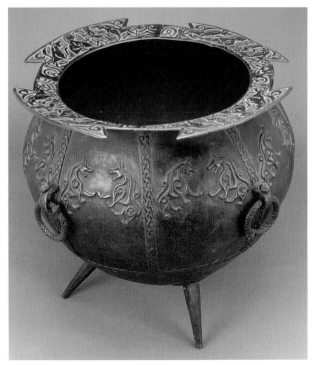

60

Persian Art
(fourteenth to sixteenth centuries)

Anatoly A. Ivanov

A new stage begins in the art of Iran in the fourteenth century, embracing every aspect of art: painting, architecture and applied art. The miniature style of the 'Injuid' school changes to what is called the 'Muzaffarid' school; at the same time, in Iranian pottery, a style of ware decoration begins to prevail which features cobalt as the only colour on a white background (demonstrating the influence of Chinese porcelain). Lustre decoration wanes in the fifteenth century (but does not disappear entirely). Kashan, one of the chief centres of production of artistic pottery in the thirteenth century, removes itself from the stage in the early fourteenth century and historical sources cease to mention it as a centre for pottery at all in the following centuries.

Furthermore it is hard to evaluate the changes that took place in textile production, as very few examples of Iranian fourteenth-century textiles have survived, and we have no knowledge at all of fifteenth-century material. However, a comparison of fragments of fourteenth-century fabric with sixteenth-century examples reveals a huge difference in approach to decorative principles; allowing us to conclude that great changes occurred, but without telling us exactly when.

It is impossible to say anything about pile carpets, weaponry or steel products – we have no fourteenth-century examples, and what we have of the fifteenth is highly conjectural; the only surviving item is a steel grille of the fifteenth century at the tomb of Imam Riza in Mashhad (or Meshhed), while fifteenth-century carpets and weapons have not survived at all.

In comparison with the materials mentioned above, bronze (brass) and copper products of the fourteenth to nineteenth centuries provide great opportunities for research. Although so far not a single specimen has been found among them with a precise place of manufacture, there are many vessels with precise dating among those that survive (from the mid-fourteenth to the mid-eighteenth centuries there are over one hundred). This enables us to create a chronology of the objects and to determine concrete changes in form and decoration.

The general principle linking all Iranian bronze (brass) and copper from the mid-fourteenth to the mid-nineteenth centuries is the treatment of the background behind the ornamental designs and inscriptions. Backgrounds are filled in with minor designs, the appearance of which can be divided into three key stages: (1) in the mid-fourteenth to mid-sixteenth centuries the background is cross-hatched; (2) in the mid-sixteenth to mid-eighteenth centuries the background is hatched; (3) in the mid-eighteenth to mid-nineteenth centuries (perhaps even longer) the background is done by *poinçon* (small punched circles or dots).

It should not be thought that background elaboration in cross-hatch was an invention of Iranian fourteenth-century metalworkers. It is found on earlier products made of different materials, but at that time it was not a general phenomenon; only a few objects had this kind of background elaboration.

Cross-hatching appears on the background of metalware by the 1330s, although the only pieces that can be objectively dated to that time are Syro-Egyptian rather than Iranian. However, Iranian copperware of the

mid-fourteenth century can be distinguished and dated by comparison with local bronze (brass) ware.

It should be stressed that a new metal, copper, begins to be used in Middle Eastern countries in the first half of the fourteenth century. Naturally copper was known from ancient times, but in this region pure copper vessels, covered with tin plate, are known only from the fourteenth century. The first copper vessels to appear are possibly imported from the Mamluk state, although further investigation is required. Up to the first half of the fourteenth century – in the period following the spread of Islam in the Middle East – we only know of products made of alloys, of copper and tin (usually known as bronze), and copper and zinc (brass).

Both the emergence of the new metal, copper, and the new type of cross-hatched background appearing on both copper and bronze (brass) objects in the fourteenth century, testify to the beginning of a new stage (or period) in the history of Iranian metalwork. Additionally, from the second half of the fourteenth century old forms gradually disappear and new ones begin to be created. At a very approximate reckoning, out of eighty types of vessel of the fifteenth to early sixteenth centuries, only nine were known in the thirteenth to early fourteenth centuries. It should also be noted that the art of bronze (brass) ware inlaid with gold and silver reaches its height in the first half of the fourteenth century, after which it begins its decline: fifteenth and early sixteenth-century objects have very little inlaid work and by the 1530s inlaid bronze (brass) products disappear. Attempts to revive them only began in the second half of the nineteenth century, but failed to make headway. The decoration of metal objects in gold and silver continues only on steel items (mainly weapons) in the form of damascening, although inlay appears from time to time.

Apart from these technological changes, there were also significant changes in the repertoire of inscriptions: script style and the filling of cartouches with inscription changed, as well as decoration.

Most strikingly an active process of language change-over begins in Iranian applied arts of the fourteenth century. Up to the mid-fourteenth century Arabic is the main language of inscriptions on metalware and Persian examples are extremely rare. At the same time Persian inscriptions are often found on various types of pottery of the thirteenth to early fourteenth centuries. There is an abrupt change from the second half of the fourteenth century: Arabic well-wishing inscriptions or titles are regularly displaced by Persian poetic texts. The majority of these are excerpts from *ghazals* (lyric poetry) by poets of the Persian language such as Sa'adi, Hafiz, Amir Khusraw Dehlavi, Kasim-i Anwar Tabrizi, Katibi Turshizi and Salihi Khorosani.

New inscriptions in Arabic only appear in the early sixteenth century, when the Safavid dynasty came to power and made the Shi'i form of Islam the state religion. In the 1510s, poetry (the authorship of which is still unknown) in honour of Ali appears as an inscription on objects, as well as blessings of Shi'i imams. Both types of inscription become very popular and are found on many historic artefacts of Iranian applied art, with the possible exception of pottery, which in the Safavid period almost entirely lacks inscription. The appearance of these two new Arabic inscriptions at the beginning of the Safavid rule is the only new feature in the development of Iranian metal production in this period. Real changes in the shapes of the objects, in ornamentation, and in inscription script only occur in the middle of the sixteenth century, when the Safavids had been in power for over fifty years.

This shows that the division of the history of Iranian art into a 'Timurid' or a 'Safavid' period is out of date and should be gradually rejected, for the real changes in Iranian art do not coincide with the periods of rule of these dynasties.

The style of script used in the inscriptions does not greatly changed throughout the mid-fourteenth to mid-sixteenth centuries: it is usually *thuluth* or *naskhi*; there are no Kufic inscriptions. The *nasta'liq* style of script, although formed in the course of the fourteenth century and widely used in manuscript correspondence in the fifteenth, is only found on metalware in the mid-sixteenth century, or a little later, at the start of the next stage, with the change from cross-hatched to hatched backgrounds.

A great change occurs when the inscription is contained within the cartouche or medallion. On early metalware (up to the mid-fourteenth century) the inscription lies quite freely in the cartouche. The words of the inscription are not disjointed and there is a lot of empty space in the background for decoration in the form of spirals or curling tendrils. The view changes from the second half of the fourteenth century: the words of the inscription become separated and the letters take up all the space in the cartouche, leaving very little room for the cross-hatched decoration in the background. This way of filling the cartouche can be seen up to the mid-sixteenth century, until the next stage commences.

As far as ornaments are concerned, a striking change takes place between the fourteenth and fifteenth centuries. While fourteenth-century bronze (brass) products often depict people, hunting, animals, receptions at court, and so on, these subjects disappear on fifteenth-century work. Only a few items are known in the beginning of the sixteenth century that depict fish. Why such an abrupt change took place is thus far unexplained.

Vegetal decoration likewise undergoes great changes from the fourteenth to the fifteenth centuries. There is a change in shape of the so-called 'Chinese lotus', and also the *islimi* arabesques (a type of intertwined vegetal decoration), while new types floral and foliate decoration become popular (see Loukonine–Ivanov 1996, no. 166; St Petersburg 2000, no. 141; St Petersburg 2004, no. 128).

And so we can state that the first stage in the development of Iranian metalware (that of the fourteenth to sixteenth centuries) can be clearly defined. The later stages are outlined and discussed in the essay on 'Persian Metalwork' in Part III (see below).

Persian Art

61

CAULDRON

Craftsman: Bu Bakr Mahmud Saffar

Iran (Khurasan), end of 11th to beginning of 12th centuries

Cast bronze (brass), relief decoration; 52.3 cm (diameter), 19.5 cm (height)

Origin: purchased in 1930

State Hermitage Museum, inv. no. TP-202

Published for the first time

This cauldron, made by the craftsman Bu Bakr Mahmud Saffar, is a so-called 'open-type' cauldron: a hemisphere-shaped vessel standing on three feet, with four horizontal wings and two vertical handles. Although this term was introduced about seventy years ago (see Orbeli 1938), it is still relevant (see Ivanov 1996, 1997 and 1999). In the years since the publication of I. A. Orbeli's article, it has become clear that the majority of surviving cauldrons were cast in the Khurasan province in the eleventh to thirteenth centuries. This is indicated by the *nisbas* of the craftsmen 'Marvazi' and 'Tusi', although works by casters with the nisbas 'Qazvini', 'Hamadani' and 'Isfahani' are also found.

Small bronze and ceramic cauldrons (perhaps toys) of exactly the same shape have been found in archaeological sites from the tenth to eleventh centuries in Khurasan and Maverannahr, suggesting that this shape of cauldron originated in Iran at the end of the tenth century, and existed until the end of the fourteenth century, although the style of inscriptions used to decorate, and the ornamentation, changed quite extensively during this period.

Currently more than a hundred large cauldrons are known (their diameter is typically 40-50 cm), as well as 19 small cauldrons which were used as either crucibles or toys. The production of such cauldrons ceased in Iran at the end of the fourteenth century, but at approximately the same time production began in the Kubachi settlement in Daghestan [see no. 50]. The casting of cauldrons, even after losing the four inflected wings, most likely continued here from the sixteenth to seventeenth centuries until the mid-1970s.

Unfortunately we know nothing of the life of the craftsman Bu Bakr Mahmud Saffar, although we do have eight cauldrons which he made and signed. The Kufic style of letters in his signatures indicates that he lived at the end of the eleventh to the beginning of the twelfth centuries. The ornamentation on his cauldrons is comparable with that on cauldrons made by craftsmen with the *nisba* 'Marvazi'. This means that Bu Bakr Mahmud Saffar can also be considered as a caster from Marv. (A.I.)

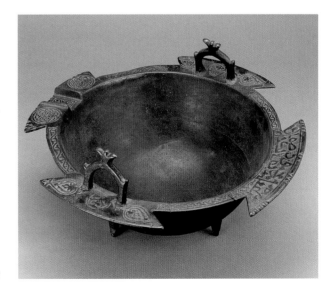

62
PLATE

Iran, 676A.H./1277-78A.D.

Stonepaste, lustre, cobalt; 22.5 cm (diameter), 5 cm (height)

Origin: acquired in 1925 from the Museum of the former Central School of Technical Drawing of Baron A. L. Stieglitz (from the Demott Collection in Paris)

State Hermitage Museum, inv. no. IR-1305

Published for the first time/not in exhibition

This plate, with its narrow and slightly inflected rim, rests on a short foot and is richly decorated on the inside and outside with lustre and cobalt. A benevolent Arabic inscription in *naskhi* script runs around the outside of the rim, at the end of which is the date: 676/1277-78. In the centre of the well there is the image of a rosette, but the decoration around it has not survived. Around the rim on the reverse side was an inscription in Persian, which has only partially survived. This is followed by a broad band with large rosettes, with lustre decoration (which is poorly preserved). (A.I.)

63
BOWL

Iran, 14th century

Stonepaste, lustre, cobalt; 13.2 cm (diameter), 6.3 cm (height)

Origin: acquired in 1925 from the Museum of the former Central School of Technical Drawing of Baron A. L. Stieglitz

State Hermitage Museum, inv. no. VG-29

Published for the first time

This small stonepaste bowl is decorated with three dark blue bands. Between these runs a band with ornamentation consisting of circles, and a second band, in imitation of inscriptions (a group of Arabic letters is repeated). At the centre are four large palmettes, covered with patches of turquoise glaze. On the outside surface are 23 radial bands, emanating from the foot. These are alternately filled with either a long, pointed (palm?) leaf, or with pseudo-inscriptions. Around the foot are four patches of turquoise glaze.

The bowl is most likely one of the last lustre items to be made in Iran around the mid-fourteenth century, after which there was a crisis and protracted stagnation in production, for reasons that are as yet unclear. (A.I.)

64
BOWL

Iran, 14th century

Stonepaste, lustre, cobalt; 12.8 cm (diameter); 6 cm (height)

Origin: acquired in 1925 from the Museum of the former Central School of Technical Drawing of Baron A. L. Stieglitz

State Hermitage Museum, inv. no. VG-27

Published for the first time

This small stonepaste bowl is decorated along the rim with a dark blue band, and inside are eight radial bands which travel up the sides from the centre. In addition to the bands, large palmettes alternate with geometric ornament. On the outside surface the decorative pattern is similar: 22 narrow bands emanate from the foot, between which long, pointed (palm?) leaves alternate with Arabic inscription in a loose style, which is indecipherable. This bowl is probably one of the last lustre pieces to be created around the mid-fourteenth century in Iran, after which there was a long period of stagnation in production, for reasons that are as yet unclear. (A.I.)

62

63

66

65

67

64

65
SMALL BOWL
Iran, first half of 14th century

Stonepaste, lustre; 9 cm (diameter), 5.3 cm (height)

Origin: acquired in 1925 from the Museum of the former Central School of Technical Drawing of Baron A. L. Stieglitz (from the Kelekian Collection)

State Hermitage Museum, inv. no. VG-61

Published for the first time/not in exhibition

This small, exquisite bowl is decorated in the centre with an unusual pattern: a large pointed leaf in the centre and pairs of leaves at the sides. On the outside, around the edge, is a broad band with ornamentation consisting of broad strokes that imitates an inscription.

It appears that this bowl was created in the first half of the fourteenth century, when the art of decorative design in Iran was heading towards a steep decline. (A.I.)

66
LOTUS TILE
Iran, end of 13th century

Stonepaste, lustre, cobalt; 20.8 cm x 20.8 cm

Origin: acquisition unknown

State Hermitage Museum, inv. no. VG-73

Published for the first time

Lotus flowers are depicted on the surface of this tile. They appear in this form in the second half of the thirteenth century in the decoration of artefacts from countries of the Middle East, when the influence of Chinese art was becoming very strong in the region. (A.I.)

67
DRAGON TILE
Iran, end of 13th century

Stonepaste, lustre, cobalt; 20.8 cm x 20.8 cm

Origin: acquired in 1923 from the State Museum Fund

State Hermitage Museum, inv. no. VG-72

Published for the first time

On the surface of this octagonal tile is the image of a dragon with terrifying open jaws, and huge feet with four toes and prominent claws. This type of dragon is typical of Chinese art, and it also appeared in this form in the art of Iran in the second half of the thirteenth century.

This mythological beast was previously depicted in artefacts from the Middle East, in the form of a snake with a terrifying head.

In the second half of the thirteenth century Chinese art heavily influenced the art of all the countries of the Middle East. (A.I.)

68
BRONZE MIRROR WITH DRAGON
China, 14th century

Bronze, tinned, silver-plating; 10.5 cm (diameter)

Origin: acquired in the 1910s (previously in the Asian Museum; 18th century, in Peter the Great's Kunstkammer)

State Hermitage Museum, inv. no. LM-916

This object is a bronze round mirror with a prominent smooth border, a conical loop in the middle, with a relief image of a dragon coiling around the loop among waves and clouds. The dragon has five claws on its paws (on the front right paw, however, there are only four claws due to a casting defect), the body is covered in scales, the mouth is open, and it has a streaming mane. The mirror was thoroughly worked on after the casting, and is partly embossed. There is a rectangular cartouche, adorned with

a shaped leaf at the top, with stylised Chinese inscription that reads: 'Made on the day of the fifth month of the twenty-second year of Hongwu', which corresponds to the year 1390 of the rule of the first emperor of the Ming dynasty (1368-1644). Its wording is typical for the ruling years of Hongwu (1368-98).

The design of an identical mirror was reproduced in a catalogue of the Imperial Palace Chinese collection of bronze, compiled in 1749 under the Qianlong Emperor (*Xi Qing du Jian* 1908 edition, p. 35).

Mirrors were considered precious items, both in China and abroad. Such objects, which were easy to transport, may have become the models for the depiction of dragons in ceramics, tiles and other articles that reproduce Chinese motifs. An identical mirror is in the collection of the Victoria and Albert Museum, London (Kerr, *Later Chinese Bronzes*, V&A, London 1990, no. 85). (M.M.)

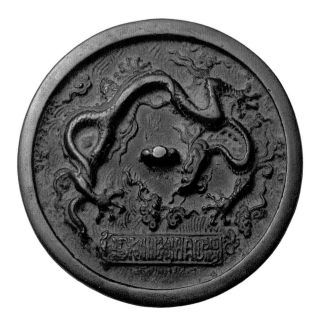

69
TILE PANEL

Iran, end of 13th to beginning of 14th centuries
Stonepaste, cobalt and turquoise glaze, overglaze pigment, gold leaf; 15 cm x 15 cm (each tile)
Origin: acquired from the State Museum Fund (markers of the D. A. Beckendorf Collection remain on four tiles)
State Hermitage Museum, inv. nos. IR-1291-1297
Published for the first time

These seven small tiles could have been part of a large panel, as they were made in Iran at the end of the thirteenth or beginning of the fourteenth centuries, possibly in the same workshop. It was during this period that the technique of decorating ceramic items with a thin leaf of gold became widely practised. (A.I.)

70
TILE WITH GAZELLES

Iran, late 13th to early 14th centuries
Stonepaste, lustre, cobalt; 20 cm x 20 cm
Origin: acquired in 1925 from the Museum of the former Central School of Technical Drawing of Baron A. L. Stieglitz (from Bing Collection, Paris)
State Hermitage Museum, inv. no. IR-1195
Published for first time

This glazed tile, in the shape of an eight-pointed star and painted in lustre and cobalt, has a Persian inscription along its edge, written in a crude *naskhi* style. Half of the inscription is indecipherable; the other half is the *beit* – a good wish (written in *mutaqarib* metre): 'May the Creator protect the owner of this [artefact], wherever the owner may be' [cf. *beit* in cat. no. 79]. In the centre there are two gazelles under a blossoming bush. The tile belongs to a large group of items painted in the same manner and technique, created in the late thirteenth to early fourteenth centuries. (A.I.)

69

70

71

72

71
TILE WITH A CAMEL

Iran, second half of 13th century

Stonepaste, lustre, cobalt; 21 cm (across)

Origin: bought in 1936

State Hermitage Museum, inv. no. IR-1275

Exhibitions: Kuwait 1990, no. 47; Amsterdam 1999, no. 155;
St Petersburg 2000, no. 175

This tile depicts a reclining camel. It is very similar in its
technique and painting style to the tile below [cat. no.
72]. The two were created roughly at the same time, but
the former is not adorned with inscriptions. (A.I.)

72
TILE WITH A GIRL

Iran, second half of 13th century

Stonepaste, lustre, cobalt; 20.5 cm (across)

Origin: acquired in 1925 from the Museum of the former Central
School of Technical Drawing of Baron A. L. Stieglitz

State Hermitage Museum, inv. no. IR-1179

Exhibitions: Kuwait 1990, no. 44; Amsterdam 1999, no. 156;
St Petersburg 2000, no. 176

In thirteenth-century Iran it was fashionable to adorn
buildings with ceramic glazed tiles shaped as crosses and
eight-pointed stars; many of these tiles were produced at
that time. Later, craftsmen used these tiles to form panels.
A fixed position was not set for each tile; every one was
regarded as an independent work of art. The tiles, with
lustre and cobalt patterns, and large-scale cursory inscrip-
tions along the edges, were created in the late thirteenth
to early fourteenth centuries. The inscriptions are almost
indecipherable. This tile may have a Persian inscription
along its edge; running over the head of the figure seated
in the centre, it reads, 'Long-lasting glory ...'. (A.I.)

73
TILE WITH A HARE

Iran, late 13th to early 14th centuries

Stonepaste, lustre, cobalt; 12 cm x 11.7 cm

Origin: purchased in 1898

State Hermitage Museum, inv. no. IR-1211

Published for the first time

This small elegant tile showing a hare belongs to a series
of decorations produced in great numbers for adorning
various buildings in the late thirteenth to early fourteenth
centuries. (A.I.)

74
TILE WITH A BIRD

Iran, late 13th century

Stonepaste, lustre, cobalt; 12.2 cm (across)

Origin: acquired in 1925 from the Museum of the former Central
School of Technical Drawing of Baron A. L. Stieglitz

State Hermitage Museum, inv. no. IR-1186

Exhibitions: Kuwait 1990, no. 45; Amsterdam 1999, no. 157;
St Petersburg 2000, no. 177

This small tile, painted in reddish lustre, has the image of
a bird painted in the centre; this image contains elements
of Chinese art. It was in the late thirteenth century that
the influence of Chinese art became apparent, and it was
to increase during the fourteenth century. (A.I.)

75
MINA'I TILE

Iran, mid-13th century

Stonepaste, enamels; 10.3 cm (across)

Origin: acquired in 1925 from the Museum of the former Central School of Technical Drawing of Baron A. L. Stieglitz

State Hermitage Museum, inv. no. IR-1188

Exhibitions: Kuwait 1990, no. 46; Amsterdam 1999, no. 154; St Petersburg 2000, no. 174

Not in exhibition

This small eight-pointed tile is rosette-shaped (instead of the traditional star shape). It belongs to a rare type of tile that was painted with colour enamels part under, part over the glaze. (A.I.)

76
TRAY

Iran, mid-14th century

Hammered brass sheet, engraving; 72 cm (diameter)

Origin: purchased in 1928

State Hermitage Museum, inv. no. IR-1535

Published for the first time/not in exhibition

This large tray is decorated with five broad bands of ornament, with a large rosette in the centre of its inner surface. The Arabic inscription in six cartouches of the fourth band reads (in the *thuluth* script): 'Glory to our great and mighty lord, the glorious sultan, the wise, the just, the winner, the victorious, the champion of faith, the inhabitant of the border [*murabit*], the exalted, respected by God, the winner, the victorious, the champion of faith, may his victory be praised!' Judging by its content, the inscripton is close to many inscriptions on fourteenth-century Syrian and Egyptian bronze items, where names of Mamluk sultans can be read. The tray suggests the influence of this region's art on Iranian craftsmen and their work; its vegetal and geometric ornamental patterns provide evidence of its Iranian origin.

The Victoria and Albert Museum in London has an early fourteenth-century Iranian tray, inlaid with gold and silver; its decorative composition and inscription bear striking resemblances to the Hermitage tray (see Melikian-Chirvani 1982, no. 94). However, this tray was created later (*circa* mid-fourteenth century). The inlay on the Hermitage tray is gone, although the letters and ornaments have dotted contours, which means that inlay could have been attached there. But there are no traces of any other metal. Thus we might assume there was initially no inlay on the tray, and the dotted contours have been deliberately designed as false contours. Further study of this phenomenon on other works of art would be of interest. (A.I.)

76

77
BOOK BINDING

Iran, 15th century

Leather, gold, carving, embossing; 51.2 cm (height), 26.6 cm (width)

Origin: acquired in 1925 from the Museum of the former Central School of Technical Drawing of Baron A. L. Stieglitz

State Hermitage Museum, inv. no. VP-84

References: Adamova 1996, p. 362, no. 23; Loukonine–Ivanov 1996, no. 15

Exhibitions: St Petersburg 2004, no. 91

In the second half of the fourteenth century, decoration of book covers for Iranian manuscripts noticeably changed. Before that time, book covers had been made of leather with stamped ornamental pattern, mostly geometric. The new decoration had many gilded ornaments (floral and geometric), and cut-through patterns with blue lining. In some cases, book covers were decorated with inscriptions.

This example has all the above-mentioned traits: both covers in the centre, as well as the flap, are decorated with oval medallions with carved pattern against the blue background. The insides of the covers have small medallions, where the name 'Ali' is carved four times.

Along the edge, near the flap, there are two cartouches containing a Persian inscription in gold contour letters (*naskhi* writing) that reads: 'May the Creator of the world protect you! May peace come at your wish, and the heavens be your ally!' This verse of good wishes (in *mutaqarib* metre) often appears on works of Iranian applied art created from the 1340s onwards; however, in such verses the last line usually comes first. The verse is found in the poetry compendium 'Bustan' by Sa'adi, so it was apparently composed by him.

This book cover is obviously a masterpiece of the fifteenth century. The vegetal ornamental pattern shows a clear influence from Chinese art. (A.I.)

78
LAMP

Iran, second half of 14th century

Hammered and lathed bronze (brass), casting, forging, inlay, engraving; 47.2 cm (height), 21 cm (diameter)

Origin: acquired in 1925 from the Museum of the former Central School of Technical Drawing of Baron A. L. Stieglitz

State Hermitage Museum, inv. no. VS-230

Published for first time

This lamp is unusual because it was assembled from several separate parts. The lamp's base is an Iranian bronze candlestick (first half of the fourteenth century) with the remains of silver inlay; the candlestick has a soldered candleholder from another object. Above there is a bowl and a cone-shaped tube that contains an oil reservoir and a wick rod.

Similar composite lamps can be found in other collections, so there can be no doubt that the lamp was created in the fourteenth century. However, inside the lamp there is a metal rod with a screw, which fixes all the parts of the lamp together. Both the rod and the screw do not appear to be ancient. They might well have been added to the construction in the nineteenth century in order to join the ancient sections together. (A.I.)

79
CANDLESTICK BASE

Iran (Khurasan), late 15th to early 16th centuries

Cast copper alloy, forging, engraving; 11.5 cm (height)

Origin: acquired in 1925 from the State Academy for the History of Material Culture (A. A. Bobrinskiy Collection)

State Hermitage Museum, inv. no. IR-2182

References: Ivanov 1969, p. 157, illus. 1; Komaroff, no. 35

Exhibition: St Petersburg 2004, no. 127

A new shape for candlestick bases appeared in Iran during the fifteenth century; their upper edge was not straight, but slightly bulging. Today we can say that such candlesticks were made in the province of Khurasan. The decorative pattern which was created within narrow bands; engraved ornaments; the graphic manner of the inscriptions and their background filled with vegetal pattern – all these features allow us to make the assumption that the candlestick was created in the workshop of Shir Ali Dimashqi, a craftsman who presumably worked in Khurasan during the late fifteenth to early sixteenth centuries. This craftsman is believed to be a descendant of coppersmiths who left Damascus for Samarkand following Timur in the 1390s.

The four cartouches in the middle contain Persian verses (*naskhi* writing, in *mutaqarib* metre): 'May the Creator of the world protect the owner of this [artefact], wherever he may be! May peace come at your wish, and the heavens be your ally'. This candlestick was kept for a while in the settlement of Kubachi (Daghestan), where it was turned into a cauldron [see cat. no. 19]. (A.I.)

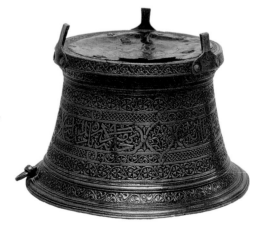
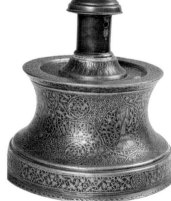

80

DISH

Iran (Mashhad), 878A.H./1473-74A.D.

Stonepaste, cobalt painting; 35 cm (diameter)

Origin: purchased in 1972 in the settlement of Kubachi

State Hermitage Museum, inv. no. VG-2650

References: Ivanov 1980, pp. 64-66; Golombek 1996, p. 121, pls. 56-57

Exhibition: Kuwait 1990, no. 76

This dish belongs to a unique group of Persian ceramics that detail the place and time of production. The narrow band that edges the central medallion has an inscription (its first part is a verse written in the *muzari* metre: 'This dish was completed in Mashhad in the year of 878' (Kuwait 1990, no. 76). The stonepaste solfdane with the date 348/1444-45, also created in Mashhad, is now kept in the Royal Museum in Edinburgh (Lane, p. 34). The composition of three flowers (chrysanthemums?) as part of a continuous sprout with leaves, filling the entire surface of the porcelain well of the dish, is close to Chinese decoration that was widespread in the early fifteenth century. The pattern that decorates the edge of the dish imitates the Chinese wave and rock pattern. (A.A.)

81

DISH

Iran, second half of 15th century

Stonepaste, cobalt painting; 44.4 cm (diameter)

Origin: purchased in 1938 in Kubachi settlement

State Hermitage Museum, inv. no. VG-2285

References: Golombek 1996, p. 117, pl. 42, col. pl. VI: 'Nishapur, second half of the 15th century'

Exhibition: St Petersburg 2004, no. 164

This deep soup dish with a deflected edge is painted with cobalt of different shades under a transparent colourless glaze. On the bottom, seated on blossoming tree branches, are two large birds facing each other. This motif, which appears on similar sixteenth-century ceramics (cf. State Hermitage, inv. no. VG-732; St Petersburg 2000, no. 260), is often found on Chinese porcelain (see Golombek, *et al.* 1996, p. 36, no. 2). The soft and delicate manner of painting appears to have appealed to Iranian taste. (A.A.)

82

DISH

Iran, 15th century

Stonepaste, cobalt painting; 37.6 cm (diameter)

Origin: bought in 1926 from R. Magomedov (Kubachi settlement)

State Hermitage Museum, inv. no. VG-726

Reference: Golombek 1996, p. 106

This dish with a bracketed rim is painted with dark blue cobalt. The pattern that decorates the well – two floating ducks and a branch with two lotus flowers above them – is a variant of a popular motif found on Chinese porcelain dishes of the fifteenth century (cf. State Hermitage Museum, inv. no. VG-725; see *Hunt for Paradise* 2004, p. 252). Two ducks floating in a pond with lotuses are a well-wishing symbol; however, it seems to have been of no particular significance to the Persian craftsman. The flowers (peonies?) on the continuous wavy scroll (on the walls), shaded arch-shaped fields, and the flowery pattern running along the edge, are imitations of Chinese ornament and are found on other dishes of this kind. As a characteristic trait of early Safavid ceramics, the patterns are painted in a cursory manner, with blurred contours; this distinguishes these articles from Chinese models and adds to their charm and orginality. (A.A.)

80

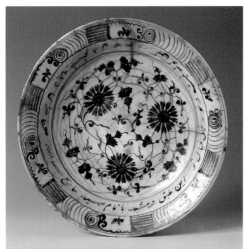

82

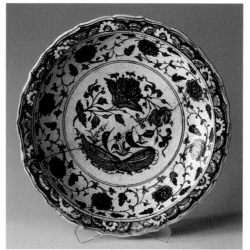

84

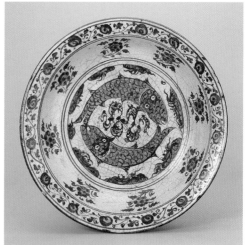

81

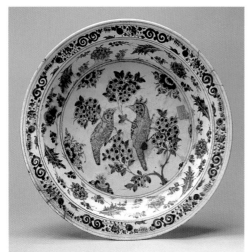

83

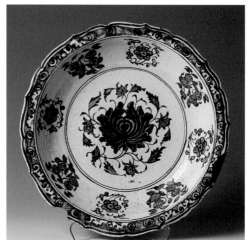

85

85

83

DISH

Iran, 16th century

Stonepaste, underglaze cobalt painting; 37.3 cm (diameter)

Origin: purchased in 1924 from S. Magomedov in Kubachi settlement

State Hermitage Museum, inv. no. VG-763

Reference: Golombek 1996, p. 122, pl. 65

This dish has a bracketed rim and is painted with dark blue cobalt. The side view of a lotus inside a circle, painted on the well, with scrolls with leaves running from the flower, is a motif frequently employed on the Persian ceramic paintings in the fifteenth to sixteenth centuries (cf. State Hermitage Museum, inv. nos. VG-2660, VG-2098; see St Petersburg 2004, nos. 167, 170). The same can be said about the blossoming branches decorating the walls of the dish, and the wave-and-spray pattern running along its rim. This dish, like a related group of early Safavid works of art, is similar in style to Chinese export porcelain dishes made in the fifteenth century. This particular dish is a high-quality work of art. (A.A.)

84

DISH

Iran, 16th century

Stonepaste, underglaze cobalt painting; 35 cm (diameter)

Origin: acquired in 1949 with the assistance of the Hermitage Purchasing Committee

State Hermitage Museum, inv. no. VG-2392

Reference: Golombek 1996, p. 120, pl. 68

Exhibitions: Amsterdam 1999, no. 230: St Petersburg 2000, no. 259

This dish is painted with cobalt of different shades. The painting has dark contours and is based on the laws of symmetry; the details yield to an overall system of concentric composition. There are two fish on the bottom, a motif often seen on works of art created in the sixteenth century (cf. State Hermitage, inv. no. VG-730; St Petersburg 2004, no. 169). This pattern also appears on a dish in Berlin, dated 971/1563-64, in one of twelve medallions depicting the signs of the Zodiac (Lane 1957, pl. 55a). The fact that the fish are painted among 'Chinese' clouds and not among ringlets symbolizing water, apparently confirms the Zodiacal significance of this motif. (A.A.)

85

JADE PENDANT

Iran, 15th century

Nephrite (jade), carving, engraving; 5.4 cm x 5.8 cm

Origin: acquired in 1901 from the Imperial Archaeological Commission

State Hermitage Museum, inv. no. IR-2091

Reference: Loukonine–Ivanov 1996, no. 164

Exhibition: Kuwait 1990, no. 78

The love of Iranians for jewellery made from nephrite or jade (an evidently imported stone) is an interesting aspect of Iranian fifteenth-century art. The fashion was inspired by Chinese art. A range of articles were brought from China to Iran at that time and we can observe traces of this influence on many Iranian pieces of jewellery made from nephrite. The Hermitage pendant is typical: both sides are decorated with a large vegetal ornamental pattern, different on each side. There is a rectangular pierced projection for a thread (or chain) on the upper part of the pendant. Jade of various colours was widely-used for cups, jugs, stamps, and hilts of daggers. (A.I.)

Timurid Art

Valentin G. Shkoda

The 1220s was a fateful decade for the history and culture of Central Asia. Genghis Khan's army swept whole towns and villages from the face of the earth, and life disappeared for many decades in the formerly very beautiful towns of the East, their ruins slowly sinking into the desert sands where only thorns grew.

It was nearly two hundred years after the Mongols' bloody campaign that towns and settlements began to rise up again. Even so this applied only to the area of Maverannahr (the Arabic name of the territory on the right bank of the Amu Darya river, literally 'that which lies beyond the river').

A major role in this re-emergence, and in the history of Maverannahr in general, was played by Timur. Timur began his career as a bandit on the high roads. He robbed caravans and cleaned out the merchants. On one such raid he broke his leg and was maimed for life; hence his nickname 'Timur-lane' ('Timur the lame'). In Western Europe he is called 'Tamerlane'.

After a certain time Timur was transformed from robber to friend and protector of merchants, and entered the service of the ruler of Samarkand, Husein. Taking part in the latter's warlike exploits, Timur rose to become a gifted war-leader and politician. In 1370 he became Emir of Samarkand and other Central Asian provinces, continuing to increase his possessions. His period of ascendancy (1370-1405) was a series of uninterrupted campaigns, in pursuit of creating a mighty empire. With his conquest of virtually all the Near and Central East, Timur created a state which caused the khans of the Golden Horde and European kings to tremble. He then began to strengthen it by trade and an ambitious building programme. Samarkand became the state capital. Ibn Arab Shah, an Arab author writing about Timur in the early fifteenth century, relates that Timur constructed settlements around Samarkand and called them Misr (Cairo), Dimshaq (Damascus) and Baghdad, intending to demonstrate that those three big capitals were nothing but simple settlements in comparison to Samarkand.

Timur built irrigation canals, bridges, roads, bazaars, workshops, palaces, mosques and madrasahs. In his day a new style of architecture

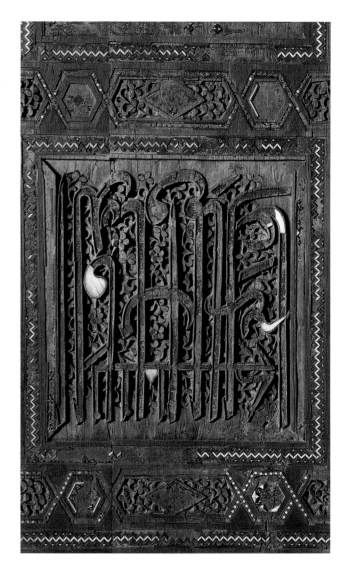

88
DOOR FROM GUR-I MIR TOMB
(see page 90)

emerged. Glazed tiles, which were initially monochrome and basically turquoise, had appeared as early as the twelfth century, but multicoloured tiles were made only under Timur and his successors, the Timurids. Timur brought home expert craftsmen in ceramics from the countries he conquered: mostly from the Konya Sultanate in Asia Minor. As a basis for tile ornamentation, albums of Roman mosaics, preserved in Asia Minor until the fourteenth century, were used. Ornamentation was of a geometric design, sometimes using Arabic letters set out in right-angled bricks or a vegetal design. The vegetal ornamentation was a continuous motif of arabesque (an ornamental design where the stem grows out of the preceding bud), evoking images of Paradise promised to every faithful Muslim after death. This type of decoration was particularly favoured on the walls of mausoleums.

Most of Samarkand's monuments date from the time of Timur. Many continued to be in use after the ruler's death: including the grand mosque Bibi Khanum, the Shah-i-Zinda necropolis, and the Gur-i Mir mausoleum. The name of this last building has an interesting story attached. Timur was well aware that the people did not honour the memory of their rulers, but they did revere the clergy. He gave orders that, on his death, he was to be buried at the feet of his spiritual adviser, Mir Sayyid Berek. Timur died before his teacher, but many years later Mir Berek was buried in the same mausoleum, which was called Gur-i Mir', i.e. 'grave of the teacher'. However, it is still known in Samarkand as 'Gur-Emir', i.e. 'Grave of the Emir' ('emir' means 'duke').

The art of the Timurids maintained all the features of the style of the preceding period. The last Timurid – Babur – founded the Mughal dynasty in India.

86
TILE PANEL
(see page 88)

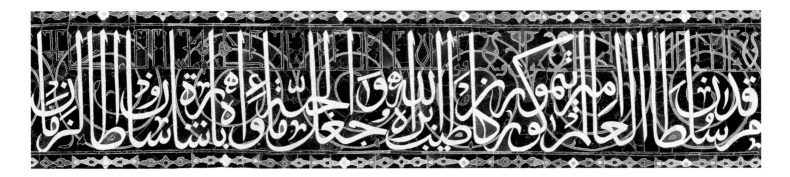

Timurid Art

86

TILE PANEL (see page 87)

Central Asia (Samarkand), 1405-15

Earthenware, underglaze design; 260 cm x 70 cm

State Hermitage Museum, inv. no. Afr. 4992

References: Veselovsky 1905; Yakubovsky 1933, pp. 55-56; Lentz–Lowry 1989, no. 8

Exhibitions: Turku 1995, no. 79; Paris 2000, no. 101; Barcelona 2000, no. 101; London 2005, no. 153

This mosaic tile panel bears two Arabic inscriptions against a blue cobalt background. One has white letters in *thuluth* script: 'The tomb of the sultan of the world, Emir of Timur Guragan. May Allah accept his faith and let him enter heaven. By order of sultan (...).' The subsequent text is lost. The title 'Guragan', or son-in-law, can be explained by Timur's marriage to a princess of the Ghengis Khan clan, whose members were considered at the time to be the true, lawful rulers of the lands of Central Asia.

The second inscription is in yellow letters, in Kufic script. It is indecipherable as the Kufic style had been virtually forgotten by the fifteenth century, although it must have had more than decorative significance: 'There is no God, other than ... there is no strength or power, but that which comes from Allah ... as Allah desires.'

Until 1905 the inscription was above the side door of Timur's tomb, Gur-i Mir in Samarkand, from where it was stolen by robbers. Soon after, in 1906, the tile panel was purchased in Constantinople for the Kaiser Friedrich Museum in Berlin. It was later acquired by the Russian government after diplomatic correspondence that lasted several years. (V.Sh.)

87

TILE PANEL

Central Asia (Samarkand), one of the tombs of Shah-i-Zinda, 14th century

Earthenware, underglaze design: 63.5 cm (diameter)

Origin: acquisition unknown

State Hermitage Museum, inv. no. Afr. 4903

Exhibitions: Turku 1995, no. 287; Barcelona 2000, no. 103

In the architecture of the Timurid period there was a clear distinction between decorative aspects and elements of construction. Increasingly more attention was paid to decorating architecture by means of large-scale decorative tiling schemes. Decoration using mosaic, and tiles with multicoloured designs, was especially well developed. The latter were an imitation of more expensive mosaic tiles. The firing of tiles with multi-coloured designs was a complex technical procedure. To avoid the different colours running into each other during firing, the design was executed using the *cuerda seca* technique, in which a gap was left between the different glazes. The soft, usually blue and green colour range on this tile from one of the mausoleums of Shah-i-Zinda is typical for Central Asian tiles from the fourteenth century. Under Timur the colour range was different, with a predominance of deep, dark blue colour that was obtained using cobalt. (V. Sh.)

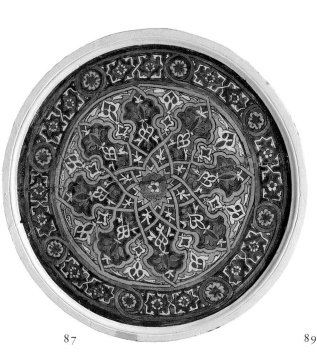

87

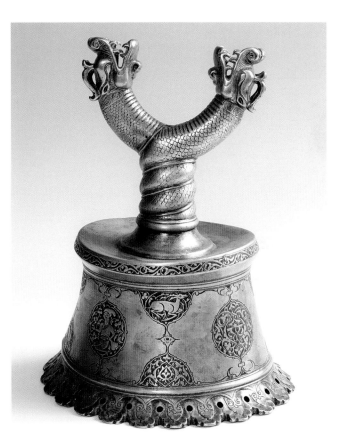

89

88

DOOR FROM GUR-I MIR (detail on page 86)

Central Asia (Samarkand), 1404(?)

Wood, carving, bone, wood and metal inlay; 134 cm x 283 cm

Origin: acquired in 1897 from the Imperial Archaeological Commission

State Hermitage Museum, inv. nos. SA-14242-14245

References: *Mecheti Samarkanda* [*Mosques of Samarkand*], 1905, pl. XIII; Kesayev 1958, pp. 147-58

Exhibition: St Petersburg 2000, no. 198

Not in exhibition

The main entrance door of the Gur-i Mir (see page 87) was located in the centre of the north façade of the building. The door-frame consisted of two vertical lintels and two horizontal beams (the lower beam has not survived). This pair of doors, each made from two boards, and the two faces of the door-frame beams, are decorated with carving and inlay. The decoration on each door is identical. The composition of the central, oblong panel consists of plant ornament, typified by a design in two planes and unusually deep carving. The lower, square, panel is decorated with ornament: four eight-pointed stars interspersed with crosses and half-crosses. The surfaces of the geometric figures are filled with plant ornament. The square upper panel contains an Arabic inscription of three lines. The lower and middle lines are in the *naskhi* style, while the upper line, one word, is in Kufic: 'In truth [this] world and riches [are given] to the King on loan.' The text indicates that the inscription was made especially for the door of the tomb.

The door was apparently made in 1404 for the tomb of Timur's grandson, Muhammad Sultan (died 1403). After the death of Timur in 1405 and his burial at Gur-i Mir, the remains of Muhammad Sultan were brought here, together with the doors from the tomb. (V.Sh.)

89

CANDLESTICK

Iran, 15th to beginning of 16th centuries (candleholders), first half of 17th century (base)

Bronze (brass), casting, forging, engraving; 26.5 cm (height)

Origin: date of acquisition unknown (from the Stroganov Family Collection)

State Hermitage Museum, inv. no. VS-1074

References: *Survey* 1959, vol. VI, pl. 1877B; Grube 1974, fig. 100; Loukonine–Ivanov 1996, no. 221

Part of a group of candlesticks with bell-shaped bases and a thick upper rim, this item poses a number of questions for researchers. The candleholders (sockets) in these pieces are in the shape of two entwined dragons, whose bodies are covered in ornament in the form of scales. However, on the bases of these candlesticks there are no such scales, or there is different ornament. Only on the candlesticks in the David Collection is the ornament in the form of scales seen on both the sockets and the base (although the base there has a different shape; Ward 1993, p. 105).

This suggests the candleholders and candlestick bases were made at different times. The base of the Hermitage candlestick was definitely made in the first half of the seventeenth century (confirmed by the hatching in the background to the ornament, and the figures of people and animals). But the shape of this base is old (fifteenth century) [cat. no. 79; Loukonine–Ivanov 1996, no. 163].

Candleholders in the form of dragons lead us to conclude that they were made in the fifteenth century (analysis of the metal of the Hermitage candlestick shows that the holders and the base were made from different alloys). So, what happened to the bases that were made in the fifteenth century for the dragon-shaped holders? Usually candlestick bases survive, but this is not so here. It is possible that future finds will solve this mystery. (A.I.)

90

BRONZE JUG

Iran (Khurasan), end of 15th century

Bronze (brass), silver, gold, casting, inlay, engraving;
12.7 cm (height)

Origin: acquired in 1925 from the Museum of the former Central
School of Technical Drawing of Baron A. L. Stieglitz

State Hermitage Museum, inv. no. IR-2043

Published for the first time

These types of jugs have a ball-shaped body on a short,
ring-shaped foot, a short, vertical neck, a lid with a small
boss and an inflected handle with the head of a dragon
on the upper tip. In the 1960s it was determined that
such jugs were made in the province of Khurasan,
between the mid-fifteenth century and the 1530s.

Literature on this subject has suggested that these jugs
were made by Iranian craftsmen who worked in Venice
during the fifteenth to sixteenth centuries. The shape has
also been a subject for debate, as no direct predecessors
have been found among known Iranian bronzes. The
collection of F. Zarre included a jug of similar shape,
apparently made in Fars at the end of the fourteenth
century (see 'Islamische Kunst' 1985, no. 336, exhibition),
but the neck was slightly conical rather than having
vertical sides.

At a Sotheby's auction on 27 April 1995 a bronze jug
with gold and silver inlay was sold; it had been made for
the Artukid prince, Maj ad-dina Isy az-Zahira, ruler of
the town of Mardina in 1376-1404 (see *Asian Art. The
Second 'Hali' Annual*, London 1995, p. 213). The shape
of this piece is very similar to the Khurasan jugs, which
were made later, except the neck is more stout in compar-
ison to the body.

It is highly likely that here we can see the progress of
shapes from the West to the East; this could be a direct

consequence of Timur's voyages [for related information
about the transfer of craftsmen, see cat. no. 79].

The jug is decorated with a fine plant ornament,
typical of all objects in this group. The ornament, and
especially the absence of figurative decoration, indicates
a total divorce from the decorative traditions of Iranian
metal pieces of the fourteenth century. Although this
jug does feature gold and silver inlay, which was very
common in the fourteenth century, there is far less inlay
than on fourteenth-century pieces.

The scalloped medallions in the central part of the
body contain Persian verses (three *beits* in *naskhi* script,
hasaj size; the cartouches in the second *beit* have been so
heavily cleaned that the legend is now illegible): 'And
then came days of happiness and roses, cup-bearer, pour
the water of life! [....] A cup is pleasant taken in the
meadow, like a rose, with tulips of red wine.' (A.I.)

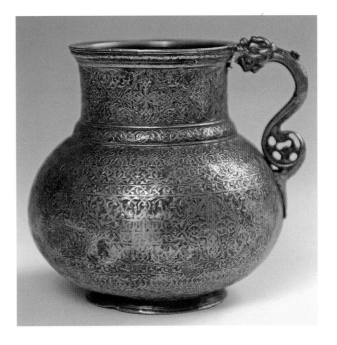

91

JADE PENDANT

Iran or Central Asia, 16th to 17th centuries

Jade, carving; 6 cm x 6.1 cm

Origin: acquired from the State Academy for the History of Material Culture

Origin: year of acquisition unknown

State Hermitage Museum, inv. no. IR-2094

Published for the first time

This large, flat pendant has a scalloped lower edge and a pointed end, featuring a square protrusion, through which an aperture runs for a string [or a chain, as in cat. no. 85]. It is decorated on both sides with ornament consisting of pinnated leaves on inflected stems. The fine plant ornament indicates that the work is of a later date than the fifteenth-century pendant [85]. (A.I.)

92

JADE PENDANT

Iran or Central Asia, beginning of 16th century

Jade, carving; 4 cm x 4.6 cm

Origin: year of acquisition unknown

State Hermitage Museum, inv. no. IR-2092

Published for the first time

This is a small, flat pendant in a heart shape, with an oblong protrusion above, and a channel for string (or a chain) passing all the way through. It has identical decoration front and back: around the edge there is a strip of inflected hatch strokes, and in the centre a large, four-leafed medallion with four pinnated leaves. Around the medallion is an undulating stem with pinnated leaves. The fine plant ornament indicates that this pendant was made much later than cat. no. 85. (A.I.)

93

JADE PENDANT

Iran or Central Asia, beginning of the 16th century

Jade, gold, carving, inlay; 6.3 cm x 6.5 cm

Origin: year of acquisition unknown

State Hermitage Museum, inv. no. IR-2093

Published for the first time

Objects made out of jade usually have no metal inlay. This almost square pendant is decorated with a plant ornament in relief on the front; on the reverse there are four cartouches along the edge, where verse 256 from the second sura of the Qur'an is spelled out. The edge of the cartouches were most likely inlaid with gold. The middle of the reverse side is decorated with a gold plant ornament.

This decorative plate has five apertures that pass through the piece: four at the corners and one in the centre (on the reverse side the apertures are surrounded by lines; probably there were some form of caps here, for fixing the piece). As the central aperture passes directly through a petal of the flower on the face, and around the apertures at the corners, pieces of jade have been chipped off. It can be assumed that the decoration of the reverse side was executed later than that on the front.

This piece decorated some other object, and was affixed in such a way that the front, with the plant ornament, was out of view.

Jade items were rarely decorated with gold. The Hermitage has one other jade stamp with gold ornament, in the form of a spiral with leaves; this piece also dates back to the beginning of the 16th century. (A.I.)

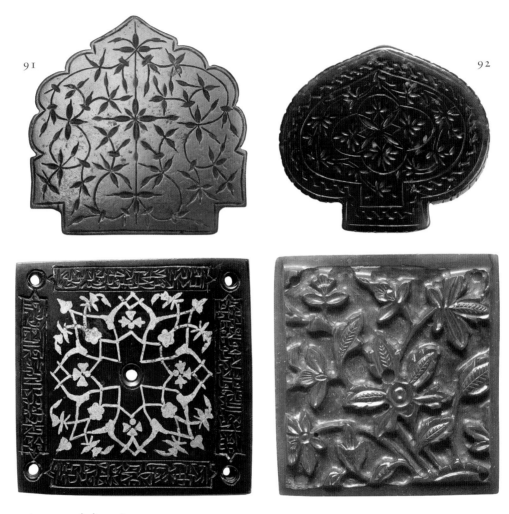

91

92

93 (reverse and obverse)

Chinese Textiles
for Islamic Countries

Maria L Menshikova

Silk textiles have been exported throughout the whole period of trade relations between China and the West. A high value was placed on textiles and many survived because they were among the valuable grave goods of important people. Exported goods from China made their way to the countries of the Middle East and to West and Central Asia. However, despite frequent references in sources to the interest Chinese silks evoked in the Muslim world, very few have actually come to light in Middle Eastern countries.

The survival of three types of Eastern silk textiles found in Egypt is thus all the more important, and today examples from the first half of the fourteenth century are scattered among the collections of various museums. These silks date from the hey-day of the Mongol empire, whose influence at that time, the thirteenth and fourteenth centuries, extended from the Pacific Ocean to the edge of the Levant on the Mediterranean. In Iran, Iraq, the Caucasus and Anatolia, the new Mongol rulers, descendants of Kublai Khan, became known as the Ilkhanids. Their rapid absorption of new territory continued for decades until in 1260 their advance was finally halted by the Mamluks who ruled over Syria and Egypt at the time. In the early fourteenth century the Ilkhanids fought the Mamluks again, this time for control of Syria. In 1323, however, the Ilkhanid ruler Abu Sa'id made peace with the Mamluks. Subsequently, despite their political enmity, extensive diplomatic, economic and artistic relations ensued between the Ilkhanids and the Mamluks. The Ilkhanids sent expensive Chinese silks made to order in Yuan China, and Chinese weavers, having fled China, came to work in West Asian countries. Trade between the two empires went on by land and sea, and trading vessels from China are known to have sailed to the Red Sea during the Yuan period. At the same time a fair number of Muslims traded and lived on Chinese soil. They absorbed Chinese traditions, but had in large measure kept their own national characteristics, religion and knowledge of their language.

The ruling Mamluk sultan of the day, Muhammad ibn Qalawun,

received many gifts from the Mongol rulers. It was during his reign (intermittently from 1294 to 1340) [see cat. no. 46] that Middle Eastern culture and art experienced the greatest influence from China, not least because of the appearance, import and collection of a great quantity of porcelain and possibly bronzeware. Arab historian Abu-l Fida (1273-1331) mentions 1323 as the year Mongol rulers presented the Mamluks with seven hundred textile items, brought on the backs of eleven Bactrian camels. It is interesting that special orders of Chinese silks designated for the Middle Eastern rulers were included in this gift.

In 1897-98 fragments of Chinese silks with floral designs found buried near El Azam, Asuit, in Upper Egypt were brought to the Imperial Hermitage by V. G. Bock as part of a collection of other textiles. Silks from the same find, acquired at the same time, can be found in world museums, such as the Victoria and Albert in London, the Kunstgeschichte Museum, Berlin, the Metropolitan Museum of Art, New York, and in the Islamic Art Museum in Cairo.

One particular blue and golden silk has a design of motifs that resemble lotus flowers interwoven with ribbon-like shoots and a gleaming pearl in rhomboid cartouches amid the shoots. Each lotus flower has a central medallion with a stylised character meaning 'longevity'; the same character in a different script is woven into an upper petal.

A second piece of blue silk, of light and dark hue, is decorated with lotus flowers with fluttering shoots; the flowers are arrayed in rows symmetrically, a mirror image of the next row. In the central medallion of the lotus there is a stylised character; and in a third type of script on the upper petal there is a stylised *fu* character, meaning happiness. The decoration of both silks has the symbolic meaning of bliss, characteristic of Chinese art, and is a wish for purity of faith, happiness and long-life.

All the fragments originally belonged to the same large pieces of textiles or clothing; the sample of the dark and light blue silk is sewn from two pieces. The cut and stitching indicate it is from the upper part of the sleeve of a dressing gown. The actual garment, from which these fragments were cut, is in the Victoria and Albert Museum. The enterprising Egyptian, Farag Kassir, who unearthed the find, cut the items up to sell in fragments.

Along with these silks other textiles were found. These are also now preserved in the State Hermitage. In particular, there is a *tiraz*, a patterned silk ordered by a named ruler and bearing an inscription in praise of him, made by Chinese craftsmen. Two inscriptions, woven around the heart of the lotus flower, proclaim, 'Glory to our Lord the Sultan, the triumphant King' and 'Nasr-Dunya wa-d-Din Muhammad Qalawun'. The *tiraz* gives the date of production, the first half of the fourteenth century.

It is possible that the high-quality textiles discussed here may well have formed part of a royal gift such as the one mentioned by Abu-l Fida, especially as their designs reflect the reason the silks were made: as expensive, symbolic presents. Chinese silks were undoubtedly used as diplomatic gifts at other periods, but due to wear and tear, and the fragility of the material and climatic impact, such textiles hardly ever survived; or if they have, they remain as yet unknown to us.

It is of interest that the kind of silk decoration seen on these fragments, with flowers and wavy shoots, was to have a great influence on the production and designs of silk and textiles in both the Middle East and in Europe, especially Italy.

Chinese Textiles
for Islamic Countries

94
SILK FRAGMENT OF A ROBE

China or Egypt, end 13th to beginning 14th centuries

Silk, damask design of light blue and yellow colours;
49cm (width) x 29 cm (length)

Inscription: 'Sultan Muhammad ibn Qalawun.'

Origin: acquired in 1898 from V. G. Bock's expedition to Egypt

State Hermitage Museum, inv. no. EG-905

There are two fragments of this fabric in the Hermitage, which feature woven ornament in the shape of the stems and flowers of the lotus. One fragment has a triangular shape and seams, while the second piece (in exhibition) has cut edges. The fabric belongs to a type of silks known as *tiraz*, a specially-ordered ornamental silk that contains the name of a ruler and a phrase in praise of him. The two signs, woven around the core of the lotus flower, on its petals, states: 'Glory to our Lord the sultan, the triumphant King' and 'Nasir-Dunya wa-d-din Muhammad Qalawun', the name of a Mamluk sultan who ruled Egypt (with an interval) from 1294 to 1340.

Together with these silks, other fabrics were discovered (fragments of these are also kept in the Hermitage, in particular two pieces of coloured Chinese patterned silks). (M.M.)

95
FRAGMENT OF SILK DAMASK

China, end 13th to beginning 14th centuries

Silk, damask design of blue and golden colours;
54 cm (width) x 32 cm (height) x 0.7 cm (edge)

State Hermitage Museum, inv. no. LT-451

Origin: acquired in 1898 from V. G. Bock's expedition to Egypt

Not in the exhibition/not pictured

This piece of silk, of light blue and golden colours, has a woven pattern in the shape of a lotus flower with interlaced shoots and ribbons; within the diamond-shaped cartouches among the shoots, there is a glowing pearl. Each lotus flower has a medallion in the middle with a styled hieroglyph *shou*, meaning longevity; the same character, although in a different style of writing, is woven on the top leaf. (M.M.)

96
FRAGMENT OF SILK DAMASK

China, end 13th to beginning 14th centuries

Silk, damask design of dark and light blue colours; 52 cm (width) x 40 cm (length) x 0.7 cm (edge)

State Hermitage Museum, inv. no. LT-449

Origin: acquired in 1898 from V. G. Bock's expedition to Egypt

Not in the exhibition

This second fragment is blue silk, decorated with lotus flowers with streaming shoots; the flowers are placed symmetrically in rows, with a mirror image in the following row. In the central medallion of the lotus there is a styled hieroglyph *shou*, which is written in a third style; in the top petal of the flower there is a styled hieroglyph *fu*, meaning happiness.

The ornaments of both pieces of silk have a symbolic meaning, distinctive in Chinese art: the wish for purity of faith, happiness and longevity.

These fragments of damask silk were brought back by V. G. Bock to the Imperial Hermitage from Egypt in 1897-98 as a part of a collection of other textiles. They were discovered in burials near Al-Azam, not far from Assiut in Upper Egypt. Examples of silks acquired at the same time are kept in other museums around the world, like the Victoria and Albert Museum, in London, Kunst-

geschichte, Berlin, the Metropolitan Museum of Art, New York, and other collections. The various fragments are parts of the same big pieces of fabric and garments, which had been cut into sections for sale.

The *tiraz* gives the date of the production of the silk as the first half of the fourteenth century. In those days the Mamluks were enemies of the Ilkhans over Syria. In 1323 ilkhan Abu Sa'id made peace with the Mamluks. Reference was made at that time, by an Arab historian Abu-l Fida, to one of the Mongol rulers presenting seven hundred pieces of fabric to the Mamluks. The possibility cannot be excluded that the existing fragments could have been a part of that gift; moreover, the ornament found on the fabric corresponds to the original purpose of the silks – as precious and symbolic presents. Judging by the ornament, and the design of the stems, the form and petals of the lotus, and the curves of the whorl, it is possible to guess that the *tiraz* was produced as a special order by Chinese master craftsmen who worked in the Middle East during the Mongolian period. (M.M.)

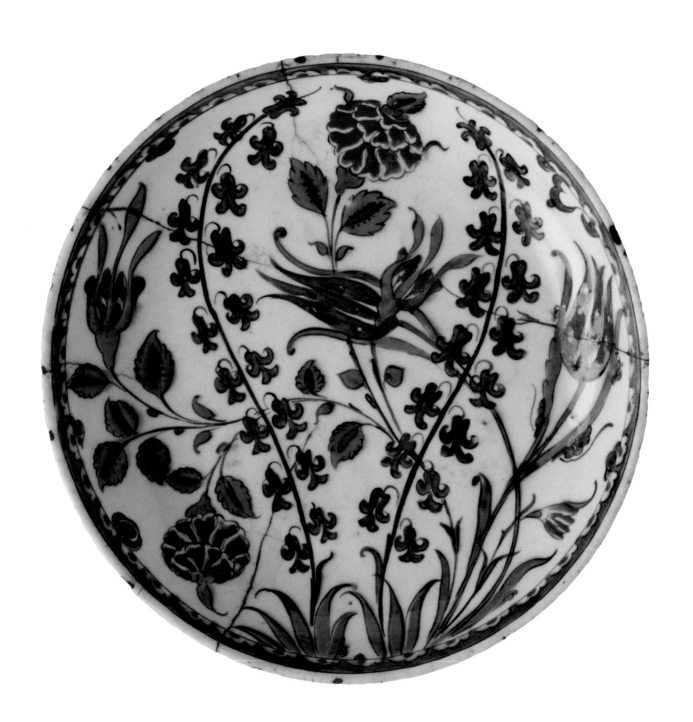

PART III: ISLAMIC ART AND EUROPE
(sixteenth to nineteenth centuries A.D.)

Lustre-painted Ceramics of Spain

Elena N. Ivanova

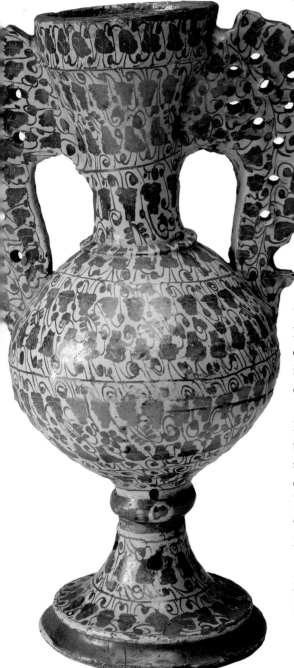

Hispano-Moresque faiences painted with golden lustre are among the most splendid and renowned achievements of the ceramic medium. They were manufactured by Moorish masters in Spain from the beginning of the twelfth century. During the fourteenth century these magnificent ceramics were known to have been made in Malaga, where the gorgeous Alhambra vases were also painted (Alhambra is a fortified palace of Moorish rulers near Granada, Spain). In the fifteenth century, workshops in the region of Valencia, located in the cities of Mislata, Paterna and especially Manises, were at their peak.

Valencian faiences were characterised by their distinctive monumental forms, large basins and plates, *albarelli* (from an Italian word for a cylindrical-shaped vessel), and vases with handles in the form of wings which were manufactured there. Many forms clearly relate back to metalwork prototypes.

The painting on Valencian lustre ceramics was predominantly monochromatic and ornamental, and they were widely exported not only to Western Europe, but also to the East. There they greatly influenced the manufacture of European ceramics, in particular Italian lustre ceramics produced in Deruta and Gubbio during the sixteenth century.

The height of Valencian faiences coincided with the rule of Alphonse V of Aragon (1416-58), who took possession of Aragon, Sicily and Naples. At that time Valencian masters combined lustre painting with elements of cobalt decoration. Considerable attention was paid to Arabic inscription, which was to become the most important element of the design.

From the beginning of the sixteenth century, during the rule of the Holy Roman Emperor Ferdinand II who conquered the Kingdom of Granada, to the end of the century, Valencian master craftsmen preferred fine, small-scale ornamentation executed in lustre and decorated to emphasize the curves of complex dish and vessel forms. They were particularly fascinated by relief adornment, and from the end of the sixteenth to the beginning of the seventeenth centuries preference was given to randomly-placed plant ornament. By then Christian Spanish ceramicists had joined the

99
WINGED VASE
(see page 103)

Moorish master craftsmen of Valencia and the lustre acquired tawny or copper-red hues. The so-called 'withered foliage' ornament which, for example, decorates the splendid four-handled vase with the coat of arms of Pope Paul V [see cat. no. 100], also appeared during that time. And a further, important element in the decoration of Valencian ceramics of the period was a variety of coats of arms which adorned vases, the umbilicus of dishes, and other ceramics.

Valencian ornament in the seventeenth century was diverse and frequently had a carpet style. Large images of eagles skilfully inserted into floral ornament were very popular, as well as those of other birds, lions, foxes and bulls. At the same time 'combed foliage' ornamentation was retained, and the use of carnations. Traditional forms of ceramic continued to be popular, but large basins with umbilicus were no longer prevalent, and in general ceramics were not made so large.

By the seventeenth century Valencian faiences had become inferior to the splendid ceramics made in the same workshops during the fifteenth and sixteenth centuries; and yet they continued to enjoy great popularity. A Spanish historian, Francesco Diago, wrote in 1613: 'Among other faiences, the objects from the town of Manises should be mentioned separately; [they were] so wonderfully gilded, and painted with such skill, that they became the focus of everyone's interest.' He also spoke of the many orders received in Manises from abroad (see Jacquemart, *Gazette des Beaux Arts* 1862, p. 270).

By the eighteenth to nineteenth centuries, Valencian producers still continued to manufacture ceramics in the old traditions, in memory of the earlier epoch of splendour when their precious faiences were the object of admiration and adoration throughout the whole of Europe.

97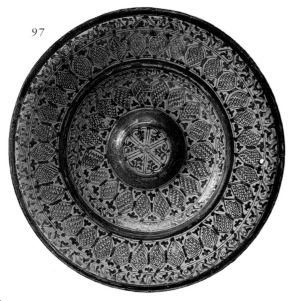

98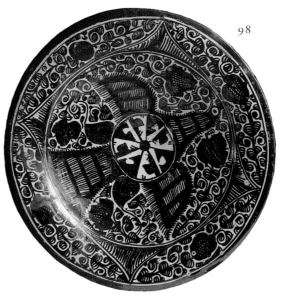

99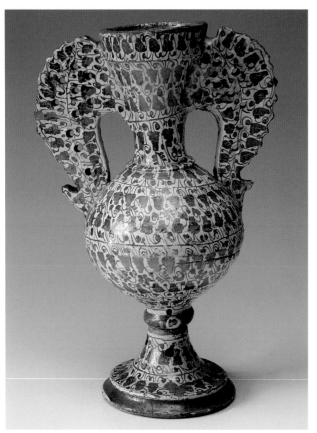

100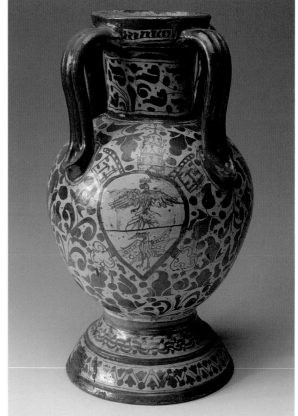

Lustre-painted Ceramics of Spain

97
DISH

Spain (Valencia), second half of 16th century

Maiolica, painted with golden lustre; 40.5 cm (diameter)

Origin: acquired in 1925 from the Museum of the former Central School of Technical Drawing of Baron A. L. Stieglitz

State Hermitage Museum, inv. no. F-3400

This dish has an umbilicus, a round elevation, in the centre. Maiolicas of this shape were made in Valencia from the fifteenth century onwards; the shape relates back to medieval metal dishes. The fine-sized golden decoration suggests it was produced in the sixteenth century, when artists attempted to imitate metal gold-plated items by applying lustre to ceramic ware. (E.I.)

98
DISH WITH AN EAGLE

Spain (Valencia), 17th century

Maiolica, painted with reddish lustre; 39 cm (diameter)

Origin: acquired in 1925 from the Museum of the former Central School of Technical Drawing of Baron A. L. Stieglitz

State Hermitage Museum, inv. no. F-3274

References: Carbonier 1899, no. 596; Kube 1940, no. 51, illus. XLI

There is an identical dish in the collection of the Hispanic Society of America in New York (see Barber 1915, pl. LXXX). (E.I.)

99
WINGED VASE (see page 100)

Spain, Valencia, second half of 16th century

Maiolica, painted with reddish lustre; 26 cm (height)

Origin: acquired in 1886 from the Golitsinskiy Museum Collection

State Hermitage Museum, inv. no. F-745

So-called winged vases represent an original Valencian style, with a spherical body and handles in the form of wings, pierced by a large number of holes. Such vases were made in Valencia from the fifteenth century. There is a wonderful example of a winged vase in the Hermitage Collection, made in the fifteenth century (inv. no. A-323). The vase in the exhibition, from the second half of the sixteenth century, has a finer decoration of vine foliage executed in a less shiny, more reddish lustre. (E.I.)

100
VASE WITH FOUR HANDLES

Spain (Valencia), 1605-21

Maiolica, painted with golden lustre; 50 cm (height)

Origin: acquired in 1920 from the M. P. Botkin Collection

State Hermitage Museum, inv. no. F-2034

References: Botkin, 1911, table 39; Kube, 1940, no. 37, illus. XXXIV

Not in exhibition

An almond-shaped shield with the coat of arms of the Borghese family of Siena appears on two sides of this vase. The shield is placed on crossed keys and crowned with the triregnum, which suggests the coat of arms belonged to Pope Paul V (1605-21), the only representative of the Borghese family to sit on the papal throne.

Two other identical vases with the coat of arms of Paul V are in the collection of the Hispanic Society of America in New York (see Barber 1915, pl. XLVIII). According to the hypothesis of A. van de Put (see 1911, p. 68), the benefactor of all these vases could have been Gaspar Borgia from Valencia, who received the title of cardinal from Paul V in 1611. This vase dates from the period of the pontificate of Pope Paul V. (E.I.)

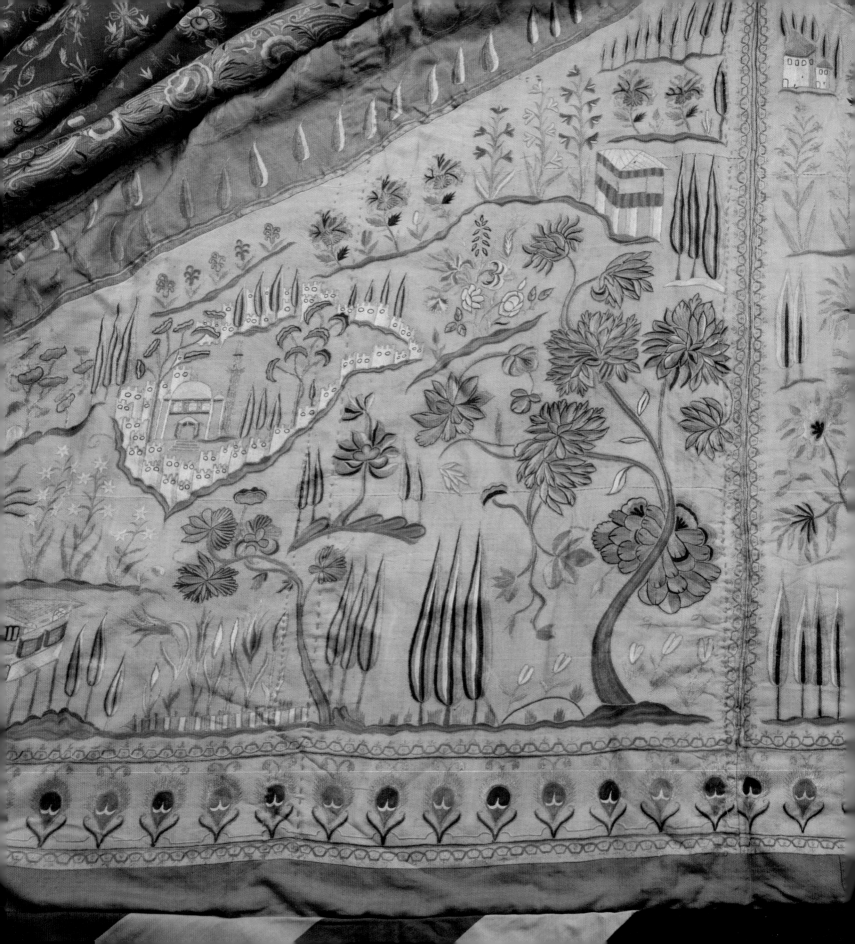

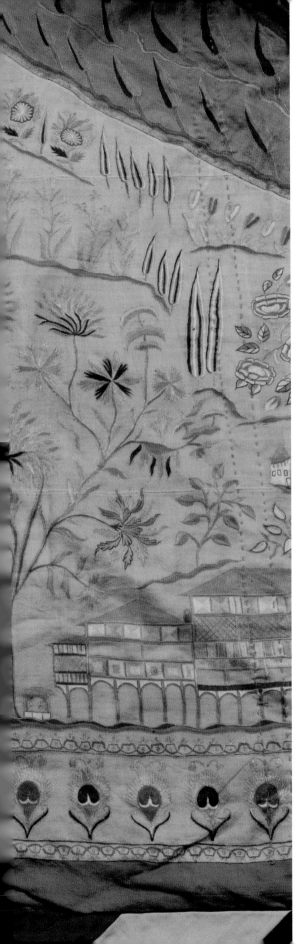

The Art of Ottoman Turkey*

Anton D. Pritula

Of all the Muslim countries whose art is on display in this exhibition probably the art of Turkey is best known to the European public: Turkey is the Muslim country where the penetration of European values and culture has gone the furthest. It would be truer to say that the link with European culture has been innate to Ottoman Turkey since it first began and it has never been entirely broken since; the country has never ceased to participate in European politics.

After the fall of the Seljuq state a large number of emirates existed in Anatolia. In the early fourteenth century one such emirate was ruled by Osman, founder of the dynasty which later united the whole Eastern Mediterranean under its rule. Under succeeding rulers many Anatolian towns were captured, including Bursa, which became capital of the new state. Under Mehmed II (1451-80), Constantinople was taken and made the new capital; the Topkapi Palace was built and the royal court transferred to it. Under Selim I (1512-20) Azerbaijan was captured, with the Safavid capital, Tabriz, along with Syria and Egypt. The Ottoman state then reached its peak under Sultan Suleiman I (1520-66), and during his reign Turkey stretched almost as far as Vienna in Europe, and North Africa in the south.

Ottoman Turkey differed from other Muslim states in its degree of centralization of every sphere of life, including culture and religion. This included *objets d'art*. The craftsmen of each trade were united in a single guild, each with its own head. Members received a fixed wage for fulfilled orders, all of which were determined centrally. The centre of production of its world-famous pottery, Iznik, was effectively the Sultan's workshop serving Istanbul and the empire as a whole. There was the same degree of centralization in the Guild of Book Miniature Craftsmen (Naqqashkhane), which in turn sub-divided into several categories: i.e. Craftsmen of Book Illumination, Text Illustrators, or Artists in general (who did portraits and pictures, unrelated to any text). The craftsmanship of Turkish artisans opened the way to the European market

ACKNOWLEDGEMENT*

I would like to express my appreciation to Yu. A. Miller for his valuable consultations on the unpublished Hermitage objects and also for providing his unpublished observations of the Hermitage exemplars of the Turkish weapons. (A.P.)

110

TENT

(see details on page 115)

and it never failed to impress. It is well-known that Italian faience (known as 'Candian ware'), for example, was greatly influenced by Iznik.

It is significant that a style of decoration, and even a universal language to describe materials, was formed in the Ottoman Empire. It was apparently first created by artists–miniaturists, before it spread to pottery and textiles. It was very important that artists, working in Naqqashkhane and other workshops, frequently supplied designs for other craftsmen of applied art: above all, floral design, almost a hallmark of Turkish products. Tulips, hyacinths, carnations, pomegranates, roses and other plants formed the basis of a 'naturalistic' line of decoration. Fantastical creatures in fabulous forests with areas of *saz* (with long twisting prototypal leaves), often with lotuses, comprised this 'fantastical' trend. Nonetheless, if these two trends had more or less complete autonomy in miniature painting, then in applied art there was a distinct tendency towards a fusion of them, although this kind of unity often hinders a precise localizing of the place of production of one or other item.

By the eighteenth century the production of Iznik pottery and high-quality Turkish textiles and carpets fell into decline. This also coincided with the economic weakening of the state, which lost increasing amounts of its possessions in bloody wars.

Simultaneously, complex processes in art began at this time, for which our knowledge is scant in comparison to the period of its ascendancy.

The basic trends in Turkish eighteenth century art are easily traceable through the material in the Hermitage tent [see cat. no. 110], which occupies a central position in the exhibition. The tent itself consists of four parts: three sections to represent the walls, and a fourth – the gable roof – which rests on two pillars.

Turkish tents from different collections throughout the world have been published in Nurhan Atasoy's catalogue (Atasoy 2000), as well as extensive information about Turkish tents noted in various other documents. Tents are known to have played an important role in court life and military operations of Ottoman Turkey. They were seen not just as a temporary change of dwelling for campaign purposes. Tents and marquees of different sizes were used for conducting important discussions (Council of State), as well as on festive occasions when their number expanded to the size of a whole town. Indeed this is not surprising, as tents are culturally linked to a former nomadic way of life.

The tents were prepared in a special workshop, Mehterhane-i Khayme, which served both court and army, but this centre could not satisfy the needs of a huge empire. Tents for official use were often acquired in Istanbul market. They were also ordered from craftsmen in Aleppo. Tents differed in size and shape, with one, two and three-poled variations. Sections, called *hazine*, were used as a unit of measurement of tent size. These were sections of the wall with a repeating pattern, although this measurement was rarely accurate. The Hermitage tent has 18 such sections.

The tents were usually made of two woollen fabrics: the outer layer being thick and the inner one thinner. They were decorated with an appliqué technique, or different kinds of embroidery. The inner surface of thin woollen fabric was sewn in drum stitch (*suzani*), using metallic thread. In the numerous documents that detail orders for different tents, those decorated with this kind of stitching are comparatively rare (Atasoy 2000, p. 122). Surviving examples with this form of stitching, are associated more with other techniques.

The wall sections of the Hermitage tent are decor-

ated with repeating arches, with a flower vase as a centrepiece. The decoration of the different sections varies somewhat, but the differences are minimal: basically the choice of flowers and shape of the poles. It is well known that while the tents were understood to be a kind of alternative to fixed architecture, their decoration often relates back to how that architecture looked: there is extensive use of arcades in repeated sections, and the tent windows are in a mesh form, imitating a grille (Atasoy 2000, pp. 79-80). The Hermitage tent is no exception. The decoration of tents also finds close parallels in carpet design. Prayer rugs decorated with arches and columns were familiar since the sixteenth century (Washington 1987, nos. 158, 159), so it is plausible that they exerted influence on the development of tent decoration. One can note in particular the similarity of tent decoration to that of so-called *saff* prayer rugs (Washington 1987, p. 225). The latter were designed for large mosques and look like tent walls with many sections placed in a line.

The motif of a flowerpot with flowers, placed in the centre of a composition within each section of the Hermitage tent, is thought to have been borrowed from European style: it is a common theme on European textiles from the late Renaissance, and especially popular in the Baroque era. A similar decorative structure can be seen on the awning of Krakow Museum (Zigulski 1988, fig. 254; Atasoy 2000, no. 99). This was done in appliqué technique and is less elegant than on the Hermitage tent. It used to be thought that the Krakow awning had been taken as a trophy at the siege of Vienna in 1683 by the Polish commander-in-chief Mikolaj Hieronim Sieniawski, when the Turkish forces were defeated by the army of the European allies (Zigulski 1988, fig. 254). However in Atasoy's opinion the Turkish

collection was added to later, and on stylistic grounds the awning should be dated to the end of the eighteenth to early nineteenth centuries (Atasoy 2000, no. 99). In addition there are similarly-decorated Turkish rugs dating to the eighteenth century, including examples in the Hermitage (inv. nos. VT-1039, 1040 and 1041).

However, the arch on the Hermitage tent has been treated in a very singular fashion, like two entwined cypresses growing out of the poles. The cypresses are also placed to the right and left of the vase. The composition on the Hermitage tent shows the least connection with European tradition.

The Hermitage tent roof is decorated inside with tympanum of different architectural constructions. Among them there are recreation pavilions, which were widespread in the eighteenth century. There is also a fountain in typical European style. Such fountains and pavilions, with canals and walk-ways, were standard in the park or garden complexes built in Istanbul on the banks of the Bosphorus, as well as in other centres of the Ottoman Empire. Regarding the fountain, this was a distinctive mark of the new European fashionable style. It can be seen depicted, for instance, on Turkish blades of the eighteenth to nineteenth centuries, along with pictures of a European-style sailing boat. In plant representations, chiaroscuro is used to good effect, for example, on a rose bush in the Hermitage tent.

In addition, we see an attempt at voluminous three-dimensional portrayal of architectural constructions. These phenomena appear in Turkish art in the eighteenth century as the result of European influence. They are noticeable in painting, court interior design and in applied art. Towards the end of the eighteenth century this influence became predominant and there was universal use of European perspective.

On the other hand, the embroidery of the Hermitage tent does contain a number of features that are standard in Turkish art. Its theme of nature in particular is directly linked to the traditional Turkish genre of the 'topographical miniature', known since the sixteenth century. Its distinguishing feature is a disruption of dimension or, more accurately, two-dimensionality. Flowers and various plants are painted as large as the buildings. There is a clear similarity between the Hermitage embroidery, for example, and works of the founder of the genre of 'topographical miniature' Matrakci Nasuh (sixteenth century) (see, for example, his view of Istanbul [Washington 1987, fig. 39 a], and the picture of the ruins of Sultaniye [Washington 1987, fig. 39 b]). As on the miniatures, the tent makes extensive use of pictures of several kinds of tulips, cypresses, hyacinths and other plants which are standard in Turkish art. Even the rough drawing of the leaves on the crown of the tree on the Hermitage embroidery is comparable to the Turkish miniatures. There is an almost obligatory element in this genre: a fortress with towers. Equally, you will find a traditional type of Turkish mosque, with a strongly convex cupola and one pointed minaret. Many such mosques are known: usually small ones such as, for example, the fourteenth-century Green Mosque in Iznik.

However, one does not find, for example, this kind of traditional element in the eighteenth-century art which embellishes the Topkapi interiors. These interiors usually display park complexes with sundry pavilions and fountains, although everything is subject to the dictates of European painting (Rogers 1988, figs. 30, 33, 37).

It is thanks to the link being maintained with tradi-

tional Turkish art that we can reasonably date the Hermitage tent to the mid-eighteenth century; and so it is an example that shows the degree of penetration of European art in Turkey, at a time when new trends were fusing with local traditions. At a later period this fashion led to an almost complete European takeover of Turkish art.

The Hermitage tent, along with other tents and carts, came to the museum from the Stables Museum after it was dissolved in 1931. Prior to this the 'tent-house came in 1842 [to the Stables Museum] from the Moscow military campaign transport, which had been its home' (according to the inscription on a leather tab on the roof of the tent made, it would appear, by the museum staff). It is called 'a little house' probably on account of its gable roof. A Stables Museum guide book in the Hermitage archives tells us that 'the tent-house acquired in 1842' was exhibited in sections in one of the rooms. However, it is not known when it actually became part of the Russian 'military campaign transport'. It must have been during one of the many Russo-Turkish wars (e.g. 1787-91 or 1806-12). Even if the tent had been seized during the 1828-29 campaign, i.e. the last one before its transfer to the Stables Museum in 1842, the tent was certainly in use in the Russian army for at least 13 years.

In the opinion of fabric restorer M. V. Denisova, the tent has manifestly later, nineteenth-century, additions which point to some serious re-sewing. It is hard to say whether this was done in Turkey or in Russia. Whatever the case, such has been the fate of this fascinating historical artefact, which not only combined elements of the art of two different worlds, but served the needs of two opposing armies.

The Art of Ottoman Turkey

101

EWER

Turkish (Iznik), beginning of 16th century

Faience; 13.2 cm (height)

Origin: received from the State Academy for the History of Material Culture

State Hermitage Museum, inv. no. T-157

Reference: Miller 1972, p. 142

Exhibitions: London 1976, no. 417; Kuwait 1990, no. 83

The shape of this object is reminiscent of Iranian bronze and brass jugs from the second half of the fifteenth and first half of the sixteenth centuries [cat. no. 90]. The ewer now has a shortened neck, and is missing a handle. Turkish ewers of the same shape, but made of silver, are also known about.

The ewer is decorated with the so-called 'Chinese cloud' design, which is very similar to the decoration of Shiraz miniatures from the mid-fifteenth to mid-sixteenth centuries; this indicates Iranian influence and allows the item to be dated. (Yu.M.)

102

DISH

Turkey (Iznik), second half of 16th century

Faience; 30.5 cm (diameter)

Origin: acquired in 1925 from the Museum of the former Central School of Technical Drawing of Baron A. L. Stieglitz

State Hermitage Museum, inv. no. T-52

This dish, which has rounded walls and a ring-shaped foot, has a typical shape for work from Iznik in the sixteenth century. Black spirals are a common form of decoration on work from Iznik, perhaps originally borrowed from Chinese porcelain decoration, which was highly popular in the Middle East. The use of the colour red, a colour with limited availability, in the decoration is first seen in pieces made in Iznik during the middle of the sixteenth century.

Dozens, if not hundreds, of examples with similar decoration are known in collections around the world. The portrayal of wild flowers with broken stem-ends is a 'trademark' of Iznik ceramics; bends and breaks in the plants made it possible to distribute the design evenly and naturalistically over the surface of the object. (A.P.)

103

DISH

Turkey (Iznik), second half of 16th century

Faience; 30.5 cm (diameter)

Origin: acquired in 1925 from the Museum of the former Central School of Technical Drawing of Baron A. L. Stieglitz

State Hermitage Museum, inv. no. T-44

Reference: Miller, 1972, p. 69

This dish differs from the previous example [cat. no. 102], in that the side is not inflected. A curious decorative aspect of Iznik ceramics is the combination of blue and red tulips; if blue is the colour traditionally used to represent this flower, red was first found in Iznik ceramics in tiles and a lamp at the Suleiman Mosque (1658). A special type of clay, applied in a thick layer, was used to obtain the colour. This explains why some red decorative components appear in relief against the surface of the object. (A.P.)

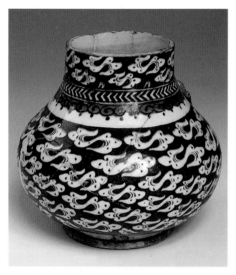

101

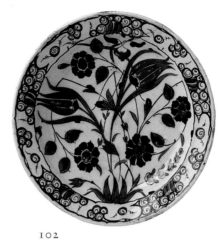

102

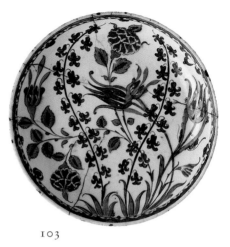

103

104
TILE FRIEZE
Turkey (Iznik), second half of 16th century

Faience; 20.5 cm x 175 cm x 6.5 cm

Origin: acquired in 1925 from the Museum of the former Central School of Technical Drawing of Baron A. L. Stieglitz

State Hermitage Museum, inv. no. T-191

Published for the first time

After mastering the use of red in the 1560s, Iznik craftsmen began to use the colour extensively. In tile-work panels and friezes, typical compositions combine the decorative 'Chinese clouds' design – frequently red in colour and curved, sometimes forming cartouches – with a green *saz* or serrated leaf. Between these leaves are flowers, as on this Hermitage frieze, or on comparable panels from the Piyale Pasha Mosque (c.1573) (panel now in Boston, Washington, 1987, p. 281, fig. 209). (A.P.)

104

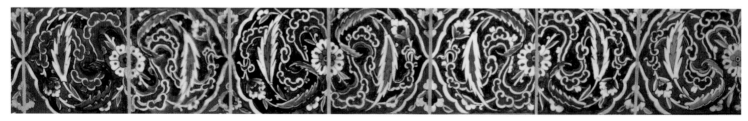

105

MANUSCRIPT OF 'FUTUH AL-HARAMAYN' (A DESCRIPTION OF MECCA AND MEDINA, IN VERSE)

Iran

Author: Muhi ad-Din Lari

Artist, calligrapher: Vasi al-Herevi, Mecca, 970A.H./1562-63A.D.

25 cm x 17.5 cm

Origin: acquired in 1939

State Hermitage Museum, inv. no. VR-941

Exhibitions: Adamova 1996, *Supplement*, no. 11, p. 358; Amsterdam 1999, no. 16; St Petersburg 2000, no. 18

'Futuh al-Haramayn' by Muhi ad-Din Lari (died 933A.H./ 1526) is a description, in Persian verse, of Mecca and Medina. The opus is a form of guide book for pilgrims performing the *hajj*, an obligatory journey for all Muslims to the main Holy Places of Islam: the Sacred Mosque (Masjid al-Haram) and the Kaaba in Mecca, as well as the Prophet's Mosque (Haram al-Nabavi) in Medina, which houses the tomb of the Prophet Muhammad. This book helped pilgrims to find their way and was apparently highly popular, especially in the sixteenth century, as indicated by the large number of contemporary copies that have survived to this day. The Hermitage's manuscript, according to the colophon, was copied in Mecca by the calligrapher Vasi al-Haravi (a native of the town of Herat, now in Afghanistan). The manuscript is written in *nasta'liq* script, in four columns with 17 lines per page, on 25 sheets; the leather binding was added at a later period. The text includes gouache and gilt illustrations on 13 pages. A special, schematic method was developed for illustrating 'Futuh al-Haramayn' and other such works: one image includes both a view from above, and one from the side (this same approach is sometimes used in modern travel guide books). (A.A.)

106
INCENSE-BURNER

China, 17th century, transitional period;
Ottoman Turkey, 18th century (mounts)

Porcelain with cobalt underglaze decoration;
23 cm (diameter, base), 22 cm (height)

Silver, gold, jade, turquoise, rubies, emeralds, smalt

Origin: acquired in 1936 from the Museum Archive of the
Gatchina Palace Museum

State Hermitage Museum, inv. no. LS-550

Published for the first time

This incense-burner consists of a plate serving as a base
for a silver, ornamental stand, which supports a vessel
of two halves (probably the body of a Chinese cobalt
porcelain vase, cut horizontally), each in a silver mount.
The incense-burner is covered with a lid, which previ-
ously culminated in a crescent (now lost). The porcelain
is decorated by the use of a repoussé and incised silver
mount. It also has an inlay of gold wires and flowers,
as well as jade plates inlaid with gold wires and precious
stones traditional in Turkish art during the Ottoman
Empire (seventeenth to eighteenth centuries).

Chinese porcelain with cobalt decoration was
collected by rulers of Middle Eastern countries, including
notable examples from the Chinese porcelain collection
at Topkapi Saray, Istanbul, and the Ardebil Shrine, Iran.
Expensive porcelain items are frequently mounted in
silver, bronze or gilded metal, especially along the rims,
in order to protect the fragile porcelain from possible
chipping, or to hide existing damage. However, various
ceramic items, or their individual parts, were also used
to form objects that were more traditional in Islamic
art, as in the case of this incense-burner. In the Imperial
Ottoman workshops, porcelain would be mounted using
precious metals and decorated with precious stones.

R. Krahl wrote: 'Having been jewelled in the palace
(and most likely only there) and kept in various treasuries,
only a few of these pieces ever found their way out of
the Saray. Those which were included in the dowries
of the princesses, or given as presents to government
officials, were generally returned after the death of
their owners.'

This incense-burner most likely joined the Imperial
Russian Collection in the 1870s, as a diplomatic gift,
and was held in the collection of Tsar Alexander III in
the Chinese Gallery at the Gatchina Palace. (M.M.)

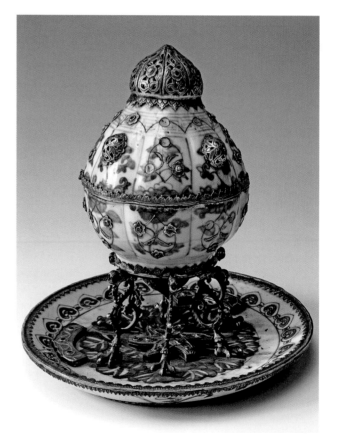

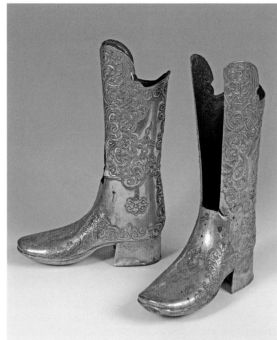

111

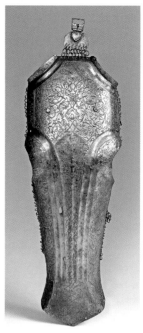

107

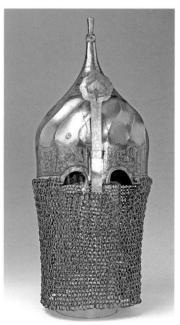

108

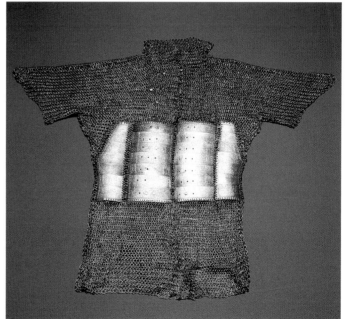

109

107
HORSE'S HEAD HARNESS
Turkey, beginning of 16th century

Steel, engraving; 60 cm (length)

Origin: acquisition unknown

State Hermitage Museum, inv. no. OP-4816

Published for the first time

This head harness is decorated with engraving, including lattice designs and stylized plant ornament, such as lotus flowers. These harnesses appeared in the fifteenth century and were made to the beginning of the eighteenth century, when they became redundant due to the development of firearms and changes in military practice. (A.P.)

108
HELMET
Turkey, beginning of 16th century

Steel, engraving; 35 cm (height), 22 cm (diameter)

Inscription (Arabic, in *naskhi* script): 'Permanent glory, and fortune, and luck, and power, and happiness, exaltation in modesty and blessing in glory.'

Origin: captured in 1929 in the town of Erzurum, Turkey, during the Russo-Turkish campaign

State Hermitage Museum, inv. no. OP-1207

Published for the first time

The curved body of this helmet is decorated with a plant design beaten into the silver, typical of sixteenth-century Turkish weapons. Such 'turban' or 'tulip-shaped' helmets were made in workshops in Istanbul and are significantly larger than most headpieces of the time, due to the way they were worn. First, a soldier would don a *misurka* (a light, thin helmet), followed by a cotton hood, on to which the helmet could then be placed. Helmets of this type are not known in the armies of other countries, such as Iran, and are an exclusively Turkish phenomenon. (A.P.)

109
ARMOUR
Turkey, beginning of 16th century

Steel, engraving; 94 cm (length)

Origin: acquisition unknown

State Hermitage Museum, inv. no. OP-1025

Published for the first time

This example of traditional jushman Turkish battle armour, decorated with stylized scrollwork, was common in the Turkish army from the mid-fifteenth century to mid-seventeenth century. Like the Hermitage's helmet [cat. no. 108] and horse's head harness [107], the armour could have belonged to a high-ranking Turkish commander in the early sixteenth century.

The armour bears a number of symbols: a circle and four stripes (three vertical stripes under one horizontal stripe). These symbols indicate that the armour was located in one of the Sultan's arsenals for some time. Such arsenals existed in many cities of the Ottoman Empire, and were mainly used to store defensive weapons. (A.P.)

111
BOOTS
Turkey, 18th century

Copper; 32 cm (height)

Origin: acquisition unknown

State Hermitage Museum, inv. no. T-178

Published for the first time

These boots, of unusually small size, also had a decorative insert sewn into the top. They are decorated with plant ornament in relief, clearly copied from a European Rococo design; this can be seen particularly well in the decoration of the rear section. (A.P.)

110

TENT (see pages 104-105)

Turkey (Istanbul), 18th century

Coloured twill fabric embroidered with metal thread (*sûsanî*) and multi-coloured silk

Origin: acquired in 1931 from the former Stables Museum

State Hermitage Museum, inv. no. VT-1607

Published for the first time

SIZES:

1. Roof (inverted 'v'): 270 cm (height); 605 cm (greatest length when folded); 290 cm (length of roof, between posts)

2. Wall (consisting of seven sections): 173 cm (height); 690 cm (length)

3. Wall (consisting of seven sections): 172 cm (height); 680 cm (length)

4. Wall (consisting of four sections): 173 cm (height); 360 cm (length) (not in exhibition)

This tent apparently belonged to a fairly low-ranking Turkish officer, judging by the absence of the colour red; it is known that the colour red was used in the tents of the senior Imperial ranks. (G.S.)

115

112
TABLE

Turkey, end of 17th to early 18th centuries

Copper, gilding; 44 cm (height), 39 cm (diameter)

Origin: acquired from the Tatishev Collection

State Hermitage Museum, inv. no. VZ-612

Published for the first time

This piece of furniture has traditionally been considered to have served as a stool. However, it would be uncomfortable to sit on a stool at such a height. Given that Turkish interiors typically had no furniture and cushions were used instead, it seems possible that this is actually a small table, which would explain the height of the piece.

According to a legend that circulated in the Tatishev family, this object was captured in 1683 during the siege of Vienna. If this is true, then we have a very early example of European influence, notably in the engraved ornamentation. However, one should treat family legends with great care; in other cases, unquestioning acceptance of similar rumours has only confused the dating of Turkish artefacts in European collections. (A.P.)

113
INCENSE-BURNER

Ottoman Turkey, 18th century

Silver, silver filigree, painted enamel; 26 cm (height), 19.5 cm (max. diameter)

State Hermitage Museum, inv. no. T-422

Origin: from the Gallery of Valuables of the main State Hermitage Collection

Published for the first time

This incense-burner is part of a set intended for an altar, or the decoration of a palace interior. The burner has the shape of an architectural structure, a temple or mosque,

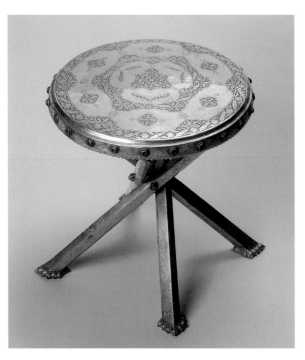

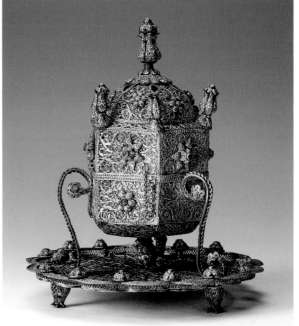

with cupolas. The shape is related to that of the incense-burner assembled from Chinese porcelain and silver [cat. no. 106]. The upper section opens, and inside there is a container for frankincense. The entire piece is made from silver wire in openwork filigree, with ornament in the form of interlaced flowers and spiral designs. The incense-burner is decorated with enamel beads, decorated with painted pink flowers. Filigree work was rarely used in Turkey, and the technique may have entered the country from Mughal India, where it was developed in the Deccan and Karimnagar in the eighteenth century, influenced by trends in China. However, the use of inserts of painted enamel is typical of jewellery in Ottoman Turkey.

The Hermitage has two further, related works of approximately the same shape, and it is thought that they belong to the same set or group of items. (M.M.)

114
FLASK
Turkey, 19th century
Faience; 15 cm (height)
Origin: acquisition unknown
State Hermitage Museum, inv. no. VG-858
Reference: Miller, 1972, pp. 165, 166

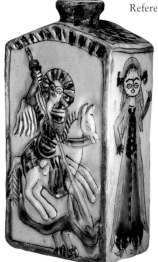

In the eighteenth century the production of ceramics in Iznik slumped. In the second half of the century the use of ceramic tiles ceased completely. Among alternative centres of ceramic production the most prominent was Kütahya, whose craftsmen specialised in the making of smaller items: jugs, cups and coffee pots. Kütahya ceramics were clearly influenced by European faience, mainly from Meissen and Vienna, and soon became popular on the European market. The techniques and decoration involved differed greatly from those at Iznik. The ceramic body was made from clay of a very light, almost white, colour. For this reason there was no need to cover the clay with a white slip. The decorative design was primitive and of a fairly low quality. The coloured glazes often ran together and colour combinations were not always successful. Among the craftsmen working in Kütahya were a large number of Christians, primarily Armenians. This is well recorded in contemporary sources, and some artefacts have inscriptions in Armenian. Consequently, Christian themes are very common in products from this location. This Hermitage flask, which depicts Saint George killing the serpent, is a typical example of such work. (A.P.)

115
TILE PANEL
Ottoman Empire (Damascus or Iznik), 16th century
Faience; 15 cm (height)
Origin: acquired in 1925 from the Museum of the former Central School of Technical Drawing of Baron A. L. Stieglitz
State Hermitage Museum, inv. no. T-89
Reference: Miller 1972, pp. 165, 166

This tilework panel is one of many examples of the re-interpretation of Christian themes in Islamic art. The motif, pairs of peacocks drinking from bowls, symbolized immortality in early Christian art. Later it passed into Byzantine and then Seljuq art, eventually entering the Ottoman repertoire. In this panel, understanding of the original theme has been lost: the birds are placed in no particular relationship to the bowl. Whether the tiles were made in Damascus during the Ottoman period is the subject of long debate. Damascan tiles typically depict living creatures, and red glaze was not normally used. It was thought that Damascus ceramics were covered with a thicker layer of less transparent glaze. However the strong similarity between these ceramics and those from Iznik makes such a distinction questionable. (A.P.)

115

116
GLAZED TILE WITH REPRESENTATION OF ST GEORGE

Craftsman: Musa son of Istafan, Aleppo, 1699

Ceramics, underglaze polychromic painting on white engobe; 19.2 cm x 19.4 cm

Origin: bought in 1935 from the State Museum Stock

State Hermitage Museum, inv. no. VG-1477

References: Miller 1957, pp. 52-54; Pyatnitsky 1996, pp. 44-46; Pyatnitsky 1988, pp. 110, 122; Pyatnitsky 2006, pp. 51-52

Exhibitions: 'Christians in the East. Art of Melchites and Non-Orthodox Christians', St Petersburg 1998, p. 122, no. 158

Decorative and anecdotal ceramic glazed tiles were well known in Byzantine art. Such tiles were used for decorating the cathedrals in Constantinople, Nicea (Iznik) and Nicomedia in the tenth to eleventh centuries; they were also found in various centres of medieval Bulgaria. Among numerous decorative glazed tiles there are examples depicting saints, Christ, and the Blessed Virgin.

In the post-Byzantine era ceramic workshops in Iznik and Kütahya developed progressively; they were the main suppliers of decorative glazed tiles in the Turkish Empire at that time. The Iznik craftsmen specialized in decorative glazed tiles, while Kütahya craftsmen produced ornamented tiles, as well as tiles with Christian subjects and symbols. In the late seventeenth century, workshops in Haleb (Aleppo) were an important centre of ceramics.

Several tiles, created in 1699 and signed by the craftsman, Musa son of Istafan, are known to specialists. The tiles bear the Arabic inscription at the bottom: 'Created by Musa son of Istafan in the town of Aleppo in 1699.' Only two subjects depicted by Musa are now known: 'St George's Miracle of the Serpent' and the 'Opprobium of Balaal's Sacrificers.' Such tiles are now located in the J. Nasrallah Collection in Paris, in G. Antaki's Collection in Beirut (previously in J. Beyhum's Collection), and in the Hermitage. The tiles differ slightly in size, border decoration, and some small details of composition. Painted in shades of blue, white, brown, and yellow, the 1699 tiles combine the traits of Greek-Byzantine iconography with Oriental (Persian) style. The composition of 'St George's Miracle' has certain similarities with

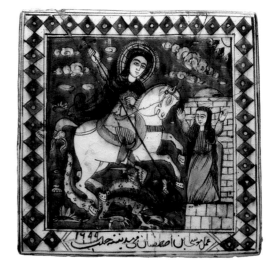

Greek icons, while some of its details were certainly borrowed from Cretan craftsmen: for example, the shape of the saint's flying cloak; the horse's tail tied in a knot; and three dots on the dragon's body. At the same time, the Princess's figure, with her raised arms, is so naïve yet credible and realistic, that it seems to have been inspired by the craftsman's own surroundings.

Painted tiles with Christian subjects were used to decorate the Holy Sepulchre in 1719, and Etchmiadzin Chapel in the Armenian Monastery of St James. Most of these tiles were produced by Armenian craftsmen in Kütahya. It is also known that the most renowned artisans of Aleppo in the seventeenth to eighteenth centuries (for example, the Al-Musawwir family) were of Armenian origin. Nonetheless, their creations were inspired by Greek models, and we can observe the same inspiration in the tiles made by Musa Istafan's son.

It has been suggested that the creation of these tiles could have been influenced by church confrontation in Aleppo. In the early seventeeth to the late eighteenth century, Aleppo witnessed the struggle for the Antiochian Patriarchal See, when the Turkish authorities appointed two church hierarchs, Cyril (1672-1720) and Athanasius IV (1686-1724), to occupy the See simultaneously. Looking at the tiles depicting 'St George's Miracle' and the 'Opprobium of Balaal's Sacrificers', we might detect a hint of disgrace aimed at one of the claimants, as well as the liberation of the Patriarchial See of that hierarch – in much the same way as St George saved the Princess and freed the town from the dragon. We are not able to say, however, which of the hierarchs – Cyril or Athanasius – might have placed an order for such tiles, as the political struggle between the two claimants was highly complicated. However, there is evidence to suggest that Patriarch Cyril, who was residing in Aleppo at the time, ordered the creation of the tiles. (Yu.P.)

117
PRAYER RUG

Konya, Turkey, beginning of 18th century
Wool; 170 cm x 121 cm
Origin: acquisition unknown
State Hermitage Museum, inv. no. VT-822
Exhibition: London 2004, no. 51

The central space on this rug, intended for performing the daily prayers (*namaz*), is decorated with a central arch design, reminiscent of mihrab niches, or doorways in mosques. Such architectural parallels are typical of Turkish rugs. (A.P.)

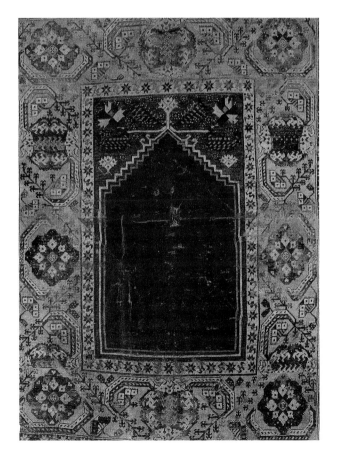

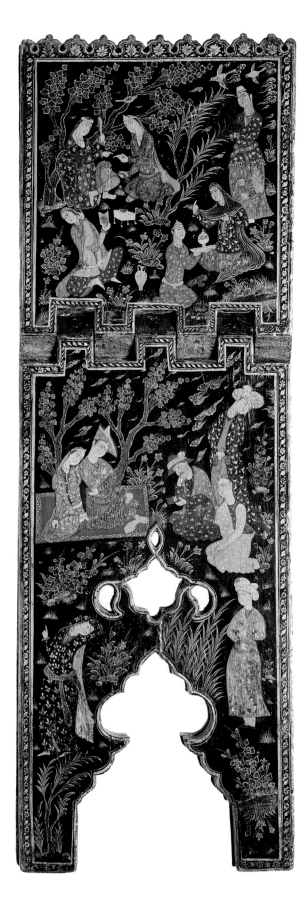

Persian Painting

Adel T. Adamova

In the foreword to his album (*muraqqa*), compiled in 944 A.H./ 1544 A.D. for the Safavid Prince Bahram Mirza, brother of Shah Tahmasp (Istanbul, Topkapi, H.2154), the calligrapher Dust Muhammad tells us that the genre of painting, as it existed in his day, was created in the time of the Ilkhanid ruler Abu Sa'id (1317-50). He explains, moreover, that even prior to Abu Sa'id, painting flourished in China and the land of the Franks, i.e. Europe (Thackston 1989, p. 345). Dust Muhammad named the countries – China and Europe – whose art had played a large role in the development of Iranian painting down the centuries, acting at different times as an important source of inspiration for Persian artists. Occasionally, for a brief period, the influence of foreign culture became so strong that it threatened the very existence of an independent, specifically Persian style of painting. However, by repeatedly absorbing those elements of foreign art that were compatible with its vision, Persian painting was able to retain its unique character.[*]

The Mongol invasion at the beginning of the thirteenth century was so destructive that any judgment about the art of the period immediately preceding it comes from merely a few surviving pieces, including a modest number of archaeological finds and also some literary sources. The bright and colourful miniatures of the sole surviving pre-Mongol manuscript – the eleventh-century Persian poet Ayyuqi's romance, 'Varqa va Gulshah' (Melikian-Chirvani 1970) – with their symmetrical structures, the frieze-like disposition of the figures in a single plane, the arraying of the pictures on a totally ornamented surface, or on a locally-painted background, show a stylistic similarity to both monumental painting and pottery decoration, whether lustre or mina'i [cat. no. 75].

[*] See, on Persian painting, Robinson 1982; also Sims 2002 where there is a complete bibliography of works on the various stages of its development.

LACQUER BOOK-STAND
(see page 135)

In the late thirteenth to early fourteenth centuries the Mongol rulers of Persia, now settled, sought to portray themselves as successors to the great traditions of the past of the country they had conquered. The idea of an indelible tie, of an unbroken period, both preceding and following the Mongol conquest, is echoed in Rashid ad-Din's history *Jami' al-Tawarikh* – a collection of manuscripts containing Iranian, Mongol and world history (Komaroff 2002, nos. 6, 7). However, the clearest stylistic feature in miniatures, illustrating Rashid ad-Din's work and other manuscripts from the Tabriz school (sometimes called 'Mongol style' after the ruling dynasty), mentions a strong Far Eastern influence, especially from Chinese art (Blair 1995). What predominates in these miniatures is the appearance of Mongol facial types, as well as Mongol and Chinese clothing, arms and armour. These are characterized by a graphic, linear style, and a modest use of colour which is consistent with the influence of Chinese painting. These features clearly set them apart from the pre-Mongol illustrations in 'Varqa and Gulshah', and also from miniatures in Shiraz copies from the first half of the fourteenth century which, thanks to the fact that Shiraz managed to avoid the destruction of the Mongol invasion, continued the artistic traditions of pre-Mongol Iranian art.

The Mongol style did not last for long. In the Mongol manuscript of Firdawsi's epic poem 'The Shahnama' known as 'The Great Mongol Shahnama' (published in Komaroff 2002, nos. 36-61), that was created for the Ilkhanid ruler Abu Sa'id, the miniatures have little in common with the Chinese-inspired illustrations in Rashid ad-Din's earlier copies. The Shahnama miniatures do, however, preserve some features that already appeared in the works of the Tabriz school under the influence of Far Eastern art. Of particular importance is the attention paid to the portrayal of depth of space, volume and movement. At the same time, one can also discern a revival of the monumental style of pre-Mongol Iranian art, preserved in the Shiraz painting school, which inherits a wealth of detail and aspects from the ancient art of Iran. These miniatures, which reproduce the events of the ancient history of Iran as described in the poem, are undoubtedly works of a separate Iranian school of art. Later, in the fifteenth to sixteenth centuries, painting frequently changed in style, but remained distinctly Persian art in character. It is to this phenomenon that Dust Muhammad evidently refers. As to the many motifs borrowed in the Mongol period from Chinese art (the dragon, phoenix, lotus flower, stylized clouds and many others), they had a long and secure role in the repertoire of all the applied arts of Persian artists and craftsmen.

In the second half of the fourteenth century, influenced by Persian lyrical poets, whose works comprised the basic content of illustrated books, yet another style began to develop. In this style, bright, clear colours, fine *recherche* lines to divide even coloured surfaces, and a flat overall design became the main artistic means whereby the content and emotional sound of poetic works were expressed. Nine miniatures in the manuscript of Khwaju Kirmani's poems (London, British Library, add. 18113), transcribed in Baghdad in 798/1396, are among the most noteworthy examples of Persian book illustration of the period known as classical, which comprises the whole of the fifteenth century and the beginning of the sixteenth.

When the Timurids, foreigners and conquerors like the Mongols before them, came to power at the end of the fourteenth century, they tried, as the Mongols had

done, to portray the Timurid dynasty as a legitimate heir to Persian kingship. This explains their orientation towards Persian cultural tradition, and as a consequence, the great role of literature, and in particular poetry, in the Persian language. In this way, the importance and aesthetic worth of books in manuscript form, and consequently of book illustration, are not only preserved, but the book painting itself becomes the predominant form of pictorial art at the court of all the Timurid rulers. Miniatures of manuscripts, made in Shiraz and Herat, which are truly distinctive in their refined technique of execution, their unusual clarity and brightness of colour, are widely recognized as unsurpassed works of Iranian or Persian miniature painting.

Active Timurid contact with China in the early fifteenth century, exchange of embassies, activating of trade and, evidently, the appearance of a large number of objects of pictorial and applied Chinese art at the court of the Timurid rulers, was reflected by Persian masters copying works of Chinese artists. The many examples of paintings, drawings, all manner of preparatory designs for textiles, embroidery, leather goods, and so on, were preserved in outstanding albums, now in libraries in Istanbul and Berlin (Grube, *et al.* 1981; Lentz and Lowry 1989) which bear witness to this. This new wave of Chinese influence, however, only partially affected the art of miniature painting. The heroes portrayed in the miniatures of the Herat School, and also from the mid-fifteenth century the Turkmen school (which developed at the court of Turkmen rulers of the Qaraqoyunlu and Aqqoyunlu dynasties), wear a cloud-collar, and the illustrations include pictures of Chinese porcelain ware. However, this influence does not succeed in extinguishing the distinctive traditional elements of the Persian miniature. The Chinese motifs do however predominate in book illuminations, in all kinds of headings and binding decoration. Phoenixes, dragons, qilins and other fantastical figures remained in vogue, along with sinuous 'Chinese' clouds, flowers, lotus flowers and many other motifs [cat. no. 77]. From the late fifteenth century, Chinese motifs prevail in the decoration of lacquer covers intended for manuscripts – evidently the work of highly-qualified painters at the workshops of the court.

Iranian craftsmen borrowed the art of miniature painting on lacquered goods from China, the home of artistic lacquer. This was so-called 'Persian lacquer' which evolved during the Timurid period in the fifteenth century. For the next four centuries this became one of the most widespread types of artistic creativity in Iran. Originally China had provided the idea of fixing a painting with a protective layer of clear lacquer. The technique, however, differs completely from Chinese lacquer work, as the Iranians did not have access to the raw material – the sap of the Chinese 'lacquer' tree. Indeed, neither the consistency of the lacquer, nor the paints, nor the overall appearance of Iranian lacquered goods, have anything in common with the Chinese ones. In the seventeenth century the chief type of lacquer painting in Iran was figurative painting, in which the composition was established overwhelmingly on a light background. From that time nearly all well-known artists used this technique, and lacquered painting completely followed the style and themes of miniature painting, which gravitated more and more towards Europe.

The acquaintance of Persian artists with works of Western painting can already be traced in a number of miniatures that illustrated fourteenth-century manuscripts. The previously mentioned Istanbul and Berlin

albums, which also preserve miniatures and drawings on individual pages (dating from the fifteenth century), are also in part influenced by the works of European artists (Rogers 1990, p. 25, fig. 4; Brend 1981; Raby 1981), even though the majority of them are still copies of the works or paintings influenced by chinoiserie. The decisive move towards European art, however, clearly does not take place until the second half of the sixteenth century. By the end of this century it is no longer miniatures from illustrated books that define the development of Iranian fine art, but individual paintings, miniatures and drawings intended for the albums of connoisseurs. Motifs now begin to appear in Persian miniatures, testifying to the artists' knowledge of works of European art: e.g. a town with towers and fortified walls visible in the distance, shepherds making music, and so on. Even the stylistic changes found in the individual paintings that were executed in the court workshops of the Safavid capitals – Qazvin and Isfahan – took place with the influence of Western art. Such changes included the increasing search by Persian artists for ways of evoking the movement and three-dimensional physicality of figures obvious in products of the late sixteenth to seventeenth centuries.

Earlier miniatures from the Tabriz school also have representations of free-standing figures of a larger size. This sense calls for a different approach: a more exact study of face, figure, clothing. The background on these pages is not usually elaborated and so the silhouette acquires particular meaning. In the second half of the sixteenth century the Qazvin school had already shifted in the direction of greater animation: figures are shown foreshortened in different degrees of complexity, preference being given to fluid poses and unexpected turns. In the miniature entitled 'Youth with a lute' [cat. no. 120], the figure of a young man, as well as the saddled horse, are represented on a clear paper background, characteristic of Qazvin miniatures on separate pages. In sixteenth-century manuscript illustrations that show multi-figure scenes of royal receptions in a nature setting, stopping-places in the hunt, and so on, this figure (a footman), with his horse, is usually shown, lute in hand, in the upper or lower corner of the composition amidst a host of other secondary figures. Quite distinct from similar scenes, the portrayal of the footman on a separate sheet acquires independent meaning: the youth makes music in an outdoor environment, while relaxing at the same time. This interest in the depiction of figures, which was by no means focussed exclusively on the upper spheres of society, and could on occasion even be devoted exclusively to the life of ordinary people, has been identified as a typical feature of the Qazvin school. It is certainly a developing trend in court painting from the second half of the sixteenth century onwards, that received further elaboration in the seventeenth century.

Another link with the Qazvin school is the development of drawings, executed with a lively calligraphic line, varying in thickness, which gave the figure a plastic, three-dimensional quality and its sense of movement, all adding to an impression of direct observation. This trend, which strives after a vivid and expressive presentation of the subjects depicted, undergoes further development in the seventeenth century and is linked with the so-called Isfahan school.

The development of painting in Isfahan, proclaimed capital in 1598 by Shah Abbas I (1587-1629), took place within a different social and political world. In his attempt to enlist European support for his struggle with Turkey, and guarantee a seller's market for Persian

silk and other products in Europe, the Shah began to expand diplomatic and trade links between Iran and European countries. Isfahan turned into a town, open not only to ambassadors, but to many different kinds of Christian missionaries, merchants and artists. One consequence of this was that real European art, and painting in particular, received the official stamp of recognition at the Persian court under Abbas I.

The aesthetic ideals of the Isfahan school found fullest expression in the work of Riza-i Abbasi, one of the creators of the school. In a lightly coloured drawing of a 'Girl in a fur hat' [cat. no. 121], a lively, naturalistic picture has been created of a girl with characteristically rather narrow, slightly slanting eyes. She is posing in a rather unusual way; resting on her right knee while keeping both hands on her left knee, which is raised. One can sense how tensed she is from her unusual body position, and from the pose she maintains briefly before rising to her feet a moment later. The ability to capture fleeting movement and hold it for an instant is a completely new phenomenon in Persian art of the late sixteenth to early seventeenth centuries. The figure is drawn with deft strokes, constantly varying in thickness. A similar treatment defines the girl's natural surroundings. Without making use of chiaroscuro or modelling, and employing only lines and strokes, the three-dimensional physicality of an elegant female figure has been caught.

In Riza-i Abbasi's double page, 'Feast in the country' [cat. no. 122] the depicted scene gives the impression of a drawing direct from nature. The figures of the people, their poses, movements, and their faces, are all so natural. There is a great deal of captured detail here. The lively animation and naturalism of these and other figures by Riza-i Abbasi is achieved by the specific way in which he draws. Over time his technique grows ever bolder and more intense, the drawings become full of dynamic interrupted lines, executed with a broad brush. However, when Riza-i Abbasi portrays landscape, he uses only traditional means and techniques to create the illusion of space.

Perspective and chiaroscuro modelling became customary in the works of Persian artists from the mid-seventeenth century onwards; undoubtedly these techniques had been borrowed from European art. The cases we know of Isfahan painters borrowing from European paintings date mainly to the 1680s. European landscapes, such as the one in the Hermitage Collection [cat. no. 123] signed by Ali-Quli ibn Muhammad and dated 1059/1649, provide proof of earlier existence of this practice. This Persian copy of a European print [cat. no. 124], is distinguished neither by the skill of its composition nor the precision of execution. It has been created by an artist to whom both the European rules of perspective and use of chiaroscuro were alien. The miniaturist has distorted the perspective of the scene, refused to entertain the play of light and shade, and intensified the sharpness of the lines: as a result, whatever had been of weight and three-dimensional physicality in the engraving, in the miniature has become ornamental and rather flat. The artist was drawn not so much by the technical skills of European craftsmen, but simply by the motif itself. It is probable, therefore, that the miniaturist added figures to the landscape that were absent in the original. European Landscape art continues to be of interest however: in the first half of the seventeenth century, in any case, Persian artists had learned to make use of European painting techniques.

Muhammad Ali's drawing, 'Monkey riding a bear'

[cat. no. 125] stands out among other mid-seventeeth century productions because of its unusual subject matter, drawing technique and light resolution. The subject matter which attracted Muhammad Ali, as well as earlier famous artists like Riza-i Abbasi and Muin Musavvir, is pure Iranian, in contrast to the technique of execution. The tree foliage and grass on the river bank in the foreground are portrayed in different shades of green; the monkey, bear, tree trunks, as well as sky and stream, are painted in gradations of brown. It is, in fact, a two-tone grisaille in brown and green – a technique borrowed from European works, as is the lettering in dots and short strokes.

Nearer the end of the century, pictures and engravings by European artists began to be copied, and in fine detail, as Persian artists sought to re-create the gradations of chiaroscuro and foreshortening.

In a portrait of a young European in armour that appears on a small lacquered pen-case [cat. no. 127], the lustre of the metallic armour, the lightness of the lace collar and hair texture, are very skilfully executed. It was painted, possibly, by a well-known Isfahan artist of the later seventeenth century, Ali Quli beg Jabbadar.

Even in paintings of traditional Persian scenes, Persian artists began to use European techniques: people's faces are modelled in chiaroscuro, landscape backgrounds are increasingly portrayed according to linear and aerial perspective, folds in textiles and the texture of the weave now emerge. One pen-case miniature by Muhammad Ali, son of Muhammad Zaman, was painted in the European manner in 1112/1700-01 [cat. no 128]. He was one of the most famous Persian painters in European style in Isfahan at the time. A lacquered pen-case dated 1120/1708 [cat. no. 129] shows a young woman wearing Persian dress, shown against a European style landscape. Using European painting techniques, the artist manages to give the fabric of her dress texture and captures the shining splendour of the pearl necklace. Great attention is paid to the execution of both figure and face. On the sides of the pen-case, there are oval medallions with female half figures in low-cut dresses. Such medallions are often found in decorations of European applied art. Distant vistas are painted between the medallions, with scattered towers among hills, houses, bridges, figures of riders – all copied from Western sources.

Foreign influence in Persian seventeeth-century art was not confined to Europe, however. The art of Mughal India from the late sixteenth century onwards also drew the ever increasing attention of Persian painters. Of particular interest is the work of Sheikh Abbasi and his two sons, whose works are to be found in the Hermitage (Adamova 1996, nos. 33-35). In the work of these artists we see a new direction in the Isfahan school of painting taking shape, characterized by an idiosyncratic mixture of Persian, European and Indian (Mughal and Daccan school) motifs as its basis. The transition towards the end of the seventeenth century to the new style, marked by a ceremonial constraint in the people depicted, a precision of line and a strong modelling chiaroscuro, evidently led Persian artists to turn to a new technique, oil painting, which could very successfully show these effects. On Ali Naqi's miniature (Adamova 1996, no. 34) there is a woman with a similar style of dress and similar clasps on the bust as the women in the portraits painted by unknown Persian artists in oil on canvas, evidently in the 1680s. These were the very earliest examples of Persian artists using oil, a new European technique for them (Sims 1976, p. 241, nos. 139-40). Later in the eighteenth to nineteenth

centuries a new genre of Persian portrait painting ensued which continued and developed this line of the Isfahan school tradition.

In the second quarter of the eighteenth century, Iran became the arena of almost unceasing wars and internal strife. The Afghan conquest in 1722, the Turkish invasion, seizing the North-West provinces in 1723-24, and the despotic rule of Nadir Shah (1736-47), all struck a heavy blow at the development of Iranian artistic culture. Oil painting, however, prevailed under Nadir Shah. Portraits, and historical and battle genres, proved the most popular. At the palace of Chihil Sutun in Isfahan an oil painting of the battle of Nadir Shah with the Mughal Emperor Muhammad Shah joins early seventeenth-century pictures showing the reception of honoured guests by Safavid Shahs and the battle of the first Safavid Shah, Ismail I, with the Uzbeks. These pictures from the Chihil Sutun palace were frequently copied in lacquered painting, which fulfilled a similar role to engravings in Europe – to circulate cheaper versions of official court painting throughout the strata of society. Today Persian lacquer continues to be a primary source for investigating Persian painting of the first half to mid-eighteenth century.

Many lacquers of the eighteenth century are decorated with very European-style pictures, often on Christian themes (Madonna with Child, Holy Family with saints and angels; see cat. nos. 130 and 131). It is worth noting, however, that the themes of the Virgin Mary and Christ were known to Persian art from the early fourteenth century. This was undoubtedly helped by the respectful and positive attitude of the Qur'an towards Mary (Mariam) and Jesus (Isa). Although the Qur'an was not illustrated, bible and gospel history from Adam to Jesus became a basic component of the

historical compositions of many Persian authors. Indeed, Persian poets (Nizami, Rumi, Saadi, *et al.*) introduced stories of the prophets into their poems, and Jesus, as is well known, occupies the place of honour after Muhammad in the Qur'an. Mention is also made of other Old and New Testament figures (Piotrovsky 2005). Persian artists readily illustrated these subjects and others. There is some basis for the belief that lacquered work with Christian themes was produced in Isfahan, where under Karim Khan Zand (1752-79) Christian missions were renewed, after they had been established in Iran after Abbas I and left the country in the second quarter of the eighteenth century. A unique subject that appears on a lacquer casket of 1776 [cat. no. 132] evidently reflects the ideas of inter-faith tolerance during this time. It may be assumed that the miniature on the box with the subject has some ideological sub-text, possibly copying a picture that adorned one of Karim Khan's palaces.

Under the Qajars (end of the eighteenth to the nineteenth centuries) the process of bringing the art of Iran closer to West European painting continued (see Diba, *et al.* 1998). Qajar court art was somewhat eclectic in nature, with a strong tendency towards retrospection. It was formed in Tehran at the court of Fath Ali Shah (1797-1834). A great influence on the formation of the Qajar style came from the inordinate pretensions of Fath Ali Shah and his nobility, to revive the grandeur of ancient Iran during the Achaemenid and Sassanid periods. However, there was no economic basis for this in the country, nor, even less, any political power or military might. The clearest manifestation of the historicizing trends of the early Qajar period were reliefs carved into Iranian rock faces, copying Achaemenid and Sassanian reliefs, which immortalized the kings of

Ancient Iran. They depicted Fath Ali Shah sitting on his throne, or defeating a beast of prey, themes also found on contemporary monumental canvases in oil. The fusion of a consciously retrospective direction in Qajar art with the ever-increasing impact of Western art, led to the eclectic nature and inner contradictions of Qajar painting, long unappreciated by lovers of classical Persian art and adherents of Western schools alike. Today, however, it is clear that these works of art are of value both in terms of their historical and artistic context. The epoch is reflected in a greatly accessible way, and the air of sheer royal ostentation which pervaded the country is wonderfully captured.

The genre of official portraiture, which long played a leading role in ancient Iranian art, and had a clearly defined propagandistic role, acquired the leading role in Qajar oil painting. Among the most outstanding works of Qajar painting are two portraits of Fath Ali Shah from the Hermitage Collection, executed by his court painter Mihr Ali. On one of them [cat. no. 135], dated 1224/1809-10, the Shah is shown for the first time standing with a sceptre in his hand, creating a new way of portraying the Shah. This is reflected in the inscription on the picture, which noted that it was approved by the Shah without comment or correction. As J. Raby has remarked, the model for this portrait was a picture of Napoleon (Raby 1999, p. 11). Another portrait [cat. no. 136], is more traditional and depicts the Shah sitting on an Eastern-style rug, with a bolster at his back. Here the symbol of authority is represented by a mace (and not a sceptre), while a be-jewelled sabre lies on the rug in the foreground. The landscape seen through the window behind the Shah has possibly been copied from a European work.

If the artist's chief aim in depicting the Shah was to create an idealized but easily recognizable portrait of the monarch, then in the pictures depicting young women (dancers, music-makers, acrobats) the prime aim was to create a picture of someone beautiful in accordance with the conventions of female beauty of the day. 'Woman with a rose' [cat. no. 137], clearly painted in the early nineteenth century, gives us a good impression of early Qajar painting. Despite the fact that Qajar painting had absorbed many elements of Western art – the technique of oil painting, the application in places of chiaroscuro modelling, such details as draping in the upper part of the window, or the glass utensils, possibly of Russian origin, and so on – it is still very closely tied to tradition. This means a tendency towards the flat treatment of space and form, clearly defined areas of rich colour, and the prominent role of ornamentation. The designs on the lady's outfit are rendered with great interest and care. The fabrics are shown traditionally in a front position, and give the whole painting an impression of elegance and rich ornamentation.

The son of Fath Ali Shah, Crown Prince Abbas Mirza [cat. no. 138], was a decided supporter of reform and the Europeanization of the country. Alla Virdi Afshar, who worked in Abbas Mirza's court in Tabriz, apparently studied in Europe or in Iran with a European painter. In his work he uses the methods of the European academic style. Other modernizing trends in the Tabriz school include a desire to show important people in westernized every-day dress, and a desire to portray real events in a naturalistic fashion.

Another of the famous painters of the mid-nineteenth century, Muhammad Isma'il, was known as *farangi-saz* because of his European style of workmanship. In the decoration of a mirror case [cat. no. 139] there are features that are characteristic of the majority

of this craftsman's known work: a crowded surface treatment using a European style of painting. His characters are even more Europeanized when compared to earlier depictions. The three-dimensional modelling of their forms is much sharper and achieved in a different way. In bringing the faces of his figures alive, Isma'il uses tiny coloured dots, sometimes using short brush strokes.

The influence of West European culture and art on Iranian artistic life was especially strong in the second half of the nineteenth century. Indeed all aspects of life were affected: the structure of the state, the cultural life of the country, even contemporary dress. It was also at this the time that the first college opened in Tehran, with the aim of introducing young Iranians to Western culture. The latter half of the century also saw the start of the process that replaced traditional forms of painting with contemporary European styles. Portrait painting remained popular, but the focus of attention now centred on the characteristics of the face. The attempt to portray people with photographic precision can be seen in the miniature 'Portrait of a man with a book' [cat. no. 140], painted c.1870 by the artist Aqa Bala who worked at the court of Nasir ad-Din Shah. Nearly all his work is portraiture, defined by a lack of ceremonial formality, and an attempt to capture the individuality of the person being portrayed. It is symptomatic of the portrait genre in Persian painting as it was evolving during the second half of the nineteenth century.

118 (folios from the Khamseh manuscript – fols. 66b, 90a, 366b; cover on opposite page)

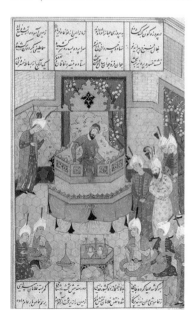
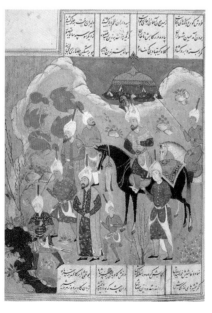
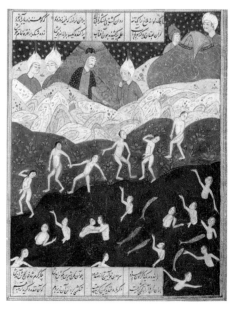

Persian Painting

118

KHAMSEH MANUSCRIPT

Author: Nizami

Iran (Shiraz), 948A.H./1541A.D.

27.5 cm x 17 cm

Origin: purchased in 1945

State Hermitage Museum, inv. no. VR-999

Reference: Akimushkin–Ivanov 1968, p. 22 and pl. 41

Exhibitions: Adamova 1996, no. 3; St Petersburg 2004, no. 82

This manuscript was copied by the calligrapher al-Husayni al-katib al-Shirazi between the Muslim months of Safar and Shaban in 948 (May to December 1541). The cover is made from *papier mâché* with a lacquered design showing illustrations to poems by Nizami and is dated to the nineteenth century. The text covers 380 sheets of *nasta'liq* script, with four columns and 19 lines per page. The text covers the area of 17.5 x 9.6 cm on each page.

The colophon does not indicate where the manuscript was made, although the presentation and the miniatures (17 in total) are in a style that is well known and well researched. This specific style is connected to Shiraz, which in the sixteenth century earned the reputation of a city where commercial manuscripts, mainly works of poetry in Persian, were produced in large numbers. The ornamental frontispiece, with the beginning of the poem 'Treasure Trove of Secrets' on folios 1b-2a, is an especially subtle and fine example of such work. This ornamental composition indicates the popularity in the sixteenth century of motifs borrowed from China, such as the 'Chinese cloud' pattern. The miniatures in the manuscript are not stylistically homogeneous. This has been frequently noted by researchers when describing other so-called 'commercial' manuscripts from Shiraz. It is as yet difficult to say whether this is the result of several artists working on each manuscript, or whether the clients who commissioned the work preferred books with a variety of types of illustrations, nonetheless produced by the same artist. One of the strengths of the illustrations in this manuscript is their range of colours: generally light without being bright, and structured around the rhythmic distribution of warm (mainly yellow and orange) and cold (blue and green) hues.

The miniatures in this manuscript are somewhat spoiled by later restoration attempts: the faces of almost all the figures have been 'corrected', and clothing details have been outlined in black paint. This most probably occurred in the nineteenth century, when the manuscript was placed in a new lacquer cover. (A.A.)

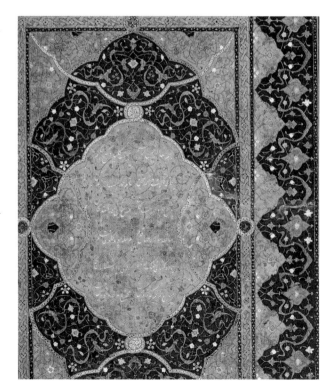

119

MANUSCRIPT OF *JAWAHIR AL-TAFSIR*
(*PEARLS OF INTERPRETATION*),
A COMMENTARY TO THE QUR'AN
(IN PERSIAN)

Author: Husein Wa'iz-i Kashifi; calligrapher: Abd al-Rahim

Iran, 986 A.H./1578-79 A.D.

36.1 cm x 24.5 cm

Origin: acquired in 1936 from the State Hermitage Library
(previously in the Lobanov-Rostovsky Collection)

State Hermitage Museum, inv. no. VR-938

Exhibitions: Turku 1995, no. 187; Adamova 1996, *Supplement*
no. 5, p. 356; St Petersburg 2004, no. 87

This manuscript is bound in black leather with a flap, and
contains 576 sheets, an expanded frontispiece on folios
1b-2a, ornamental designs on folios 149b, 365b and
527b, and gilt manuscript edges.

Almost the entire surface of the cover of the manu-
script is enhanced with gold embossing, while a central
medallion and the corners are decorated with headings
cut out of leather and laid over coloured backgrounds;
this type of cover is typical of Shiraz manuscripts from the
second half of the sixteenth century. The frontispiece is
also in Shiraz style, and spread over two facing pages, on
each of which there is a large medallion in the centre
which contains text, and two half-medallions filled with
designs. In addition to other motifs, the 'Chinese cloud'
pattern is frequently used over the entire surface of the
cover and the frontispiece. This motif is one of the most
typical aspects of the Shiraz style of manuscript decora-
tion (Uluc 2000, p. 184ff.). (A.A.)

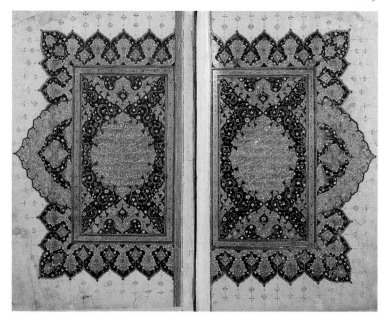

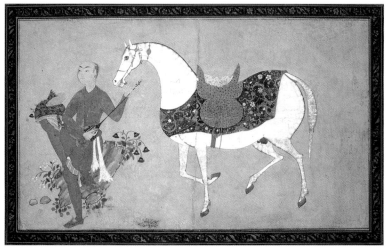

120

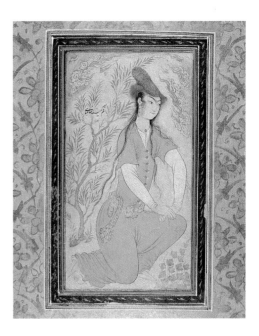

120
YOUTH WITH A LUTE

Artist: Sharaf al-Husayni al-Yazdi

Iran, 1003A.D./1594-95A.D.

Paper, gouache, gold; 12 cm x 20.8 cm (miniature)

Origin: acquired in 1924 from the Museum of the former Central School of Technical Drawing of Baron A. L. Stieglitz

State Hermitage Museum, inv. no. VR-701

References: Akimushkin–Ivanov 1968, p. 24, pl. 52; Veimarn 1974, illus. 180

Exhibitions: Adamova 1996, no. 8; London 2004, no. 68

Other works by the creator of this miniature (signed in the lower part, near the frame: 'amila fakir ... al-raji Sharaf al-Husayni') are unknown, although the fine quality of this work makes it possible to suppose that the artist worked in a studio in the Safavid capital, Qazvin, which at that time was attached to the court. The miniature depicts a character who is highly recognizable because of his clothes: a short kaftan with a cut in front, underneath which a tunic-like undergarment can be seen, as well as stockings and soft shoes. The figure is a foot-man, who would accompany his master on journeys. In the miniature the youth is waiting for his master, and spending the time making music, seated on a rock. The white horse, with light blue hooves and thin legs painted with henna, has brocade trappings and a gilt saddle covered with extremely fine designs, among which the traditional 'Chinese cloud' pattern is particularly noticeable. (A.A.)

121
GIRL IN A FUR HAT

Artist: Riza-i Abbasi, 1011A.H./1602-1603A.D.

Paper, gouache, watercolour, gilding; 14.8 cm x 8.4 cm (painting)

Origin: acquired in 1924 from the Museum of the former Central School of Technical Drawing of Baron A. L. Stieglitz

State Hermitage Museum, inv. no. VR-705

References: Stchoukine 1964, pl. XXXIIa; Akimushkin–Ivanov 1968, pl. 61; Veimarn 1974, illus. 181; Canby 1996, cat. no. 39

Exhibitions: Adamova 1996, no. 14; London 2004, no. 73

This tinted drawing is the earliest of the known and dated works of Riza-i Abbasi, a famed artist of the Isfahan school, and signed: 'painted by the meek Riza-i Abbasi. 1011' (1602-03). Indeed, this is one of the best female images in the work of Riza-i Abbasi, or in Iranian painting as a whole. There exists a long series of works depicting a girl resting on one knee. Sometimes the figure portrayed is referred to as a youth, despite the long locks of hair tumbling over his (or her) shoulders. The picture is meant to be the visual personification of an image from poetry, although the image frequently remains vague in the poetry itself. (A.A.)

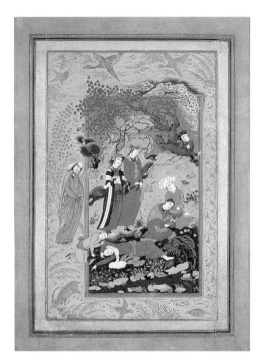

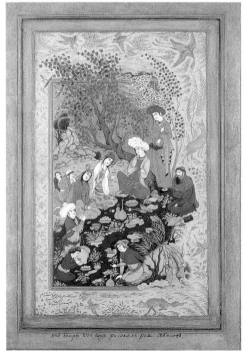

122
FEAST IN THE COUNTRY (DOUBLE PAGE)

Artist: Riza-i Abbasi, Iran, 1020A.H./1612A.D.

Paper, gouache, gilding; 26 cm x 16.7 cm (sheet on right); 26.2 cm x 16.5 cm (sheet on left)

Origin: acquisition unknown

State Hermitage Museum, inv. nos. VR-740/I, VR-740/XVIII

References: Akimushkin–Ivanov 1968, pls. 59-60; Stchoukine 1964, pls. XXXIII-IV; Veimarn 1974, illus. 183, 184; Canby 1996, no. 55

Exhibitions: Stockholm 1985, p. 171, no. 54, illus. on p. 173; Adamova 1996, no. 15; Amsterdam 1999, no. 89; St Petersburg 2000, no. 94; London 2004, nos. 74, 75

This composition contains multiple images, spread across two adjacent sheets: a royal youth, surrounded by his retinue, and feasting in a country setting. This is justly considered to be one of the best works by Riza-i Abbasi. It is possible that these two miniatures comprised the frontispiece of a manuscript or album that has not survived. Both halves of the double page are signed by the artist at the bottom, in the decorated borders. On the right side of the double page, at the very bottom, there is a Russian inscription on the card backing (a Russian translation of the Persian inscription) which, judging by the handwriting, was made no later than the eighteenth century. On the reverse side of both sheets, a Persian stamp has been applied, with the date '1171/1757-58'. It appears that the sheets entered Russia no earlier than the second half of the eighteenth century.

In comparison to other works by Riza-i Abbasi, the double page is unusually bright, and has a unique range of colours based around the combination of yellow/brown and blue/purple hues. The sonority and diversity of the colour combinations are the main tools used here to create a cheerful and festive mood, while the strict rhythm of all the coloured areas ties together the figures and other elements of the composition. (A.A.)

123

EUROPEAN-STYLE LANDSCAPE (see next page)

Artist: Ali-Quli ibn Muhammad

Iran, 1059A.H./1649A.D.

Paper, gouache; 9 cm x 12 cm (miniature)

Origin: acquisition unknown

State Hermitage Museum, inv. no. VR-950

Reference: Gyuzalyan 1972, pp. 163-69

Exhibition: Adamova 1996, no. 24

As established by L.T. Gyuzalyan, this miniature was copied by Ali-Quli – the artist's signature, 'rakam-e kamine Ali-Quli ibn Muhammad 1059', is located on a rock in the foreground – from an engraving published by Marc and Aegidius Sadeler, the Dutch engravers, which in turn was originally taken from a painting by Roelandt Saverey, a landscape and animal artist famous in the seventeenth century [see cat. no. 124]

The rural setting depicted in the miniature, with houses, a windmill and a bridge over a river, also includes a number of figures absent in the original engraving. For example, a villager carrying a bag on his back can be seen hurriedly following a donkey over the bridge; elsewhere two dogs have been added. Of particular interest are the addition of a cross to the roof of the house on the right, and the figure of a wild boar in the bottom right-hand corner, apparently added to make the landscape more 'European' in the eyes of the artist. (A.A.)

124

TYROLEAN LANDSCAPE (see next page)

Artist: Roelandt Saverey (1576-1639)

Engraver: Aegidius Sadeler (c.1570-1629)

Publisher: Marc Sadeler (1614 to after 1650)

Incision etching technique; 15 cm x 21.5 cm

Origin: acquired before the 1820s (part of the so-called 'Main Collection' of Graphic Arts in the Imperial Hermitage)

State Hermitage Museum, inv. no. OG-144131

References: Nagler 1996, p. 1063, no. 3779; Prague, 1988, pp. 418-19

This engraving, based on an original by Roelandt Saverey in the early seventeenth century, is a typical example of Mannerist landscape painting, a tradition developed by artists working for the Prague court of Rudolph II, the Holy Roman Emperor, who brought together an international group of artists from Italy, Flanders, the Netherlands and Germany. The Sadeler family, who were painters, engravers, draughtsmen and publishers, played an important role in Prague as a centre for the arts – which included no less than Roelandt Saverey, one of the creators of modern European landscape painting. A painter, engraver and draughtsman, Saverey was born into a family of Flemish migrants in the Netherlands, received an art education in Amsterdam, travelled widely in Europe, and worked for the courts of Emperors Rudolph II and Matthias from 1603 for about ten years. He mostly worked in landscapes, townscapes and animal painting. Like many other artists from the relatively flat Netherlands (for example, Allart van Everdingen, Herman Saftleven the Younger and Jacob van Ruisdael), Saverey painted mountain views with enthusiasm. He had the opportunity to study and sketch during his travels in the Tyrol and in the area previously known as Czechoslovakia. (R.G.)

133

123

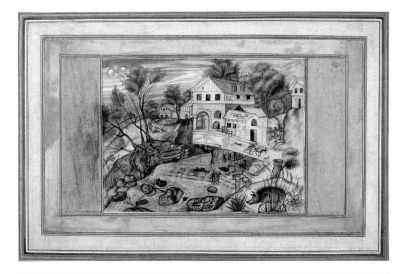

125

124

126

125

MONKEY RIDING A BEAR

Illustrator: Muhammad Ali, mid-17th century

Paper, gouache; 16.5 x 8.9 cm (miniature)

Origin: acquisition unknown

State Hermitage Museum, inv. no. VR-948

Exhibition: Adamova 1996, no. 26

The creator of this drawing, Muhammad Ali (his signature, 'mashakahu Muhammad Ali Musavvir', is located bottom left, the last few letters obscured by the frame when mounted onto the album page) was a famous Isfahan painter, and his dated works were produced in the mid-seventeenth century. Many were produced using the grisaille technique, including this piece in the State Hermitage Collection. A mirror image of the Hermitage's miniature, again with the signature of Muhammad Ali, is also known (Binyon, *et al.* 1933, pl. CX A, no. 366). Further works are known which depict a monkey riding a goat (see Grube 1962, no. 109a; Robinson 1966, p. 62, fig. 12), or a lion (Robinson 1992, no. 273; Atil 1978, no. 26). In describing the drawing 'Monkey riding a Lion' by Mu'in Mussavir, E. Atil suggested that the painting depicted animals that had been specially tamed by the artists to perform. The monkey riding on the back of the lion is wearing a dervish's hat, and carries a dervish's rod or lance in his paw. The true meaning of these images, which are patently interconnected, is not yet clear, although the same themes were explored by the most renowned artists, such as Riza-i Abbasi, Mu'in Musavvir and Muhammad Ali, suggesting that such images were highly popular during the seventeenth century. (A.A.)

126

LACQUER BOOK-STAND (see page 120, detail opposite)

Iran, 17th century

Wood, lacquer design; 58 cm x 20 cm

Origin: acquired in 1924 from the Museum of the former Central School of Technical Drawing of Baron A. L. Stieglitz

State Hermitage Museum, inv. no. VR-184

References: Veimarn 1974, illus. 216

Exhibitions: Adamova 1996, no. 37; St Petersburg 2000, no. 326

The outer sides of the stand are decorated with popular Persian themes – girls in a garden, a married couple, dervishes, and hunters on horseback – painted in bright colours and gold on a black background. The range of colours and its bright decorative quality suggest links to lacquer work of the sixteenth century, where decorative motifs and even scenes with multiple characters appear to dissolve into the scrolling ornament, forming one homogenous design. The landscape elements are painted in brown, red and green, and the tree trunks, leaves and flowers are additionally outlined with a gold trim – a technique which enhances the decorative effect and dates back to lacquer painting of the sixteenth century.

There is no date on the stand, but an important aspect for dating the work is the stylistic similarity of the painted scenes to the works of Riza-i Abbasi in the second half of the seventeenth century. Moreover, the clothes of the characters, especially the headwear, can be dated to the 1630s or 1640s. (A.A.)

128

127 (left)
129 (right)

127
QALAMDAN (PEN-CASE)

Iran, end of 17th century

Papier mâché, painting, lacquered; 23.3 cm x 3.8 cm x 3.5 cm

Origin: acquired in 1924 from the Museum of the former Central School of Technical Drawing of Baron A. L. Stieglitz

State Hermitage Museum, inv. no. VR-125

References: Ivanov 1974, pp. 56-59; Busson 1976, p. 133

Exhibitions: Stockholm, 1985, p. 150, no. 19; Adamova 1996, no. 38

This qalamdan or pen-case is decorated with a portrait of a young European in armour, surrounded by a frame of flower and plant motifs, in gold against a black background. A similar portrait (a miniature on paper) can be found in the Guimet Museum, Paris, and has been known to researchers of Persian painting for a long time (Martin 1912, vol. II, pl. 172). A. Ivanov has suggested that both the miniature and the qalamdan painting depict Louis XIV in his youth, and that both works were copied from the same original, by the same artist – Ali Quli beg Jabbadar, who was famous in the second half of the seventeenth century, and whose name is written on the miniature at the Guimet Museum. In addition, the image on the qalamdan was clearly not painted directly onto the box; most likely a miniature on paper was cut down to size and glued onto the *papier mâché* case for decoration. Undoubtedly, as in the miniature at the Guimet Museum, the arms were originally outstretched in front, the right hand holding a staff, and a luxurious bow tied at the figure's back. Examination of the item under a microscope has shown that the miniature portrait and

the decorative design were not created at the same time.

All known works by Jabbadar, signed in his own hand, are miniatures on paper. (A.A.)

128
QALAMDAN (PEN-CASE)

Artist: Muhammad Ali ibn Muhammad Zaman, 1112 A.H./1700-01 A.D.

Papier mâché, painting, lacquered; 26.9 cm x 6 cm x 4.8 cm

Origin: acquired in 1924 from the Museum of the former Central School of Technical Drawing of Baron A. L. Stieglitz

State Hermitage Museum, inv. no. VR-126

References: Ivanov 1960.1, pp. 52-53; Adle 1980, fig. 12

Exhibitions: Stockholm, 1985, p. 150, no. 19; Adamova 1996, no. 41

This qalamdan is undeniably one of the masterpieces of Persian lacquer painting. The artist has achieved a remarkable unity of design between the decoration of the sides and the thematic design on the lid. The artist's signature, 'painted by Muhammad Ali, son of the late Muhammad Zaman. 1112' (1700-01), as noted by A. Ivanov, indicates that Muhammad Zaman, one of the most famous artists of the second half of the seventeenth century, died no later than the year 1701.

Like his father, Muhammad Ali painted miniatures on paper and on lacquer, working in the European manner.

A young man and a beautiful girl, dressed in Isfahani fashion of the end of the seventeenth century, are shown sitting against the background of a landscape, painted using the techniques of linear and aerial perspective. This is the earliest known work by Muhammad Ali. (A.A.)

129
QALAMDAN (PEN-CASE)

Artist: Zaman, 1120A.H./1708A.D.
Papier mâché, painting, lacquered; 24.5 cm x 4.3 cm x 3.5 cm
Origin: acquired in 1924 from the Museum of the former Central School of Technical Drawing of Baron A. L. Stieglitz
State Hermitage Museum, inv. no. VR-6
Exhibition: Adamova 1996, no. 42

The note above the head of the woman, at the edge of the painting, states 'Ya sahib az-zaman. 1120' (an epithet of the twelfth Shi'i Imam Muhammad al-Mahdi). It indicates the qalamdan was decorated by the artist Zaman in 1120/1708. The same Shi'i refrain was used in several works by Muhammad Zaman (died c.1700). Regarding the creator of this qalamdan, it is possible the same artist made the qalamdan in the Victoria and Albert Museum, London, dated 1126/1714 (*La Perse et la France* 1972, no. 79) and the qalamdan from the Historical Museum of Bern, dated 1161/1748 (Robinson, 1970, p. 47). (A.A.)

130
QALAMDAN (PEN-CASE)

Iran, mid-18th century
Papier mâché, painting, lacquered; 23.7 cm x 4.3 cm x 3.4 cm
Origin: acquired in 1924 from the Museum of the former Central School of Technical Drawing of Baron A. L. Stieglitz
State Hermitage Museum, inv. no. VR-124
Exhibition: Adamova 1996, no. 47

This qalamdan depicts the 'Adoration of the Magi'. The central figures are the Holy Mother and the Divine Child, both with haloes, which are rare in Persian lacquers. Mary and Jesus, as well as the figures to their left and right (the kneeling youth, shepherd with a herd of swine, the old men, the women and the angel) appear against a mountainous background and European-style buildings.

On the sides of the qalamdan, various smaller scenes are shown against a landscape in the background; one scene shows an old man and a youth in Indian clothes, common in lacquer work of the eighteenth and nineteenth centuries. (A.A.)

131
MIRROR CASE (see next page)

Iran, second half of 18th century
Papier mâché, painting, glass, lacquer design; 17 cm x 12.5 cm
Origin: acquired in 1924 from the Museum of the former Central School of Technical Drawing of Baron A. L. Stieglitz
State Hermitage Museum, inv. no. VR-26
Exhibition: Adamova 1996, no. 48

On the case lid is an image of the Madonna, standing on an elevation in front of three kneeling figures. To the rear is an angel, standing with arms crossed over the chest. Perhaps the most striking aspect is that the Madonna and angel are depicted in poses typical of compositions showing the Annunciation from the Italian Renaissance and later. However, the angel is standing apart and looking into the distance, with no connection to the other figures; the scene as a whole is not a reproduction of a specific European image, but a composition of figures borrowed from several different sources. The theme of the Holy Family with saints and angels was popular in Persian lacquers, not only in the second half of the eighteenth century, but in the nineteenth century as well. (A.A.)

132
LACQUER CASKET

Iran, 1190A.H./1776-77A.D.

Papier mâché, painting, lacquered; 47.3 cm x 33 cm x 21 cm

Origin: acquired in 1927 from the Museum Fund

State Hermitage Museum, inv. no. VR-141

Reference: Adamova 1972

Exhibition: Adamova 1996, no. 49

Two separate scenes are depicted on the lid of this casket, each symbolizing the Christian and Muslim worlds. Both are of teaching (or preaching). On the left is a Christian clergyman, and in front of him are kneeling figures (the same group as in the mirror; see cat. no. 131). On the right is a spiritual elder wearing a white *imamah* (turban), and a youth in Indian clothes. To emphasize the Christian character of the scene on the left, the artist has included numerous details and motifs, typically seen as Christian by Muslims: a herd of swine and a shepherd in European clothes, a candle, angels and European-style buildings. Conversely, the building with high, slender columns, a herd of sheep, and a shepherd

of Middle Eastern appearance are intended to reinforce the Muslim character of the scene on the right.

The two scenes are separated by a river with winding banks, crossed by a bridge, recognizable as the Allahverdi Khan bridge which connects Isfahan with its suburb, New Julfa, where Armenians have lived since 1605 after being settled there from Armenia by Shah Abbas I. This was also where almost all Christian missions built in Iran since the beginning of the seventeenth century were located. The miniature depicts Isfahan and New Julfa as embodiments of the Muslim and Christian worlds, apparently living in harmony. Certainly the appearance of a miniature with such images in the second half of the eighteenth century is not a coincidence. After the capture of Isfahan by the Afghans in 1722, New Julfa was abandoned. Catholic and other missions left Persia. The privileges of European and Armenian merchants were restored under Karim Khan Zand (1752-79), who made every effort to observe the policies of the Safavid rulers. Hence the theme here corresponds to the ideas and moods of the time.

The Indian clothes worn by the youths in the scene on the right reflect the enthusiasm of contemporary painters for Indian (Mughal) painting. (A.A.)

133
FLOWERS

Artist: Muhammad Mahdi; signature, bottom left: 'work of the slave Muhammad Mahdi'

Iran, 18th century; paper, gouache; 31 cm x 20.5 cm

Origin: acquired in 1924 from the Museum of the former Central School of Technical Drawing of Baron A. L. Stieglitz

State Hermitage Museum, inv. no. VR-548

Exhibitions: Adamova 1996, no. 51; St Petersburg 2000, no. 269; London 2004, no. 96.

Paintings and miniatures depicting flowers appeared in the work of seventeenth-century Persian master craftsmen, possibly influenced by art from Mughal India and Western Europe. Such images became particularly popular in eighteenth and nineteenth-century Iranian art, when they were one of the main themes in miniatures, both on paper and in lacquers. The outlining of petals and leaves with a gold line is a characteristic typical of lacquer painting in the eighteenth century. Similar flowers can be seen on eighteenth-century fabric (Hermitage inv. no. VT-1649; Adamova 1996, p. 273), where the border design contains the inscription 'made by Muhammad Mahdi'. If this is the same artist, then the custom must have been for fabrics to carry the name of the creator of the design, rather than the weaver. (A.A.)

134
FLOWERS

Artist: Shaykh; signature: 'humble Shaykh'

Iran, 1191A.H./1777A.D.; paper, gouache; 30.3 cm x 20.5 cm

Origin: acquired in 1924 from the Museum of the former Central School of Technical Drawing of Baron A. L. Stieglitz

State Hermitage Museum, inv. no. VR-551

Exhibitions: Adamova 1996, no. 52; St Petersburg 2000, no. 270; London 2004, no. 97

These two miniatures [cat. nos. 133-34] clearly formed a two-page spread in an album (since lost): they are of almost identical size, prepared as facing album pages, and the miniatures themselves, although depicting different species of flowers, are painted in the same style. This is a form of 'fantasy' art, a composition made up of different flowers growing from the same root. They are spread over the paper as in a herbarium, with the decorative style being the main principle of design. (A.A.)

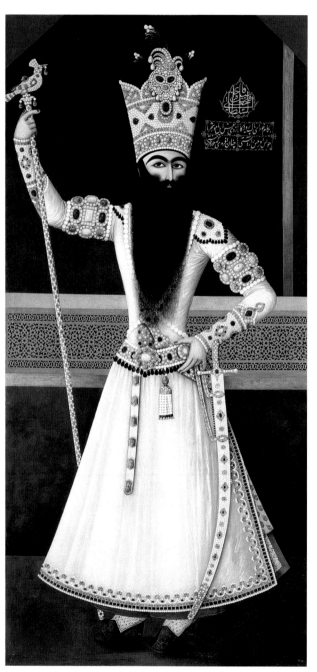

135

PORTRAIT OF FATH ALI SHAH

Artist: Mihr Ali

Iran, 1224A.H/1810A.D.

Oil painting on canvas; 253 cm x 124 cm

Origin: acquired in 1932 from Gatchina Palace Museum

State Hermitage Museum, inv. no. VR-1107

References: Amiranashvili 1940, pl. XXXIV; Adamova 1971;
Raby 1999, pp. 11-14

Exhibitions: Adamova 1996, no. 64; London 1998, no. 39;
St Petersburg 2000, no. 327; London 2004, no. 105

The name of the subject of this painting is written in the
medallion and the box cartouche underneath – 'Sultan
Fath Ali Shah Qajar' – together with a poem dedicated
to the portrait (see Adamov 1996, p. 287). In the bottom
left-hand corner is an inscription stating that the image,
executed by the hand of the insignificant Mihr Ali, was
approved by the Shah. This portrait is the earliest image
of Fath Ali Shah standing, holding a sceptre, and
crowned by the figure of a hoopoe (the messenger bird of
King Solomon, as mentioned in the Qur'an) in his hand.
Here the Shah is dressed in luxurious vestments: a huge
crown with three plumes made from heron feathers (for
the Qajar dynasty, the heron is an attribute of royalty), a
silk dress, sabre, belt, *bazubands* (armbands) and sceptre,
are bejewelled with precious stones. (A.A.)

136
PORTRAIT OF FATH ALI SHAH

Artist: Mihr Ali

Iran, 1229A.H./1813-14A.D.

Oil painting on canvas, 253 cm x 118 cm

Origin: acquired in 1932 from Gatchina Palace Museum

State Hermitage Museum, inv. no. VR-1108

References: Amiranashvili 1940, pl. XXXV; Adamova 1971

Exhibitions: Adamova 1996, no. 64; London 1998, no. 40

In the medallion on the right, at the level of the subject's face, is the name of Fath Ali Shah, and the box cartouche contains a poem dedicated to the portrait. This version is one of two that appear in other Mihr Ali portraits of Fath Ali Shah [see Adamova 1996, p. 289]. The artist's signature is at the bottom left-hand corner: 'the work of the insignificant slave Mihr Ali, in the year 1229.'

The Shah is portrayed sitting on a carpet, against the background of a window in which can be seen a landscape: a plain leads into hills on the horizon, with a slender tree to the left, apparently lit by moonlight. The red colour of the Shah's dress, and the white-gold hues of the crown, contrast well with the cold hues of the landscape. Mihr Ali painted several portraits of this type, of which the Hermitage's version, made in 1229/ 1813-14 is the most recent. (A.A.)

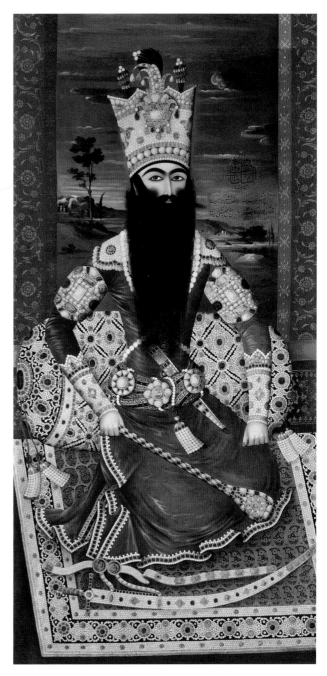

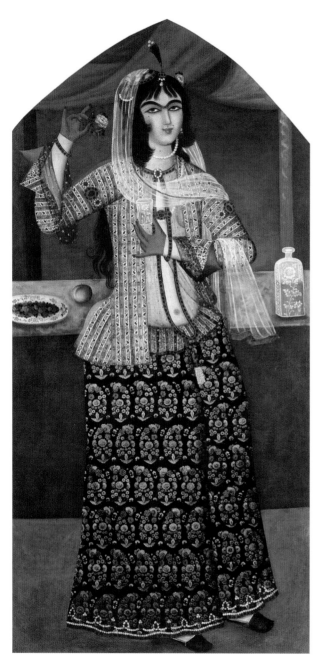

137
WOMAN WITH A ROSE

Iran, first quarter of 19th century

Oil painting on canvas; 184 cm x 94 cm

Origin: acquired in 1924 from the Museum of the former Central School of Technical Drawing of Baron A. L. Stieglitz

State Hermitage Museum, inv. no. VR-1113

References: Amiranashvili 1940, pl. XXVI; Adamova 1972a

Exhibitions: Adamova 1996, no. 67; London 1998, cat. no. 56; Amsterdam 1999, St Petersburg 2000, no. 329

The stylistic aspects, as well as the clothes of this woman, make it possible to date this picture to the beginning of the nineteenth century. Over the translucent shirt (*pirohan*) is a blouse (*nitmane*) made from typical Iranian, striped fabric and broad *shalwars*, decorated with a repetitive pattern of stylized betel leaves (*buta*). The woman is wearing a small, round hat and a so-called *jiga* on the crown of her head, as well as a pearl, hung below the chin on a thread.

Such pictures were made specifically to decorate the walls of the grand halls of the Shah and noblemen. This purpose behind the picture is confirmed by the pointed shape of many of these paintings, and an obligatory open window in the background, through which a blue sky can be seen (an apparent desire to create the illusion of windows in the walls of the grand halls). (A.A.)

138
PORTRAIT OF ABBAS MIRZA

Iran, c.1820

Paper, gouache, gold; 23.8 cm x 14.5 cm (miniature)

Origin: acquired in 1924 from the Museum of the former Central School of Technical Drawing of Baron A. L. Stieglitz

State Hermitage Museum, inv. no. VR-666

Exhibitions: Adamova 1996, no. 78; London 2004, no. 98

The identity of this subject, suggested in the Russian inscription on the reverse of the sheet ('pr[ince] Abbas Mirza, son of Fath Ali Shah'), would appear to be correct. Upon comparison with famous portraits of Abbas Mirza (Maslenitsina 1975, illus. 124; Adamova 1996, no. 77), an undeniable similarity can be found, which allows us to identify this work as a portrait of the Crown Prince Abbas Mirza. The dress style with rich decoration of the chest and shoulders – precious stones and pearls sewn into the fabric – also matches. In the Hermitage miniature, the Qajar prince, apart from the usual attributes indicating the subject's place in the ruling dynasty (pearl pendants, bands of precious stones hanging from the belt, sabre and dagger) is also holding a sceptre – the same sceptre found in the work by Allah-Verdi Afshar, the court painter of Abbas Mirza (Maslenitsina 1975, illus. 124). The manner in which the clouds are portrayed, and the method of casting shadows over clothes, suggest that this portrait is the work of the court painter Abbas Mirza, who died in 1833, a year earlier than his father. (A.A.)

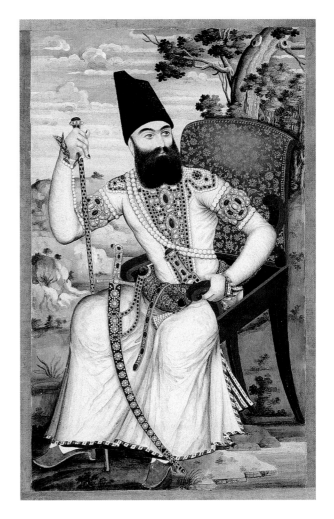

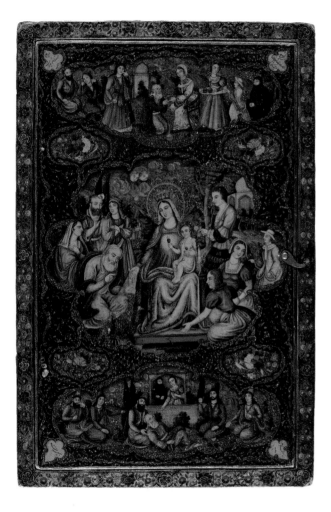

139
MIRROR CASE

Muhammad Isma'il

Iran, 1276A.H./1859-60A.D.

Papier mâché, lacquer design; 30.5 cm x 20.2 cm

Origin: acquisition unknown

State Hermitage Museum, inv. no. VR-35

Exhibitions: Adamova 1996, no. 89

Both external sides of the case are decorated with numerous small scenes: the Holy Family with saints and angels (in the central cartouches), illustrations describing the legend of Sheikh Sanan and the Christian woman (in the upper and lower cartouches), and flowers and birds. The inside of the lid is decorated with a woman on horseback, in European riding dress, and a young man dressed as a European craftsman, holding a stonemason's hammer in one hand (this may be a highly-Europeanized version of the theme 'Shirin visits Farhad', a traditional subject of Persian painting). There are eleven cartouches on each side of the case, in an ornate configuration and framed by a gilded, leafy design, imitating baroque ornamental motifs. The combination of traditional and European themes in one work, of both 'Muslim' and 'Christian' material, is also typical of other works by this same master, one of the most unique painters of his time.

The inscription on the outside of the lid, in the corners, declares that the case was commissioned by Ihtisham ad Dawla, the Qajar Prince Abd al Ali Mirza, son of Farhad Mirza and grandson of Abbas Mirza.

The work of Muhammad Isma'il is described in a number of sources (see Robinson 1967; Karimzade 1991, p. 68; and Ekhtiar 1990). (A.A.)

144

140
PORTRAIT OF MAN WITH A BOOK

Artist: Aqa Bala

Iran, c.1870

Paper, watercolour; 20.5 cm x 15.5 cm (miniature)

Origin: acquired in 1933 from the Leningrad Institute of History and Linguistics

State Hermitage Museum, inv. no. VR-692

Exhibitions: Adamova 1996, no. 91

The artist's signature (in a decorative cartouche at the bottom) states: 'executed by slave of the court, Aqa Bala. 128[?].' The last figure is erased, but the miniature was created between 1280/1863-64 and 1289/1873. The term 'slave of the court' indicates that the artist worked at the court of Nasir ad-Din Shah. Works by this artist (almost entirely portraits) were created in the 1860-80s. In this particular portrait – of a man with a book – the desire to emphasize the subject's state of enlightenment is evident. It is possible that the painting depicts a member of the Iranian Enlightenment movement, which was heavily influenced by the cultures of Western Europe and Russia. The image is enclosed in an oval, a composition typical of many painted and graphic portraits in Europe and Russia in the eighteenth and nineteenth centuries. The border, painted with gouache, appears to imitate the silver mount of European miniature portraits. (A.A.)

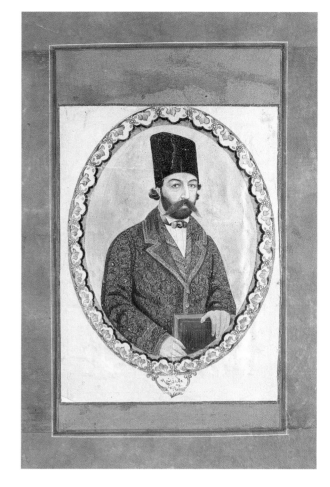

141

BOX

Iran, second half of 19th century

Wood, painting, lacquer design; 32 cm x 20.5 cm x 14.5 cm

Origin: acquired in 1925 from the Modern Applied Arts Department

State Hermitage Museum, inv. no. VR-139

Exhibitions: Adamova 1996, no. 97; St Petersburg 2004, no. 224

The circles and medallions, into which the images of flowers, birds and butterflies are inscribed, and which decorate the lid and sides of the box, are framed by an ornate baroque border. The box is part of a large group of lacquer artefacts in the Hermitage Collections, decorated with ornamental compositions, as well as the images of flowers, birds and butterflies. The dates of these pieces mainly cover the period from the 1870s to the beginning of the twentieth century. Such decorative lacquer painting, predominantly on boxes and small qalamdans, is usually executed with exceptional care, similar to the care required in jewellery work. It is not surprising that some of these pieces, including this box, originate from the collection of the famous St Petersburg jeweller, Peter Carl Fabergé. (A.A.)

142

PLAYING CARDS (SEVEN ITEMS)

Iran, 19th century

Papier mâché, painting, lacquer design; 6.3 cm x 4.3 cm (max. size)

Origin: acquired in 1925 from the Museum of the former Central School of Technical Drawing of Baron A. L. Stieglitz

Exhibition: Adamova 1996, no. 107

Playing cards became common in Iran in the eighteenth century. Packs of cards usually consisted of five series, each of which contained four identical cards: *shah* (king), *bibi* (dame), *kuli* (dancer), *as* (lion) and *sabraz* (soldier). (A.A.)

FATH ALI SHAH RIDING A HORSE
HORSEMAN FIGHTING A LION

Origin: acquired in 1925 from the Museum of the former Central School of Technical Drawing of Baron A. L. Stieglitz

State Hermitage Museum, inv. nos. VR-362, VR-376

WOMAN WITH JUG
WOMAN SITTING ON ARMCHAIR WITH CHILD ON HER KNEES

Origin: purchased in 1945

State Hermitage Museum, inv. nos. VR-1040, VR-1041

FATH ALI SHAH ON THE THRONE
TWO DANCERS IN PERSIAN CLOTHES
LION AND SUN

Origin: acquired in 1935 from the Museum Archive

State Hermitage Museum, inv. nos. VR-231, VR-221, VR-232

VR-362

VR-376

VR-1040

VR-1041

VR-231

VR-221

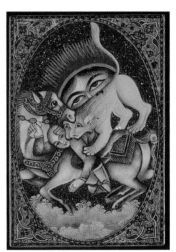

VR-232

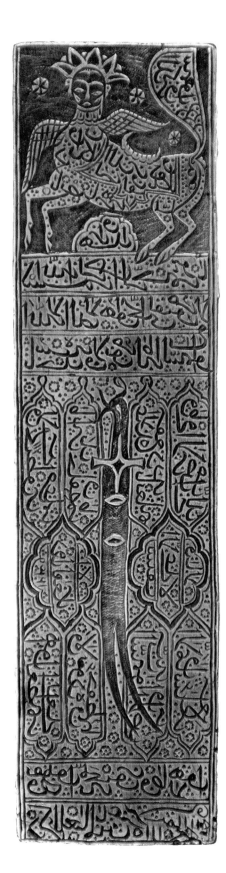

Persian Metalwork
(sixteenth to nineteenth centuries)

Anatoly A. Ivanov

The second stage in the art of Iran (see essay on 'Persian Art', page 70) began around the mid-sixteenth century and ended in the mid-eighteenth century. Formal changes can now be seen in the ornamentation of the background of inscriptions; it was done in hatching. There was a kind of transitional period from the mid-sixteenth century until its end, which is evident in some items of the period with backgrounds that incorporated both hatching and cross-hatching.

The metal used in metalwork remained the same, however: bronze (brass) and copper. But by the second stage the appearance of steel products can be seen (chiefly weapons and door ornaments), although these should be left to one side in a general survey, as research is still at data collection stage. We cannot speak of gold and silverware of the sixteenth to eighteenth centuries: they simply have not survived in any number. (Isolated items of the period cannot as yet provide us with a true sense of development. Our knowledge of precious objects comes only from the memoirs of envoys of Russia and Europe, and other travellers from these countries).

The art of inlay disappeared entirely towards the beginning of this period. New types of metalware came into being with the start of this second stage, but only 36 types have survived (far less than in the first stage).

However, Persian inscriptions became more numerous at this stage, with the appearance of sixty new texts unknown during the first stage; there were more than twenty texts used at both stages. Basically only two types of Arabic inscriptions were used: the poetry in honour of Ali and the blessings of Shi'i Imams, which was introduced under the Safavids. The exceptions are the many excerpts from the Qur'an found on magical incantation bowls.

A new type of script also came into vogue in this second stage of later Iranian metalwork: *nasta'liq*. Inscriptions in the cartouches were again written in lines (as on fourteenth-century items), and spiralling, curly stems began to appear in the background (although they were treated differently to the fourteenth-century examples), or there may have been individual plant-like designs.

MOULD FOR AMULETS
(see page 152)

Meanwhile, products of the second stage, especially in the seventeenth century, began to depict people and living beings, a subject virtually absent in the art of the first stage. All these different features of ornament allow us to say that a new stage of Iranian metalwork appeared in the sixteenth century, although there were fewer changes at this time than at the beginning of the first stage (in the second half of the fourteenth century).

The onset of changes in metal production began to be felt in approximately the last quarter of the seventeenth century, when the letters of the inscriptions started out in broad ('fat') flourishes and the actual inscriptions once again began to fill the allocated space in full.

We know of comparatively few bronze (brass) objects dated to the first half of the eighteenth century, but all the same we may consider that the end of the second stage took place around the mid-eighteenth century (a more precise dating cannot be given). Objects which can be dated to the second half or the end of the eighteenth century have a completely different form of background decoration, ornamentation and inscription; hatching disappeared and punching appeared in the shape of small circles. It was precisely this punching that was to be used to elaborate the background on all copper (in the first instance) and bronzeware of nineteenth-century Iran.

In the mid to late eighteenth century the forms of vessels changed again, as at the beginning of the first and second stages. We can successfully date about eighty different types of ware to the seventeenth and early eighteenth centuries, but only ten of them survived to the nineteenth century.

The very same thing happened with the inscriptions. Of the many (over eighty) texts on seventeenth to early eighteenth-century products, we can thus far identify only eleven on nineteenth-century ware.

The basic script remained *nasta'liq*, as in the second stage, but it lost the character of fine calligraphy. The script on nineteenth-century ware was very untidy, inscriptions do not always fill the cartouche, and words sometimes remained unfinished.

It is very interesting that the poems and blessings for Shi'i Imams of the preceding stage are not used on nineteenth-century ware (with the exception of the magical bowls). Shi'ism remained the main Islamic sect in Iran, and the disappearance of Shi'i inscriptions on nineteenth-century objects of daily use is surprising.

With regard to decoration on nineteenth-century objects we see new plant designs (above all flowers) and a mass of portrayals of people and fantastical beings. Thus the background detail, shapes and inscriptions all reveal a sharp break with tradition. It is generally clear that in Iran of the second half of the eighteenth century the second stage of metalware development was coming to an end, and the next one, the third, was beginning, but the study of this period is in its infancy. When we compare the technical level of workmanship of stages two and three, we have to recognize the start of a steep decline in copper workmanship. The same can be said of other groups of Iranian applied art at this time.

Apart from the problem of establishing exact stylistic periods in the historical development of Iranian metalware, there is also the problem of determining the precise centres of production for the different historical periods from the fourteenth to twentieth centuries. It has to be stated at the outset that of over eight hundred known examples from the period, not one gives the precise place of manufacture. On circumstantial evidence we can assign a group of little bronze (brass) jugs to the second half of the fifteenth to first third of the sixteenth centuries. They are all similarly shaped and decorated

with gold and silver inlay. These have been quite correctly linked to the Khurasan province. In the same province and at the same period, Shir Ali Muhammad Dimashqi's workshop was active (Ivanov 1969, no. 79; Komaroff 1992, pp. 101-105, 219-22).

In actual fact, none of the researchers into Iranian art has dealt in depth with the question of establishing places of origin. The solution proposed by J. Allan as to the origin of the copper and bronze artefacts of this same period (with a large plant pattern) being the Western Iran area, is highly problematic and calls for further proof (cf. Allan 1991).

For the later period (mid-sixteenth to early nineteenth centuries) we cannot highlight any significant groups of products that could be related to a particular town or territory (on historical grounds we know of the existence of the Court 'Misgarkhane', or workshop of copperware, in Isfahan, the Safavid capital, but it is impossible to categorize its ware).

Seventeenth-century metalware exists that has poetry (*rubai*) inscribed on it, which speaks of the ritual procession around the tomb of Imam Riza in Mashhad (Ivanov 2003, pp. 630-33). However, there is no stylistic unity in the decoration of this ware, and one must doubt whether it was all made in the one centre.

The craftsmen's names on the objects give little information, as the written sources provide nothing to go on. But the few names of copper craftsmen that have come down from the sources (most often from *tazkira*, poetical analogies) do not help to localise the products, as all the anthologies provide are poetic pseudonyms – *takhallus*. Pseudonyms could scarcely be used on copperware, and we have been unable to discover the actual poems of the coppersmith–poets on them.

Meanwhile, European and Russian travellers and diplomats mention in their works and reports the production of metalware in Isfahan, Shiraz and Kashan, but it is impossible to single out these items from the mass of surviving material.

A. S. Melikian-Chirvani poses the question of copper and bronzework in eighteenth-century India. Possibilities certainly exist for this research. For example, on the base of a lamp in Mashhad Museum is an inscription that states it came from Lahore, India. There is a date on it: 946/1539-40. On the lamp-base the background is cross-hatched, as on Iranian work of the first stage, but its plant decoration is quite different.

Some years ago the State Hermitage Museum bought the knob finial of a religious standard (*alam*), made in India, judging by the inscriptions, in 1035/1625-26. The background on the finial is hatched, as on the Iranian ware of the second stage, but the hatching is not always in one direction. There is not much plant ornamentation on the finial and it is difficult to compare it with Iranian decoration. An investigation should be made into the similarities and differences that undoubtedly existed between Iranian and Indian bronze (brass) ware of the sixteenth to seventeenth centuries, and the author has thus far made a comparative study of Iranian and Indian items of the nineteenth century.

The history of the development of Iranian metalware, principally of bronze (brass) and copper, has been studied only in outline so far, although the line of study pursued has been encouragingly fruitful. Further effort is required in the future to study an even greater number of items, in order to verify the conclusions reached at the beginning of this century.

Persian Metalwork

143
LAMP-STAND

Iran, last quarter of 16th century

Bronze (brass), casting, engraving; 43 cm (height)

Origin: acquired in 1925 from the Museum of the former Central School of Technical Drawing of Baron A. L. Stieglitz

State Hermitage Museum, inv. no. IR-2209

Reference: Ivanov 1960.2, pp. 337-45

Exhibition: St Petersburg 2004, no. 130

Not in exhibition

In the mid-sixteenth century, possibly in the second half of the century, a new type of lighting apparatus appeared in Iran: the lamp or torch, consisting of a hollow, tall stand (base) and the torch itself. The base of such lamps was usually façeted, but sometimes decorated with winding ornamentation. The earliest known example has a definite date of manufacture of 946A.H./1539A.D. – it is held in the museum at the shrine of Imam Riza in Mashhad – and was made in India by the craftsmen Iskander ibn Shukrallah and Davud Rihtgar. The Hermitage has two bases for such lamps, heavily decorated with plant ornamentation, against a broad lattice design in the background. Such objects are linked to Iran from the first half of the sixteenth century, and their ornamentation differs greatly from ornamentation on the base of the lamp dated 946/1539.

On this lamp there are verses from the Bustan by Sa'di in *nasta'liq* script, in *mutaqarib* metre: 'I remember one night, when my eyes did not sleep, I heard how a moth told the candle: "I am in love [and] if I am doomed to burn up, [then] why must you weep and burn".'

In the upper part of the base there are verses by the poet Ahli Shirazi in *nasta'liq* script, in *hazaj* metre: 'Thanks to you I see by the lit candle people of noble mind. In all wise men I see a heart that looks to you.

You are the aspiration of the world, let no hair on your head diminish, for I see the world as a hanger-on on the tip of one of your hairs.'

On the lower part of the base are verses by Heyreti Tuni in *nasta'liq* script, in *mutjass* metre: 'When the heart [is full] of love for our idols, that burns my soul, [then] love every moment sears me with a different seal. I am like a butterfly before a candle, for if I charge forward, my wings and feathers will burn.'

The background of the ornamentation and inscriptions is a fine lattice, indicating that this lamp was made in the latter quarter of the sixteenth century. (A.I.)

144
CASKET

Iran, 1570-80s

Bronze (brass), casting, engraving; 15.8 cm (height)

Origin: acquisition unknown

State Hermitage Museum, inv. no. IR-2257 a, b

Exhibition: St Petersburg 2000, no. 139

The shape of this vessel, with its expanded upper part and the lower part narrowing towards the base, is virtually unique and has no comparisons among Iranian metalwork artefacts from the sixteenth or seventeenth centuries. The purpose of the vessel is unknown. It is possible, however, that this was a box used for storing valuables – a *hukka*, as in the verses by Hazif Shirazi, engraved into the upper part near the edge in *nasta'liq* script in *muzari* metre: 'The Sufi threw out his net and opened the *hukka*. He laid a foundation for a cunning and deceitful sky. Come hither, cup-bearer, for the fair woman is the idol of the Sufis – she hid before, but now she has once more emerged.'

It is extremely difficult to deduce the purpose of the vessels from the verses engraved on them; the word *hukka* is found on vessels in the verses of Abd ar-Rahman Jami, but these boxes have a different shape: a small, ball-like body and a lid (St Petersburg 2000, no. 331). Obviously boxes used to hold valuables could have had different shapes, and this vessel could also be a *hukka*. (A.I.)

145
BOWL
Iran, end of 19th to beginning of 20th centuries

Steel, gold, forging, engraving, embossing;
20.6 cm (diameter), 9.8 cm (height)

Origin: acquisition unknown

State Hermitage Museum, inv. no. VC-624

Published for the first time

The Eastern Department of the State Hermitage Museum holds an interesting collection of Iranian steel artefacts, decorated with gold and silver embossing. With the exception of a kashkul (dervish's bowl) with a falsified date of 1207A.H./1792-93A.D. (see Loukonine–Ivanov 1996, no. 253), none of these objects has ever appeared in print. Only in 2004 were six objects displayed at an exhibition in the Hermitage (see St Petersburg 2004, nos. 144-46 and 148-50).

A large bowl, also belonging to this group, is decorated on the outside surface, around the rim, with eight cartouches, containing imitations of inscriptions executed in so-called 'square Kufic'. The letters of these pseudo-inscriptions are decorated with gold. The cartouches are separated with four-leafed medallions and flower ornamentation. Below are twelve garlands of flowers. The contours of the garlands and flowers are decorated with gold embossing.

Inside the bowl, in the bottom, is a small circular medallion with flower ornamentation.

The bowl is, most likely, a typical example of work by Isfahan craftsmen in the beginning of the twentieth century [see also cat. no. 150]. (A.I.)

146
MOULD FOR AMULETS (see page 148)
Iran, 18th to 19th centuries

Bronze (brass), engraving; 5.8 cm x 21.5 cm

Origin: purchased in 2001

State Hermitage Museum, inv. no. IR-2337

Published for the first time/not in exhibition

Moulds of this type have failed to attract the attention of researchers. It is highly likely that they were used to print amulets (the narrow format may indicate that the sheet bearing text was rolled into a scroll and carried in a special case). On one side of the mould, the sword of Zulfakar and Buraq, the winged horse of Muhammad, are depicted; while the entire central space is filled with verse 256 from the second sura of the Qur'an. On the reverse side of the upper part, a rosette holds the names of Shi'i Imams in circular medallions along the edge and Arabic inscriptions which have not yet been deciphered. As the names of Shi'i Imams are listed here, it can be supposed that this is a tribute to an Iranian circle from the eighteenth to nineteenth centuries. (A.I.)

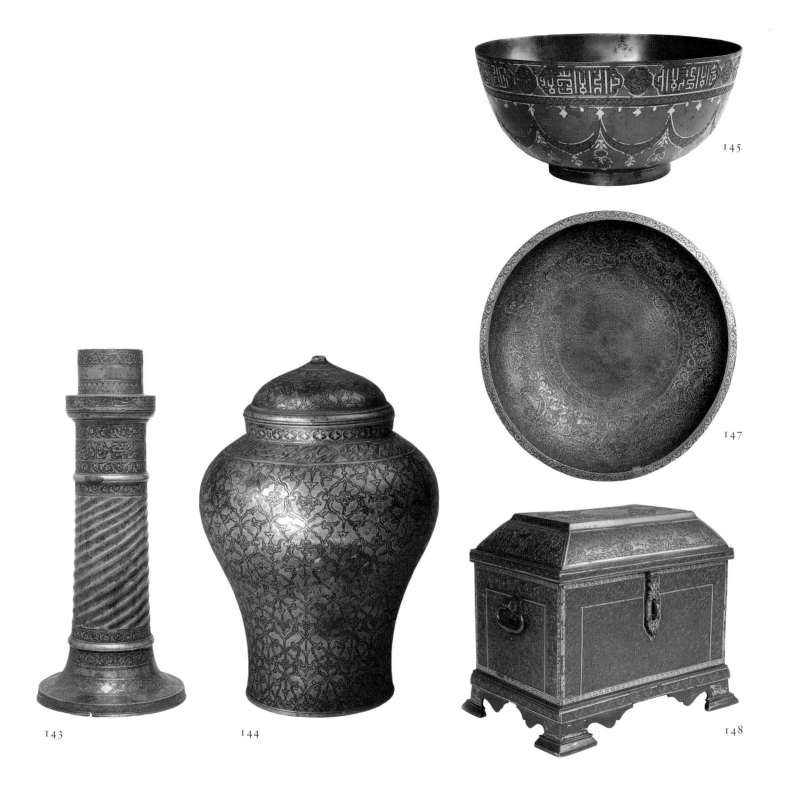

145

147

143 144 148

147
BOWL WITH HOLY VIRGIN

Craftsman: Muhammad Hakkak

Iran, 1259A.H./1843A.D.

Copper, tin, forging, engraving; 17.2 cm (diameter), 5 cm (height)

Origin: acquired in 1925 from the Museum of the former Central School of Technical Drawing of Baron A. L. Stieglitz

State Hermitage Museum, inv. no. VS-43

Exhibitions: St Petersburg 2004, no. 138

To date six works by this coppersmith are known, including three with precise dates (1243/1827, 1252/1836-37 and 1259/1843), although there is no information about his life or where he worked. The shapes and ornamentation of the majority of objects by this craftsman differ very little to those by his contemporaries.

However, this bowl does differ from others, in that the medallions on the outside twice portray the Madonna and Child, and once portray Palladia Athena (most likely). These are very unusual themes for a bowl, decorated with Persian verses and the images of beautiful women, servants, musicians and acrobats. The choice of decorative themes here probably reflects the interest shown by Iranian society in the 1840s in the art of European countries. (A.I.)

148
CASKET

Iran, end of 19th to beginning of 20th centuries

Steel, gold, forging, engraving and embossing; 20.8 cm x 14.3 cm, 18.2 cm (height)

Origin: purchased in 1925

State Hermitage Museum, inv. no. VS-873

Published for the first time

This casket has a lid, attached by two hinges and a hasp in the form of a loop, two decorative handles, and an oblong body standing on four short feet. The edges of the lid and the body are decorated with gold embossing. One large medallion and two small ones (without ornament), surrounded by various flowers, leaves and birds, decorate the top of the lid. The sloping edges of the lid display hunting scenes.

The designs used to decorate the four sides of the body are identical: a wide frame of flower ornament and birds on three sides, and a hunting scene within the frame (one such panel shows a hunt for wild animals, while dragon hunts are shown in the remaining three). The ornamentation on this casket is a typical product of Iranian applied arts from the end of the nineteenth and beginning of the twentieth centuries. (A.I.)

149
DOOR DECORATION

Iran, 17th century

Steel, carving; 35.8 cm x 24.5 cm, and 34.5 cm x 26.8 cm (max.)

Origin: acquired from the Museum of the former Central School of Technical Drawing of Baron A. L. Stieglitz

State Hermitage Museum, inv. no. VC-1080

Reference: Polovtsov 1913

Exhibitions: 'The Muslim East' 1925, pl. XIV; Kuwait 1990, no. 91; St Petersburg 2000, no. 4

The art of steel decoration has been developed in Iran since ancient times, although few examples of this art have survived to this day (primarily, weapons). We know that the art of decorating doors by attaching steel plates of different sizes and shapes, frequently decorated with quotations from the Qur'an, became widespread during the Middle Ages.

A good example of such decoration is this set of eight plates from the Hermitage Collection. Judging by the plant ornamentation and the background of inscriptions, these were made in the seventeenth century, but it is not known in which Iranian town they were made. The 24th verse from the eighth sura, and the 63rd verse from the

tenth sura, of the Qur'an, are carved onto the two large plates. The smaller plates bear the phrase: 'Oh He, glorified by his virtues', and 'Oh He, opener of doors.' (A.I.)

150
KASHKUL (BEGGAR'S BAG OR BOWL)

Craftsman: Haji Abbas

Iran, early 20th century

Steel, gold, forging, engraving, embossing; 21 cm x 12 cm x 9.5 cm

Origin: acquisition unknown

State Hermitage Museum, inv. no. VS-803

Published for the first time

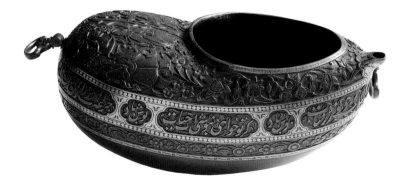

Beggar's bags or bowls were made from various materials. Many such surviving bowls were made from the halves of a special species of coconut (*coco-de-mer*), which grows on the shores of the Seychelles Islands, and whose shells are carried by sea currents through the Indian Ocean to the Persian Gulf and to Zanzibar (see Amsterdam 1999, nos. 73-75). This steel kashkul, made by Haji Abbas, is in the shape of one of these coconuts.

On the upper part of the kashkul two sheikhs are depicted sitting under a tree. One is smoking a hookah, while the other smokes a pipe. To the right and left of them are attendants; the attendant on the left is holding out to the sheikh something that is probably a kashkul (it appears that two more kashkuls are hanging from the branches of the tree). The remaining surface of the upper part is decorated with an incised ornamental flower design. On one side of the kashkul there is a small spout for drinking water, and at two ends ornate loops for a chain or string are attached. Below, on the side of the piece, gold bands decorated with circles surround cartouches containing verses of Persian poetry, separated by four-leafed medallions. In four of these the Persian refrain 'Be healthy!' has been carved; and in two others there is the craftsman's signature, 'Made by the pauper Haji Abbas' – in which the word 'Haji' is spelt incorrectly, with the wrong letter for 'Ha'. All the inscriptions are made in the *nasta'liq* script style. Further down there is another carved strip of incised flower ornament; and on the very bottom are three large medallions, formed from fine gold threads.

As J. Allan notes in his 1994 article, the craftsman Haji Abbas lived and worked in Isfahan and died there in 1380/1960-61 (see Allan 1994). The Hermitage kashkul was therefore made in the first decades of the twentieth century. It is unclear why 'Haji' is spelt incorrectly on this piece, yet correctly on other works signed by this craftsman. (A.I.)

Persian Ceramics

Adel T. Adamova

156
BOTTLE WITH A HUNTER
(see page 163)

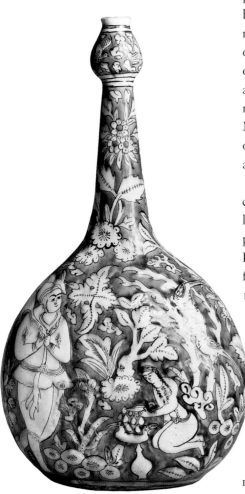

Chinese themes such as the phoenix, dragon, and the lotus, appear on Iranian ceramic products by the second half of the thirteenth century. They can be found on lustre vessels and tiles, which continued to be made in Kashan, the main centre of lustre pottery in Iran still in existence after the Mongol invasion. They can also be found on new types of pottery such as lajvardina pottery (named after the Persian word for the blue semi-precious stone lapis lazuli (*lajvard*) because of its predominant turquoise blue colour) [cat. no. 69], and the Sultanabad type (Watson 2004). As noted more than once in specialist literature, Chinese themes on Persian pottery of this period were mainly borrowed from Chinese textiles and other items of Chinese applied art, but not from pottery products. In general Persian artistic pottery of the Mongol period is not closely related to contemporary Iranian pictorial art. However, such a link was characteristic of pre-Mongolian lustre products and mina'i ceramics, where the dominant form of decoration included figures of birds and animals, with people seen as an element of design.

Under the Timurids at the beginning of the fifteenth century, increasing contact with China and the activation of trade and exchange of embassies led to a new wave of interest in works of Chinese art. Interest in Chinese porcelain rose at this time and it was subsequently collected by the wealthy. Evidently it was in use at the courts of rulers, and proof of this can be gleaned from Persian miniatures (Krahl 2003, p. 266). From the fourteenth century mass-produced porcelain from China with cobalt decoration appeared almost simultaneously in the Middle East and Europe. Appreciation of the aesthetic worth of porcelain from China, as well its value and popularity, drove Persian craftsmen to copy it. They began to imitate porcelain ware from China, decorated in cobalt, and this new type of Persian pottery continued to be manufactured right down to the early eighteenth century.

The Hermitage has the world's greatest collection of Iranian pottery of the fifteenth to early sixteenth centuries. This pottery is referred to as 'Kubachi' in the literature, as most of the ware comes from Kubachi, a mountainous settlement in Daghestan. They are mainly large heavy dishes

and deep bowls of soft porous reddish faience decorated over white engobe under a very thin layer of transparent glaze [cat. nos. 80-84]. There is a preponderance in this group of products with cobalt decoration, while another rarer type has a decoration of black paint under a transparent turquoise or green glaze. In every case the decoration shows clear evidence of imitation of Chinese faience. The rare surviving examples, with indication of date and place of production (among which is the dish from the Hermitage [cat. no. 80], form a basis for the study of Persian items which have the same technical and stylistic features (Golombek, *et al. 1996*). Researchers have judged that the capital town of Tabriz, in the north west, was the centre of production of these 'Kubachi' wares. To this we must add that the most important centres mentioned in manuscripts were Nishapur and Mashhad.

Persian pottery of the late Timurid and early Safavid period notably repeats the forms and decoration of Ming porcelain of the early fifteenth century. The distribution of the designs on the surface of the goods, and also the motifs which occur most frequently on such pottery, i.e. birds on a flowering branch, ducks in a pond, peonies, lotuses and other plant motifs, testify to a direct acquaintance with Chinese products. Even so, Persian craftsmen manufacturing 'Kubachi' pottery do not so much copy as vary Chinese themes to create an effect that would have appealed to Iranian tastes (Bailey 1992, pp. 179-90). In contrast to the accurate and precise execution of the decoration on the Chinese prototypes, the Persian blue-and-white faience pieces were painted in a free, rather careless style with a swift brush, the paint spreading everywhere, forming a 'painting smudge'. It is this distinctive soft style of painting that gives this Persian pottery its particular charm and originality.

The process of adapting Persian pottery to Chinese norms intensified from the end of the sixteenth century. In the pottery from Kerman and Mashhad, the largest centres of production of cobalt pottery in seventeenth-century Iran, we can observe the desire to copy the Chinese model more closely and precisely. This may be connected to the personal whims of Shah Abbas I (who is known to have had a large collection of Chinese porcelain) and the ever-growing fashion for Chinese porcelain both in the Middle East and in Western countries. A large role was played by economic causes, such as the Shah's general policy of establishing trade relations with Europe. In the same way as textiles, the trade in pottery came to be regulated by the state. At the end of the sixteenth and particularly in the seventeenth centuries, there was a significant increase in the import of Chinese porcelain to Europe, much of it transported through Iran. English and Dutch trading companies, founded in the early seventeenth century, took an active part in this process. Due to the political and economic crisis in China and the fall of the Ming dynasty in 1644, there was a temporary break in Chinese trade with Western Europe in the mid-seventeenth century. In Kerman, Mashhad and possibly other towns, faience products were not only made very similarly to the Chinese originals, but they even imitated the Chinese potters' painted marks. These products were marketed in Europe as Chinese originals. Although the production and export of Chinese porcelain was renewed in 1683, the production of imitation ware continued in many Iranian towns, seemingly for internal consumption.

Seventeenth-century Persian blue and white ceramics are made from faience with a hard body of white colour, reminiscent of Chinese porcelain. The decoration is extremely similar to that of Chinese porcelain of the

later sixteenth to early seventeenth centuries. A new classification for this pottery has emerged in Y. Crowe's research on the collection of Safavid cobalt pottery in the Victoria and Albert Museum (over six hundred objects). The problems of interaction between the artistic pottery of Iran and that of China have also been studied and designated by the author as 'the Persian ceramic dialogue with China' (Crowe 2002, p. 43). She has observed that although Persian craftsmen of the seventeenth century had Chinese originals as their models, their compositions were frequently borrowed from more than one example. The same motif may be repeated over a lengthy period. So, for example, the Chinese figures (depicted on the Hermitage dish, cat. no. 151) seated on a background of rocks, reservoirs and trees, often in pairs, with one partially covering the other and always shown with a bare leg to one side or raised, frequently feature on dishes, bowls and flasks produced over several decades (Crowe 2002, nos. 27-29, 73, 236, 251, 252). After studying other Chinese motifs, Crowe came to the conclusion that the meaning of the decoration was unimportant for Persian craftsmen; it only had to look 'Chinese' (Crowe 2002, p. 54). The decoration on seventeenth-century products was done in cobalt of different shades with a dark (and later black) inky edging, that with time became more and more imprecise in both reproduction and execution of the borrowed themes.

In his essay on Persian pottery M. Rogers notes that 'the fatal error was to attempt to compete with the Chinese on the export market'; this was one of the reasons that Persian pottery craftsmen became 'imaginatively, as well as economically, bankrupt' (Rogers 1989, p. 269). It appears that the craftsmen themselves by the mid-seventeenth century had realised that end-less imitation had come to a dead end, and so began to introduce Iranian motifs into the types of pottery originally borrowed from China. The same thing happened in products imitating celadon, which along with cobalt vessels began to assume priority for Shah Abbas I. 'Iranian celadon' is faience with a hard white body, reminiscent of porcelain, with a thin layer of pale-green glaze, very near the tone of Chinese celadon. 'Chinese celadon' manufactured, it is thought, in seventeenth-century Kerman, often has the standard Iranian plant motif in white engobe [cat. no. 155].

The same can be said of another type of pottery (known as white monochrome), an imitation of Chinese porcelain by craftsmen from Fukien Province, made in Iran. Also in Iran, thin-walled products of white porcelain-like material, similar to china, were decorated with applied elements, engraved or etched ornamentation (the designs being mainly Iranian), and covered with a transparent, colourless, lead glaze [cat. no. 154].

Other types of Iranian seventeenth-century ceramics demonstrate the continuation and revival of purely Iranian artistic traditions. A feature of this faience is a return to contemporary Iranian graphic arts as a source of inspiration. The connection with the miniature painting of the Isfahan School is reflected not only in the borrowing of subjects and motifs, but in the particular 'picturesque' style of highly ornate surface decoration.

An especially beautiful example of Kirman polychrome faience is the bottle from the Hermitage [cat. no. 157]. It shows a combination of Chinese-influenced motifs, usually done in cobalt, along with Iranian arabesques and motifs such as fallow deer and cypress. The Iranian type of bottle decoration also adds to the prevailing symmetrical principle.

On the bottle where the design is in relief and decor-

ated with cobalt [cat. no. 156], the subjects are purely Iranian and linked to Iranian graphic art as opposed to the majority of cobalt ware which has a preponderance of Chinese motifs. Figures of hunters, the woman holding a bowl, and many other motifs, are borrowed from miniatures and drawings of the seventeenth century.

The seventeenth century also saw the revival of the old, long-forgotten, type of pottery with lustre decoration which was highly developed in twelfth to thirteenth-century Iran. It is the only type of Iranian pottery with virtually no Chinese influence. However, pictorial designs on lustre products of the period, mainly small-format bowls, little vases and high narrow-necked flasks, do not repeat the old traditional Iranian motifs either. They reflect the tastes of the Safavid period and have a stylistic link with Iranian textile and other artistic craftwork designs. Plant motifs feature most frequently, and sometimes animals and birds, but unlike those decorating the old lustre pottery, these are executed not in reserve but in silhouette, the norm for

Safavid cobalt pottery. On a plate from the Hermitage Collection (VG-53) there is a landscape with a stream, cypress trees and flowering shrubs. The decoration has been done with strokes of lustre which has given the whole design a vivid pictorial effect. The picture is generally close to contemporary miniature style.

The graphic art of the period showed a general fascination with European art and this was reflected in the decorative ceramics of the seventeenth century. The faience flask, covered with a bright green glaze, with pictorial relief work, imitates the compositions of well-known painters [cat. no. 158]. A popular subject in the Isfahan school of painting, a young cup-bearer in European dress, is seen on a tray decorated in cobalt [cat. no. 159].

Safavid pottery, developing in close contact with other forms of artistic craftsmanship, and Iranian painting, elaborated upon a variety of pictorial themes and decorative techniques which made it one of the most developed areas of Iranian applied art.

Persian Ceramics

151
DISH

Iran, second half of 17th century

Faience, cobalt decoration; 45.5 cm (diameter)

Origin: acquired in 1923 from the Museum Archive

State Hermitage Museum, inv. no. VG-408

Reference: Rapoport 1969

The design on this dish is made with cobalt of a bright blue colour, outlined with a dark hue under a transparent glaze. In the centre is a three-tiered composition, consisting of motifs borrowed from Chinese pieces from the late sixteenth and early seventeenth centuries. The two pairs of figures, portrayed sitting against the background of a wall in the central tier, is a motif frequently found in Persian cobalt ceramics of the seventeenth and early eighteenth centuries (Crowe 2002, nos. 27-29, 236, 251 and 252). This motif, like the landscapes depicted above and below, with high cliffs, pagodas and huts (also shown on the edge of the dish) are very similar to Chinese pieces. Two concentric circles on the base on the reverse side contain a mark, consisting of four symbols (also copying Chinese tradition), which is particularly typical of this type of dish – i.e. faience works imitating Chinese porcelain. (A.A.)

152
BOWL

China (Jingdezhen, Jiangxi Province), end of 16th century

Porcelain, cobalt design; 22 cm (diameter), 18.8 cm (height)

Origin: acquired in 1925 from the Museum of the former Central School of Technical Drawing of Baron A. L. Stieglitz

State Hermitage Museum, inv. no. LK-352

Reference: Arapova 1977, no. 25

This bowl is semi-circular, with a slightly folded, fluted rim, decorated on the outside with the image of horses charging through waves and bands of cloud (*haima*), blossoming branches and birds. Along the inside rim, and on the bottom of the bowl, are landscapes, while *chakras* ('Wheels of Life') are depicted on the sides of the bowl. The motif of charging horses first appeared in China in the second half of the thirteenth century, and became popular under the rule of the Mongol dynasty; while during the Ming period (1368-1644) it was introduced into the emblems of bureaucrats of the ninth rank. The depiction of landscapes, and the meaning given to them, indicates the influence of monochromatic painting on designs for porcelain. Landscapes such as those on the bowl are frequently used by Persian ceramics craftsmen to decorate dishes, bowls, and so on, which is confirmed by the design of dishes in the Ardebil Collection (Pope 1955, pl. 92) and the Hermitage Collection [cat. no. 151]. (T.A.)

153
EWER

China (Jingdezhen), 16th century

Porcelain with slight relief, cobalt decoration; 22.8 cm (height)

State Hermitage Museum, inv. no. LK-1745

Origin: acquired in 1936 from a Lenpromtorg store

References: Arapova–Rapoport 1971, pp. 25-41; Arapova 1977, no. 13, pp. 18, 19, 41 and 133

This wine ewer or jug has a pear-shaped body on a short, ring-shaped foot, a cylindrical neck that expands towards the long, inflected spout, and a loop-shaped handle. Jugs of this shape appeared in China at the beginning of the fifteenth and in the sixteenth centuries. When Chinese porcelain was becoming popular in Persia

and the famous Ardebil Collection was founded, under the rule of Shah Abbas, jugs like these reached Iran and were widely imitated, first in ceramics and then, in the seventeenth and eighteenth centuries, in metal (Pope, pp. 87-88).

This jug is decorated with a blue underglaze design: on the main body, in two heart-shaped medallions, in relief, a charging lion and qilin are depicted; around the medallions are stylized figures of lions and Buddhist emblems; while on the neck there are the same emblems and pointed leaves. The depiction of a lion (keeper of the Buddha's throne) is a link to Buddhist art. At the same time the lion is considered a symbol of valour and strength, and images of lions were embroidered onto the court clothes of military officials in the second rank. With time the image of lions began to signify the desire for successful promotion, due to the similar pronunciation of the corresponding Chinese characters. In China, the qilin was a symbol of kindness, happiness and, later, prosperity. The generally benevolent mood of the design is complemented by an inscription on the bottom of the jug, consisting of four characters: *van fu yu tun* ('may abundance and happiness never end'). (T.A.)

154
EWER

Iran, second half of 17th to first third of 18th centuries
Faience; 11.5 cm (diameter), 17.6 cm (height)
Origin: acquired in 1925 from the Museum of the former Central School of Technical Drawing of Baron A. L. Stieglitz
State Hermitage Museum, inv. no. VG-3
Published for the first time

This white ware ewer or jug was made in Iran, imitating Chinese porcelain. However, the shape (a spherical body, faceted spout and wide neck) and the decoration with raised ornamentation (on the shoulders, around the base of the spout, and in a band at the handles, comprised of small, scalloped rhomboids) is of purely Iranian origin. The decoration of white, monochrome pieces strives to underscore the beauty of the material and enliven the otherwise uniformly smooth surface. (A.A.)

155
PLATE

Iran, early 18th century
Faience, green glaze, white slip decoration; 23.5 cm (diameter)
Origin: purchased in 1926 from A. Aliev
State Hermitage Museum, inv. no. VG-2488
Reference: Rapoport 1972, issue 34, pp. 23-24

This plate is decorated with a blossoming bush that follows the shape of the bottom of the piece, with long, narrow leaves painted at rhythmic intervals using white slip against a celadon background, under a transparent glaze. A thin, undulating band adorns the plate's edge. Researchers confidently trace faience pieces imitating Chinese celadon to Kerman, Iran (seventeenth century). (A.A.)

151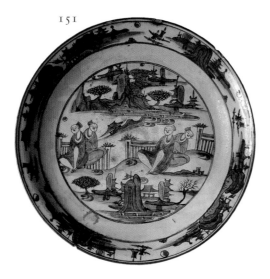

152

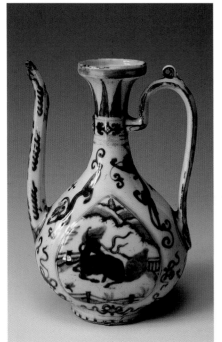
153

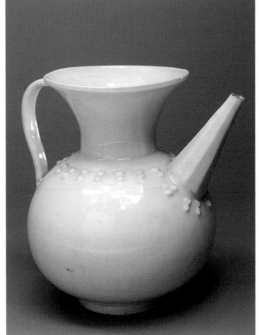
154

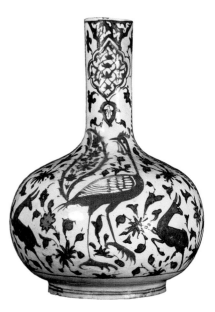
157

156
BOTTLE WITH A HUNTER (see page 156)

Iran, 17th century

Faience, cobalt decoration; 36.3 cm (height)

Origin: acquired from the State Museum Archive (year unknown)

State Hermitage Museum, inv. no. VG-290

Reference: Rapoport 1975, pp. 50-53

Exhibitions: Stockholm 1985, p. 147, no. 6; Kuwait 1990, no. 100; Amsterdam 1999, no. 232; St Petersburg 2000, no. 261; St Petersburg 2004, no. 179

Unlike the majority of cobalt pieces with predominantly Chinese motifs, the themes here are purely Iranian. On one side of the bottle there is a hunting scene: a young hunter fires a rifle at a charging beast, and to the right a large bird takes flight, scared by the shot. In another scene a young woman, with bowl in hand, sits under a tree, in which birds are sitting; there is a bottle on the ground before the woman, similar in shape to this one, and a vessel in the shape of a boat, with bird heads at either end, is filled with fruit. To the right of the woman a hunter approaches with a slain gazelle over his shoulders. The horns of the animal hang from his belt.

At least 15 bottles are now known to be decorated with the same scenes with insignificant variation. There are three bottles in the Hermitage (VG-294, VG-927 and VG-1023) (see also Canby 1999, no. 149, p. 156; Welch 1973, no. 89, p. 126; Crowe 2002, p. 148, nos. 231-34). The designs on these bottles display varying artistic interpretations, and the development of the themes can be observed along with a simplification or even loss of details. The exhibited bottle is an early example in which details are developed with exceptional care. These bottles are considered to have been made in Mashhad, Iran. (A.A.)

157
BOTTLE

Iran, 17th century

Faience, polychrome underglaze decoration (neck section has been cut); 26.4 cm (height)

Origin: acquired in 1925 from the Museum of the former Central School of Technical Drawing of Baron A. L. Stieglitz

State Hermitage Museum, inv. no. VG-345

Exhibition: Adamova 1996, *Supplement*, p. 364, no. 39

The design is executed on a white background, in cobalt and a red slip. On the body of the bottle, on two opposite sides, the red slip has been used to paint two large figures of pheasants with decorative tails, filled with images of blossoming carnation branches. Directly above them, on the neck of the bottle, are large but highly detailed scalloped medallions, containing arabesque designs. Similarly, between the figures of pheasants, stylized cypress trees are painted with the same red slip, observing the favoured method of symmetrical composition; the crowns of the trees are represented graphically, and reach as far as the neck of the bottle. Smaller images, apparently filling the spaces between these main figures, are made using cobalt, and, unlike the main figures, are freely distributed over the surface of the vessel. Jumping gazelles and numerous flower motifs, drawn with rapid and loose strokes, add a dynamic element into this well-constructed composition, painted with obvious care and confidence. The bright cobalt and the thick red slip create a successful contrast of colours. The underneath of the piece displays a mark, imitating Chinese tradition. Ceramics of this type are thought to have come from Kerman, Iran. (A.A.)

163

158
FLASK

Iran, second half of 17th century

Faience decorated in relief and covered with green glaze; 18 cm (height)

Origin: acquired in 1925 from the Museum of the former Central School of Technical Drawing of Baron A. L. Stieglitz

State Hermitage Museum, inv. no. VG-2354

Reference: Rapoport 1972a, pp. 149-56

This flask is one of a few surviving examples of Safavid faiences, decorated with images in relief and covered with a bright green glaze. On one of the flat surfaces is a European theme: the half-length figure of the Madonna holding the Child; while on the other side there is a dragon, in deference to the themes of Chinese porcelains, but painted against a background of a typically Iranian landscape. One opinion suggests that such faiences were made in Isfahan in the seventeenth century, as the image on this flask and other similar objects resembles the Isfahan school of painting. (A.A.)

159
TRAY

Iran, early 18th century

Faience, cobalt decoration; 21 cm x 15.3 cm

Origin: acquired in 1925 from the Museum of the former Central School of Technical Drawing of Baron A. L. Stieglitz

State Hermitage Museum, inv. no. VG-352

Reference: Rapoport 1969, vol. 10, no. 40, pp. 168-85

The large number of surviving trays and small plates, of different sizes and shapes and with cobalt decoration, are predominantly decorated with Chinese motifs. A cup-bearer is frequently depicted, full-length, in either Persian or Chinese clothes (Lane 1957, pl. 71A; Crowe 2002, pp. 128-38, nos. 204-205). On the bottom of this octagonal tray from the Hermitage Collection is a cup-bearer in European-style clothes, wearing a European-style hat with a feather, and carrying an Iranian-style bottle. Along the edge is a zig-zag band in reserve, which is common in such pieces. On the reverse side is a mark, in imitation of the Chinese tradition. All of these characteristics are typical of pieces made in Kerman. (A.A.)

160
QALYAN

Iran, 17th century

Faience, polychromatic underglaze decoration; 6.4 cm (diameter), 24 cm (height)

Origin: acquisition unknown

State Hermitage Museum, inv. no. VG-366

Exhibition: St Petersburg 2004, no. 187

This qalyan, with its complex shape, is unusual in many ways. The octagonal, faceted body crowns a tray with a figure of a beast lying on it: it is an extremely rare example of a vessel that is decorated with a small sculpture. Unlike Persian ceramics of the twelfth to fourteenth centuries, which are abundantly decorated with various inscriptions, Safavid pieces usually do not have such inscriptions, with a few exceptions, such as the Hermitage qalyan. The inscription (along the edge of the tray) celebrates a certain qalyan smoker who needed only to touch it with his lips for the mouthpiece to turn into sugar-cane and the tobacco smoke into pearls. More typically for Safavid ceramics, cobalt is used to decorate the human figures on the walls of the vessel. Three sides are decorated with the standing figure of a man in European clothes; while a woman in Persian clothes is shown on the fourth side. (A.A.)

160

161
PLATE

Iran, early 18th century

Faience, cobalt decoration; 21.3 cm (diameter)

Origin: acquired in 1925 from the Museum of the former Central School of Technical Drawing of Baron A. L. Stieglitz

State Hermitage Museum, inv. no. VG-2357

Reference: Rapoport 1968, issue 29, pp. 42-44

Cobalt of a greyish colour is used on this plate to portray a standing figure against a background of a wall, and crowned by a halo. In one hand he holds a fish (or a bowl covered with dots, while in the other he holds an object similar to a Chinese fan. This theme is found in a number of faience pieces from the beginning of the eighteenth century; in the Hermitage there are seven objects with similar designs: six plates and one bowl. On such pieces a wall is visible behind the 'saint', and behind the wall are blossoming bushes and clouds depicted in Chinese style. The division of the sides into scalloped areas is also Chinese in origin, with each containing butterflies flying towards the flowers. The figures are dressed in long, loose-fitting clothes, previously considered to be representations of Catholic or Jesuit clergyman. Another interpretation of this theme was suggested by Y. Crowe: '… the robed figure does not represent a Jesuit priest, as it was once suggested, but is modelled on sixteenth century images of the Bodhidharma crossing the Yangze river' (Crowe 2002, p. 188, nos. 307-308). (A.A.)

162
TWO TILE PANELS

Iran, 17th century

Faience, polychrome decoration; 186 cm x 134 cm (VG-1281), 188 cm x 138 cm (VG-1282)

Origin: acquired in 1925 from the Museum of the former Central School of Technical Drawing of Baron A. L. Stieglitz

State Hermitage Museum, inv. nos. VG-1281, VG-1282

Exhibition: St Petersburg 2000, no. 265

Two panels, created as a mirror image of each other and assembled from individual tiles, form a decorative composition, intended to adorn the tympanum of a building. They are decorated with a multicolour design on a blue background. At the centre of the composition is a dragon, wound around a thick tree, crushing a dappled deer with its powerful tail. These figures are surrounded by animals and birds, desperately running from danger in all directions. Luxuriously blossoming bushes fill the space between the figures of the animals. Typically for tilework pictures, the colours are highly arbitrary: the tree trunk is light blue, the dragon is yellow, the deer is green. The battle between animals, frequently involving the dragon, simurgh, qilin, and other mythical beasts, is a traditional theme in Iranian decorative arts symbolizing the power and strength of rulers.

The Hermitage panel has, on the whole, survived in good condition, and has apparently only lost an ornamental border, consisting of several separate tiles that surrounded the composition. This panel, just like the other from the Hermitage Collection, with a design on a yellow background, most likely originated in Isfahan and appears to have framed the entrance to a small park pavilion. (A.A.)

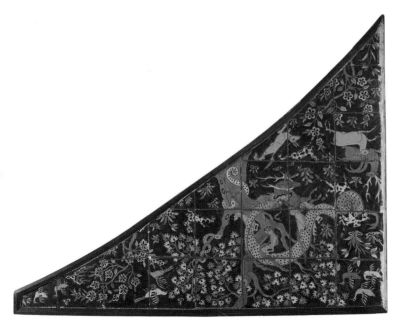
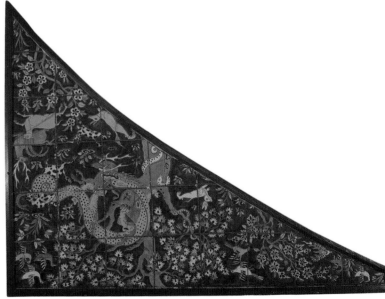

163

TILE

Iran, 17th century

Faience, polychrome decoration; 95.5 cm x 23.4 cm

Origin: acquisition unknown

State Hermitage Museum, inv. no. VG-1319

Exhibitions: Amsterdam 1999, no. 233; St Petersburg 2000, no. 263

Not in exhibition

This panel, consisting of four tiles with polychrome decoration against a blue background, bears the image of a man in short clothes, a short *imamah* or turban of striped cloth, and bare feet. He stands with arms outstretched, as if offering something to an invisible figure who, judging by the direction of his gaze, is sitting on the ground. This scene takes place in a garden, among blossoming bushes and birds. Undoubtedly this is a fragment of a larger ceramic panel, with a thematic composition including a number of figures – apparently a banquet in a garden. Such decorative panels, consisting of separate tiles, were widely used in Iran to decorate buildings, especially during the rule of Shah Abbas I (1587-1629), and in connection with the grandiose construction work in Isfahan, which was declared the Iranian capital in 1598. (A.A.)

164

TILE (see next page)

Iran, 19th century

Faience, polychrome decoration; 35.3 cm x 41.5 cm

Origin: purchased in 1935

State Hermitage Museum, inv. no. VG-1649

Exhibition: 'Iran at the Hermitage' 2004, no. 192

The portrayal of elegant ladies and gallant gentlemen against the background of a landscape and architecture is executed in relief on this tile, using a polychrome underglaze design. The relief frieze shows a blossoming stem with birds. The careful and precise drawing, the bright colours, the pure, bright glaze of this and other tiles of the early Qajar period, indicate the high level of craftsmanship of their creators. Tiles such as these were probably used as architectural decoration for palace buildings. (A.A.)

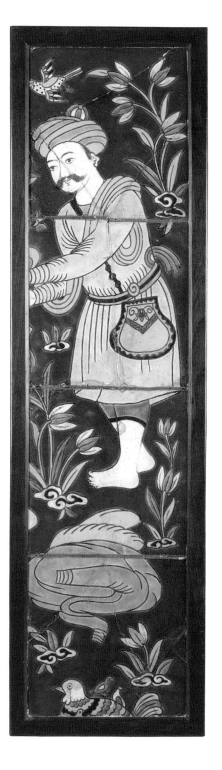

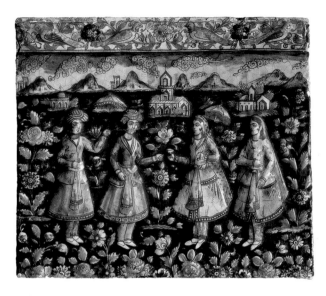

164

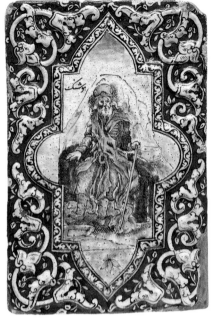

165

165

TILE

Iran, 19th century

Faience, polychrome decoration; 50 cm x 32.5 cm

Origin: acquired in 1933 from the State Museum Archive

State Hermitage Museum, inv. no. VG-1650

Published for the first time

This ornate relief cartouche contains a representation of Hushang, one of the ancient Shahs of Iran, and this name is inscribed in the cartouche. Hushang sits on an elevation, and holds a royal sceptre in his hand. According to epic tradition, recorded in the *Shahnama*, Hushang taught people to mine metal, started the blacksmith's trade, taught people to plough and sow, and to sew clothes from fur and animal pelts (the Shah's dress and

green throw in the tile are apparently made from animal pelts). Hushang also instituted the Feast of Sada, in celebration of his discovery of fire. As Hushang traversed a mountain path, a huge beast came towards him, and he threw a stone at the animal. The stone struck the cliff and created a spark, and this is how people learned to make fire (Robinson 2002). It is apparently for this reason that a mountain is depicted behind Hushang, and a stone is found to his left, while yellow tongues of fire can be seen on both sides of the figure.

Around the cartouche is a winding plant motif, created in reserve and in relief against a blue background. The Hermitage has one other tile from this series of ancient Shahs, where a similar cartouche depicts Alexander the Great, in the guise of a warrior, wearing armour and a helmet. (A.A.)

The Art of Central Asia
(mid- to late nineteenth to the beginning of the twentieth centuries)

Svetlana B. Adaxina

The mid-nineteenth century was an important period in the political history of Russia and Central Asia. The defeat of Russia in the Crimean War forced the Russian government to desist temporarily from actively campaigning in the Balkans and Middle East and to devote more attention to strengthening its position in the countries of Central Asia. The countries drawing the most attention from Russia at that time were the Bukhara, Khuqand and Khiva khanates, with which it maintained close commercial links. This arose from the geographical proximity of the Central Asian khanates to Russia, along with a certain amount of dovetailing between economic conditions in the Russian empire and those of the Central Asian khanates during the first half of the nineteenth century. Capitalism was at this time experiencing considerable growth in Russia, while Central Asia, comparatively an economic backwater, was a convenient seller's market for industrial goods and a rich source of raw materials.

British trade and political expansion provided an additional stimulus, bringing about increased political activity by Russia in Central Asia. After extensive diplomatic and military reconnaissance throughout 1857-62, the Tsarist government in 1863-68 expanded its rule over southern Kazakhstan and northern Kirghizia, as well as the Tashkent and Samarkand oases, and forced the large Central Asian khanates of Bukhara and Khuqand to recognize the suzerainty of the Russian empire. In order to govern these extensive Central Asian territories that were now part of the Russian empire, the territory of Russian Turkestan was formed on 11 July 1867. Lieutenant General K. P. Kaufman was appointed Governor-General of Russian Turkestan and granted unlimited powers in the new territories by a decree of the Tsar dated 17 July 1867. He had previously taken part in military activity in the Caucasus and was in charge of the chancellery of the War Ministry, later occupying the post of Governor-General of Vilna. He quickly became the real potentate of Turkestan: little wonder the locals called him *yarym-podsho* ('Semi-Tsar').

On 23 June 1868 the Russian empire and the Emir of Bukhara concluded a peaceful settlement offering Russian subjects the right of free trade and of forming trading agencies in the khanate, the right of passage through its territory to other states, and guaranteed freedom of person and property. At Russia's behest the emir agreed to pay a contribution of 500,000 roubles.

By the time nineteenth-century Europe turned its attention to Turkestan, the Silk Route had long since become a legend. Trade caravans criss-crossed the Bukhara, Khuqand and Khiva khanates in mutual competition for power and influence. However, until the time of the Russian conquest, Turkestan had been distant from political events and was chiefly preoccupied with its own affairs.

The Bukhara khanate had been conquered in 1740 by Nadir Shah of Iran. After Nadir Shah's death in

1747, the Bukhara emirate existed with its capital in the town of Bukhara, where the Mangit dynasty ruled, until 1920. The year 1868 saw the beginning of active trade and cultural relations between Russia and Central Asia. Russia sent many expeditions to Central Asia: some for military reconnaissance, others from the Russian Geographical Society, there to study the natural resources of Central Asia. In addition, the new lands were visited by numerous travellers, historians, ethnographers and adventurers, interested in the culture and lifestyle of the acquired territories.

Russia gave nineteenth-century Central Asia the railway, the telegraph and incipient industrialization. There was, nonetheless, little compatibility between the rapidly-changing political circumstances of the time and the traditional lifestyles and cultures that were initially left largely untouched by this process. However, in the early twentieth century the situation began to change quickly as new towns emerged which had little in common with the ancient oasis-towns, and everywhere grazing lands gave way to fields of cotton cultivation. The information about Central Asia obtained by Russian travellers at the end of the nineteenth and beginning of the twentieth centuries is thus all the more valuable, as the ancient customs and traditions they observed soon disappeared under the pressure of modernization.

One of the people who valued and collected Central Asian art was the equerry Aleksandr Aleksandrovich Polovtsov the younger, who was *tovarishch* (deputy) from 1916-17 to the minister of Foreign Affairs. The collection of objects he made for the Museum of the former Central College of Technical Design of Baron A. L. Stieglitz (or Shtiglitz) was donated to the Hermitage in 1925-26 and forms the major part of the museum's collection of Central Asian applied art of the end of the eighteenth to nineteenth centuries.

Noteworthy among the items in this exhibition are various pieces of embroidery, a traditional art form of Central Asia. Almost all items of clothing and household furnishings in Central Asia were decorated with embroidery. They were prepared over many years, and usually formed part of a bride's dowry. Embroidered garments included robes, headgear, trousers, blouses and *shalwar* (loose trousers). Household items included embroidered carpets, *suzane* (wall hangings), wedding sheets (*ruyjo*), covers, wrappings for a child's cradle, and even items of military attire such as men's riding trousers [cat. no. 202], horsecloths and campaign chests for storing *piala* (cups or tea bowls) which were covered with multicoloured embroidery [cat. no. 213].

The art of embroidery in gold reached its peak in Bukhara in the second half of the nineteenth century. It was primarily used on clothing for the ruler and rich nobility: most of the craftsmen skilled in gold embroidery, *zarduz*, resided at the Bukhara court. The main fabric employed for gold embroidery was imported or local velvet, the colours used being red, violet, green and dark blue. Widespread in the art of gold embroidery was the technique, *zarduzi zaminduzi,* whereby the entire background was embroidered in gold [cat. no. 197]. The main decoration on gold embroidery was plant designs [cat. no. 198], while geometrical ornamentation was more rare [cat. no. 197].

The shape and style of dress were dictated by both tradition and climatic conditions, together with rites and customs. A robe was usually worn on top of a long undershirt, in the case of men, or over a dress for women. Summer gowns were made from light fabric [cat. no. 199], while the winter variety was quilted or

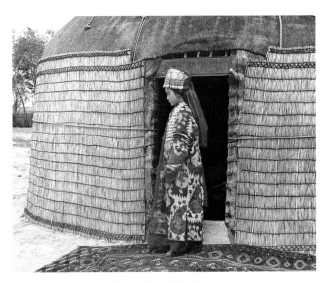

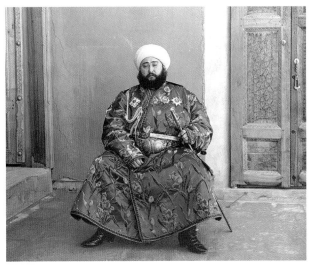

Illus 1: A girl from nomadic people, c.1907-15.
[photograph: S. Prokudin-Gorskii; Library of Congress]

Illus 2: Emir of Bukhara, 1911.
[photograph: S. Prokudin-Gorskii; Library of Congress]

had a cotton lining. While gold-embroidered robes were worn only by high-ranking individuals, an elegant robe was made for a bridegroom on his wedding day, sewn with silk threads on a cotton base. The surface of these robes was entirely covered by solid cross-stitch embroidery of multicoloured plant decoration. These garments usually had a lining of silk *ikat* [cat. no. 201]. The basic type of women's robe was the *mursak* [see illus. 1], a tunic-like dress without a fastening or collar. The *mursak* was long, right down to the ground, with a lining of quilted cotton wadding or very thin cotton (or silk in the summer version) [cat. no. 200]. Every bridal dowry consisted of two to ten of these *mursak*, (sometimes even 18), both for going out, made of expensive fabric, and for domestic use, of hand-made *mata*. Up to the early twentieth century many people included a *mursak* as part of the clothing sent by the groom's family to the bride on the day of her betrothal.

After the beginning of the twentieth century the *mursak* completely lost its significance as a piece of clothing and was worn only for funerals.

Robes and belts (*kamar*) were important constituent parts of Central Asian dress. The belts exhibited in the Hermitage Collection vary from gold-embroidered examples, inlaid with precious stones, to simple embroidered canvas [cat. no. 208]. The belts might have loops for knives, or pouches for money [207] and tobacco.

Headgear played a large part in an individual's attire. People would not go out with uncovered heads in Central Asia (it was considered sinful, above all for women). Old men said that the guardian angel would fly away from any woman who ate without wearing a scarf. Headgear was very varied but most common was the male *tupi* (embroidered skull cap) and various types of women's hats. These too, like other Central Asian forms of clothing, were richly embroidered [cat. nos.

171

204, 205]. Male headgear consisted of a lower, usually undecorated hat, thickly quilted to absorb sweat, with an embroidered *tupi* on top of it, on which a turban could be wound. The fabric was of one colour or striped. Those worn by the wealthy could be embroidered with gold or silver thread. Women's headgear from ancient times consisted of two scarves. Traditionally only women of loose morals wore *tupis*, but by the end of the nineteenth to early twentieth centuries female *tupis* were widely used, which initially provoked the wrath of conservative society.

Men's trousers, the embroidered edge of which was visible from under the robe, had a very wide, straight cut [cat. no. 203]. Men also wore hard leather boots, often high-heeled [cat. no. 215], or soft boots of fine leather, on top of which were leather slippers without a heel [cat. no. 210].

Central Asian dress as a rule had no pockets, so both men and women used small bags called *kiset* [cat. nos. 206, 207]. *Kiset* were worn either around the neck or on the waist. These too were decorated with several kinds of embroidery.

Among the embroidered handicrafts displayed in the exhibition, a special place goes to one of 17 sections of a marquee tent, a present from the penultimate Emir of Bukhara, Abdulahad-Khan (1885-1910) [see illus. 2, previous page], to Tsar Alexander III during the Emir's visit to St Petersburg in 1893 [cat. no. 196].

Tents were a traditional form of summer residence in Central Asia. Well-to-do townsfolk pitched them in their courtyards. Normally the outer wall of these tent-marquees was plain, while inside they were decorated with embroidery and appliqué work. The tent on show [cat. no. 196] is the best example of this kind of work, undoubtedly made in the Bukharan court workshops. It is richly decorated on the interior and the exterior, combining gold stitching and solid silk embroidery with appliqué work in multicoloured silk and velvet. Unfortunately the Russian records of the last century do not tell us whether the tent was ever pitched in St Petersburg. All we know is that it was displayed in the Petrograd Stables Museum in the 1920s.

As well as the embroidery from the Hermitage Collection of Central Asian applied art, there is also a good selection of traditional metalware in the exhibition [cat. nos. 166 and 167], along with some magnificent specimens of ceramic ware [cat. nos. 168, 169 and 170]. As well as continuing to manufacture traditional products, nineteenth-century potters sought new shapes and ways of making pottery. An interesting group of exhibits is comprised of various bowls, dishes and vessels, made in Rishtan in obvious imitation of Chinese porcelain. They have plant decoration, made in cobalt on white engobe under a clear glaze. On the base of these vessels, marks copying or imitating the Chinese hallmarks can often be found. It is customary in the literature to call this type of Central Asian pottery 'Chini' ('Chinese').

166

172

The Art of Central Asia

166
EWER

Central Asia (Karshi), 1886-96

Copper, repoussé, engraving, silver inlay, turquoise; 31 cm (height)

Origin: acquired in 1970 via the State Hermitage Acquisitions Commission

State Hermitage Museum, inv. no. SA-15810

Exhibition: Turku 1995, no. 309

This jug, part of a washing set [pair with cat. no. 167] is inlaid with silver. On the neck, lid and spout are five bands with cavities for securing turquoise stones, which have partially survived. (S.A.)

167
BASIN

Central Asia (Karshi), 1886-96

Copper, repoussé, engraving, silver inlay, red paint; 30.7 cm (diameter), 12 cm (height)

Origin: acquired in 1970 via the State Hermitage Acquisitions Commission

State Hermitage Museum, inv. no. SA-15811

Exhibition: Turku 1995, no. 310

This washing basin, or *dastshuyak* [pair with cat. no. 166] is covered with stylized plant ornament and inlaid with silver. Cavities are covered with niello, and the individual stripes are painted red. The body has four engraved medallions. (S.A.)

168
HEARTH

Central Asia, second half of 19th century

Clay, glaze; 31 cm x 14 cm

Origin: acquired in 1925 from the Museum of the former Central School of Technical Drawing of Baron A. L. Stieglitz

State Hermitage Museum, inv. no. PE-197

This clay fire stand has the form of a tall, four-cornered box with straight sides, resting on four feet, with an opening in the shape of a pointed arch. The underglaze slip decoration uses turquoise, violet, blue and yellow glazes. (S.A.)

169
VASE

Central Asia (Rishtan), 19th century

Clay, white slip, cobalt decoration under a transparent glaze; 9.7 cm (diameter), 18.8 cm (height)

Origin: acquired in 1925 from the Museum of the former Central School of Technical Drawing of Baron A. L. Stieglitz

State Hermitage Museum, inv. no. PE-146

Exhibitions: Turku 1995, no. 321

This vase of light pink clay is decorated with a plant ornament, using cobalt over a white slip, and covered in transparent glaze. On the bottom is a mark, also in cobalt, in imitation of the marks of Chinese master craftsmen. In the nineteenth century Central Asian potters from the Rishtan settlement copied the ornamentation and marks of expensive Chinese porcelain. (S.A.)

170
FOOTED TRAY

Central Asia, (Khuqand), 19th century

Clay, white slip, cobalt decoration under a transparent glaze; 33.2 cm (diameter), 16.4 cm (height)

Origin: acquired in 1931 from the State Hermitage Museum of Applied Arts and Industrial Technologies

State Hermitage Museum, inv. no. PE-339

Published for the first time

On the tray Persian poem in *nasta'liq* script (read and translated by Dr. D. Vasilyeva):

'The nightingale got into the cage due to its craftsmanship, / Due to the lack of skill the crow is left alone. / I cried in a foreign land, no one missed me, / I lost my life in cage – the hunter didn't set me free.'

This footed tray of light pink clay is decorated with plant and geometric ornament, in cobalt on a white slip, and covered with a transparent glaze. Between two bands of plant and geometric ornament is a band containing an inscription in Persian verse. (S.A.)

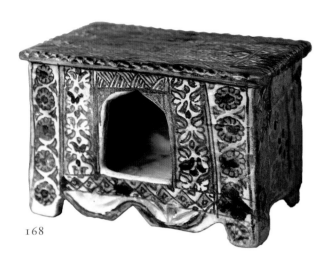

168

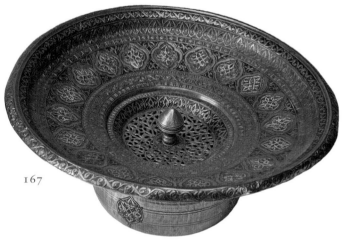

167

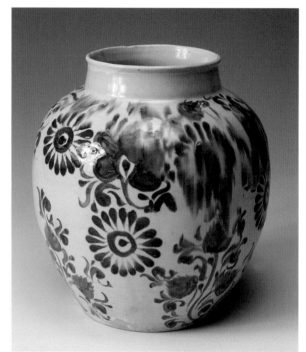

169

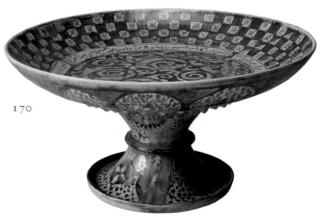

170

Jewellery of Central Asia

Tamara I. Zeimal

Decorative jewellery in Central Asia formed an integral part of national dress, supplementing and embellishing it. One cannot talk about Central Asian women's national dress without decorative jewellery. There are different types of decorative jewellery, but they all share a common predeliction for silver and specific gemstones such as carnelian, turquoise, coral, pearl and mother-of-pearl. Birds' feathers, such as heron and pheasant, are frequently part of the attire.

Adornments are worn from childhood to advanced old age. A strict etiquette, according to age, is observed. The restrictions relate to the number of pieces of ornamentation and their arrangement. In early childhood young girls wear tiny ear-rings and bracelets of coloured beads, which are meant to protect the wearer from the evil eye. As they grow up the quantity and quality of ornamentation increases; silver bracelets and coral necklaces appear. When the future bride's dowry is prepared, part of it includes head-gear, chest and neck decorations, bracelets, rings, load rings – whether of the hanging, waist or hair variety – and metal containers of different kinds for prayers and fragrance suspended from chains.

The number of adornments depends on family means. Some will be newly commissioned, others passed on from mother or grandmother. There were sometimes occasions when the decorations were borrowed from friends and relatives for the period of the wedding celebrations, if the family of the bride was not in a position to buy them.

Up to the birth of the first, and sometimes second child, a young woman could wear the maximum number of adornments. Gradually part of it was stowed away in a trunk for future generations. These included forehead decorations [cat. no. 177], *kosh-tillo*, and chest adornments (*nozi-gardan*) [cat. no. 175].

Up to advanced old age, women wore silver rings with carnelian. This adornment was considered to make the owner's hands clean. On festival days elderly women could wear silver ear-rings of a *khalka* type [cf. cat. no. 171], and adorn their necks with coral beads.

The wearing of carnelian, turquoise and coral was considered by all Central Asian peoples as being beneficial. They brought well-being to

family life, along with health and success. A carnelian stamp on a silver ring brought men success in trade deals, while a turquoise on a weapon or waist protected the owner from misfortune. Coral necklaces were worn by women who wished to keep their husband's love and to have many children. Healing properties were also ascribed to precious stones and pearl.

Female decorative jewellery was made most often from silver and sometimes gilt. For the court of the Emir of Bukhara and his officials, Bukharan jewellers made golden objects with inset precious stones [cat. nos. 220 and 222]. Around four hundred master jewellers were known to have worked in Bukhara towards the end of the nineteenth century, and a considerable number of them administered to the needs of the Emir and his court.

Bukharan jewellers were famed throughout Central Asia, but craftsmen from other cities (Khiva, Samarkand, Khuqand) also enjoyed a fair degree of success. Craftsmen from Afghanistan were brought in who basically serviced the southern regions of Uzbekistan and Tajikistan. They arrived with their own materials (metal and stone) and stayed for a short time in a *kishlak* (or village). They prepared adornments to order for all the prospective brides in the area, and then moved on to somewhere else. The same can be said of the master jewellers of the Caucasus. We know that jewellers from Daghestan were invited to Bukhara at the end of the nineteenth century. They brought a whole array of ear-rings with load rings, which were successfully 'adapted' to Central Asia and adopted there (*khalka*).

Despite the traditional nature of decorative jewellery in Central Asia, each region was distinct and had its own style, although there was no sharp boundary between them.

There were also changes in fashion in the arrangement of ornamentation. Coral necklaces, for example, came to be thought of as peasant jewellery by the 1920s and were replaced by coin ones. The number of openwork load rings in ring ear-rings was also changed: instead of the three to five load rings formerly in fashion, ear-rings with eleven to thirteen load rings came into vogue. Some forms of decoration went completely out of use. They were not thrown out, however, but cut into pieces, and grandmothers would give their grandchildren a wedding present made out of them for luck (*zulfi-tillo*).

178
BRACELET
(see page 180)

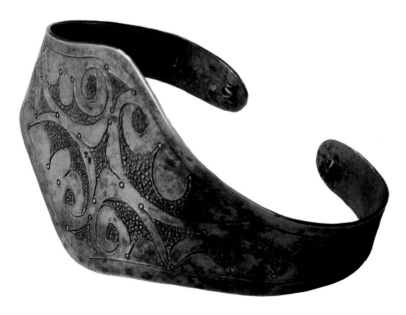

Jewellery of Central Asia

171
EAR-RINGS

Central Asia (Bukhara, Samarkand, South Tajikistan), end 19th to beginning 20th centuries

Silver, openwork filigree, granulation; 6.3 cm, 6.6 cm (length)

Origin: acquired in 1925 from the Museum of the former Central School of Technical Drawing of Baron A. L. Stieglitz

State Hermitage Museum, inv. no. VZ-361

Published for first time

These silver ear-rings (*khalka*) are ring-shaped with a lace-work insert fixed to the inside of the ring (Chvyr 1977, pls. 4, 6). Below are five pendants made from lace-work beads, granulated baubles and pyramids. They were common in Uzbekistan and Tajikistan, and worn by women of all ages as obligatory day-to-day decorative jewellery. There was a vast range of different versions, from simple modest ear-rings to those made from gold, precious stones and pearls. The size differed, as well as the number of pendants (three, five or seven). Certain variations were popular in some local areas. (T.Z.)

172
EAR-RINGS

Central Asia (Bukhara, Samarkand), 19th century

Silver, pearl, glass, gilding, granulation, openwork filigree; 12.5 cm (length)

Origin: acquired in 1925 from the Museum of the former Central School of Technical Drawing of Baron A. L. Stieglitz

State Hermitage Museum, inv. no. VZ-618

Published for the first time

This pair of ring-shaped ear-rings is gilt silver with a lace-work rosette inside the ring, and three long pendants made from red and green glass beads, small pearls and granulation. (T.Z.)

173
EAR-RINGS

Central Asia (Bukhara, Samarkand), 19th century

Silver, coral, glass, small pearls, openwork filigree, granulation, gilding; 11.5 cm, 13 cm (lengths)

Origin: acquisition unknown

State Hermitage Museum, inv. no. VZ-619

Exhibition: Amsterdam 2003

These ring-shaped pieces form a pair, with a lace-work rosette on the inside of each ring, while below are three coral pendants, red and green glass beads, oval silver baubles, small pearls and granulated enamel. The central pendants are further decorated with shaped bars and smaller pendants. (T.Z.)

174
EAR-RINGS

Central Asia (Bukhara, Samarkand, Tashkent, West Ferghana), 19th century

Silver, turquoise, coral, glass, niello, bosma, putty; 15.8 cm, 16 cm (lengths)

Origin: acquired in 1982 via the State Hermitage Acquisition Commission

State Hermitage Museum, inv. no. SA-16060 a, b

Published for the first time

These ear-rings are ring-shaped pieces with five pendants on each. The central pendant is the longest, with a cap decorated by niello, with turquoise inserts along the edge, and seven pendants on chains of coral, and smaller, almond-shaped pendants. The remaining four pendants are shorter, and those at the sides have hemispherical caps, but of a smaller size and with fewer pendants.

The ring section of the ear-rings is decorated in the lower section with a lace-work lattice.

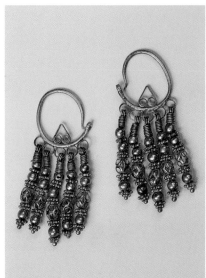

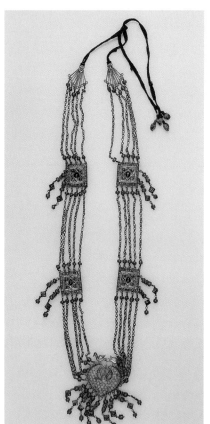

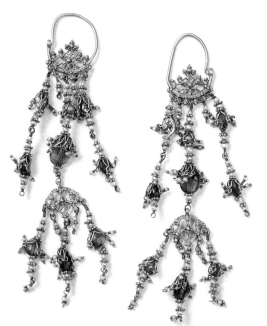

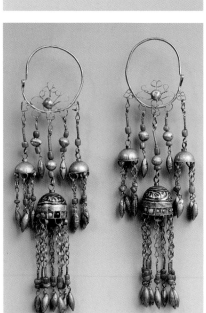

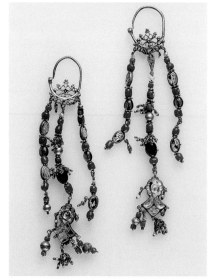

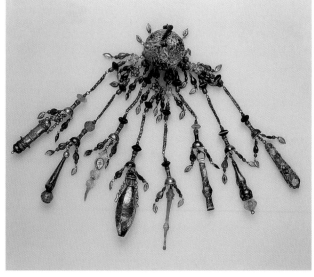

171 (above)
172 (below)

175 (above)
173 (below)

174 (above)
176 (below)

There are numerous variations on such ear-rings, which were extremely common and favoured by women throughout Uzbekistan and Tajikistan (Fahretdinova 1988, p. 121; Chvyr 1977, pls. 4, 14). They can have differing numbers of pendants, from three to eleven, but most frequently have five or seven (there must always be an odd number of pendants). There are differences in the arrangement and individual components of pendants, which can include stones, glass, seeded baubles and can end with smaller, stamped pendants. (T.Z.)

175
CHEST DECORATION (NECKLACE)

Central Asia (Bukhara, Samarkand, Tajikistan), end of 19th century

Silver, coloured glass inserts, coral, turquoise, lace (silk) ribbon, inlay, gilding, openwork filigree, stamping; 75.2 cm (length)

Origin: acquired in 1933

State Hermitage Museum, inv. no. VZ-616

Exhibitions: Turku 1995, no. 369; Amsterdam 2003, p. 191, illus. 223

This necklace, or *nozi-gardan*, decorates the chest or neck, and consists of a central, heart-shaped medallion, inlaid with turquoise, with birds on top; four square side bars with inserts of coloured glass are framed with turquoise, and two triangular lace-work bars have knots of silk lace. All the details of the jewellery are interconnected with silver chains and coral, and every fifth bar has coral pendants, seeded baubles and stamped decorative disks.

Such jewellery was worn by young women in Bukhara, Samarkand and Tajikistan at the end of the nineteenth and beginning of the twentieth centuries (Fahretdinova 1988, p. 138). The depiction of birds in the central medallion was the symbol of family happiness and prosperity. (T.Z.)

176
COSMETIC SET

Central Asia (Bukhara, Korezm), mid-19th century

Silver, turquoise, coral, coloured glass, repoussé, gilding, embossing, niello; 23 cm (length)

Origin: acquired in 1925 from the Museum of the former Central School of Technical Drawing of Baron A. L. Stieglitz

State Hermitage Museum, inv. no. VZ-358

Exhibitions: Turku 1995, no. 367; Amsterdam 2003, no. 224

Such decorations (*peshavez*), in the form of a small dome with pendants, were carried by Bukharan and Korezm women (Fahretdinova 1988, p. 140; Sycheva 1984, illus. 20). They were usually attached at the chest to a dress opening or a belt. The set of cosmetic items included tweezers, spoons for cleaning the ears, small bottles for antimony and myrrh, small boxes for medicine, and rods for drawing eyebrow lines, cleaning toenails, and so on.

A similar alternative to such jewellery were domes with pendants, at the end of which hung small keys or lace-work balls. These served purely decorative ends. Others (also with small keys) emphasized the status of the wearer of such pieces (*peshihalta*) as the lady of the household. (T.Z.)

177
FOREHEAD DECORATION

Central Asia (Samarkand, Bukhara), 19th century

Silver, turquoise, coral, glass, fabric, gilding, stamping, bosma; 35 cm (length)

Origin: acquired in 1982 via the Acquisitions Commission

State Hermitage Museum, inv. no. SA-16061

Exhibitions: Turku 1995, no. 370

This forehead decoration (*tilya-barchak*) consists of 15 identical square blocks, connected by hinge joints. At the centre of each block is a coral insert with turquoise around the edge. Each square is decorated on the underside with two stamped rosettes, and with turquoise in the centre. Attached to the top of the eighth square block is an additional decoration with inserts of coloured glass and turquoise. The sixth and tenth square blocks have oval blocks on the upper part, which are also decorated with inserts of coloured glass and turquoise. The blocks are sewn onto a strip of fabric.

Tilya-barchak is a common type of forehead decoration, found at the end of the nineteenth and beginning of the twentieth centuries among Tajiks and settled Uzbeks

(Fahretdinova 1988, p. 103). It was worn over a head-scarf, and affixed using a hook attached to the central block via a chain. (T.Z.)

178 (see page 176)
BRACELET

Central Asia (Bukhara, Samarkand, Tajikistan), end of 19th to beginning of 20th centuries

Silver, engraving; 6.5 cm (diameter)

Origin: acquisition unknown

State Hermitage Museum, inv. no. VZ-511

Published for the first time

This 'C'-shaped flat, silver bracelet has a wide section in the middle covered with engraved plant ornament. As an inexpensive type of jewellery for everyday use, it was fairly common in many areas of Uzbekistan and Tajikistan. The simple engraved ornament was highly variable; the models for such bracelets are often found during archaeological research in Central Asia. (T.Z.)

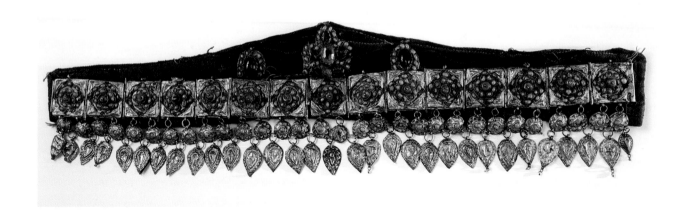

China and Islam

Maria L. Menshikova

Muslim culture has, at different times in history, spread over a huge territory, right to the south-east borders of China. Trade relations between the far-distant countries under Muslim rule meant that an exchange of ideas between their various cultures can be seen in the production and development of handicrafts, the nature of decoration and symbols used in works of art, and in borrowings in the sphere of writing and calligraphy.

Relations between China and Middle Eastern countries go back to the beginning of our era. Initial contacts took place chiefly by sea, but also overland through Eastern Turkestan. Even today a considerable part of the Muslim population of the world lives in Sinkiang, an autonomous region of north-west China, and in the Yunan and Guangdong provinces of southern China. There are over 30,000 mosques and more than sixty million Muslims in China today.

Trading vessels from Ancient Arabia called at Ceylon and South-East Asia on their way to the East. Merchants settled on islands and riverbanks. These were the earliest links between refugees from Western Asia and distant China at the beginning of the first millennium of our era. Around the year 400 a Chinese traveller, Faxian, mentions people from Arabia living in China. These were the people who prepared the way for seafarers from Arabia; in the year 300 in Nanhaitsyun (later Guangzhou) settlers from Arabia had founded the first Arabian colony. In a legend recorded in the late seventeenth century, it was said of the origin of Islam (*Hui-hui yuan lai*: 'Mohammedanism') that the T'ang emperor, in a dream, saw a man in a turban who had driven out an unclean force (i.e. devils) from the emperor's palace. He then approached Western

rulers who, in their turn, sent the uncle of the Prophet Muhammad, Sa'ad ibn Abi Waqqas, to Chang'an. With him he brought the first Qur'an ever to appear in China.

In 29 A.H./651 A.D., twenty years after the Prophet Muhammad's death during the rule of Caliph Uthman, the Arabs sent their first embassy to the edge of the world: China. A few more embassies came to Chang'an during the seventh to eighth centuries. In addition, in 713, gifts from the far west came to the court of the Chinese Emperor Xuanzong (712-56). A large Arab trading settlement took shape in Guangzhou during the rule of the T'ang dynasty (618-907), and the first mosques in China were built under the orders of the Emperor Taizong (626-49). To show his admiration for Islam, Taizong ordered the establishment of mosques in Chang'an, Nanjing and Guangzhou. The magnificent Huaisheng Mosque in Guangzhou, Guangdong Province ('remember the Sage') and the minaret, though rebuilt, still stand today after nearly fourteen centuries. Additionally the T'ang period saw the penetration of China by Muslims, beginning overland from the north-west. They crossed Eastern Turkestan, settled in villages along the Great Silk Route and controlled the trade. However, relations between Chinese and Muslims were not always harmonious. Uprisings frequently broke out and persecution came to adherents of Islam. Thus, for instance, the Chinese were greatly troubled over the capture of the port of Guangzhou by the Arabs and Persians, leading to an uprising against the Muslims in the year 875 led by Huang Chao.

In spite of this trading relations continued, and the Muslims who settled in China kept their faith, carried out their rites and built mosques. In time, however, they

integrated into Chinese society; they began to speak Chinese, changed their Muslim names for local ones, began to wear Han Chinese dress, ate local food and married Chinese women. In the Song dynasty (960-1279) Muslims exercised a strong influence on the Chinese economy. An official of any faith whatsoever could be employed in Confucian China; thus, in the port of Guangzhou, Muslim officials were actually in charge of coastal trade, for the most part working in the administrative offices, dispatching and receiving cargo. An Arab cleric came to China at this same period to preach Islam, and in 996 he founded one of the oldest mosques still standing in Peking, Nuijie Mosque. It is interesting to note that the building originally conformed to Arab architecture, but in later years it was successively rebuilt and now looks Chinese.

During the Yuan dynasty (1279-1368) Islam held on in China, partly because the Mongols had a policy of tolerance towards the beliefs of others, and brought from the captured cities of Bukhara and Samarkand their own Muslim craftsmen who continued to practise their religion. The earlier fourteenth century marks the period during which China exerted the greatest influence on Middle Eastern culture and art, with the appearance in the Middle East of a great amount of imported porcelain and possibly bronze items for collectors. Decorative motifs from these Chinese objects, such as cloud scrolls and ornamental flowers, were borrowed by West Asian art.

The Ming dynasty (1368-1644) saw the ultimate acceptance of Muslims in Chinese society. Many emperors were loyal to Islam and some took an interest in the religion of Allah, particularly Emperors Hongwu (1368-98) and Zhengde (1505-21). One version of the history suggests that they tried to learn the Arabic language and its calligraphy and even became secret Muslims. Certainly, after the collapse of the Yuan dynasty in 1368, books in Arabic were found in the royal library and translated into Chinese by the decree of Emperor Hongwu. Nanking, the first capital of the Ming emperors, became the centre for the study of Islam and Muslim literature. Islam under the Ming dynasty became in part a court religion, as it was followed by the court eunuchs. At that time trade relations between China and the Muslim states of Western Asia became highly significant. The famous traveller and sea-voyager Zheng He (1371-1433) was also a Muslim. It is considered to have been the most favourable time for the extension of Islam in China.

During the Qing dynasty (1644-1911) the position of Muslims became complicated. There were frequent Muslim uprisings, especially among the Uighurs of Sinkiang. They were cruelly suppressed by the Manchus throughout the eighteenth and nineteenth centuries, although under Emperor Kanxi (1661-1722) money had been made available for the repair of mosques, particularly the old mosque of Peking, and the Cantonese mosques which acquired their contemporary shape in 1695. Emperor Qianlong (1736-95) had a gate built at the entrance to the mosque in the 1770s; it was used as a minaret so that one of his concubines from Kashgaria (Eastern Turkestan) could hear the correct time for her prayers. Moreover, despite persecution in the Gansu Province in the nineteenth century, a number of independent sultanates arose, although they did not last long and were destroyed by the ruling dynasty.

Muslim culture won over more and more adherents. The Qur'an saw its first Chinese edition in Arabic in the nineteenth century. New mosques, schools and

madrasahs were built under the Qing dynasty rule in the sixteenth to seventeenth centuries and later for the growing Muslim population. Naturally these had to be decorated with ritual objects, and thus porcelain, bronze and enamelled goods with Arabic inscriptions were made in China. As these objects were found on Chinese soil, they were probably made specially for Muslims and their religious institutions within China. Many of the surviving bronze objects, censers and altar utensils for the most part have Arabic inscriptions, particularly suras (verses) from the Qur'an, and date from the sixteenth to nineteenth centuries.

Muslims, however, built their structures according to Chinese architectural norms, utilising traditional Chinese materials, both externally and internally.

To those accustomed to Near-Eastern mosques, the interior of a Chinese mosque might look very severe. At the entrance there was normally a Chinese-style wooden altar, on which lay three altar utensils: a censer, a box for incense, and a vase containing the incense pieces [see illus. below]. More rarely used were massive vapour vases or bronze censers of cloisonné (enamel) or porcelain. The items decorating the mosque were traditionally Chinese, although in earlier periods the forms of

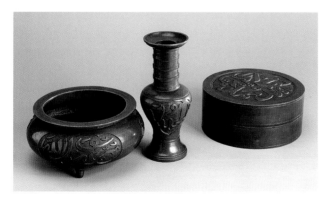

Illus: A set of Chinese bronze objects with Arabic inscriptions. (State Hermitage Museum)

objects in the mosque may have been borrowed from the Middle East. What distinguished them from purely Chinese objects was their purpose and use, as well as the use of intertwined Arabic inscriptions, occasionally with designs and features of script taken from Chinese calligraphy.

The main commodities of Arab import into Chinese ports over a very long period were copper, ivory, frankincense and textiles; those for export, silk and porcelain. Famous collections of Chinese porcelain of the twelfth to seventeenth centuries have been assembled in the Topkapi Palace in Istanbul and in the Ardebil Shrine in Tehran. Chinese porcelain was copied in the Middle East where the technique was emulated in order to fashion very fine products with cobalt ornamentation, in an attempt to produce Chinese decoration and symbols.

Dragons, flowers and birds, all traditional to Chinese art, can often be seen in Middle Eastern pottery. In China there was an exchange of technical skills and philosophical ideas between Chinese and Middle Eastern cultures; literacy and calligraphy were valued by both, and imported incense was in use in a ritual context in both cultures. Muslim populations absorbed the new artistic products and textiles they met with, adapting them to tradition and often imitating them. This was reflected not only in the actual objects, but in their names: for example, Central Asian pottery in the Chinese style was called 'Chini', ('Chinese'). Chinese stones (jades) were used for decoration and traditional dress could be cut from Chinese satin. Chinese Muslims were assimilated into the country, kept their faith and traditions and, far from the Imperial Palace, Chinese motifs found their reflection in Sino-Islamic art and handicraft.

China and Islam

179
FLASK

China, Qing dynasty, Qianlong period (1736-95),
end of 18th century

Cloisonné (enamel), bronze, brass, gilding; 44 cm (height with lid)

State Hermitage Museum, inv. no. LM-1239 a,b

Origin: acquired in 1926 from the Museum of the former Central
School of Technical Drawing of Baron A. L. Stieglitz (previously in
Bobrinsky-Polovtsov Collection)

Parallels (a set of three items with enamelled decoration):
H. Brinkler and A. Lutz: *Chinese Cloisonné. The Pierre Uldry
Collection* (New York 1989), no. 340

Published for the first time

This large water flask with lid, of a square shape and with
rounded edges, stands on a square foot, has two handles
at the shoulders, and a crescent on the lid. The body of
the flask is made using the technique of cloisonné enamel
(traditional in eighteenth-century China) on a bronze
base with gilded details. The body of the flask, on each
of the two flattened sides, bears a stylized calligraphic
inscription from the Qur'an in *thuluth* script: 'al-Hafiz'
– 'Guardian' – an epithet of Allah in black enamel over
a turquoise background. The inscription is framed by a
plant design with lotus flowers in a strip, and the handles
are made from gilt bronze scrolls.

This piece is particularly interesting as it would appear
to have been commissioned by a Muslim client for use in
a mosque in China. For this reason Arabic graphic art
has been used in the decoration, although the range of
enamel colours has been limited. The flask is predomi-
nantly decorated in a greenish turquoise colour, which is
traditional for Chinese objects and acceptable in Muslim
art as the traditional colour of Islam. The ornamentation
of the lotus flower and the inscription are executed in
black, yellow, green and white, again all traditional for
Islamic art, while red and other bright colours commonly
used on objects for the Chinese market have been exclu-
ded. The former colours are commonly used in an Islamic
context for tile glazes, and for the decoration of Islamic
architecture.

Flasks of this shape could have been used in either
Chinese or Islamic cultures, and it is hard to say where
they first appeared. The inscription without doubt
indicates that this richly-decorated vessel was intended
for use in a mosque. Usually such objects were created
in pairs, although there is only one such flask in the
Hermitage. A similar vessel was recently submitted for
auction in London. (M.M.)

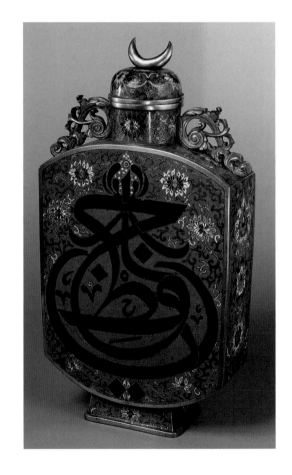

180

BRONZE INCENSE-BURNER
WITH SHAHADA INSCRIPTION

China, Xuande mark (1426-35), 18th century

Brass, patina; 6.5 cm (height), 13 cm (mouth lip diameter)

Origin: acquired in 1931 from an archaeological society

State Hermitage Museum, inv. no. LI-883

Parallels: R. Mowry, *China's Renaissance in Bronze, Robert Clague Collection*, Phoenix Art Museum 1993, no. 25; a set of three items but with enamelled decoration [see cat. no. 179]; H. Brinkler and A. Lutz: *Chinese Cloisonné. The Pierre Uldry Collection* (New York 1989), no. 340

Published for the first time

This incense-burner is part of an altar set consisting of three pieces: a vase, an incense-burner and a box for incense. Although such sets were traditionally Chinese, both in shape and composition, this set departed from Chinese traditions with the inscription of the following Arabic quotation from the Qur'an in *naskhi* script: 'There is no God but Allah, Muhammad is the prophet of Allah, the most wise of all people.' The quotations are written in a beautiful, calligraphic script, enclosed in decorative cartouches on the incense-burner, and on the vase of the same set, as well as in a circle on the lid of the box. Thus the role of the object is no longer that of the traditional Chinese altar set: this incense-burner was now meant for use in a mosque, by Muslims living in China.

All the objects are made of brass, not bronze, and are covered in a reddish patina to give them an appearance of age. Old Chinese traditions are revisited here, as the incense-burner echoes as an ancient Chinese bronze vessel of the *li* type, and a mark consisting of six characters is punched into the bottom of the incense-burner, corresponding to the mark of the years of Xuande's rule (1426-35) in the Ming dynasty (1368-1644). Interestingly, the round box of the set and the details of two other objects are not cast, as traditional in the making of bronze objects in China. Instead it was turned and the separate parts assembled. The inscription is made in relief, and the background effect is made by round punching. (M.M.)

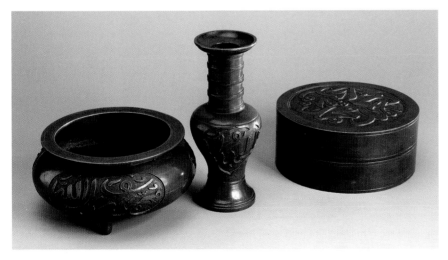

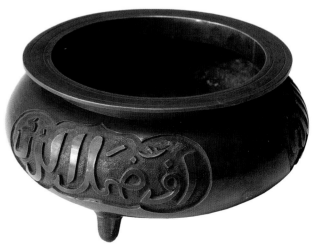

185

PART IV: DIPLOMACY, WARFARE AND TRADE
THE MUSLIM WORLD AND RUSSIA

Trade Connections between the Islamic World and Russia

Irina N. Ukhanova

The diplomatic and economic connections between the countries of the Islamic world and the Russian state were established over centuries. At first trade was moderately successful, but as political situations changed it developed quickly. Interest in the establishment, maintenance and development of trade relations was mutual and economically justifiable.

In the distant past the trading routes between Russia and Eastern countries followed the paths of the rivers Dnieper and Don, and out into the Black Sea. After the Kazan and Astrakhan khanates had joined the Russian state in 1586, the river Volga, which emerges in the Caspian Sea, became the main waterway. Thus for the exchange of commodities, an expanded market region was generated, one with more convenient and practical opportunities. While Veliky Novgorod had been the main centre of trade for many centuries, Moscow took its place from the sixteenth century; at that time all goods began to flow into Moscow, together with merchants and craftsmen from different countries.[1] The next stage was the redistribution of this valuable cargo among other Russian towns, settlements and villages. Consequently Eastern rarities could be found anywhere: in places like Solvychegodsk and Arkhangelsk, in Vologda, Yaroslavl, Nizhniy Novgorod and many other cities; as well as in the ancient Russian monasteries, for example Solovetskiy on the White Sea.

Routes of trade caravans were frequently dangerous. Merchants, both Eastern and Russian, tried to join diplomatic embassies whenever possible, as they were accompanied by armed guards when they travelled.

Trade and diplomacy thus became linked by expediency.

Russian merchants sold fur, wax, honey, mica, 'fish tooth', walrus bone, leather, and a variety of handicraft articles like wooden dishes, trunks, iron-sided caskets, metalwork, and so on. Caravans from the East delivered all kinds of spices, precious stones, pearls, as well as sabres of Damascus steel, knives and axes to Moscow. Textiles, however, were considered the most important commodity.

Weapons made for representation rather than actual use by Turkish or Persian master craftsmen in the sixteenth century were of interest not only for the use of Damascus steel, which was admired by all, but also for their decorative appearance. They were often gilded and inlaid with precious stones. These weapons were predominantly commissioned as gifts, but a small percentage of such articles also went on general sale [cat. no. 185]. The interest of Russian master craftsmen in these items was so significant that many became apprentices to Eastern specialists. Nikita Davydov was one such individual. He arrived in Moscow from Murom[2] and worked in the Armoury Chamber workshops of the Moscow Kremlin for more than fifty years, creating many outstanding articles for military use. The quality of the finish, and their decorative appearance, into which Arabic characters were introduced, testified to the highly professional skill of this master. Indeed, such were Davydov's abilities, that they were noted and he was sent to Constantinople for special training with Eastern craftsmen on the manufacture of weapons. This example confirms the truth of an opinion expressed by

one S. Maskevich, a traveller, who wrote in his diary (1594-1621) after a visit to Moscow: 'All Russian craftsmen are excellent, very skilful and so clever, that even though they haven't seen something before – never mind that they haven't made it – they will understand it at first glance and work on it as well as if they were familiar with it from their infancy; in particular, the Turkish goods like caparison [horse trappings], saddles, and sabres with gold damascening.'[3]

It was therefore not surprising that the Persians were keen to obtain armour, helmets, hauberks, pistols, guns, knives and *zertsala* (plates for the protection of chest, sides and back) from Russian merchants. These commodities were always welcomed by the soldiers. Nonetheless, some of the most magnificent examples of the Eastern-style weapons, often unique, were designated as gifts for the Russian Tsars and their closest entourage at court. Today these items are kept in the collections of the museums of Moscow and St Petersburg.

Blacksmiths in Russia, working alongside the Tsars' master craftsmen, specialised in the mass production of arms and armour. Although decorated more plainly, these items also attracted the attention of Eastern buyers.

However, the most sought-after goods from Eastern master craftsmen in the Russian state were textiles, and the Tsar in Moscow held the monopoly on their import. Precious textiles were required for the court and church [cat. nos. 181-83]; they were used as rewards for employees or given to foreign visitors as gifts. One list of textiles delivered to Moscow in vast quantities during the sixteenth to seventeenth centuries is very extensive with more than twenty different types of silk and cotton textiles alone. The main types are discussed below.

Merchants brought various kinds of damask from Turkey and the Crimea as early as the end of the fifteenth century: damask is a thick, closely woven fabric with an identical pattern on both sides. Muscovites called it 'Bursa', after the town where it was produced, a former residence of the Turkish sultans. Byzantine, Shami (from Syria) damask, and damask from Damascus, were also familiar materials. Pile weave was also brought from the aforementioned town of Bursa, and from cities in Iran such as Kashan, Tabriz, Isfahan and Yazd. A golden pile weave, with an image of the 'Immaculate Mother of God with the Infant and Angels above them with a Star', was exported specifically to Moscow in the sixteenth century. Typically, Turkish velvets were produced with overall lattices of pointed ovals, carnations in the shape of a fan, hyacinths, pomegranates or tulips. These were spectacular textiles, used in the making or tailoring of the best secular, royal and church clothing, in the decoration of the tsars' and boyars' mansions, where they served as covers and curtains, and also for horse furnishings and saddles. Sixteenth-century velvets by Persian master weavers, complete with images of people and animals inspired by illustrations of the Persian poet Nizami's poetic love story Layli and Majnun,[4] are unique today [cat. no. 182].

Another luxurious type of velvet with threads of spun gold was already known in Russia back in the twelfth century. It is not accidental that in the seventeenth century Russian icon painters began to depict the saints in regal clothes made of this fabric.

The designs of Eastern velvets inspired a creative rethink among Russian craftsmen; and, as early as the seventeenth century, designs of flowers and fruit borrowed from such velvets were applied to printed canvas, used for clothes, and many other purposes.

Silk-producing regions in Iran and Azerbaijan sup-

plied the Russian market with an assortment of fabrics. Apart from velvets, satin, taffeta, and *âbdâr*, damask and *dorogi* were also imported from there.

Satin is a silk fabric which is mainly plain; the weavers from Shemaha were particular famous for satin production. It is known that the kaftan of the Moscow Patriarch Nikon, in the seventeenth century, was made of Qizilbash (Persian) satin.

Taffeta is a thin fabric of plain colours; it was produced in the towns of Bursa, Tokat, Damascus and Shemaha.

Âbdâr is a fabric that is highly regarded in domestic Russian life, and used for outer clothes such as *opashens* (formal cloak-like outdoor garments for men), kaftans, *telogreyas* (long loose dresses buttoned-up or belted at the front), fur coats, hats and church garments. The content of silk threads, combined with spun golden and silver threads, is a feature of Eastern *âbdâr*.

Dorogi, on the other hand, is a cheap striped fabric with fine geometric or floral designs. In the seventeenth century it was called 'Persian taffeta'. This type of Eastern fabric was very much to the taste of the Russian weavers and as a result they began to call their own printed fabric versions *dorogi*, meaning roads.

Cotton textiles, like calico, printed textiles and muslin, soon became widespread; they were usually delivered by merchants from Bukhara and Hivin in Inner Asia, while sheeting and *pestryad*, a multicolored checked wool fabric, arrived in Russia from Aleppo.

Woollen fabrics, on the other hand, typically came from the countries of Western Europe and Turkey; for example, the thick woollen fabric *zuf*,[5] a Turkish derivative of the Arabic word 'suf', was sent from Ankara.

During the eighteenth to nineteenth centuries the fabric trade with Eastern countries was gradually dying out: the changing political dynamics in the region contributed to this decline. Nevertheless, the import of tobacco, dry fruit, cotton, raw silk, stonepastes, metalwork, leather and fabric still continued. The Persians, for example, delivered not only the aforementioned goods to the Russian market, but also carpets, and shawls with delicate designs which were popular in Russia and Western Europe at that time. The shawls were produced by the master weavers from Mashhad and Kerman.

Although the production of silks continued in Kashan, Isfahan and Khurasan, the silk trade gradually began to decline as Russia's own silk-weaving manufacturing was established.

Another type of exotic item brought in from Eastern countries during the sixteenth to seventeenth centuries was coconut. The shells were used to make all different kinds of vessels.[6] At the turn of the seventeenth to eighteenth centuries, Russian craftsmen started to make ceremonial stoups and goblets from coconut, using the techniques of bone- and wood-carving, and decorating its surface with different ornaments like portraits of royal personages, and symbolic images.

In summary, the above provides a general picture of the trade relation between the Islamic world and the Russian state over the centuries. It has been a relationship that was not only about the movement of commodities to and fro, but, more importantly, a relationship that engendered an artistic dialogue between Russian and eastern artisans and the exotic goods they encountered.

NOTES:

1 M. B. Fehner: *Trade between the Russian State and the countries of the East in the sixteenth century* (Moscow 1956); M. G. Rabinovich: *Articles on the material culture of the Russian feudal town* (Moscow 1988).

2 M. M. Denisova: 'Artistic armour and weapons' in *Russian decorative art from the ancient times until the eighteenth century*, in three volumes (Moscow 1962), vol. 1, p. 406.

3 S. Maskevich: *Diary 1594-1621* (St Petersburg 1834), p. 54.

4 (See Wikipedia.) 'Layli and Majnun', or 'Leyli and Madjnun'. A classical Persian love story, supposedly based on the real story of a young man called Qays ibn al-Muwallah in the Umayyad era, who, upon seeing Layli, fell in love with her most passionately and went mad when her father prevented them from marrying; for that reason he came to be called Majnun Layli, literally 'Crazy for Layli'. A variety of incredibly passionate romantic Arabic poems were attributed to him and they are considered to be among the foremost examples of the Udhari school. From Arab folklore, the story passed into Persian literature, and the Persian poet Nizami wrote a famous account of their love. (Trans.)

5 V. Klein: *Foreign fabrics prevailing in Russia in the eighteenth century and their terminology* (Moscow 1925); N. N. Sobolev: *Essays on the history of fabric design* (Moscow/ Leningrad 1934); I. A. Alpatova: 'Printed fabric' in *Russian decorative art from the ancient times until the eighteenth century*, ibid., pp. 434-52.

6 I. N. Ukhanova: 'Coconut in the art of the Russian craftsmen in the seventeenth to eighteenth centuries from the collection of the Hermitage', in *Cultural artefacts. New Discoveries* (annual edition, 1990) (Moscow 1992).

Trade Connections between the Islamic World and Russia

181

COPE

Turkey (Bursa), first half of 17th century (fabric)

Russia, first half of 17th century (neckpiece)

Silk, velvet, silver thread; 150 cm (length)

Origin: acquired in 1936 from the State Russian Museum

State Hermitage Museum, inv. no. VT-1034

Reference: Atasoy 2001, pp. 149, 152, pl. 105

Exhibition: London 2004, no. 55

The fabric of this cope is decorated with stylized lotus flowers. Inside each of the flowers are alternating tulips and carnations. This is an example of the flexibility of Turkish floral designs, as used to decorate various materials. The serrated leaf, like the other plant elements in this fabric, is a decorative element also widely used in ceramics.

Turkish fabrics from Bursa were in great demand in Russia, where they were used to make cloaks for the Russian clergy. They were additionally used in domestic life, for example at the Romanov Estate (Moscow) in the seventeenth century. (A.P.)

182

MAJNUN COPE

Iran, end of 16th century (fabric)

Russia, 17th century (neckpiece)

Velvet, silver thread; 136 cm (length)

Origin: acquired in 1930 from the State Historical Museum, Moscow

State Hermitage Museum, inv. no. IR-2327

References: Kverfeldt 1940, pl. iii; Loukonine–Ivanov 1966, no. 182

Exhibitions: München 1912, Taf. 195; Maastricht 1994, no. 26; Amsterdam 1999, no. 79; St Petersburg 2000, no. 85; London 2004, no. 52

Although largely surviving only in fragment form, some splendid examples of Iranian silk and brocade fabrics remain from the sixteenth and seventeenth centuries. Many of these are decorated with images of people, animals and birds, and the themes of some compositions are drawn from Persian poetry. One of the most spectacular examples is a brocade velvet fabric decorated with an image of Majnun, hero of the poem 'Layli and Majnun' by Nizami, in a desert surrounded by wild animals. This theme has often been illustrated in the manuscripts of Nizami's poem, as late as the beginning of the twentieth century.

This brocade fabric was created at the end of the sixteenth century. Later it found its way to Russia, where it was used to make a vestment for a Russian priest; it was at this point that the neckpiece was added. This practice of preparing luxurious clothes from Iranian and Turkish cloth was common in Russia in the seventeenth century. (A.I.)

183
COPE

Iran, 17th century (fabric)

Russia, end of 17th century (neckpiece)

Size: 141 cm (height)

Origin: acquisition unknown

State Hermitage Museum, inv. no. VT-1030

Exhibitions: Kuwait 1990, no. 107; St Petersburg 2000, no. 90

The splendid silk fabrics made in Turkey and Iran were in demand in many countries. In Russia they were commonly used in the vestments of the Russian clergy. Thanks to this practice, examples of Turkish and Iranian fabrics have been preserved into the twentieth century in the treasuries of Russian churches and monasteries. A striking example of the use of Iranian brocade in the seventeenth century is this vestment of a Russian priest, where the neckpiece, as was the usual practice, was Russian-made (traces of Turkish ornament can be seen in the embroidery). The design of the Iranian fabric includes series of floral sprays with carnation flowers and smaller groups of tulips made with different silks (red, pink, yellow, light and dark blue, green and dark green), while the background is interwoven with silver thread. Artistic fabrics with such artfully executed patterns and complex palettes provide an insight into the sophisticated luxury of court life in Safavid Iran. (A.A.)

184
SILK SASH

Iran, 18th century

Size: 379 cm x 59.5 cm

Origin: acquired in 1925 from the Museum of the former Central School of Technical Drawing of Baron A. L. Stieglitz

State Hermitage Museum, inv. no. VT-1107

Exhibition: St Petersburg 2004, no. 208

This sash of brocade has a fine, interwoven geometric pattern of rosettes and flowers with multiple petals. The motifs repeat in a horizontal line and diagonally, merging into an unending, rhythmic pattern. The ends of the sash are decorated with four almond-shaped motifs, each one densely packed with flowers and reminiscent of a bouquet of flowers (the betel leaf, or *buta* motif).

In Iran such sashes became fashionable from the end of the sixteenth century, and remained an important element of clothing much later: in the seventeenth and eighteenth centuries they were used to tie gowns. In the seventeenth century, silk sashes became fashionable in Europe, especially in Poland, where the production of sashes copying Iranian originals was centred in the town of Slutsk. (A.A.)

185
SABRE WITH SHEATH

Turkey, 17th century

Inscription: Russia, 17th century

Steel, silver, gilding, cinnamon stone, turquoise and brocade; 78 cm (length)

Origin: acquired from the Tsarskoe Selo Arsenal

State Hermitage Museum, inv. no. OR-3888

Published for the first time

The sheath of this sabre is covered with brocade, while the mouth and the tip are completely covered with a gilt silver sheet, with inlay of large turquoise stones, while the central part of the sheath is enclosed with more brocade. The handle of the sabre is made from a coloured stone. The blade is clearly the work of Turkish armourers, although the rounded end is not observed very frequently on Turkish weapons. The blade bears a gold inscription in Old Russian, stating that the object was made for the *boyar* Mikhail Borisovich Shein, a famous Russian political figure of the early seventeenth century, executed in 1634 for the defeat by the Polish army. (A.P.)

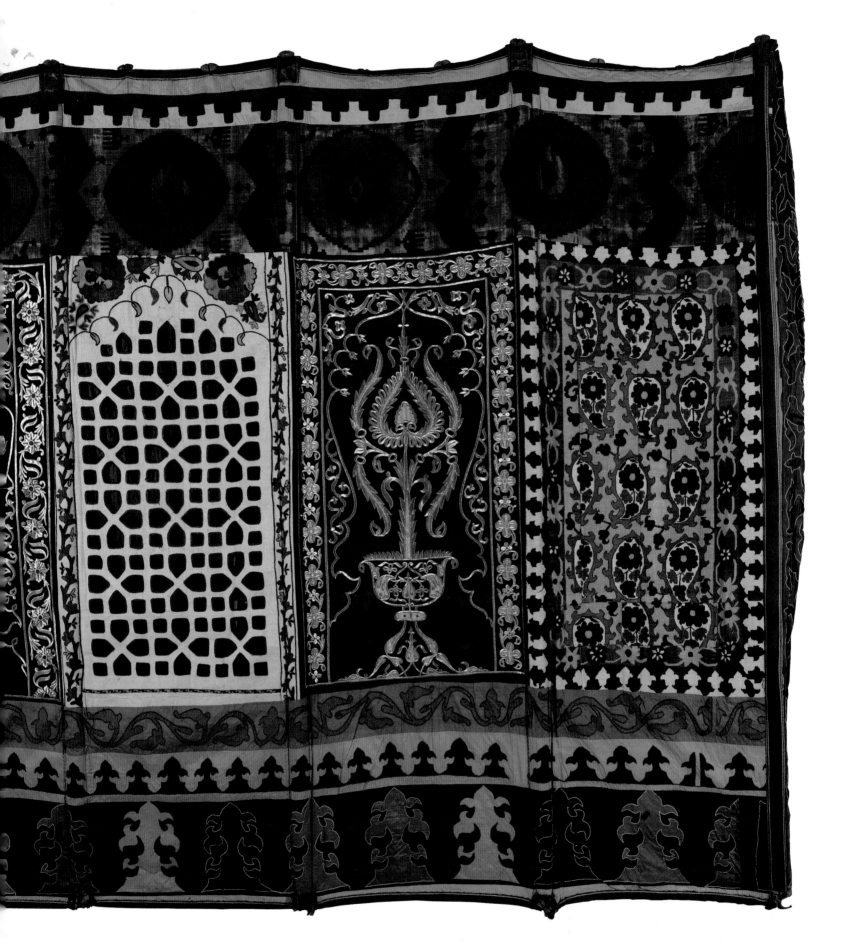

Diplomatic Gifts and Trophies

Anatoly A. Ivanov

196
TENT
(see page 205)

Russia's relationship with Islamic countries began in the thirteenth century when Islam made its first inroads into Inner Asia with the Khanate of the Golden Horde. However, it only became the dominant faith there in the first third of the fourteenth century. Initially relationships were highly complex, as the Russian principalities served as vassals to the Khans of the Golden Horde. Material evidence concerning the exchange of embassies or military trophies between the thirteenth and fifteenth centuries has not survived. After the collapse of the Golden Horde at the end of the fifteenth century, and the liberation of what was now the state of Muscovy from its dependence on the former, we find the beginnings of active diplomatic and military links with Crimean and Kazan khanates. After the incorporation of the Astrakhan khanate into Russian territory in the second half of the sixteenth century, Russia came into direct contact with Iran. In fact Persian sources state that Russians were living in Herat during this period, but this cannot be confirmed from Russian documents. During the reign of Shah Abbas I (1587-1629), several embassies arrived in Russia from Iran, bearing gifts which are now kept in the Armoury Section of the Moscow Kremlin. There were also regular diplomatic exchanges with the Ottoman empire during this period. These embassies brought Moscow, as capital of the Russian empire, various gifts, which are also kept in the Armoury Museum. Because the gifts were well chosen, wonderful examples exist to this day of jewellery, arms and precious textiles from the two countries.

Links with the Central Asian khanates were not as well developed in the seventeenth century in comparison to those maintained with Iran and Turkey. The

situation changed, however, at the end of the seventeenth century, when Russia began the search for an outlet to the Black Sea and the wars with Turkey commenced. These wars continued into the eighteenth century, and by the second half of the century Russia gained its outlet to the sea by conquering the steppes in the south of what is now Ukraine, and by incorporating the Crimean khanate.

In the first half of the eighteenth century contact with Iran was restricted to military conflict which led to the incorporation of part of northern Daghestan into the Russian empire. Trophies acquired after the cessation of war with Iran and Turkey are of great interest for research, but it has been impossible thus far to distinguish these trophies from other surviving Middle Eastern arms. After numerous wars with Turkey in the eighteenth and nineteenth centuries, Russia's collections obtained thousands of pieces. Most of them are arms [cat. nos. 186-89, 192-94] or different military equipment [cat. nos. 110, 190, 191].

The new capital of Russia, St Petersburg, was founded in 1703, and soon embassies began to arrive bearing gifts. Unfortunately these embassy gifts are very difficult to assign to their respective origins. Documents charting the arrival of embassies in St Petersburg only mention the gifts in passing, or simply list them without any description. This does not allow us to identify individual pieces. The Hermitage inventory usually indicates the date when the gifts arrived, without, however, indicating their origin.

The Hermitage itself was created in 1764 and gradually transformed into a museum. Different precious objects were stored in Catherine II's personal apart-

ments, and there is an inventory of these items which was compiled in the 1770-80s. However, even if Eastern objects of interest exist within this inventory, we know neither their date nor the context in which they originated.

In Russia's Foreign Policy Archives there survive thousands of pages that deal with Russia's connections with, especially, Turkey and Iran, as well as other Muslim countries. No individual involved in research in this field has read them, or even listed them in their search for documents describing embassy gifts. There are a few fortunate exceptions, such as the description of Nadir Shah's embassy of 1741 (see cat. nos. 223-25).

Judging by documents concerning gifts from the khans of Central Asia from the end of the nineteenth and early twentieth centuries, they were never meant to be museum exhibits but were actually used by members of the Imperial household. Others were assigned to the palace administration. Carpets, for example, were distributed among different palaces. Nonetheless only a small number of these gifts have survived, and any conclusion about what some of them were is almost impossible due to the lack of precise details.

The same can be said of military trophies, especially arms. They allow us to assess technical achievement, and at the same time, given their decoration, are examples of applied art. There is a problem with correct attribution, however. Pieces of armour pass easily from one country to another, and from one hand to another. When these trophies happened to reach Russia, there was no rush to record their place of origin. The best examples of Middle Eastern armour arrived in 1886 from the Arsenal at Tsarskoe Selo. The basis of the Arsenal was Nicholas I's collection, which was added to after his death. What is not always known is how these items found their way to the Arsenal in the first place. The same can be said of the collection of banners, originally collected as trophies and subsequently kept in the churches of the Guard regiments, only to be acquired by the Hermitage in the 1940s.

In conclusion it can be said that this is only the beginning of the study of works of art from the Islamic world that reached Russia in the shape of embassy gifts or military trophies. New finds and discoveries still await us.

Diplomatic Gifts and Trophies

186
GUN

Ottoman Empire (Balkans), 18th century

Steel, silver, velvet; 146 cm (length)

Inscription: 'Amal Hajji Muhammad in 1213A.H./1837-38A.D., converted to Christian (early 19th century)'

Origin: acquired from the Tsarskoe Selo Arsenal

State Hermitage Museum, inv. no. OR-797

Published for the first time

This weapon is one of a wide range of weapons manufactured in the Balkans for the Turkish army. They were usually decorated with velvet, repoussé silver, mother-of-pearl, and often bore various inscriptions. (A.P.)

187
GUN

Ottoman Empire (Algiers), 18th century

Steel, silver, coral; 157.7 cm (length)

Origin: acquired from the Tsarskoe Selo Arsenal

State Hermitage Museum, inv. no. OR-813

Published for the first time

This rifle is one of very few such weapons to be decorated with coral, although there are similar examples in museums around the world. The production of such weapons may have taken place in Algiers. (A.P.)

188
DAGGER

Turkey, 18th century

Steel, silver, repoussé; 48 cm (length)

Inscription (on sheath), in Arabic in *naskhi* script: 'ma sha Allah' (a protective motto)

Origin: acquired from the Tsarskoe Selo Arsenal

State Hermitage Museum, inv. no. OR-267

Published for the first time

The handle and sheath are completely covered with silver, decorated with repoussé and blackened ornament, with elements of rococo design (for example, the shells and cartouches). (A.P.)

189
DAGGER

Turkey (Istanbul), 18th century

Steel, silver, turquoise, repoussé; 37.5 cm (length)

Origin: acquired from the Tsarskoe Selo Arsenal

State Hermitage Museum, inv. no. OR-471

Published for the first time

The handle and sheath are completely covered with a sheet of silver with turquoise inserts. The use of repoussé silver and turquoise was common in the decoration of Turkish daggers of the eighteenth to nineteenth centuries, and this piece was probably made in Istanbul. Judging by the ornamentation, in which baroque influence is noticeable, this dagger can be dated to the eighteenth century. (A.P.)

186

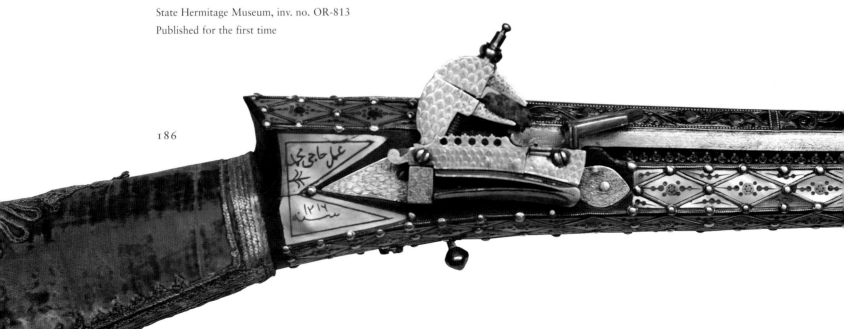

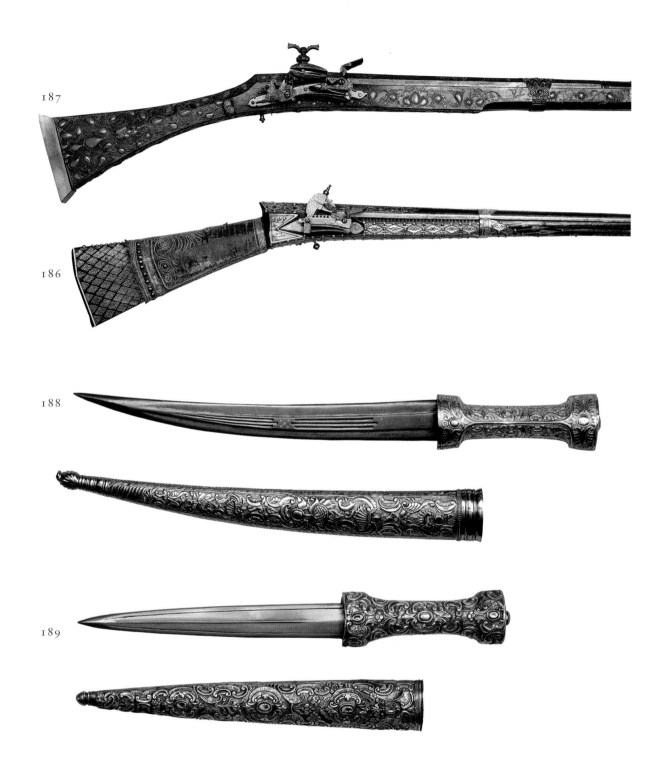

187

186

188

189

190
BASHAW'S HORSETAIL
Turkey, 19th century
Horse hair, coloured thread, wood, plaiting; 250 cm (height)
Origin: acquired in 1948 from the Artillery History Museum
State Hermitage Museum, inv. no. EZn-5901 (G.V.)

191
MARINE PENNON
Turkey, 18th century
Canvas, painting; 69 cm x 419 cm
Origin: acquired in 1948 from the Artillery History Museum
State Hermitage Museum, inv. no. EZn-5994
Not in exhibition

Fish are depicted on the width with two plaits of white colour and a border of green colour. There are inscriptions on the top edge: 'Allah wished thus' and 'Hope for Allah.' The pole is brown with a finial. (G.V.)

192
YATAGHAN (SABRE WITH SHEATH)
Turkey, end of 18th to beginning of 19th centuries
Steel, silver, leather, wood; 82 cm (length)
Inscription (on sheath), in Arabic in *naskhi* script: 'ma sha Allah' (a protective motto)
Origin: acquired from the Tsarskoe Selo Arsenal
State Hermitage Museum, inv. no. OR-3493
Published for the first time

The yataghan was one of the most popular types of arms in Turkey in the eighteenth to nineteenth centuries. Some earlier examples are known, such as the famous yataghan from the Topkapi Collection made for Suleiman I in 1527, and decorated by court jewellers (Washington 1987, no. 86).

As many surviving yataghans bear inscriptions in verse, which refer to the weapon itself, it can be confidently argued that in Turkey such weapons were in fact not called a yataghan, but *bichaq* (knife). 'Yataghan' is probably a collective term for all forms of cutting instruments. In European literature, yataghan now refers to the type of weapon exhibited here.

The yataghan combines the properties of a knife (cutting), an arm (stabbing), and a sabre (slicing). The blade was usually curved in two directions. Yataghans were most likely carried tucked into a belt.

The handle is completely covered with a sheet of silver. The sheath is made of leather, with a silver tip and mouth. The sheath also bears the image of a European-style sailing ship, typical of the end of the eighteenth to beginning of the nineteenth centuries. (A.P.)

193
YATAGHAN (SABRE WITH SHEATH)
Turkey, beginning of 19th century
Steel, silver, coral, ivory, wood; 75 cm (length)
Origin: acquired from the Tsarskoe Selo Arsenal
State Hermitage Museum, inv. no. OR-476
Published for the first time

The ivory handle is decorated with a silver strip and large corals, while the sheath is decorated with an embossed gold lattice pattern. It is thought that the shape of this yataghan handle imitates the shinbone of an animal [see also cat. no. 192].

Unlike other Turkish weapons in this catalogue, this item can be dated confidently to the beginning of the nineteenth century, as elements of European empire style are visible in the decoration, like the crossed 'trophy' weapons located inside oval medallions on the sheath. (A.P.)

190

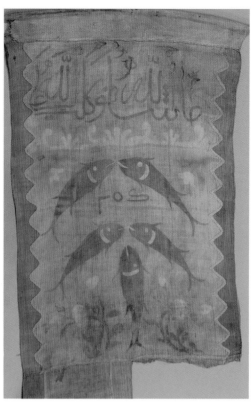

191

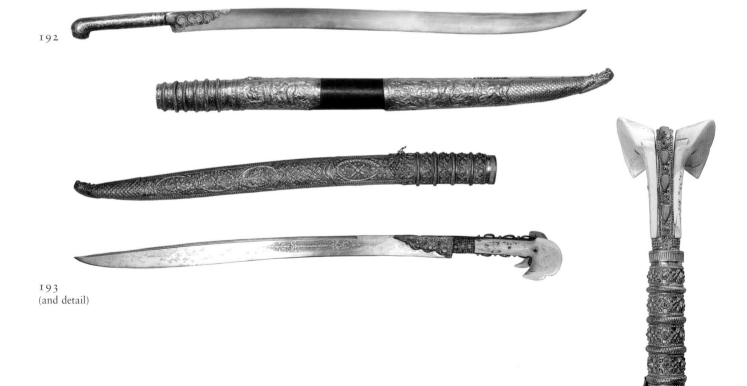

192

193
(and detail)

194

EMBROIDERY (PORTRAIT OF RUSSIAN TSAR ALEXANDER II)

Iran, 1292A.H./1875A.D.

Craftsman: Ruhallah

Broadcloth with embroidery and appliqué in gold, coloured glass; 177 cm x 121 cm

State Hermitage Museum, inv. no. VT-1468

Origin: acquired in 1954 from the West European Art Department of the State Hermitage (possibly from the Collection of the Winter Palace)

Exhibition: Turku 1995, no. 208

On a small mat of red broadcloth is a portrait of the Russian Tsar Alexander II (1855-81). He is portrayed sitting on an armchair, adorned with medals, with a rose in one hand. Inserts of black and white broadcloth are used, as well as embroidery and gold appliqué. The clothes and armchair are decorated with inserts of coloured glass. The borders of the embroidery show flower motifs. In a cartouche in the corner is the Persian inscription, 'amila ustad Ruhallah 1292' (1875).

Shah Nasir ad-Din (1831-96) arrived in St Petersburg in 1873 and spent five days in the city. His visit was recorded in a number of watercolours by Zichi, a court painter to Alexander II (St Petersburg 2004, nos. 250-53). (A.A.)

195
LACQUER BOX

Iran, 1301A.H./1883-84A.D.

Craftsman: Master Abu'l Qasim al-Husaini al-Isfahani

Wood, lacquer, painted decoration; 9.5 cm x 32 cm x 12.5 cm

Origin: acquired in 1941 from the State Museum of Ethnography of the Peoples of the USSR

State Hermitage Museum, inv. no. REG-390.0-168

Exhibition: St Petersburg 2004, no. 230

This box is oblong with a removable lid. Its surface is decorated with a traditional Iranian lacquer miniature with a colourful painted design of flowers and birds. Along the edge of the lid are two bands with inscriptions in Arabic. On the front face of the lid is a copy of the Russian Imperial crown and the name 'Mikhail' in the form of a Turkish monogram. On the inside wall of the lid is the Arabic inscription: 'Made by Abu'l Qasim al-Husaini al-Isfahani', and verses of Persian poetry. On the reverse side of the lid, in black paint over a gilded background, is a round medallion containing the Persian inscription: 'Commissioned by Mirza, Christian and interpreter of the General Consul of the High Russian State. 1301 (1883-1884).' This box was probably one of the commissioned gifts intended for the Russian Emperor from the Persian Shah Nasir ad-Din of the Qajar dynasty. (I.U.)

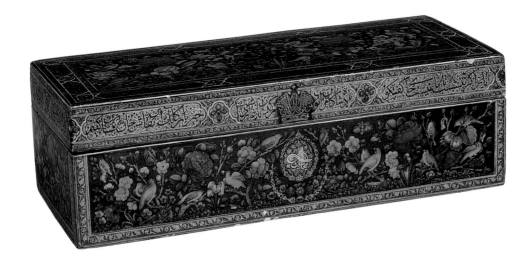

196

TENT (see page 196)

Bukhara (Karshi), second half of 19th century

Adras, velvet, silk, gold and silver thread, embroidery;
973 cm x 214 cm (max. height with rods 224 cm)

Origin: acquired in 1931 from the former Stables Museum

State Hermitage Museum, inv. no. VT-1606

Published for the first time

This tent was presented to Alexander III by the Emir of Bukhara on 4 January 1893. The exhibit includes the walls of the tent (or *shatyor*) for receiving the guests of the Emir. The entire tent consists of 15 vertical sections, separated by rods and sewn in; both ends of the rods are sheathed in leather. It has loops of multicoloured silk threads and wooden 'buttons' for attaching the remaining parts and the tent ceiling. Each part of the wall is decorated with original designs. In the centre are inserts which imitate windows, which are made using a variety of techniques. Some of the central inserts are covered with embroidery using silk threads in a solid cross-stitch pattern; four bouquets are embroidered with gold and silver threads on magenta velvet; two lace-work windows have openings cut from white and pink silk. The windows are covered from the inside with curtains made of green and dark blue silk. Above and below are ornamental strips of silk, decorated with appliqué made of silk of a different colour. In the upper part of the wall there are a number of inserts of multicoloured silk velvet. The inside surface of the *shatyor* wall is also richly decorated with multicoloured silk inserts, with plant ornament appliqué work. One such appliqué of light green silk bears the legend: 'Factory of the Trading House of Brothers M. and I. Shyerbakov, Kolomensk District.'

It would appear that this silk was purchased in Russia, which became common practice in trade with Central Asia during the 1880s. (S.A.)

205

197
ROBE WITH GOLD THREAD
Bukhara, second half of 19th century

Velvet, gold and silk thread, *ikat*, embroidery; 224 cm (width), 145 cm (height)

Origin: acquired in 1926 from the Museum of the former Central School of Technical Drawing of Baron A. L. Stieglitz

State Hermitage Museum, inv. no. VT-1537

Published for the first time

This robe belonged to an emir or high-ranking bureaucrat. It includes embroidery with gold thread on silk velvet, with lining made from *ikat* silk with embroidered ribbon. On the outside, the entire surface is covered with embroidery in the form of geometric patterns, using gold threads with inserts of green velvet, upon which a stylized plant ornament has been created. On the inside is a stylized plant ornament in crimson, white and violet over a yellow base.

The gown has been decorated using the technique of *zardozi zaminduzi*, in which a solid gold base is embroidered. Using this technique, gold thread is used to cover entirely the fine braids attached to the fabric. (S.A.)

198
ROBE WITH GOLD THREAD
Bukhara, second half of 19th century

Velvet, gold and silk thread, *ikat*, embroidery; 200 cm (width), 137 cm (height)

Origin: acquired in 1926 from the Museum of the former Central School of Technical Drawing of Baron A. L. Stieglitz

State Hermitage Museum, inv. no. VT-535

Exhibition: Amsterdam 2003, no. 218

Another robe of an emir, or a high-ranking bureaucrat, this example includes embroidery with gold thread on silk velvet, and the lining is made from *ikat* silk with embroidered ribbon. On the outside there is plant ornament over a dark green base. On the inside is a crimson and violet pattern on a yellow base. (S.A.)

199
ROBE
Bukhara, mid-19th century

Broadcloth, silk thread embroidery; 201 cm (width), 138 cm (height)

Origin: acquired in 1926 from the Museum of the former Central School of Technical Drawing of Baron A. L. Stieglitz

State Hermitage Museum, inv. no. VT-538

Exhibition: Amsterdam 2003, no. 218

This robe is decorated with plant ornament using white, dark blue and yellow colours, with green and dark blue runners over a red base. This robe is not lined and the lower hem is not decorated. (S.A.)

200
SILK ROBE
Bukhara, second half of 19th century

Ikat silk; 188 cm (width), 147 cm (height)

Origin: acquired in 1926 from the Museum of the former Central School of Technical Drawing of Baron A. L. Stieglitz

State Hermitage Museum, inv. no. VT-394

Published for the first time

This woman's robe is made from *ikat* silk, and a printed cotton fabric lining. The flaps are lined with *ikat* fabric, and have a multicoloured fabric fringe. A stylized plant ornament (pomegranate seed design?) is applied to a green base in the form of red circles with yellow centres and white outlines. (S.A.)

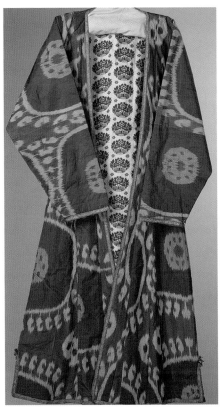

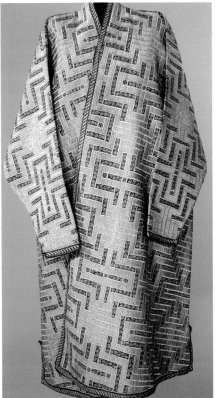

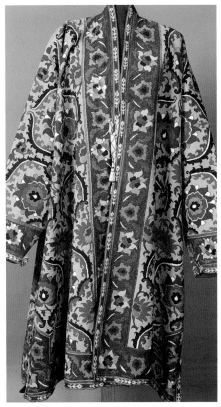

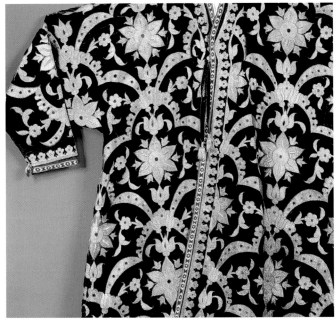

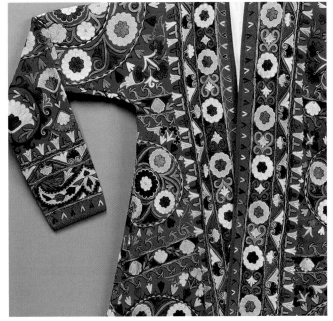

198

199

201
ROBE

Bukhara, second half of 19th century

Cotton fabric, silk threads, embroidery; 207 cm (width), 142 cm (height)

Origin: acquired in 1931 from the former Stables Museum

State Hermitage Museum, inv. no. VT-662

Published for the first time

This man's garment is embroidered with silk threads over cotton fabric, with a multicoloured fabric fringe. The surface is completely covered with solid cross-stitch embroidery using multicoloured silk threads, in a plant ornament over a yellow base. The lining is *ikat* silk. (S.A.)

202
TROUSERS

Bukhara, second half of 19th century

Chamois, embroidery; 108 cm x 64 cm

Origin: acquired in 1931 from the State Hermitage Museum of Applied Arts and Industrial Technologies

State Hermitage Museum, inv. no. VT-300

Published for the first time

These riding trousers were worn by high-ranking soldiers from Bukhara. The embroidery in the form of flowers and runners is executed using silk threads in a tambour stitch, separated by a multicoloured, embroidered border. (S.A.)

203
TROUSERS

Bukhara, second half of 19th century

China, second half of 19th century (silk)

Silk, embroidery; 110 cm x 67 cm

Origin: acquired in 1931 from the State Hermitage Museum of Applied Arts and Industrial Technologies

State Hermitage Museum, inv. no. VT-291

Published for the first time

These dress trousers for men are of black Chinese silk with a printed pattern in the form of rosettes and dragons. The upper section is smooth, while the lower part (from the middle) is covered in multicoloured plant ornament, made using silk threads in tambour stitch. Along the edges of the leg sections is a stitched border. The inner lining is made from printed cotton fabric. The use of Chinese silk illustrates the active trade relations Bukhara maintained in the second half of the nineteenth century, not only with Russia and Europe but also with the East. (S.A.)

204
CAP

Central Asia, end of 19th century

Satin, cotton fabric, embroidery; 15 cm (height)

Origin: acquired in 1931 from the Antiquities Warehouse of the State Academy

State Hermitage Museum, inv. no. SA-14945

Published for the first time

This skull-cap is made of red satin on a cotton lining. The embroidery uses dark blue, brown and white silk. In the centre is an eight-pointed rosette, surrounded by ornamental bands and figures in cartouches. The cap has an extension at the back, continuing the solid embroidery of the cap itself (S.A.)

202

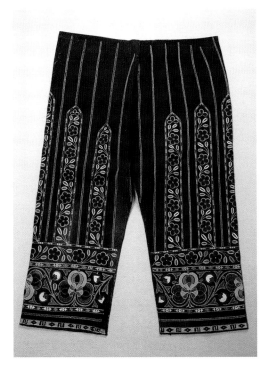

203

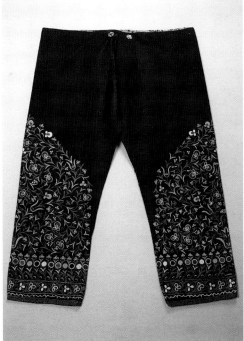

206

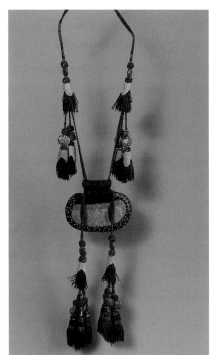

207

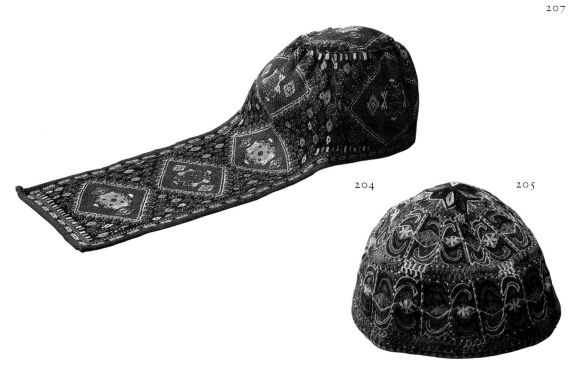

204 205

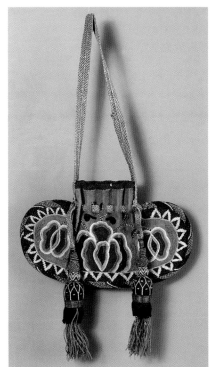

205
CAP

Bukhara, second half of 19th century

Cotton fabric, silk, embroidery; 42.5 cm x 23.5 cm

Origin: acquired in 1926 from the Museum of the former Central School of Technical Drawing of Baron A. L. Stieglitz

State Hermitage Museum, inv. no. VT-551

Published for the first time

This woman's cap has solid, multicoloured embroidery using silk threads on a cotton base, with stylized vegetal and geometric ornament. (S.A.)

206
PENDANT PURSE

Bukhara, second half of 19th century

Brocade, felt, silk, white metal; 7.5 cm x 9.6 cm

Origin: acquired in 1926 from the Museum of the former Central School of Technical Drawing of Baron A. L. Stieglitz

State Hermitage Museum, inv. no. VT-523

Published for the first time

This purse was an accessory for girls, worn over the chest. The main part of the purse is made from gold brocade, while the upper part is made from black broadcloth. The opening is lined with red ribbon, and the lower part with blue ribbon with red and yellow flecks. The pendants are made from brown silk thread tied into 16 small tassels, decorated with red and yellow woven silk ornaments and white-metal baubles. (S.A.)

207
PURSE

Bukhara, second half of 19th century

Chamois, silk; 15.9 cm x 9.9 cm

Origin: acquired in 1926 from the Museum of the former Central School of Technical Drawing of Baron A. L. Stieglitz

State Hermitage Museum, inv. no. VT-526

Published for the first time

This purse is made of light brown chamois leather, and decorated with multicoloured silk thread embroidery. A multicoloured silk ribbon is sewn around the edge. The pendant is woven from light blue silk thread, and decorated at the ends with two small tassels of brown and light blue silk. (S.A.)

208
BELT

Bukhara, second half of 19th century

Canvas, silk; 322 cm x 8.5 cm

Origin: acquired in 1926 from the Museum of the former Central School of Technical Drawing of Baron A. L. Stieglitz

State Hermitage Museum, inv. no. VT-509

Published for the first time

This canvas belt is embroidered on the outside with crimson and dark green silk threads, in a stylized plant ornament. A light brown ribbon is sewn along the edge. (S.A.)

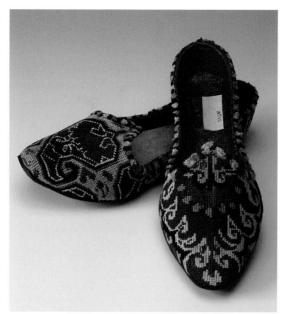

212

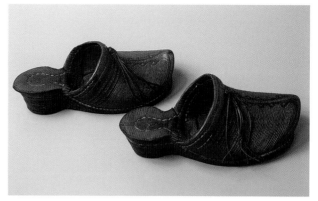

210

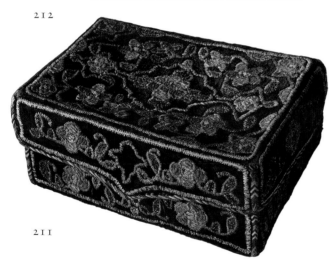

211

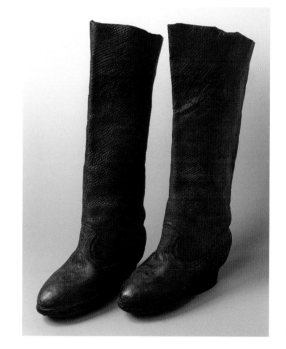

215

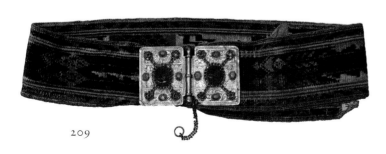

209

208

209
BELT
Bukhara, second half of 19th century

Velvet, copper(?), glass, paste; 140 cm x 10.8 cm

Origin: acquired in 1926 from the Museum of the former Central School of Technical Drawing of Baron A. L. Stieglitz

State Hermitage Museum, inv. no. VT-512

Published for the first time

This man's belt of silk velvet has a geometric pattern on both sides. The buckle is made of copper (base metal) decorated with an engraved plant ornament, and inserts of coloured glass and paste imitating precious stones. (S.A.)

210
SHOES
Central Asia, second half of 19th century

Leather; (a) 23 cm, (b) 23 cm (length)

Origin: acquired in 1926 from the Museum of the former Central School of Technical Drawing of Baron A. L. Stieglitz

State Hermitage Museum, inv. nos. PE-426 a,b

Published for the first time

These men's shoes of red leather have a small, round heel, open at the top, and are decorated with strips of tooled geometric ornament and black paint. On top of the shoe is a tassel of six rawhide straps. The toes are pointed with upturned tips. (S.A.)

211
CASKET
Bukhara, second half of 19th century

Leather, velvet, silk; 15 cm x 10 cm x 6.7 cm

Origin: acquired in 1926 from the Museum of the former Central School of Technical Drawing of Baron A. L. Stieglitz

State Hermitage Museum, inv. no. PE-408

Published for the first time

The outside of this oblong, leather casket is covered with crimson velvet and decorated with embroidery using gold and silver thread, and green as well as light blue silk, in a plant ornament. On the inside the casket is lined with silk fabric, printed with a pattern of small flowers. (S.A.)

212
WOMAN'S SLIPPERS
Bukhara, second half of 19th century

Leather, silk; (a) 24.7 cm, (b) 24.5 cm (length)

Origin: acquired in 1926 from the Museum of the former Central School of Technical Drawing of Baron A. L. Stieglitz

State Hermitage Museum, inv. nos. PE-424, 425

Published for the first time

These shoes are made from leather, with a low heel. They come from two different pairs. The surface is covered with solid, multicoloured cross-stitch embroidery using silk threads in a stylized plant ornament. (S.A.)

213

CASE FOR TEA BOWL

Bukhara, second half of 19th century

Leather, copper wire, porcelain; 48 cm (length, case), 9.7 cm (height); 13.5 cm (diameter, *piala*), 6 cm (height)

Origin: acquisition unknown

State Hermitage Museum, inv. nos. SA-15104 a,b

Published for the first time

This travelling case for a tea bowl, or *piala*, was attached to a saddle. It is made from leather, is hemispherical, and is sewn from four sections, with a long strap that ends in a loop. It is embroidered with green stripes and copper wire. The case contains a porcelain *piala*, decorated with four medallions, containing flowers. On the bottom of the piece is an imitation Chinese mark. The bowl may have been made at the factory of F. Gardner in Moscow at the end of the nineteenth century. (S.A.)

214

CASE FOR TEA BOWL

Bukhara, end of 19th century

Leather, velvet, ribbon, silver, embossing, enamel; 14 cm (diameter), 24.5 cm (length)

Origin: acquisition unknown

State Hermitage Museum, inv. no. VZ-718

Published for the first time

This case was intended to hold a tea bowl, or *piala*, which could be used when travelling, and was designed to be attached to a belt. The case consists of two halves: one has the same shape and size as the *piala*, while the other is a flat lid. The halves are connected by a hinge, and a ribbon with a silver hasp, covered with dark blue enamel, is attached to the long handle. The outside part of the case is made from embossed leather, while the inside is lined with green velvet. Both halves are connected by a long handle with a ribbon on the end. The case (together with the *piala*) was presented with a number of other items to Tsar Alexander III in January of 1893 by the Emir of Bukhara. (T.Z.)

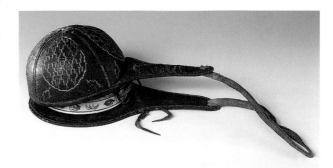

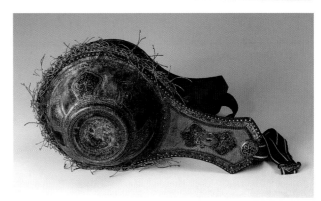

213 (above), 214 (below)

215

MAN'S BOOTS (see page 211)

Bukhara, second half of 19th century

Leather; 23 cm (length), 47 cm (height)

Origin: acquired in 1926 from the Museum of the former Central School of Technical Drawing of Baron A. L. Stieglitz

State Hermitage Museum, inv. nos. PE-423 a, b

Published for the first time

This pair of men's boots is made from red Morocco leather, and mounted on a high, dark-coloured heel. The sole is red, and the lower part of the boots is decorated with ornamental bands of embossed circles and stripes. (S.A.)

216

SADDLE

Central Asia, 19th century

Wood, gold, precious stones, turquoise, pearls, glass; 47.5 cm (length), 33 cm (width), 29 cm (height)

Origin: acquired in 1886 from the Tsarskoe Selo Arsenal

State Hermitage Museum, inv. no. OP-1178

Published for the first time

This saddle was made from wood and covered on both sides with a sheet of gold. The upper part of the saddle is decorated with a large-scale plant ornament, while the ornament on the front and rear parts of the saddle includes precious stones and glass inlays (many of which have been lost). The saddle was presented to Tsar Alexander II in 1868 by the Khan of Khuqand. (A.I.)

217

SABRE AND SHEATH

Khuqand, 19th century

Steel, gold, precious stones, pearl, wood, forging, engraving, inlay; 98 cm (length in sheath)

Origin: acquired in 1886 from the Tsarskoe Selo Arsenal

State Hermitage Museum, inv. no. OP-1848

Exhibition: St Petersburg 2000, no. 306

The decoration of this sabre is the second most common style used to decorate sabres and daggers in Central Asia during the nineteenth century (as far as we now know): the sheath and handle are covered in a sheet of gold with vegetal ornament, onto which precious stones are set, sometimes covering most of the core underneath.

The blade is inflected, and forged from Damascus steel with a fine ornamental pattern. Near the handle is a cartouche containing an Arabic inscription in a very careless hand: 'Made by Asadallah.' Above this is a large, scalloped medallion with a Persian inscription, also in a careless hand: 'Shah Abbas.' Neither inscription can be considered genuine; the blade could have been forged in Central Asia, considering the brevity and crudeness of the inscriptions. The cross-guard is also steel, with an ornament of gold crosses along the edge. The handle is enclosed by a case of heavily worn velvet.

The sheath has two steel rings for attaching to a belt (or special sword belt) with an ornament of gold crosses along the edge. The front and reverse sides of the sheath are covered in a sheet of gold with extensive plant ornament. Along the edge of the front is a narrow band of small pearls. Near both the mouth and tip of the sheath is a rich pattern of precious and semi-precious stones: emeralds, rubies, spinels and garnets.

As far as we know at the present time, this style of decoration was common in Khiva. (A.I.)

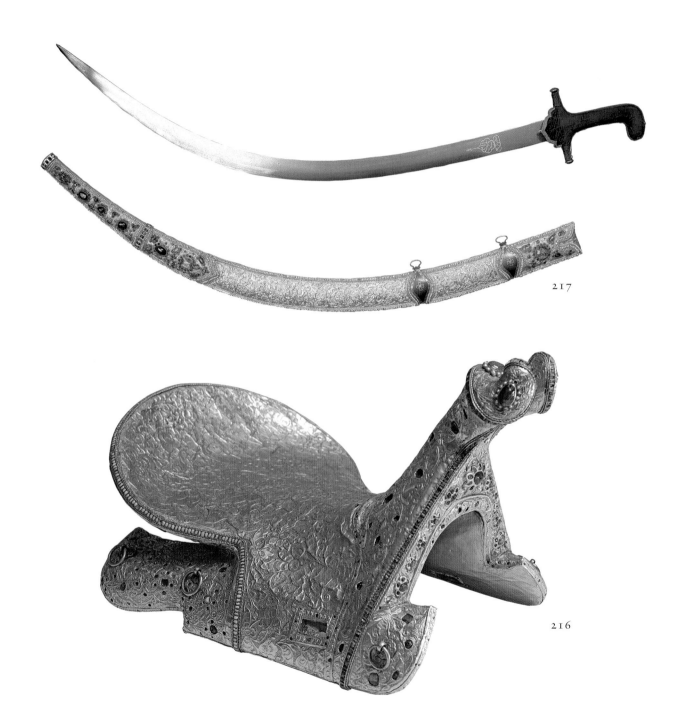

217

216

218

SABRE AND SHEATH
ATTACHED TO RED SILK BELT

Khuqand, 19th century

Silver, steel, turquoise, glass, fabric, wood, forging, engraving, inlay; 95 cm (length in sheath)

Origin: acquired in 1886 from the Tsarskoe Selo Arsenal

State Hermitage Museum, inv. no. OP-167

Published for the first time/not in exhibition

Little is known about the history of weapons in Central Asia in the nineteenth century, and only now has work begun to study and gradually attribute existing artefacts. The publication of any item that almost definitely originates in this area is of great interest.

This inflected sabre blade was made from Damascus steel and has a fine decorative pattern. Near the handle is a cartouche containing an Arabic inscription: 'Made by Asadallah Isfahani.' There is also a round medallion with a palmette above and a Persian inscription: 'slave of Shah his Holiness [i.e. Ali] Abbas.' The style of the inscriptions is not sufficiently clear and calligraphic, so it is difficult definitively to attribute this piece to the seventeenth century, when Shah Abbas I lived (although

Abbas II ruled in the same century). Master Asadallah Isfahani, about whom we know little, could have lived during the rule of the Safavid Shah Abbas I (1587-1629). However, according to indirect sources, it is most likely that both inscriptions are falsified, which is the case with the vast majority of blades bearing the name 'Asadallah'.

The blade could have been forged in Iran or in Central Asia. The sabre's cross-guard is steel and has no decoration. The handle is decorated with a silver back-plate covered with small turquoise stones, and a sabre knot made from a red cloth. The sheath has two rings, surrounded by small glass inserts, and decorated on the front with scalloped medallions and glass inserts. The reverse of the sheath is smooth. The entire front surface of the sheath is decorated with small turquoise stones in silver settings set against a scale-patterned background.

The belt is made from red silk ribbon, onto which a small, double suspension with a hook is attached, as well as a large, round rosette, and four large and three small decorative plates. The hasp, rosette and plates are also decorated with small turquoise stones, as is the sheath.

The sabre was presented to Tsar Alexander II by the Khan of Khuqand in 1874. (A.I.)

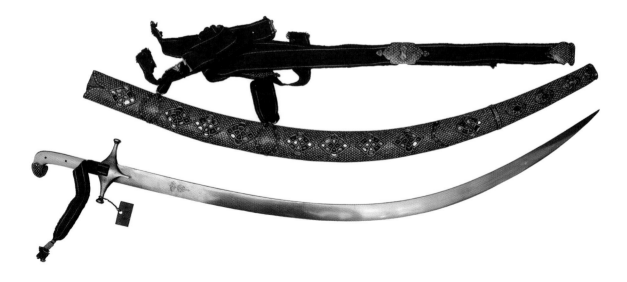

219

SAMOVAR

Bukhara, 19th century

Silver, coloured enamel, casting, repoussé, gilding, blacking;
6.2 cm (diameter), 57 cm (height) 23.7 cm (height, pipe alone)

Origin: purchased from the Alexandrovsky Palace

State Hermitage Museum, inv. no. VZ-603

Published for the first time

This is a gilt silver samovar. The façeted, pear-shaped
body sits on a square base, with feet. The upper part of
the body, the flat lid and pipe with handle are covered in
repoussé vegetal ornament with coloured enamel (dark
blue, turquoise, white and red). These techniques were
used by metalworkers in nineteenth-century Bukhara,
who supplied the court of the Emir. A large collection
of such items is stored in the Bukhara Museum and
Nature Reserve, acquired from the estate of the Emir
of Bukhara. This particular samovar could have been
among ambassadorial gifts to the court of the Russian
Tsars. (T.Z.)

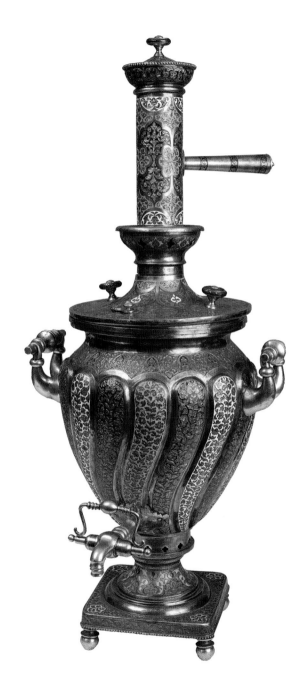

220
BELT

Bukhara, second half of 19th century

Gold, coloured gemstones, glass, leather, velvet, mastic; plates sewn on apertures with gem on mastic insets, silver brocade with golden thread embroidery; 128.9 cm (length), 8 cm (width), 8.8 cm (height of buckle)

Origin: acquired in 1924 from the Tsarskoe Selo Arsenal

State Hermitage Museum, inv. no. VZ-4

Published for the first time

This is a silver brocade belt, with two layers of red and white velvet on a leather base. On the exterior there are ten golden ornamented plaques fixed onto the belt by means of a string threaded through the plaque loops. These alternate with images of the plaques of a similar shape, but embroidered in gold. The buckle is made of two plaques of the same appearance, joined to each other with an oblong ornamented plate that has a groove for the pin.

The plaques are decorated with coloured gem insets, including rubies, emeralds, beryls, spinels, tourmalines, and so on. Presented by the ambassador extraordinary of Bukhara to Tsar Alexander III (1893). (T.Z.)

221
SILVER DISH ON FEET

Bukhara, 19th century

Silver, coloured gemstones, turquoise, engraving, niello; 35.5 cm (diameter), 7.9 cm (height)

Origin: acquisition unknown

State Hermitage Museum, inv. no. VZ-286

Published for the first time

This silver dish on eight ball-shaped feet has a wide rim, on which there are nine super-imposed medallions with Persian script and vegetal ornament. On the edge of the rim there are scalloped cartouches decorated with engraved ornament, gilt, niello, enamel. In between there are fine coloured gemstones and turquoise insets.

The centre of the dish is decorated with a round double medallion and six diamond-shaped super-imposed plates around it, containing engraved human figure and turquoise insets. (T.Z.)

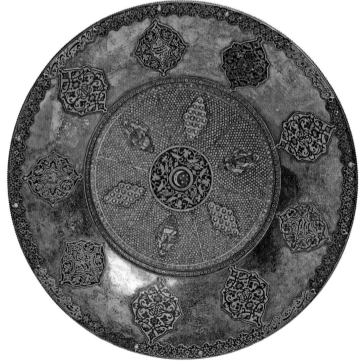

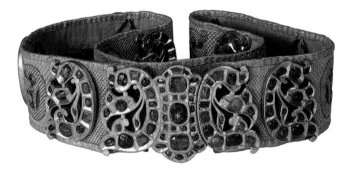

222

HAT

Bukhara, end of 19th century

Gold, emeralds, rubies, spinels, pearls, glass, velvet, fur, feathers, embroidery; 34.5 cm (height including plume), 21.5 cm (height of plume)

Origin: acquisition unknown

State Hermitage Museum, inv. no. VZ-232

Exhibition: Turku 1995, no. 365

This green velvet hat has beaver fur trimming and a grey sheepskin lining. There are four golden plates on the crown, which are decorated with openwork ornament with gemstone insets. The plate joints are framed with bands of fine pearls. One of the four plates has a pipe-shaped socket for the plume, which is made of black feathers, and four golden feathers with pearl pendants. The feathers are mounted onto a pin with embroidery thread; there is a six-petal rosette with coloured insets and pearl pendants on the top of the pin.

The hat is likely to have been among the ambassadorial gifts received by the court of the Tsar of Russia (Alexander III or Nicholas II). (T.Z.)

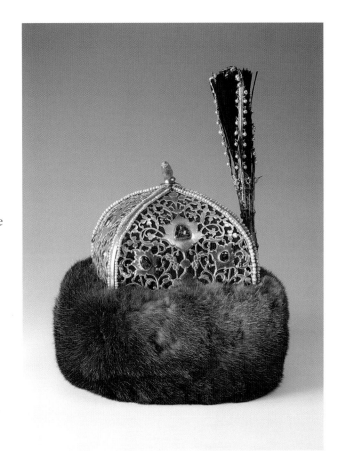

223

ROSEWATER SPRINKLER

India, 17th century

Gold, diamonds, emeralds, rubies; 26 cm (height)

Origin: brought in 1741 by the embassy of Nadir Shah
as a gift to Tsar Ioann Antonovitch

State Hermitage Museum, inv. no. VZ-714

References: *The Hermitage* 1981, p. 95; Ivanov, *et al.* 1984,
no. 94; Zebrowski 1997, illus. 50

Exhibitions: St Petersburg 2000, no. 339; London 2004, no. 122

Similar bottles were probably used for rose water. Their
shape is widely popular in the Middle East, from
Istanbul to Delhi. On the neck of the sprinkler there is
an inscription in Arabic that cannot be fully deciphered.
It is interesting to note that the large emeralds on the
sprinkler are decorated with engraved lines, which is a
very rare feature. (A.I.)

224

TABLE

Craftsman: Situram

India, 17th century

Gold, diamonds, rubies, emeralds, pearls, enamel;
23.7 cm x 23.7 cm, 10 cm (height)

Origin: brought in 1741 by the embassy of Nadir Shah
as a gift to Tsar Ioann Antonovitch

State Hermitage Museum, inv. no. VZ-728

References: Ivanov, *et al.* 1984, no. 95; *Great Art Treasures*
1994, vol. I, no. 473; Zebrowski 1997, illus. 48

Exhibitions: London 1931, no. 314E; St Petersburg 2000,
no. 336; London 2004, no. 121

This is probably the only example of Indian jewellery of
the seventeenth century which has retained the crafts-
man's name. It is carved on the interior side of the table:
'made by Siturma mourassa'kar' (the last word means

'one that decorates with gemstones'). Unfortunately his
name has not yet been found in written sources. The
table is a fine example of the Kundan technique that was
used with such brilliance by Indian jewellers of the
seventeenth to nineteenth centuries. The table was
brought to St Petersburg in 1741 with other gifts from
the embassy of Nadir Shah, which had been sent from
Delhi in October 1739 after the usurpation of the
Mughal capital [with cat. nos. 223 and 225]. (A.I.)

225

TRAY

India, 17th century

Gold, rubies, emeralds, enamel; 30.8 cm (diameter)

Origin: brought in 1741 by the embassy of Nadir Shah
as a gift to Tsar Ioann Antonovitch

State Hermitage Museum, inv. no. VZ-724

References: *Survey* 1939, pl. 1437B; Dyakonova 1962, no. 72;
Ivanov, *et al.* 1984, no. 98; *Great Art Treasures* 1994, vol. I,
no. 469; Zebrowski 1997, illus. 27

Exhibitions: London 1931, no. 314D; London 1982, no. 328;
St Petersburg 2000, no. 341; London 2004, no. 123

With reference to the Hermitage Art Collection, we
can conclude that octagonal trays were typical of Indian
gold and silverware of the seventeenth century. It is likely
that the tray should have contained an octagonal box,
similar to those which are part of complete sets from
the Hermitage Collection (State Hermitage, inv. nos.
VZ-706 and 707; Amsterdam 1999, no. 288) and those
from Nasser D. Khalili's Collection (Amsterdam 1999,
no. 289). The tray is decorated with a large number of
gemstones and magnificent enamel. On the reverse side,
in the centre, there is a large carved rosette. (A.I)

223

225

224

Appendix

Objects in the National Museums of Scotland

226
SMALL DISH
Iraq (Samarra?), 9th century
Earthenware, opaque white tin glaze, overglaze lustre painting; 13.2 cm (diameter)
Origin: bought in 1971 from Bluett and Sons, London
National Museums of Scotland (NMS), inv. no. A.1971.685

This small dish has sloping sides and rests on a low circular foot-ring. Its earthenware body has been covered with an opaque white tin glaze and was pre-fired before receiving its gold-green lustre decoration. This consists of a six-pointed star enhanced by three abstracted floral stalks and three elongated abstract designs, which may have been derived from individual Kufic letters. (U.Kh.)

227
DISH
Iraq, 9th century
Earthenware, opaque white tin glaze, cobalt blue and copper-green in-glaze painting; 20.5 cm (diameter)
Origin: bought in 1971 from Bluett and Sons, London
NMS, inv. no. A.1971.686

This shallow circular dish has sloping walls and a low circular foot-ring. Its earthenware body has been covered with an opaque white tin glaze. A central Arabic inscription in Kufic lettering occupies the centre of the dish. The inscription has been read as a repetition of the name 'Muhammad'. Radial splashes in copper-green surround the inscription. The rim is enhanced by striped and scalloped border in cobalt blue. (U.Kh.)

228
FRAGMENT OF WOVEN LINEN
Egypt (al-Drounka), 11th to 12th centuries
Woven and embroidered linen; 38.1 cm (height), 10.16 cm (width)
Origin: acquired in 1898 from Henry Wallis
NMS, inv. no. A.1898.489

A linen textile fragment comprising a horizontal panel of embroidered decoration with a repeat composition of two wider sections that alternate twice with two narrow sections. These are separated from each other by double borders in black wove. The wider panels have alternating blue and purple cursive inscriptions bordered by

scrolling bands above and below. The narrow sections contain 'S'-scrolls arranged vertically, beneath which is a continuous border of alternating inverted crescents and circles.

This textile fragment is a good example of the artistic influence that the Coptic communities who settled in Egypt had on textile production during the Fatimid period. There remains to this day a sizeable Coptic population in Egypt. (U.Kh.)

229
FRAGMENT OF WOVEN LINEN
Egypt (Akhmim), 11th to 12th centuries
Woven linen and silk; 16 cm (height), 19 cm (width)
Origin: bought in 1911 from the Hilton-Price Collection
NMS, inv. no. A.1911.268

This is a fragment of woven linen with two super-imposed decorative bands separated from each other by an area of plain weave. Both bands are identical in design: guilloches rendered in a yellowish gold colour, set against a blue background. The central areas of the guilloche's loops have light-coloured palmette-leaves in them, which are set against either a red or black

background. The guilloche band is flanked above and below by two red stripes, each containing a light-coloured Kufic inscription enhanced by regularly disposed, gold-coloured scrolling motifs; the outer borders of these are formed by a system of interlocking wave-like designs. The inscription has been deciphered as: 'victory comes from God.' Akhmim in Egypt lies on the east bank of the River Nile. The linen-weaving industry was an important one in Akhmim, and textiles and handicrafts are still produced there today. Interestingly, the history of Akhmin is closely linked with that of the Coptic community in Egypt and retains a sizeable Coptic population. (U.Kh.)

230
DISH
Iran, late 13th to early 14th centuries
Fritware, cobalt blue glaze, overglaze red and white pigment, gold leaf; 19.7 cm (diameter), 4.78 cm (height)
Origin: bought in 1957 from Sotheby's, London
NMS, inv. no. A.1957.273

This shallow dish has a narrow horizontal rim and low foot. It was covered with a cobalt-blue glaze and fired before the application of the decoration. A pseudo-Kufic inscription runs around the rim. The well is filled with delicate floral scrolls and sprigs, which provide a background for four phoenix-like birds in flight. The foot-ring is unglazed but has patches of turquoise glaze in the centre underneath. Wares of this type, known as 'lajvardina' (Persian: *Lapis lazuli*), tend to be floral or abstract. Figural motifs like the birds seen here are comparatively rare. (U.Kh.)

230

226

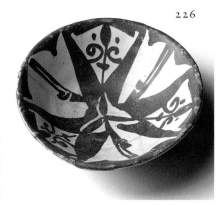

232

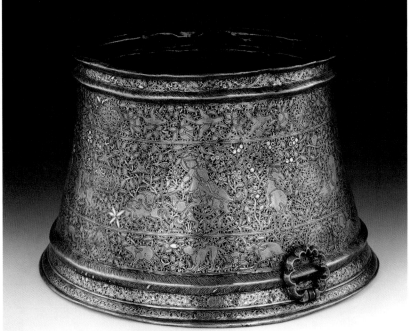

231

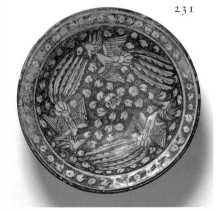

227

231
DISH

Iran, late 13th to early 14th centuries

Fritware, underglaze painting in grey-brown slip and black pigment, clear glaze; 19.7 cm (diameter)

Origin: acquired in 1927 from A. Garabed

NMS, inv. no. A.1927.78

This shallow circular dish has a narrow horizontal rim and a low circular foot-ring. It is decorated with a phoenix design in the well, showing the mythical birds in a group of three. Their revolving arrangement emphasizes the birds' long, curving tail feathers. The birds are set against an abstracted vegetal background. The rim carries a simple pearl-and-leaf border. The decorative scheme on this plate is most probably derived from imported Chinese lacquer pieces. (U.Kh.)

232
CANDLESTICK BASE

Iran, early 14th century

Hammered and turned brass, originally inlaid with silver and gold; 30.5 cm (diameter), 20.3 cm (height)

Origin: acquired in 1909 from J. Abercromby

NMS, inv. no. A.1909.547

Reference: Komaroff 2002, pp. 190-92, 279, no. 166, fig. 228

This candlestick base is engraved with hunting scenes in cartouches, fantastic animals, cartouches with inscriptions and flowers. All were originally inlaid with silver. Its dynamic figural style suggests that several of its motifs may have been taken from contemporary book paintings or drawings. Candlesticks like this one were made for the Mongol élite of Iran and used at court. It is interesting that the original museum record identifies the piece as a 'tray stand', an indication of the fact that damaged metal items such as this one were often deemed precious enough to be re-used and handed down the generations in other functional capacities. (U.Kh.)

233
FOOTED DISH OR TAZZE

Turkey (Iznik), 1570-90

Stone-paste (fritware), underglaze cobalt blue pigment, clear glaze; 34.5 cm (diameter), 6.7 cm (height)

Origin: purchased in 1979 from Spink and Son Ltd, London

NMS, inv. no. A.1979.159

Reference: Atasoy–Raby 1989, p. 123, fig. 202

This dish has a wide, shallow well, curved walls and a narrow horizontal rim with a scalloped edge. It rests on a low foot-ring. The design in the well, contained within a roundel, consists of six flowers on curvaceous, leafy stems with tiny *fleur-de-lys* extensions, surrounding a small flower-head in the centre. The cavetto shows seven floral sprigs, the rim a debased wave-and-rock design. The underside of the cavetto has six floral sprigs. This dish belongs to a group of Iznik wares identified by Atasoy and Raby (1989) as 'flower scroll dishes', produced in the Iznik workshops between 1525 and 1590. Within this group the dish represents a late example, dateable to c.1570-90. The two authors mentioned above published this dish as having been sold at auction at Sotheby's, London on 9 Mar 1974, lot 43. In fact it was sold again at auction at Spink and Son, London in 1979, and it was on this occasion that the item was purchased for the Royal Museum. (U.Kh.)

233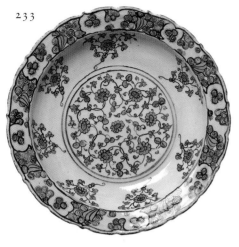

234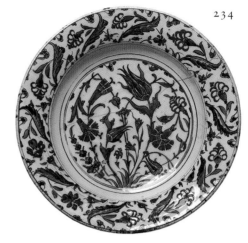

235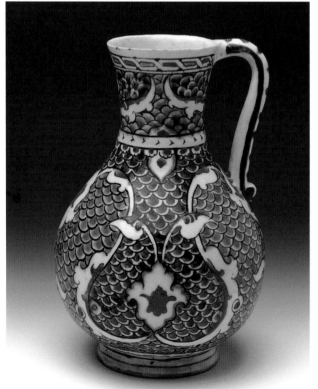

236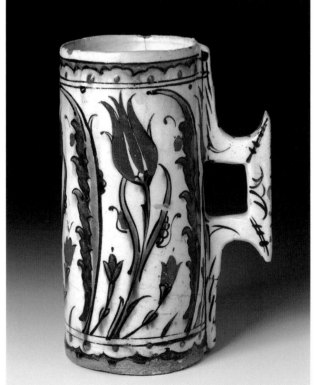

234
FOOTED DISH OR TAZZE

Turkey (Iznik), late 16th century

Stone-paste (fritware), green, blue, red and black underglaze pigment, clear glaze; 46.4 cm (diameter)

Origin: bought in 1910 from the Irvine Smith Collection

NMS, inv. no. A.1910.22

Reference: Atasoy–Raby 1989, p. 227, figs. 397-99

This stone-paste (fritware) dish has a 'tondino' shape, characterized by a very shallow wide well and a broad and flat horizontal rim. This shape is derived from early sixteenth-century Italian maiolica (tin-glazed earthenware) dishes. The plate rests on a wide and very low, circular foot-ring. Both the inside and the underside of the dish are decorated extensively.

The well has a naturalistically drawn flower arrangement of carnations, tulips, prunus blossoms and stylized roses, rising from a tuft of green grass. The wide rim displays a fluid band of alternating roses and serrated leaves flowing in an anti-clockwise direction. Small floral and vegetal motifs are set in between the main composition. The underside of the dish is enhanced by 14 flower heads alternating with pairs of blue tulips. The decorative style adopted on this plate assigns it to the second half of the sixteenth century, when the naturalistic rendition of flower sprays on Iznik wares reached its peak. (U.Kh.)

235
JUG

Turkey (Iznik), 1580-85

Stone-paste (fritware), green, blue, black underglaze pigment, bole-red underglaze slip, clear glaze; 16.5 cm (diameter overall), 24 cm (height)

Origin: bought in 1884 from the Castellani Collection

NMS, inv. no. A.1884.44.25

References: Atasoy–Raby 1989, figs. 731-33, 743-45; exhibition catalogue 1985, p. 153, nos. 2/30, 2/31

This fritware jug has a bulbous pear-shaped body, resting on a low, circular foot-ring. The neck is cylindrical and widens towards a rimless mouth. An 'S'-shaped handle is attached to the lip and shoulder. Both the neck and the body are covered with alternating blue and green fish-scale patterning; each area separated from the other by sinuous split-palmette borders. A guilloche border runs below the lip and around the lower body; a narrow white collar with dotted detailing sits around the lower neck. The all-over textural covering of this jug is akin to the engraved (repoussé) decoration of contemporary metalwork, and it therefore illustrates the extent to which designs were transferred between different media during the Ottoman period. Iznik pieces with this characteristic overall fish-scale design have been attributed to 1580-85. (U.Kh.)

236
TANKARD

Turkey (Iznik), mid-late 16th century

Stone-paste (fritware), blue, green, black and bole red underglaze pigment, clear glaze; 20.3 cm (height)

Origin: gift from Miss Beatrice Danford, Newton Street, Boswells (1953)

NMS, inv. no. A.1953.171

Reference: Atasoy–Raby 1989, p. 47, figs. 700, 705

This tankard is of cylindrical shape. It has a flat angular handle with curved projections at the top and bottom. The tankard is decorated with a succession of tall, undulating red tulips and blue-green, so-called *saz* leaves that alternate with smaller red and blue flowers. All the flora springs from a decorative band around the lower body, enhanced by blue and red detailing. This decorative band is repeated around the lip. The handle shows crude abstract detailing. This type of tankard first appears in Ottoman ceramics in the mid-late sixteenth century and was widely exported. Metal prototypes of this type are known from the Balkans. Leather or wood models may also have contributed to the development of this ceramic type. (U.Kh.)

237
JUG

Italy (possibly Venice), late 19th century

Tin-glazed earthenware (maiolica) painted in imitation of 16th-century Iznik ware; 32 cm (height)

Origin: given by H. J. Pfungst

NMS, inv. no. A.1905.430

During the late nineteenth and early twentieth centuries many Italian factories specialised in producing imitations of sixteenth century Italian maiolica as well as Iznik ware of the period. (R.W.)

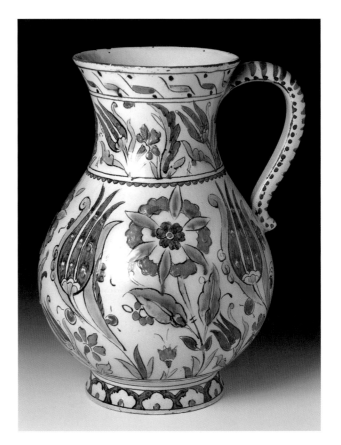

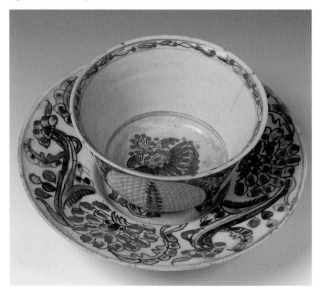

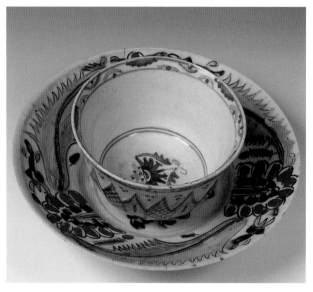

238
SAUCER

Turkey (Kütahya), 18th to 19th centuries

Stonepaste, underglaze polychrome pigment, clear glaze;
18.4 cm (diameter)

Origin: purchased in 1957 from R. Neuman, Edinburgh

NMS, inv. no. A.1957.164

This small saucer has European prototypes. In the centre
it has a small rosette, surrounded by abstracted quatre-
foils and 'S'-scrolls alternating. The well is decorated
with three stylized tree-of-life motifs alternating with
large and sinuous serrated leafs. The saucer would have
once formed a set with a small coffee bowl. Kütahya was
famous for such coffee sets and it seems that there was
some stylistic interaction between European coffee cup-
and-saucer designs imported into Ottoman Turkey and
those made in Kütahya to be exported to the Middle
East and back to Europe. (U.Kh.)

239
SAUCER

Turkey (Kütahya), 18th to 19th centuries

Stonepaste, underglaze polychrome pigment, clear glaze;
17.8 cm (diameter)

Origin: purchased in 1957 from R. Neuman, Edinburgh

NMS, inv. no. A.1957.163

This small saucer has a small circular well and a very
broad horizontal rim. It rests on a circular foot. There
is a flower head in the centre, surrounded by three
abstracted 'S'-scrolls. The rim is decorated with three
chrysanthemum-like motifs alternating with sinuous
leafs and half palmettes. The saucer would have once
formed a set with a small coffee bowl. Kütahya was
famous for such coffee sets and supplied them to regions
as far apart as the Crimea and Egypt during the late
eighteenth and early nineteenth centuries. (U.Kh.)

240

COFFEE BOWL

Turkey (Kütahya), 18th to 19th centuries

Stonepaste, underglaze polychrome pigment, clear glaze;
12 cm (diameter)

Origin: purchased in 1879 from Messrs Mackay and Chisholm

NMS, inv. no. A.1879.55.1

This small deep bowl has steep, slightly tapering walls
and rests on a very low circular foot-ring. Its outer
walls are textured. The bowl has designs of slender tree-
of-life motifs underneath a densely-ornamented system
of arcading around the outside. A narrow border of
abstract motifs and floral detailing enhance the interior
of the bowl. This bowl would have been used for drink-
ing coffee. Kütahya was famous for the production of
ceramic coffee sets. (U.Kh.)

241

COFFEE BOWL

Turkey (Kütahya), 18th to 19th centuries

Stonepaste, underglaze polychrome pigment, clear glaze;
11 cm (diameter)

Origin: purchased in 1879 from Messrs Mackay and Chisholm

NMS, inv. no. A.1879.55.2

This small deep bowl has steep, slightly tapering walls
and rests on a very low circular foot-ring. Its outer walls
have a band of abstracted, vertically disposed and
adjoining leaf-shaped designs, filled either with a criss-
cross lattice or with colour and a central vertical stroke.
Small triangular motifs formed from three dots occupy
the spaces between the leaves' points and a narrow border
runs around the outer edge above. A similar bowl and
floral detailing enhance the inside of the bowl. (U.Kh.)

242

DISH

England (London), 1880-1900

Decorator: William de Morgan

Tin glazed earthenware decorated in two shades of red lustre
on a white ground; leaves and concentric circles painted on the
reverse; 36 cm (diameter)

Mark: 17 impressed

Origin: bequeathed by A. Raffalovich

NMS, inv. no. A.1934.299

William de Morgan was a decorator who originally
bought his vases, dishes and tiles from Staffordshire
potteries and later employed a thrower to produce
shapes he designed. The animals and birds de Morgan
used in his designs were rarely representations of known
species; they were sometimes stylized, adopting heraldic
positions and often purely imaginary. (R.W.)

References and Bibliography

(Abu-l-Faraj al 'Ush 1972) Abu-l-Faraj al 'Ush: 'A Bronze Ewer with a High Spout in the Metropolitan Museum of Art and Analogous Pieces', in *Islamic Art in the Metropolitan Museum of Art* (New York 1972).

(Adamova 1971) A. T. Adamova: 'Two portraits of Fath Ali Shah from the collection of the State Hermitage and Qajar official style', in *Collection of State Hermitage* (Leningrad 1971), vol. XXXIII.

(Adamova 1972) A. T. Adamova: 'On the theme of one Persian miniature on a casket', in *Collection of State Hermitage* (Leningrad 1972), issue 34.

(Adamova 1972a) A. T. Adamova: 'Two pictures of the early Qajar period', in *Collection Central Asia and Iran* (Leningrad 1972).

(Adamova 1996) A. T. Adamova: 'Persian painting and drawing of the 15th to 19th centuries in the Collection of State Hermitage', in *Slavia* (St Petersburg 1996).

(Adle 1980) C. Adle: 'Ecriture de l'Union. Reflets du temps des troubles', *in Oevres picturales (1083-1124/1673-1712) de Haji Mohammad* (Paris 1980).

(Adykov 1962) K. Adykov: 'An original ewer', in *News of AS of Turkmen SSR, Series of Social studies* (Ashgabat 1962).

(Akimushkin, *et al.* 1968) O. F. Akimushkin and A. A. Ivanov: *Persian miniatures of 14th to 17th centuries* (Moscow 1968).

(al-Garnati 1971) *The travel of Abu Khamid al-Garnati to Eastern and Central Europe (1131-1153)* (Moscow 1971).

(al-Khamis 1998) U. al-Khamis: 'An early Islamic bronze ewer re-examined', in *Muqarnas* (Leiden 1998), vol. 15.

(Allan 1977) J. W. Allan: 'Silver: the Key to Bronze in Early Islamic Iran', in *Kunst des Orients* (1977), vol. XI.

(Allan 1982) J. W. Allan: *Islamic Metalwork, in the Nuhad Es-Said Collection* (London 1982).

(Allan 1986.1) J. W. Allan: *Metalwork of the Islamic World, The Aron collection* (London 1986).

(Allan 1986.2) J. W. Allan: 'Venetian-Saracenic Metalwork: The problems of provenance', in *Atti dwl Primo Simposio Internationale sull'Arte Veneziana e l'Arte Islamica Venice, 9-12 December 1986* (1986).

(Allan 1991) J. W. Allan: 'Metalwork of the Turcoman dynasties of Eastern Anatolia and Iran', in *Iran* (London 1991), vol. XXIX.

(Allan 1994) J. W. Allan: 'Hajji Abbas', in *Iran* (London 1994), vol. XXXII.

(Allan 2003) J. W. Allan: 'My Father is Sun, and I am the Star: Fatimid Symbols in Ayyubid and Mamluk Metalwork', in *Journal of the David Collection* (2003), vol. 1.

(Allan 2004) J. W. Allan: 'Solar and Celestial Symbolism in Medieval Islamic Art', in *Image and Meaning in Islamic Art* (London 2004).

(Alpatova 1962) I. A. Alpatova: 'Printed textiles', in *Russian decorative art from the ancient period until the 18th century*, three volumes (Moscow 1962), vol. 1.

(Amiranashvili 1940) Sh. Ya. Amiranashvili: *Iranian easel painting* (Tbilisi 1940).

(Amsterdam 1999): *Earthly Beauty, Heavenly Art: Art of Islam* (Amsterdam 1999), exhibition catalogue.

(Amsterdam 2003) *Liefde uit de Hermitage* (Amsterdam 2003), exhibition catalogue.

(Arapova 1977) T. B. Arapova: *Chinese porcelain in the collection of the Hermitage. End of the 14th to first third of the 18th century* (Leningrad 1977).

(Arapova, *et al.* 1971) T. B. Arapova, and I. V. Rapoport: 'The history of the cultural links of Iran and China in the 16th to the beginning of the 18th centuries (on the materials of ceramics production)', in *Art and archaeology of Iran, all-Union conference 1969, talks* (Moscow 1971).

(Atasoy 2000) N. Atasoy: '*Otag-I Humayun*', *The Ottoman Imperial Tent Complex* (Istanbul 2000).

(Atasoy 2001) N. Atasoy, W. Denny, L. Mackie and H. Tezcan: 'The Crescent and the Rose', in *Imperial Ottoman Silks and Velvets* (London 2001).

(Atasoy–Raby 1989) N. Atasoy and J. Raby: *Iznik: The Pottery of Ottoman Turkey* (London 1989).

(Atil 1978) E. Atil: *The Brush of the Masters: Drawings from Iran and India* (Washington 1978).

(Atil 1981) E. Atil: 'Renaissance of Islam', in *Art of Mamluks* (Washington 1981).

(Atil 1987) E. Atil: *The Age of Sultan Suleyman the Magnificent* (Washington 1987).

(Atil, *et al.* 1985) E. Atil, W. T. Chase and P. Jett: *Islamic Metalwork in the Freer Gallery of Art* (Washington 1985).

(Baer 1987) E. Baer: 'Wider aspects of some Ghaznavide bronzes', in *Rivista degli studi orientali.* (Roma 1987), vol. LIX, fasc. I-IV (1985).

(Baer 1989) E. Baer: *Ayyubid Metalwork with Christian Images* (Leiden 1989).

(Bailey 1992) G. A. Bailey: 'The dynamics of Chinoiserie in Timurid and early Safavid ceramics', in *Timurid Art and Culture, Iran and Central Asia in the fifteenth century in Studies in Islamic Art and Architecture*, supplements to Muqarnas (1992), vol. VI.

(Bakmeister 1779) I. Bakmeister: *Experience of the Library and the Study of Rarities and Natural History of the St Petersburg Imperial Academy of Science* (St Petersburg 1779).

(Balashova 1972) N. Balashova: 'An earthenware ewer of the 12th to 13th centuries with epic scenes', in *Central Asia and Iran* (Leningrad 1972).

(Barber 1915) E. Barber: *Hispano-Moresque Pottery in the Hispanic Society of America* (New York 1915).

231

(Barcelona 2000) *Asia, ruta de las estepas De Alejandro Magno a Gengis Kan* (Barcelona 2000), exhibition catalogue.

(Bashkirov 1931) A. S. Bashkirov: *Art of Daghestan: Carved Stones* (Moscow 1931).

(Binyon, *et al.* 1933) L. Binyon, G. V. S. Wilkinson and B. Gray: *Persian Miniature Painting* (London 1933).

(Blair 1995) S. S. Blair: *A compendium of Chronicles. Rashid al-Din's Illustrated History of the World. The Nasser D. Khalili Collection of Islamic Art*, XXVII (London 1995).

(Bolshakov 1958) O. G. Bolshakov: 'Arabic inscriptions on the slipware of the 9th to 12th centuries', in *Epigraphy of the East* (1958), no. 12.

(Braun 1932) J. Braun: 'Das Christliche Altargerät', in *Seinem Sein und in Seiner Entwicklung* (Munich 1932).

(Brend 1989) B. Brend: 'Christian Subjects and Christian Subjects: An Istanbul Album Picture' in *Islamic Art* I (1981).

(Brimo de Laroussilhe 1995) E. Bertrand: *Emaux limousins du Moyen Age* (Paris, Brimo de Laroussilhe [gallery] 1995).

(Busson 1976) A. Busson: 'Note sur une miniatures Moghole d'influence europeene', in *Ars Asiatique* (1976), vol. XXXIV.

(*Byzantine Hours* 2001) *Byzantine Hours, Works and Days in Byzantium* (Athens 2001), exhibition catalogue.

(*Byzantine Women* 2003) *Byzantine Women and Their World* (New Haven/London 2003).

(Canby 1996) S. R. Canby: *'The Rebellious Reformer', The Drawings and Paintings of Riza-i Abbasi of Isfahan* (London 1996).

(Canby 1999) S. R. Canby: *The Golden Age of Persian Art: 1501-1722* (British Museum Press 1999).

(Carboni, *et al.* 2001) S. Carboni and D. Whitehouse: *Glass of the Sultans* (New York 2001).

(Carboni 2004) S. Carboni: 'Fifteenth-century Enamelled and Gilded Glass made for the Mamluks: the end of an Era, the beginning of a new one', in *The Society for Near Eastern Studies in Japan* (2004).

(Carbonier 1899) A. Carbonier: *Catalogue of items of earthenware, faiance and maiolica produce* (St Petersburg 1899).

(Chvyr 1977) L. A. Chvyr: *Tadjik jewellery decorations* (Moscow 1977).

(Crowe 2002) Y. Crowe: *Persia and China: Safavid Blue and White Ceramics in the Victoria and Albert Museum 1501-1738* (London 2002).

(Crowe 2003) Y. Crowe: 'Sixteenth-century Persian Ceramics', in *Hunt for Paradise, Court Arts of Safavid Iran 1501-1576* (New York/Milan 2003).

(Dalton 1911) O. M. Dalton: *Byzantine Catalogue of Early Christian Antiquities and Objects East in the British Museum* (London 1911).

(Darcel 1865) A. Darcel: 'Musée retrospectif. Le moyen âge', in *Gazette des Beaux-Arts* (1865), vol. 19.

(Darcel 1874) A. Darcel and A. Bazilevsky: 'Collection Bazilevsky', in *Catalogue raisonné précédé d'un essai sur les arts industriels du Ier au XVIe siècle* (Paris 1874), 2 volumes.

(David Collection) *The David Collection, Islamic Art* (Copenhagen 1975).

(Denisova 1962) M. M. Denisova: 'Artistic armour and weapons', in *Russian decorative art from the ancient period until the 18th century*, 3 volumes (Moscow 1962), vol. 1.

(Diba, *et. al.* 1998) L. S. Diba (ed.) with M. Ekhtiar: *Royal Persian Paintings. The Qajar Epoch 1785-1925* (London 1998).

(Dorn 1871) B. A. Dorn: *Ansichten, Juschriften und andere abbildungen zu B. Dorn Reise in dem Kaukasus und den Sudlichen Kusfenlander des Kaspischen Meeres* (St Petersburg 1871).

(Dorn 1895) B. A. Dorn: *Atlas for the travel of B. A. Dorn along the Caucasus and Southern coast of Caspian Sea* (St Petersburg 1895).

(Dushanbe 1980) Dushanbe: *The Central Asian Art of Avicenna Epoch* (Dushanbe 1980).

(Dyakonov 1947) M. M. Dyakonov: 'Bronze slab of the first centuries of Khidjra', in *Works by the Oriental department of the State Hermitage* (Leningrad 1947), vol. IV.

(Dyakonova 1962) N. V. Dyakonova: *Art of the people of the foreign East in the State Hermitage* (Leningrad 1962).

(Egyed 1955) E. Egyed: 'A kozelkeleti allat-plaztikakrol', in *Az iparmuveszeti museum evkonyvei* (Budapest 1955), II.

(Ekhtiar 1990) M. Ekhtiar: 'Muhammad Isma'il Isfahani: Master Lacquer Painter', in *Persian Masters: Five Centuries of Painting* (Marg Publications 1990).

(Enlart 1925) C. Enlart: *'Les monuments des croisés dans le royaume de Jérusalem'* (Paris 1925).

(Ettinghausen 1950) R. Ettinghausen: *Studies in Islamic Iconography I, The Unicorn* (Washington 1950).

(Fahretdinova 1988) D. A. Fahretdinova: *Jewellery Art of Uzbekistan* (Tashkent 1988).

(Fehervari 1976) G. Fehervari: *Islamic Metalwork of 8th to 15th century in the Keir Collection* (London 1976).

(Fehner 1956) M. B. Fehner: *Trade of the Russian State with countries of the East in the 16th century* (Moscow 1956).

(Foelkersam 1902) A. Foelkersam: 'Ein altliv-landisches Trinkhorn', in *Jahrbuch fur genealogie, heraldic und sphragistik* (Mitau 1902).

(Folsach 2001) K. Folsach: *Art from the World of Islam in the David Collection* (Copenhagen 2001).

(Forkl, *et al.* 1993) H. Forkl, J. Kalter, Th. Zeisten and M. Pavaloi: *Die garten des Islam* (Stuttgart 1993).

(Fraehn 1839) Ch.-M. Fraehn: 'Neber ein menkwurdiges volk des Kaukasus, die Kubatsehi', in *Bulletin scientifique, publie par l'Academie imperiale des sciences de St Petersbourg* (1839), t. IV, no. 3, col. 33-45, et no. 49, col. 49-53.

(Frankfurt/Main 1992) *Yemen: 3000 Years of Art and Civilisation in Arabia Felix* (Frankfurt/Main 1992), exhibition catalogue.

(Fry 1910) R. Fry: 'The Munich Exhibition of Mohammadan Art', in *Burlington Magazine* (London 1910), vol. XVII.

(Fyodorova 1982) N. V. Fyodorova: 'Two silver vessels from the Surgut region', in *Soviet archaeology* (Moscow 1982), no. 1.

(Gauthier and Francis 1987) M. M. S. Gauthier and G. François: *Emaux méridionaux: Catalogue international de l'oeuvre de Limoges* (Paris 1987), vol. I.

(Golombek, *et al.* 1996) L. Golombek, R. B. Mason and G. A. Bailey: *Tamerlane's Tableware: A New Approach to the Chinoiserie Ceramics of Fifteenth-Sixteenth Century Iran* (Costa Mesa California 1996).

(Gonosova and Kondoleon 1994) A. Gonosova and C. Kondoleon: *Art of Late Rome and Byzantium in the Virginia Museum of Fine Arts* (Richmond 1994).

(Grabar 1988) O. Grabar: *The formation of Islamic Art* (New Haven/London 1988).

(Grabar, *et al.* 1980) O. Grabar and S. Blair: *Epic Images and Contemporary History: The Illustrations of the Great Mongol Shahnama* (Chicago 1980).

(*Great Art Treasures* 1994) *Great Art Treasures of the Hermitage Museum* (St Petersburg/New York/London 1994), vols. I-II.

(Grübe 1962) E. Grübe: *Muslim Miniature Painting from the 13th to the 19th century from the Collections in the United States and Canada* (Venice 1962).

(Grübe 1966) E. Grübe: *The World of Islam* (London 1966).

(Grübe 1974) E. Grübe: 'Notes on the decorative arts of Timurid period', in *Gururajamanjarika. Studi in onore di Guiseppe Tucci* (Naples 1974).

(Grübe, *et. al.* 1981) E. Grübe, E. Sims, S. Carswell, eds.: *Islamic Art, An Annual Dedicated to the Art and Culture of the Muslim World* (New York 1981), vol. 1.

(Gyuzalyan 1959) L. T. Gyuzalyan: 'Inscriptions on the local ceramics from Oren-Kala', in *Works of the Azerbaijan (Oren-Kala) archaeological expedition* (Moscow/Leningrad 1959), vol. I.

(Gyuzalyan 1968) L. T. Gyuzalyan: 'The bronze qalamdan (pen-case) 542/1148 from the Hermitage Collection (1936-1965)', in *Ars orientalis* (Ann Arbor 1968), vol. VII.

(Gyuzalyan 1972) L. T. Gyuzalyan: *Eastern miniature, depicting western landscape in Central Asia and Iran* (Leningrad 1972).

(Gyuzalyan 1978) L. T. Gyuzalyan: 'Second Great pot (Fuld's pot)', in *Works of the State Hermitage* (Leningrad 1978), vol. 19.

(Hardie 1998) P. Hardie: 'Mamluk Glass from China?', in *Gilded and Enamelled Glass from Middle East* (London 1998).

(Hermitage 1981) *History and Collections: State Hermitage* (Moscow 1981).

(Ierusalimskaya 2002) A. A. Ierrusalimskaya: *Dictionary of textile terms* (St Petersburg 2002).

(Ilyasov 1993) J. Ya. Ilyasov: 'Medieval mortars from Budrach settlement', in *Bulletin of the Silk Road. Archaeological resources* (Moscow 1993), issue 1.

(*Islamische Kunst* 1985) *Islamische Kunst, Loseblattkatalog unpublizierte Werke aus Deutschen Museen* (Mainz 1985), vol. II.

(Ivanov 1960.1) A. A. Ivanov: 'Box with the name of Muhammad Ali, son of Muhammad Zaman', in *Collection of State Hermitage* (1960), issue XVIII.

(Ivanov 1960.2) A. A. Ivanov: 'On the original purpose of the so-called Iranian "candlesticks" of the 16th to 17th centuries', in *Researches on the history of culture of the people of the East. Compilation in the honour of academic Orbeli, I. A.* (Moscow/Leningrad 1960).

(Ivanov 1969) A. A. Ivanov: 'Group of the Khurasan copper and bronze items of the second half of the 15th century. The works by craftsman Shir-Ali ibn Muhammad Dimashqi', in *Works of the State Hermitage* (Leningrad 1969), vol. 10.

(Ivanov 1974) A. A. Ivanov: 'Qalamdan with a portrait of a young man in armour', in *Collection of State Hermitage* (1974), issue XXXIX.

(Ivanov 1977) A. A. Ivanov: 'Kubachi bronze cauldron of the 14th century', in *Reports by the State Hermitage* (Leningrad 1977), issue LXII.

(Ivanov 1980) A. A. Ivanov: 'Faience dish of the 15th century from Mashhad', in *Reports by the State Hermitage* (Leningrad 1980), issue XLV.

(Ivanov 1981) A. A. Ivanov: 'On bronze items of the end of the 14th century from Khodja Akhmed Yasavi mausoleum', in *Central Asia and its neighbours in the ancient times and the middle ages (history and culture)* (Moscow 1981).

(Ivanov 1987) A. A. Ivanov: 'Persian inscriptions from Kubachi', in *Rivista degli studi orientali* (Roma 1987), vol. LIX, issue I-IV.

(Ivanov 1996) A. A. Ivanov: 'Central Asia: Metalwork 8th to 19th centuries', in *The Dictionary of Art* (London 1996), vol. 6.

(Ivanov 1996) A. A. Ivanov: 'Iranian and Daghestan cauldrons of the open type', in *Science conference in the memory of Alisa Vladimirovna Bank (1906-84), for the 90th anniversary, abstracts of the talks* (St Petersburg 1996).

(Ivanov 1997) A. A Ivanov: 'Iranian bronze cauldrons of open type', in *Oriental studies in the 20th century, achievements and prospects. Abstracts of the Papers CIS scholars for the 35th ICANAS, Budapest, July 7-12 1997* (Moscow 1997), vol. 1.

(Ivanov 1998) A. A. Ivanov: 'Central Asian Metalwork in the pre-Mongol Period', in *The Art and Archaeology of ancient Persia. New Light on the Parthian and Sassanian Empires* (London/New York 1998).

(Ivanov 1999) A. A. Ivanov: 'Iranian cauldrons of open type', in *Proceedings of the Arabic and Islamic Section of the 35th International Congress of Asian and North African Studies – ICANAS* (Budapest 1999), vol. II.

(Ivanov 2003) A. A. Ivanov: 'Applied Art: Metalwork, Ceramics and Sculpture', in *History of Civilization of Central Asia* (Paris/UNESCO 2003), vol. V.

(Ivanov 2004) A. A. Ivanov: 'A second Herat bucket and its congeners', in *Muqarnas* (Leiden 2004), vol. 21.

(Ivanov, *et al.* 1984) A. A. Ivanov, V. G. Lukonin, L. S. Smesova: *Jewellery of the East. Ancient and medieval periods* (Moscow 1984).

(Jacquemart 1862) A. Jacquemart: 'L'art dans les faïences hispano–moresques', in *Gazette des Beaux Arts* (March 1862).

(James 1977) D. James: *Arab Painting* (Bombay 1977).

(Karimzade 1991) M. A Karimzade-Tabrizi: *The Lives and Art of Old Painters of Iran* (London 1991), vols. I-III.

(Kerr 1990) R. Kerr: *Later Chinese Bronzes* (London 1990).

(Kesayev 1958) V. N. Kesayev and R. Kesati: 'A wooden carved door from Gur-i Mir', in *Works of the State Hermitage* (Leningrad/Moscow 1958), vol. II.

(Kilchevskaya 1959) E. V. Kilchevskaya and A. S. Ivanov: *The vernacular arts of Daghestan* (Moscow 1959).

(Kilchevskaya 1962) E. V. Kilchevskaya: *Decorative art of the aul Kubachi* (Moscow 1962).

(Kilchevskaya 1968) E. V. Kilchevskaya: *From representation to ornament* (Moscow 1968).

(Kilchevskaya 1973) E. V. Kilchevskaya: 'Art of the people of the Northern Caucuses', in *History of the art of people of the USSR* (Moscow 1973), vol. II.

(Klein 1925) V. Klein: *Foreign textiles in use in Russia before the 18th century and their terminology* (Moscow 1925).

(Komaroff 1992) L. Komaroff: *The Golden Disk of Heaven: Metalwork of Timurid Iran* (Costa Mesa 1992).

(Komaroff 2002) L. Komaroff and S. Carboni, eds: *The Legacy of Genghis Khan: Courtly Art and Culture in Western Asia 1256-1353* (New Haven/London 2002), exhibition catalogue.

(Kondakov 1891) N. P. Kondakov: *Index of the Middle Ages and Renaissance Department* (The Imperial Hermitage: St Petersburg 1891).

(Kondakov 1891) N. P. Kondakov: *Russian antiques in artefacts* (St Petersburg 1891), vol. IV.

(Korn 2003) L. Korn: 'Datierung durch Metallanalyze? Eine vergleichende Studie zu Bronzeobjekten und Kupfermunzen aus Ostiran und Zentralasien', in *Tribus* (Stuttgart 2003), no. 52.

(Krahl 2003) R. Krahl: 'Chinese Ceramics in Early Safavid Iran', in *Hunt for Paradise, Court Arts of Safavid Iran. 1501-76* (J. Thompson and S. R. Canby, eds) (New York/Milan 2003).

(Kroeger 1999) Kroeger: 'Fustat or Nishapur, Questions about Fatimid Cut Glass', in *L'Egypte Fatimide, son art et son histoire* (Paris 1999).

(Kryzhanovskaya 1926) N. A. Kryzhanovskaya: *Coptic candlesticks of the Hermitage* (Leningrad/State Hermitage Museum 1926), Leningrad 3.

(Kryzhanovskaya 1991) M. Ya. Kryzhanovskaya: 'Western European vernacular art of the Middle ages and Renaissance from the collection of A. P. Bazilevsky' in *Reports of the State Hermitage* (1991).

(Kubachi 1976) Kubachi: *Art of Kubachi.* (Leningrad 1976).

(Kube 1921) A. N. Kube: *Guide book of the department of the Middle Ages and Renaissance.* (The State Hermitage: St Petersburg 1921).

(Kube 1940) A. N. Kube: *Hispano-Mauritanian ceramics* (Moscow/Leningrad 1940).

(Kühnel 1963) E. Kühnel: *Islamische Kleinkunst* (Braunschweig 1963).

(Kuwait 1990) *Masterpieces of Islamic Art in the Hermitage Museum* (Kuwait 1990), exhibition catalogue.

(Kverfeldt 1940) E. K. Kverfeldt: 'Features of realism in the drawings on the textiles and rugs of the Safavid period', in *Works by the Oriental Department* (Leningrad 1940), vol. III.

(*La Perse et la France* 1972) *La Perse et la France: Relations diplomatiques et culturelles du XVIIe au XIXe siecle. Musee Cernuschi. Catalogue d'exposition* (Paris 1972), exhibition catalogue.

(Lane 1957) A. Lane: *Later Islamic Pottery* (London 1957).

(Lapkovskaya 1971) E. A. Lapkovskaya: *Applied art of the Middle Ages in the State Hermitage: Metalware* (Moscow 1971).

(Leningrad 1925) *Muslim East/Musulmanskij Vostok 1925, Exhibition* (Leningrad 1925), exhibition catalogue.

(Leningrad 1935) *Catalogue of the international exhibition of historic pieces of Iranian art and archaeology. State Hermitage* (Leningrad 1935), first issue, exhibition catalogue.

(Leningrad 1986) *West European applied art of the Middle Ages and the Renaissance from A. P. Bazilevsky's Collection. State Hermitage Museum* (M. Kryzhanovskaya ed.) (Leningrad 1986), exhibition catalogue.

(Lentz–Lowry 1989) T. W. Lentz and G. D. Lowry: *Timur and the Princely Vision: Persian Art and Culture in the Fifteenth Century. The Sackler Gallery, Smithsonian Institution, Washington DC and The Los Angeles County Museum of Art* (Washington DC 1989), exhibition catalogue.

(Linas 1886) Ch. de Linas: 'Les Emaux limousins de la collection Bazilevsky à Saint-Petersbourg. Le Tryptique de la Cathédrale de Chartres', in *Bulletin de la Societé scientifique, historique et archéologique de la Corrèze* (1886), 8, n2.

(London 1931) *Catalogue of the International Exhibition of Persian Art* (London 1931), exhibition catalogue.

(London 1976) *The Arts of Islam. Hayward Gallery. 8 April to 4 July 1976* (London 1976), exhibition catalogue.

(London 1982) *The Indian Heritage. Court Life and Arts under Mughal Rule* (London 1982), exhibition catalogue.

(London 2005) *Turks. A journey of a thousand years, 600-1600* (London 2005), exhibition catalogue.

(Loukonine–Ivanov 1996) V. G. Loukonine and A. A. Ivanov: *Persian Art* (St Petersburg: Bournemouth 1996).

(Maastricht 1994) *Treasures from the Hermitage, St Petersburg. The European Fine Art Fair. MECC. Maastricht, 12 to 20 March* (The Netherlands 1994), exhibition catalogue.

(Mammaev 1987) M. M. Mammaev: *On the influence of Islam on the pictorial creativity of the peoples of Daghestan: Artistic culture of medieval Daghestan* (Makhachkala 1987).

(Mammaev 1989) M. M. Mammaev: *Decorative applied art of Daghestan. Sources and formation* (Makhachkala 1989).

(Mango 1986) M. Mundell Mango: *Silver from Early Byzantium. The Kaper Koraon and Related Treasures* (Baltimore Maryland 1986).

(Marshak 1972) B. I. Marshak: 'A bronze jug from Samarkand', in *Central Asia and Iran* (Leningrad 1972).

(Marshak 1978) B. I. Marshak: 'Early Islamic bronze dishes (Syro-Egyptian and Iranian tradition in the art of the Caliphate)', *in Works of the State Hermitage* (Leningrad 1978), vol. 19.

(Marshak 1986) B. I. Marshak: *Silberschätze des Orients* (Leipzig 1986).

(Martin 1912) F. R. Martin: *The Miniature Painting and Painters of Persia, India and Turkey from the 8th to the 18th Century* (London 1912), 2 vols.

(Maskevich 1834) S. Maskevich: *Diary. 1594-1621* (St Petersburg 1834).

(Maslenitsina 1975) S. Maslenitsina: *The art of Iran in the Collection of the State Museum of the art of the peoples of the East* (Leningrad 1975).

(Mayer 1959) L. A. Mayer: *Islamic Metal-workers and their works* (Geneva 1959).

(Mecheti Samarkanda 1905) *Mosques of Samarkand* (Gur-Emir 1905), issue I.

(Meinecke 1976) M. Meinecke: 'Fayence-dekorationen seldsehukiseher Sakralbauten', in *Kleinasien* (Tübingen 1976), teil I-II.

(Meinecke-Berg 1999) V. Meinecke-Berg: 'Fatimid Painting: on Tradition and Style,' in *L'Egypt Fatimid. Son art et son histoire* (Paris 1999).

(Melikian-Chirvani 1970) A. S. Melikian-Chirvani: 'Le roman de Varque et Golshah. Essai sur les rapports de l'esthetique litteraire et de l'esthetique plastique dans l'Iran pre-mongol, suivi de la traduction du poeme', in *Ars Asiatique* (Paris 1970), XXII.

(Melikian-Chirvani 1982) A. S. Melikian-Chirvani: *Islamic Metalwork from the Iranian World* (London 1982).

(Melikian-Chirvani 1987) A. S. Melikian-Chirvani: 'Anatolian Candlesticks: the eastern element and the Konya school', in *Rivista degli studi orientali* (Roma 1987), vol. LIX.

(Migeon 1907) G. Migeon: *Manuel d'art musulman* (Paris 1907), t. II.

(Miller 1957) Yu. A. Miller: 'Dated 17th century tile from Khaleb', in *Communication of the State Hermitage* (Leningrad 1957), 12th issue.

(Miller 1972) Yu. A. Miller: *Artistic pottery of Turkey* (Leningrad 1972).

(München 1912) *Meisterwerke, Die Ausstellung von Meisterwerken muhammadanischer Kunst in München 1910* (München 1912), exhibition catalogue.

(Museum 1741) *Museum imperialis Petropolitani* (1741), vol. II, pars 1.

(Nagler 1996) G. K. Nagler: 'Die Monogrammisten' Bd. IV. (New York 1996), in *Enamels of Limoges 1100-1350, Metropolitan Museum of Art* (New York 1996), exhibition catalogue.

(Nedashkovskij 2000) L. F. Nedashkovskij: *The Golden Horde city of Ukek and its environment* (Moscow 2000).

(Orbeli 1938) I. A. Orbeli: *Albanian reliefs and bronze pots: Historic relics from the time of Rustaveli* (Leningrad 1938).

(Orbeli–Trever 1935) I. A. Orbeli and K. V. Trever: *Sassanid metalwork* (Leningrad 1935).

(Paris 1865) *Exposition de 1865. Union centrale des Beaux-arts appliqués à l'industrie. Musée rétrospectif* (Paris 1867), exhibition catalogue.

(Paris 1867) *Exposition universelle de 1867 à Paris. Catalogue général. Histoire du travail et monuments historiques* (Paris 1867).

(Paris 1878) *Exposition universelle de 1878 à Paris: Les Beaux-Arts et les arts décoratifs* (Paris 1879), 2 vols. (Louis Gonse, ed.), exhibition catalogue.

(Paris 1903) *L'exposition des Arts Musulmans* (G. Migeon, ed.) (Paris 1903), exhibition catalogue.

(Paris 1971) *Arts de l'Islam des Origines a 1700 dans les collections publiques francaises. Orangerie des tuileries* (Paris 1971).

(Paris 1977) *L'Islam dans les collections nationals* (Paris 1977), exhibition catalogue.

(Paris 2000) *L'Asie des steppes d'Alexandre le Grand à Gengis Khân* (Paris 2000), exhibition catalogue.

(Paris 2002) *L'Orient de Saladin. L'art des Ayyoubides* (Paris 2002), exhibition catalogue.

(Piotrovsky 1999) M. I. Piotrovsky: *Earthly Beauty, Heavenly Art: Art of Islam* (Amsterdam 1999).

(Piotrovsky 2001) M. I. Piotrovsky: *On Muslim art* (St Petersburg 2001).

(Piotrovsky 2005) M. I. Piotrovsky: 'Historical Legends of the Qur'an', in *Slavia* (St Petersburg 2005).

(Polovtsov 1913) A. A. Polovtsov: 'Notes on Muslim art (from his works in the Museum of Baron Stieglitz)', in *Olden Times* (October: St Petersburg 1913).

(Prague 1988) *Prag um 1600. Kunst und Kultur am Hofe Rudolfs II* (Essen 1988).

(Pritula 2004) A. D. Pritula: 'Arab artistic metalwork of the 13th century: problems of attribution', in *Report of the State Hermitage* (St Petersburg 2004), no. 62.

(Pyatnitsky 1996) Yu. A. Pyatnitsky: 'Melchite icons in the Hermitage Collection' in *Hermitage readings in memory of V .F. Levinson-Lessing* (1996)

(Pyatnitsky 1998) Yu. A. Pyatnitsky: 'Art of the Syro-Palestinian region', in *Christians in the East. Art of the Melchites and non-Orthodox Christians* (1998).

(Pyatnitsky 2006) Yu. A. Pyatnitsky: 'Pilgrims' eulogies from The Holy Land in The Hermitage Museum Collection (St Petersburg)' in *Eastern Christian Art in its Late Antique and Islamic Contexts* (Leiden 2006), vol. 2.

(Rabinovich 1988) M. G. Rabinovich: *Essays on the material culture of the Russian feudal town* (Moscow 1988).

(Raby 1981) J. Raby: 'Samson ans Siyah Qalam', in *Islamic Art* I (1981).

(Raby 1999) J. Raby: *Qajar Portraits* (London/New York 1999).

(Rapoport 1968) I. V. Rapoport: 'On one little known group of Iranian ceramics of the 18th century', in *CSH* (1968), issue 29.

(Rapoport 1969) I. V. Rapoport: 'Kerman ceramics with cobalt painting of the 16th to 18th centuries in the collection of the Hermitage', in *The works of the State Hermitage* (Leningrad 1969), vol. 10.

(Rapoport 1972) I. V. Rapoport: 'To the question on the Chinese influence in the ceramics of Iran ('Iranian celadons')', in *CSH* (1972), issue 34.

(Rapoport 1972a) I. V. Rapoport: 'Monochromatic ceramics of Iran in the 16th to 17th centuries with relief images. On the links between ceramics and miniature painting', in *Central Asia and Iran* (Leningrad 1972).

(Rapoport 1975) I. V. Rapoport: 'On one group of Iranian faience bottles', in *CSH* (1975), issue 40.

(Recklinghausen 1985) *Türkische Kunst und Kultur aus osmanischer Zeit* (Recklinghausen 1985), nos. 2/30, 2/31, exhibition catalogue.

(Rice 1953) D. S. Rice: 'Studies in Islamic Metalwork IV', in *BSOAS* (1953), XV/3.

(Rice 1957.1) D. S Rice: 'Two Unusual Mamluk Metal Works', in *BSOAS* (1957), XX.

(Rice 1957.2) D. S. Rice: 'Brasses of Ahmad al-Dhaki al-Mausili', in *Ars Orientalis 3* (1957).

(Rice 1958) D. S. Rice: 'Studies in Islamic Metalwork VI', in *Bulletin of the School of Oriental and African Studies* (London 1958), vol. XXI, pt. 2.

(Robinson 1966) B. W. Robinson: 'A Lost Persian Miniature' in *Victoria and Albert Museum Bulletin* (April 1966), vol. II, no. 2.

(Robinson 1967) B. W. Robinson. 'Lacquer Mirror-case of 1854', in *Iran* (1967), vol. V.

(Robinson 1970) B. W. Robinson: 'Persian Lacquer in the Bern Historical Museum', in: *Iran* (1970), vol. VIII.

(Robinson 1982) B. W. Robinson: 'A Survey of Persian Painting (1350-1896)', in *Art et societe dans le monde Iranien* (Paris 1982).

(Robinson 1992) B. W. Robinson: *L'Oriend' un collectionneur. Miniateres persanes, textiles, ceramiques, orfevrerie rassembles par ajean Pozzi* (Geneve 1992).

(Robinson 2002) B. W. Robinson. *The Persian Book of Kings. An Epitime of the Shahnama of Firdawsi* (London 2002).

(Rogers 1973) M. Rogers: 'The Eleventh Century: a Turning Point in Mashriq Architecture?', in *Papers on Islamic History III: Islamic Civilization 950-1150* (Oxford 1973).

(Rogers 1988) J. M. Rogers, K. Cig, S. Batur and C. Koseoglu: *Topkapi Architecture: the Harem and other buildings* (London 1988).

(Rogers 1989) M. Rogers: 'Ceramics', in *The Arts of Persia* (R. W. Ferrier, ed.) (Yale University Press: New Haven/London 1989).

(Rogers 1990) J. M. Rogers: 'Siyah Qalam', in *Persian Masters: Five Centuries of Painting* (S. R. Canby, ed.) (Marg Publications 1990).

(Ross 1962) M. C. Ross: *Catalogue of the Byzantine and Early Mediaeval Antiquities in the Dumbarton Oaks Collection* (Washington 1962), vol. 1.

(*Royal Persian Paintings* 1998) : *Royal Persian Paintings. The Qajar Epoch 1785-1925* (L. S. Diba, ed. with M. Ekhtiar) (London 1998).

(Rupin 1890) E. Rupin: *L'oeuvre de Limoges* (Paris 1890).

(St Petersburg. 1905), table 13.

(St Petersburg 1992) O. Ya. Neverov: *From the Collection of Peter the Great's Kunstkammer* (St Petersburg 1992), exhibition catalogue.

(St Petersburg 1996) *Treasures of the Ob River Region* (St Petersburg 1996), exhibition catalogue.

(St Petersburg 1996a) *Peter I and Holland* (St Petersburg 1996), exhibition catalogue.

(St Peterburg 1998) *Christians in the East. Art of the Melchites and non-Orthodox Christians* (St Petersburg 1998), exhibition catalogue.

(St Petersburg 2000) *Earthly Art, Heavenly Beauty. Art of Islam* (St Petersburg 2000), exhibition catalogue.

(St Petersburg 2004) *Iran at the Hermitage. The formation of the collections* (St Petersburg 2004), exhibition catalogue.

(Salmony 1943) A. Salmony: 'Daghestan sculptures', in *Ars Islamica* (Ann Arbor 1943), vol. X.

(Shchukin 1907) P. I. Shchukin. *Persian items of the Shchukin Collection* (Moscow 1907).

(Sims 1976) E. Sims: 'Five Seventeenth-century Persian Oil Paintings', in *Persian and Mughal Art* (B. W. Robinson, T. Falk and E. Sims, eds.) (London 1976).

(Sims 2002) E. Sims, B. Marshak and E. J. Grube: *Peerless Images. Persian Painting and its Sources* (New Haven/London 2002).

(Sobolev 1934) N. N. Sobolev: *Essays on the history of fabric decoration* (Moscow/Leningrad 1934).

(Sobranie M. P. Botkin 1911) Botkin: *M. P. Botkin Collection* (St Petersburg 1911).

(Sotheby's 1992) *Sotheby's. Islamic and Indian Art, Oriental Manuscripts and Miniatures. London, Thusday 22nd and Friday 23rd Oct. 1992* (London 1992), auction catalogue.

(Soucek 1978) P. P. Soucek: *Islamic Art from the University of Michigan Collections* (Ann Arbor 1978).

(Stchoukine 1964) I. Stchoukine: *Les peintures des manuscrits de Shah Abbas I-er a la fin des Safavis* (Paris 1964).

(Stockholm 1985) *Islam. Art and Culture* (Stockholm 1985), exhibition catalogue.

(Strzygowski 1904) J. Strzygowski: *Koptische Kunst, Catalogue. Generaldes antiquites Egyptiennes du Musee du Caire* (Vienna 1904).

(*Survey* 1939) *A Survey of Persian Art* (London/New York 1939), vol. VI.

(Sycheva 1984) N. Sycheva: *Jewellery decorations in the peoples of Central Asia and Kazakhstan* (Moscow 1984).

(Thackston 1989) W. M. Thackston: *A Century of Princes: Sources of Timurid History and Art* (Cambridge, Mass. 1989).

(Trever 1959) K. V. Trever: *Essays on the history and culture of Caucasian Albania of the 4th century BCE to 7th century CE* (Moscow/Leningrad 1959).

(Turku 1995) *Islamic Art Treasures from the Collections of the Hermitage. 16.06-10.09.1995* (Turku 1995), exhibition catalogue.

(Ukhanova 1990) I. N. Ukhanova: 'The coconut in the art of Russian craftsmen of the 17th to 19th centuries from the Hermitage Collection', in *Cultural inheritance. New discoveries. Annual 1990* (Moscow 1992).

(Uluc 2000) L. Uluc: *Arts of the Book in Sixteenth Century Shiraz* (New York University, 2000), dissertation.

(van de Put 1911) A. van de Put: *Hispano-Moresque Ware* (London 1911).

(Veimarn 1974) B. V. Veimarn: *The art of the Arab countries and Iran of the 7th to 17th centuries* (Moscow 1974).

(Venice 1994) *Eredita dell'Islam. Arte islamica in Italia. A cura di Giovani Curatola* (Venecia 1994), exhibition catalogue.

(Veselovsky 1900) N. I. Veselovsky: *The history of the Imperial Russian archaeo-logical society of the first fifty years of its existence in 1846-1896* (St Petersburg 1900).

(Veselovsky 1905) N. I. Veselovsky: *Mosques of Samarqand. I. Mosque Gur-Emir* (1905).

(Ward 1989) R. Ward: 'Metallarbeiten der mamluken-zeit, hergestellt für den export nach Europa', in *Europe und der Orient 800-1900* (G. Sievernich, and H. Budde, eds) (Berlin 1989).

(Ward 1993) R. Ward: *Islamic Metalwork* (London 1993).

(Ward 1998) R. Ward: 'Glass and brass: parallels and puzzles', in *Gilded and Enamelled Glass from Middle East* (Rachel Ward, ed.) (London 1998).

(Ward 1999) R. Ward: 'The Baptistere du Saint Louis – a Mamluk Basin made for Export to Europe', in *Islam and the Italian Renaissance. EDP, Autumn 1999* (1999).

(Watson 1998) O. Watson: 'Pottery and glass: lustre and enamel', in *Gilded and Enamelled Glass from Middle East* (Rachel Ward, ed.) (London 1998).

(Watson 1999) O. Watson: 'Fritware: Fatimid Egypt or Saljuq Iran?', in: *L'Egypt Fatimide. Son art et son histoire* (Paris 1999).

(Watson 2004) O. Watson: *Ceramics from Islamic Lands: The al-Sabah Collection, Dar al-Athar al-Islamiyyah, Kuwait National Museum* (London 2004).

(Welch 1973) A. Welch: Shah Abbas and the Arts of Isfahan (The Asia Society 1973).

(Weitzmann, *et al.* 1979) K. Weitzmann, ed.: *Age of Spirituality. Late Antique and Early Christian Art, third to seventh century* (New York 1979), catalogue of the exhibition at the Metropolitan Museum of Art.

(Wien 1998) *Schaetze der Kalifen. Islamische Kunst zur Fatimidenzeit* (Wien 1998).

(Wiet 1932) G. Wiet: *Catalogue general du Musée Arabe du Caire. Objects en Cuivre* (Caire 1932).

(Wulf 1909) O. Wulf: *Altchristliche und Mittelalterliche Byzaninische und Iitalienische Bildwerke, Teil i: Altchristliche Bildwerke, Beschreibung der Bildwerke der Christlichen Epochen, Konigliche Museen zu Berlin* (Berlin 1909), band III, teil I.

(Yakubovsky 1933) A. Yu. Yakubovsky: *Samarkand under Timur and the Timurids* (Leningrad 1933).

(Zebrowski 1997) M. Zebrowski: *Gold, silver and bronze from Mughal India* (London 1997).

(Zigulski 1988) Z. Zigulski: *Sztuka Turecka* (Warsaw 1988).